Common Ground / Uncommon Vision

Common Ground/Uncommon Vision

The Michael and Julie Hall Collection of American Folk Art

in the Milwaukee Art Museum

This exhibition and catalogue sponsored by Lila Wallace - Reader's Digest Fund

Milwaukee Art Museum	April 16 - June 20, 1993
Nelson-Atkins Museum of Art	July 18 - September 5, 1993
Albright-Knox Art Gallery	November 12 - January 2, 1994
Phoenix Art Museum	March 5 - May 15, 1994
Delaware Art Museum	June 10 - September 4, 1994
Abby Aldrich Rockefeller Folk Art Center	October 3, 1994 - January 2, 1995

This exhibition and catalogue sponsored by Lila Wallace - Reader's Digest Fund

Additional funding provided by the National Endowment for the Arts.

ISBN 0-944110-33-9

Library of Congress Cataloging-in-Publication Data
Milwaukee Art Museum.
Common ground/uncommon vision: the Michael and Julie Hall Collection of American folk art / [Milwaukee Art Museum: essays by Lucy Lippard, Jeffrey Hayes, Kenneth Ames; introduction by Russell Bowman].
p. cm.
Milwaukee Art Museum, April 16-June 20, 1993: Nelson-Atkins Museum of Art, July 18-September 5, 1993 and others.
Includes bibliographical references and index.
ISBN 0-944110-33-9 (softcover): $45.00
1. Folk art — United States — Exhibitions. 2. Hall, Michael D. — Art collections — Exhibitions.
3. Hall, Julie — Art collections—Exhibitions. 4. Folk Art — private collections — Wisconsin — Madison — Exhibitions.
5. Milwaukee Art Museum— Exhibitions.
I. Lippard, Lucy R. II. Hayes, Jeffrey Russell. III. Ames, Kenneth L. IV. Title.
NK805.M55 1993 93-95442
745'.0973'07477595—dc20 CIP

Book production coordinated by Mary Garity LaCharite
Designed by John Irion and Susan Marie Kujawa
Color photography and pp. 148, 229, 234, 266, 268, 296 by John Nienhuis/Lighting by Jeff Salzer
Black and white photography by Efraim Le-ver
Films and color separations by Silver Eagle Graphics. Printing by Burton & Mayer, Inc.
Manufactured in the United States of America

Front cover: *The Newsboy* (Trade sign for the *Pawtucket Record* newspaper, cat. no. 30), Anonymous, 1888
Back cover: *Lynx* (cat. no. 193), Felipe Archuleta, 1976

The Michael and Julie Hall Collection of American Folk Art
was acquired through the gift of

Joseph and Ellen Checota

Friends of Art

Jane and Lloyd Pettit Foundation

Kohler Foundation

Marianne and Sheldon B. Lubar

Joan M. Pick

Evan and Marion Helfaer Foundation

Kenneth and Audrey Ross

with additional support from

Donald and Barbara Abert Fund
in the Milwaukee Foundation

Donald and Donna Baumgartner

Richard and Erna Flagg

Jane and George Kaiser

the Laskin Family

Stackner Family Foundation

Robert and Jo Ann Wagner

BDO Seidman

and Johnson Foundation

Contents

Contents

Preface

The acquisition and exhibition of the Michael and Julie Hall Collection of American Folk Art is the single most important event in the history of the Milwaukee Art Museum's involvement with American folk art. The museum's commitment to the field began as early as 1951 with the gifts of two works by contemporary self-taught Wisconsin artist Anna Louisa Miller. However, it was during the 1960s and 1970s that the collection of folk art material significantly expanded under the leadership of Tracy Atkinson (director from 1962 to 1976). A number of important works on paper were purchased in 1963, followed by a major group of Shaker furniture and objects in 1966, an Ammi Phillips portrait also in 1966, and a Wilhelm Schimmel eagle in 1967. During the 1970s, John Kane's *Bust of a Highlander*, a calligraphy work by James Gibbs, and a number of important textiles entered the collection. Nineteenth-century holdings were further enhanced in 1981 with the important gift of twenty-five works from the estate of Edgar William and Bernice Chrysler Garbisch. With the museum's 1981 organization and circulation of an exhibition drawn from the well-known collection of Herbert W. Hemphill Jr., now in the National Museum of American Art at the Smithsonian Institution, the permanent collection began to embrace the twentieth-century and contemporary material that Hemphill recognized and introduced in his 1974 book *Twentieth-Century Folk Art and Artists*. Works by twentieth-century artists added to the collection during the 1980s included, among others, Lawrence Lebduska, Ralph Fasanella, Joseph E. Yoakum, Eddie Arning, Felipe Archuleta and three self-taught artists from Wisconsin, Simon Sparrow, Josephus Farmer and "Prophet" William J. Blackmon. These acquisitions over a period of some thirty years gave the Milwaukee Art Museum a representative selection of both traditional folk art from the nineteenth century and the more individualistic, even visionary, expressions of the twentieth century.

The stage was set, then, for consideration of a major commitment to the expansion of the collection. Michael and Julie Hall had been friends of the Milwaukee Art Museum since Michael Hall interviewed Bert Hemphill for the catalogue of the exhibition organized in 1981. When the Halls approached the museum in 1988 (the museum's centennial year) with the idea of a partial purchase/partial gift arrangement to bring the collection into an institutional setting, the museum leadership — under then President of the Board of Trustees Susan M. Jennings and the Acquisitions and Collections Committee — enthusiastically committed to developing the necessary funding. Happily, a number of far-sighted and generous patrons throughout the community joined forces to make the acquisition possible. They are listed after the title page of this publication, and the museum owes the acquisition of one of the nation's foremost collections of American folk art to the generosity of these donors and to that of the Halls. I would particularly like to cite Joe and Ellen Checota and the museum's Friends of Art for their extraordinary support of this project. The Checotas made the initial contribution to this effort and committed to raise an equal amount. Their efforts will be recognized with the naming of the permanent gallery housing the Hall Collection as the Joseph and Ellen Checota Gallery. The Friends of Art, the museum's major support group for acquisition fund-raising, devoted parts of their proceeds over three years to this project, representing the enthusiastic support of hundreds of volunteers at myriad events.

The Hall Collection was appealing to the museum not only for the reputation it carried among folk art enthusiasts and scholars as one of the nation's most important, but also because of the breadth of the material and the extraordinary care and discernment with which it was put together. Trained as artist and art historian respectively, Michael Hall and Julie Hall approached the collection with both the passion of true collectors and a grounding in professional assessment and appreciation of the material. As is evident from this publication — which represents not only those objects chosen for the traveling exhibition but also a catalogue of the entire collection as it exists in the museum today — the Hall Collection represents most of the traditional categories of folk art, i.e., portraits, still lifes, views, trade signs, weathervanes, ceramics, canes, lodge paraphernalia, whirligigs, and much more. In addition, it includes many of the best known artists to have emerged in the twentieth century, such as John Scholl, Wil Edmondson, Martin Ramirez, Elijah Pierce, Edgar Tolson, Sister Gertrude Morgan, Reverend Howard Finster and many others. The Hall Collection then, particularly with its emphasis on sculpture, was the ideal complement to the

already existing permanent collection. With its entry into the twentieth century, it also complemented the major collection of Haitian naïve art which had been on loan to the museum since 1975 and which was given by Richard and Erna Flagg in 1991.

I am grateful to the Halls, first for bringing the collection to the attention of the Milwaukee Art Museum, and second for their generous contribution of a portion of its value. Both Michael Hall and Julie Hall have given unstintingly of their time and their accumulated body of information about the objects in the collection. My profound appreciation is also extended to all the donors who made the acquisition of the collection possible. Without their vision, generosity and support, this collection could not have found its home in Milwaukee. Their contributions to the museum and the community are immeasurable. The advice of many individuals helped guide the project from the very beginning, including that of Kenneth L. Ames, chief of historical and anthropological surveys and state historian, New York State Museum, Albany; Ramona Austin, assistant curator for African art, Art Institute of Chicago; the late Robert Bishop, former director of the Museum of American Folk Art, New York; Joanne Cubbs, director of special projects, John Michael Kohler Arts Center, Sheboygan, Wisconsin; Lynda R. Hartigan, associate curator, National Museum of American Art, Smithsonian Institution, Washington, D.C.; and Eugene W. Metcalf, associate professor of interdisciplinary studies, Miami University of Ohio. The knowledge and insight they so generously shared was greatly appreciated.

My colleagues in the organization of this exhibition and publication must also be acknowledged. Jeffrey R. Hayes, associate professor of art history at the University of Wisconsin-Milwaukee, acted as consulting curator for this project, bringing not only his keen interest in folk art and his knowledge of American art, but also providing guidance to the group of graduate students at the University of Wisconsin-Milwaukee who worked so diligently on researching parts of the collection and providing the entries for this catalogue. I would especially like to thank Julia Guernsey for her herculean efforts in organizing the materials submitted by the various authors, writing many entries, and editing all of the manuscripts. Julia also had a central role in the submission of the grant in support of this exhibition and the organization of the symposium in conjunction with it. As project coordinator, she has truly

been a co-participant in the realization of this exhibition and catalogue.

Deep appreciation goes to the Lila Wallace-Reader's Digest Fund for their extraordinary support for this project. Without it, the conservation of many of the objects, the creation of the exhibition and book in their present form, the symposium, and the many other educational materials surrounding this exhibition would not have been possible. I would particularly like to acknowledge Selwyn Garroway of their staff for his advice and encouragement. We are grateful, too, for the support of the National Endowment for the Arts in the planning process for this exhibition, and to the Institute of Museum Services for a conservation grant allowing us to conserve a number of the objects. Finally, I would like to thank the leadership of the participating institutions for their commitment to the national tour: Marc Wilson, director, and Ellen Goheen, administrator for special exhibitions, at the Nelson-Atkins Museum of Art; Douglas G. Schultz, director of the Albright-Knox Art Gallery; James K. Ballinger, director of the Phoenix Art Museum; Stephen T. Bruni, director, and Rowland Elzea, curator, at the Delaware Art Museum; and Carolyn J. Weekley, director, and Barbara Luck, curator, at the Abby Aldrich Rockefeller Folk Art Center.

Common Ground/Uncommon Vision: The Michael and Julie Hall Collection of American Folk Art is intended to honor the vision of the Halls in the formation of the collection, the donors in bringing the collection to the Milwaukee Art Museum and, finally, the artists, both known and unknown, who have, without benefit of academic training, produced a singular art.

Russell Bowman

Acknowledgments

An exhibition and publication of the scope of *Common Ground/ Uncommon Vision* requires the efforts of many people, both outside the institution and on the museum staff. First, we must extend thanks to all of the gallery owners, dealers, collectors, and friends and family of the artists represented in the Hall Collection who generously responded to our inquiries — their insights contributed greatly to our understanding of the artists and their work. Although too numerous to list here, each individual is credited within the catalogue entries or footnotes.

Among the researchers from the University of Wisconsin-Milwaukee associated with the catalogue, mention must first be made of Debra Brindis who, from the very inception of the project, assisted in a range of capacities that included extensive research, the authorship of entries, and artistic supervision of black and white photography. Object files rapidly developed under the guiding hand of Barbara Urich. Margaret Andera, Kathleen Battles, Suzanne Ford, Jennifer Hachemi, Gina Kallman, Katharine Malloy, Mary Plaski, Daniel Shyu, Barbara Urich, and Linda Van Sistine, all art history graduate students at the University of Wisconsin-Milwaukee, contributed their research skills and writing abilities in formulating the catalogue entries.

On the museum staff, Leigh Albritton, registrar, coordinated the transportation and storage of the multitude of objects. Dawn Frank, registrar's assistant, organized photographic files and assisted with photography. The administrative skills of Megan Powell were greatly appreciated, as were those of Jessie Winecki who carefully organized the acquisition of catalogue reference photos. Likewise, the procurement of countless folk art books and resources was handled by librarian Suzy Weisman.

Confronting conservation issues specific to this material, Jim DeYoung, associate conservator, treated all two-dimensional works, and was instrumental in obtaining grants for conservation and storage facilities. Consulting conservator Christine Del Re performed extensive object conservation, and advised Demetra Copoulos, who coordinated object preparation for photography and designed sculpture shipping trays. Assisting with conservation treatment was Therese White.

Editing and production of this catalogue was orchestrated by Mary Garity LaCharite, director of design and publications. The catalogue design was created by Sue Kujawa and John Irion, who was also responsible for the exhibition design. Karl Janssen designed the handsome catalogue cover and exhibition poster. Color photography was masterfully executed by John Nienhuis, with lighting and technical assistance from Jeff Salzer, and the black and white photography was proficiently rendered by Efraim Lev-er.

As always, Lawrence Stadler, facilities manager, and his staff were stalwart in the face of diverse presentation demands. Joseph Kavanaugh, lead technician, organized the set-up of objects for photography with the able assistance of John Dreckman. David Moynihan, with the help of David DeSalvo, created the object crates for shipping. And the support of technicians Joseph Boblick, Patrick Burke, and Edgar Jeter contributed to a well-coordinated exhibition.

Interpretation of the exhibition and catalogue was organized by the education department under the supervision of Barbara Brown Lee, director of education. Coordination of all media was the responsibility of Dedra M. Walls, with the assistance of Ariana Huggett, and Sharon Steinmetz arranged school programming.

Special thanks must also be extended to Fran Serlin-Cobb, director of audience development, and Nancy Riege, audience development assistant, for their expert direction of all marketing activities. Likewise, Nancy McDonald, director of communications, and Katie Barron, communications assistant, efficiently coordinated all press, advertising and public relations affairs. And lastly, the entire project could never have progressed without the assiduous grant-writing efforts of Vicky Hinshaw, grant consultant.

It is with deep gratitude that we acknowledge the contributions of all these individuals to the realization of this project.

Russell Bowman, Jeffrey R. Hayes, Julia Guernsey

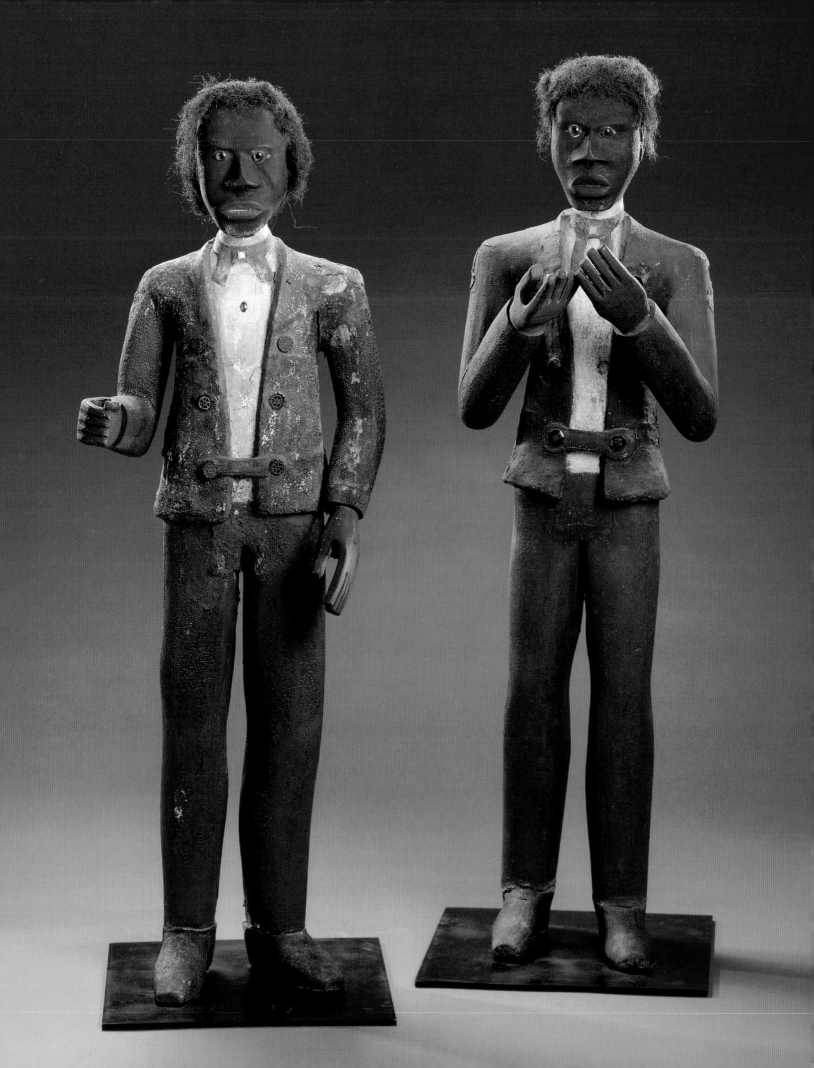

Introduction: A Synthetic Approach to Folk Art

Russell Bowman

Several recent publications indicate that the "term warfare" that has long surrounded the folk art field is far from over. In their introduction to the recent edition of *Folk Art and Art Worlds*, John Michael Vlach and Simon T. Bronner review a number of publications since 1980 and conclude that the lines of battle are, if anything, more tightly drawn. They cite with approbation a number of recent studies that treat folk art within a cultural context. In this they hew very closely to the original definition of folk art as it issued from anthropologists in the late nineteenth century: folk art is the production of untrained artisans working within a framework of tradition and shared communication within isolated cultures. While Vlach, Bronner and their colleagues, who explore folk art from an anthropological, material culture or folklore stance, would undoubtedly apply this definition more broadly to include the diversity present in all cultures and perhaps even to so-called vernacular or popular culture, the essential definition of folk art as the expression of self-taught creators within their cultural milieu remains.[1] As to the opposing point of view, the recent exhibition and catalogue for *Parallel Visions: Modern Artists and Outsider Art* can be seen as symptomatic of the tendency to view the production of untrained artists formally or aesthetically and wrench them from any cultural context. Calling the show another *"Primitivism" in Twentieth-Century Art* (referring to the 1984 Museum of Modern Art exhibition that presented African and Oceanic art in conjunction with the modern art that had been inspired by it), critic Christopher Knight attacks the exhibition as the worst sort of historical relativism — lifting the production of self-taught artists out of their particular histories and backgrounds based on the work's similarity to or possible inspiration of academically trained fine artists.[2]

For his part, the curator of *Parallel Visions*, Maurice Tuchman, argues that the interest of fine artists in the work of untutored, eccentric, and even insane artists has a long and influential history within the development of modern art. Growing out of the Romantic infatuation with exotic cultures, the Impressionists' interest in Japanese art and Gauguin's voyage to Tahiti, the developing ideal of primitivism involved the search not only for new artistic solutions, but also for a kind of universal expression unfettered by the conventions of Western thought. In the twentieth century the quest for both formal stylization and primal expression extended from Picasso's admiration for African art to Kandinsky's interest in Bavarian folk art and the art of children, to the study of the art of the insane by Klee, the Surrealists and Dubuffet. *Parallel Visions* followed this tradition into recent years with an appraisal of the Chicago Imagists' inspiration by folk and so-called outsider art, and the involvement of contemporary German and Austrian artists such as Georg Baselitz, A. R. Penck and Arnulf Rainer with the work of institutionalized artists.[3] Although the thesis of the exhibition weakened in the contemporary area where the influence seemed either inferred by the curators or clichéd on the part of the artists, the exhibition traced what is undoubtedly a significant, even formative, tradition within modern art.

While *Parallel Visions* focused on the extreme end of this tradition, on untrained artists on the fringes of society or romanticized as such, the same tradition of primitivism applies to the introduction of folk art into the American consciousness. As frequently cited, American folk art was "discovered" not by anthropologists but by artists. In the late 1910s, a number of American artists including Robert Laurent, Bernard Karfiol and William Zorach, worked at the summer art colony sponsored by Hamilton Easter Field near Ogunquit, Maine. They discovered that Field had decorated their cottages with the limner portraits, weathervanes and simple furniture indigenous to the area. Having absorbed the lessons of the 1913 Armory Show but stung by the criticism of that show as dominated by Europe, these artists and others such as Elie Nadelman and Yasuo Kuniyoshi saw folk art as an acceptable American precedent for the formal stylization they were adopt-

Unidentified Artist, *Pair of Black Figures*, ca. 1880 (cat. no. 194a, b)

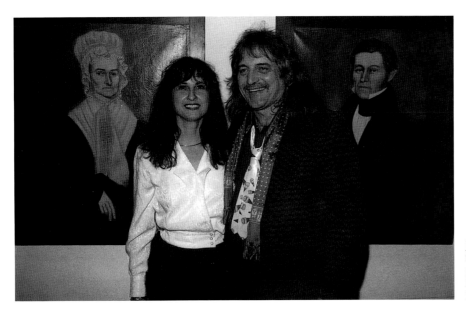

Julie and Michael Hall in front of Erastus Salisbury Field's *Pair of Portraits* during the preview exhibition of the Hall Collection, Milwaukee Art Museum, March, 1990. Photo by Stanley Ryan Jones.

ing from modernism. Following their example, early folk art dealers, collectors and curators tended to emphasize traditional fine art media such as painting and sculpture and value the formal devices already accepted by modernism. The development of this tradition, begun during the Depression years when America's isolationism and search for roots reinforced an investigation of indigenous material, extended from Holger Cahill's pioneering shows to early dealer Edith Halpert's advising Abby Aldrich Rockefeller to the important publications by Jean Lipman, Nina Fletcher Little, Adele Earnest, Mary Black and others from the 1940s through the 1970s. All these figures valued folk art for formal qualities they already appreciated in modern art and added a patriotic gloss of folk art as representative of America's common man.[4] These attitudes continue to the present day in exhibitions such as *Five Star Folk Art: One Hundred American Masterpieces*, organized for the Museum of American Folk Art by Jean Lipman and Robert Bishop. In fact, Lipman's foreword is entitled "A Concept of Quality."[5] Vlach, Bronner and others argue that this aestheticizing approach is precisely what undercuts the study of folk art as an expression of the cultures that produce it.[6] And it cannot be denied that shows like *Parallel Visions* accept folk/outsider art in terms of an aesthetic or formal appreciation based on its similarities to and inspiration of fine art.

How then are we to look at folk art? And how do these varying approaches apply to both the formation and the understanding of the collection assembled by Michael and Julie Hall? These questions are further complicated by the fact that the Hall Collection has now entered the Milwaukee Art Museum and, by its institutionalization in a general art museum, has taken on a role of defining cultural artistic standards. This publication seeks to address these issues while fully cognizant that it cannot resolve them. The general thrust of this catalogue is to attempt to integrate or synthesize the principles of anthropology and material culture with those of art history and criticism in addressing folk art.

This catalogue and the exhibition it documents, then, combine contextual information and artistic assessment when confronting the range of objects in the Hall Collection. First, the collection is placed in the context of the collectors themselves, and the interviews with Michael and Julie Hall reflect their understanding of the collection's development and its goals. Second, a series of essays investigates varying perspectives on folk art, especially in the twentieth century, and how these viewpoints may be embodied in the Hall Collection. Critic Lucy R. Lippard addresses ethnicity and how its impact enriches both our art and our culture. Consulting curator Jeffrey R. Hayes examines the treatment (or non-treatment) of folk art within American art history and applies a synthetic

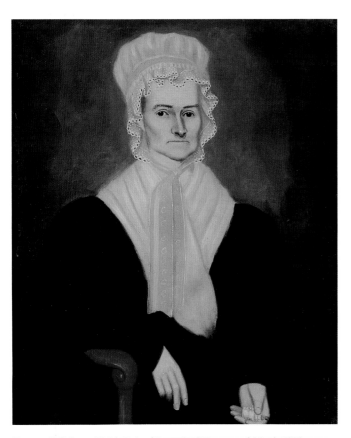
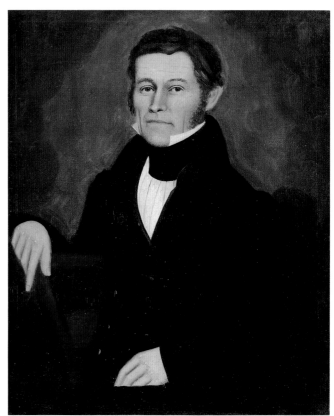

Erastus Salisbury Field, *Pair of Portraits (Woman and Man)*, 1833
(cat. no. 1a, b)

analysis to specific items in the Hall Collection. He argues that such a combined approach to both folk and fine art leads to a breakdown of artificial barriers between them and to a unified history of American art. In perhaps the most polemical and provocative essay in the series, cultural historian Kenneth L. Ames raises some challenging questions about the assumptions underlying the Halls' approach to collecting and, indeed, the motivations and meaning behind the absorption of the collection into the museum setting. All these interviews and essays direct their multiple perspectives — personal, ethnic, historiographic and cultural — toward a full contextual understanding of folk art and its role in culture today. Finally, the organization of the entries under categories of media, function and subject matter as well as the integration into the individual entries of biographical, contextual and critical assessment attempts to apply a fully synthetic evaluation to each object.

The Halls' process of collecting made it possible to approach the collection in terms of a synthetic evaluation. Both trained in art, they first tended to look at folk art with eyes attuned to modern art and its involvement with primitivism. Also, Michael Hall is a sculptor (working in a welded Constructivist-inspired mode keyed to his interest in vernacular forms such as grain elevators, fuel tanks, and storage buildings), and it was perhaps inevitable that he would be drawn to sculptural expression. Julie Hall wrote *Tradition and Change: The New American Craftsman* in 1977, and it is not surprising that it was she who first responded to and sought out the work of Edgar Tolson at a Kentucky craft fair. The Halls' chance meeting with collector Herbert Hemphill in 1968 undoubtedly reinforced their aesthetic disposition because, while Hemphill unquestionably did much to expand the area of folk art to include objects produced in the twentieth century, he did so from a point of view fully informed by his early art training, his

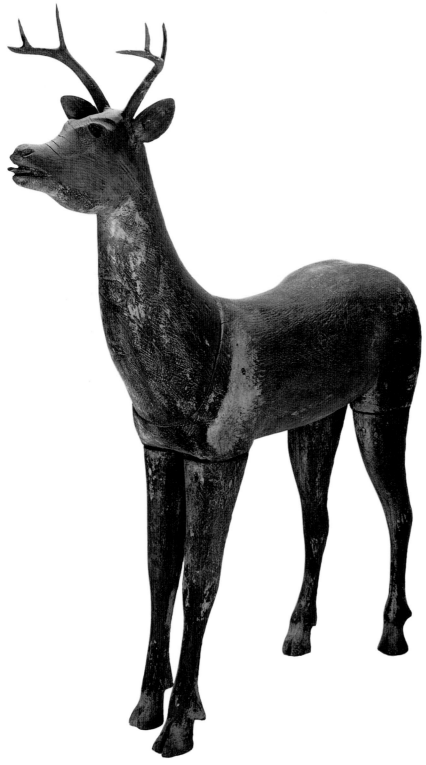

Unidentified artist, *Deer*, ca. 1880 (cat. no. 28)

interest in collecting African and Precolumbian art and his involvement with the classic collectors and historians of folk art in the 1950s and 1960s.[7] As expressed in his 1974 book *Twentieth-Century Folk Art and Artists*, Hemphill's responses (at a time when he was probably closest to the Halls) were primarily formal. He states in the introduction written with Julia Weissman:

> "In this century, in the period after World War I and particularly in the last thirty years, the folk artist is often . . . coming from . . . another direction: that of aesthetic or creative drive alone rather than, and quite separate from, utilitarian intent"[8]

Interestingly, the Halls, through their programmatic study of the folk art field, both under Hemphill's tutelage and on their own, turned toward an exploration of some of the more traditional categories of American folk art. The great early pair of nineteenth-century portraits by Erastus Salisbury Field unquestionably fulfills the "classic"

definition of folk art propounded by Lipman and others. Utilitarian forms such as weathervanes, whirligigs, decoys, canes, ceramics and others were also sought out. While the Halls' acquisition of such utilitarian objects may have initially been an effort to fill the various expected categories, these collections within the collection eventually assumed additional meaning for the Halls. During the 1980s, probably through their reading and their friendship with American studies scholars such as Ames and Eugene Metcalf, they began to appreciate the social, economic, and even political contexts of some of these objects.[9] At the same time, the Halls remained very aware of individual artists and their distinctive visions — first through their acquaintance with Tolson, then meeting and befriending Elijah Pierce. While to the Halls these artists first seemed absolutely isolated innovators, they gradually came to understand them as representative of their respective Appalachian and African American cultures and as exemplars of a distinctive brand of Christian fundamentalism which crossed geographic and racial borders. As expressed in his

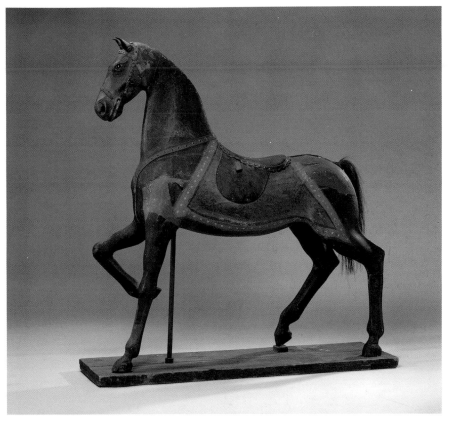

Unidentified Artist, *Horse*, ca. 1880 (cat. no. 29)

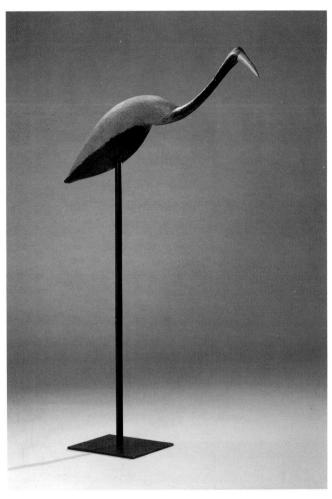

Unidentified Artist, *Great Blue Heron*, ca. 1900 (cat. no. 72)

make it ideal for a museum setting and the kind of study initiated here.

The test of any collection, though, is the ability of the objects in it to expand our notions both of art and the culture that produced it. Certainly the Hall Collection offers ample opportunities to achieve this synthetic understanding. The late nineteenth-century *Newsboy*, justifiably iconic in recent histories of folk art, is functional as a trade sign; as an expression of cultural ideals of hard work, competitiveness, and pursuit of the American Dream; and as vital and active sculptural form. Although we cannot assume the formal elements were a part of the intention of the now unknown maker, we know enough about the work's period and location to grasp something of the meaning it must have had for the citizens of Pawtucket, Rhode Island, at the end of the century. Similarly, *Miss Liberty*, erected as a lawn ornament or holiday decoration, expresses and extends a national tradition of liberty figures, and has a scale and totemic simplicity of form that makes it distinctive within folk sculpture. The Hall Collection abounds with traditional forms of folk art that can be seen aesthetically: the verve of trade signs from the rhythmic *Horse* to the subtly carved *Deer*; the elegant simplicity of the *Heron* and the rustic power of the *Root Head Goose* (especially appealing in terms of the twentieth-century interest in found object sculpture); the imaginative symbolism and form of face jugs and canes; and crank toys and whirligigs such as *The World of Work* and *The Sport World* expressive of commonly held cultural values. More individual expressions range from the religiously inspired visions of Pierce, Tolson, Wil Edmondson, John Perates, Sister Gertrude Morgan, and Howard Finster; to the very personal visions of Ramirez, Joseph Yoakum, Lee Godie and Ted Gordon. All of these works and many more in the Hall Collection combine aspects of the artist's lived experience, his or her cultural surround and a distinctive formal invention. Though they are not always created for a group, and often interact with the twentieth century's popular and media cultures, they are created by untutored artists who reflect an aspect of their culture; they are folk art. Because they incorporate a powerful and original formal vocabulary to express the artists' cultural or personal ideals, they are art. Despite being non-participants in the dialectical history of what defines art, they do participate in the dialectic of the broader culture and deserve to be seen on a par with any meaningful artistic expression.[12]

writings, Michael Hall came to see these figures as singular artists who took the elements of their cultures and evolved them into highly original artistic expressions.[10] He admits to being slow to take up the outsider cause, partly because it seemed to him to be beyond existing folk categories. However, he not only made the leap to an appreciation of Martin Ramirez's work, but by 1985 argued cogently that even outsiders should not be romanticized as the "other" but rather investigated in terms of cultural determinants and forms.[11] Thus the Halls gradually built a synthetic approach into their collection, and the range and varied perspectives their collection offers

Rane Hall observing Edgar Tolson carve a pair of oxen, Campton, Kentucky, 1978. Photo by Michael Hall.

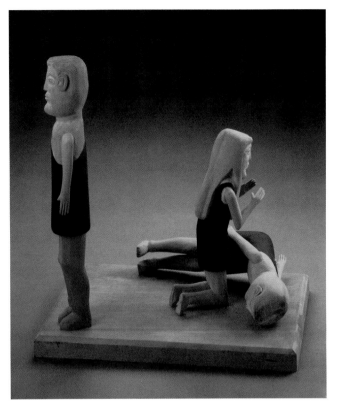

Edgar Tolson, *Cain Going Into The World*, 1970 (cat. no. 205h)

The clearest way to demonstrate these assertions is through one central example in the Hall Collection, Tolson's *The Fall of Man*. Tolson stands at the beginning of the Halls' involvement with folk art. He also can be seen as the artist who convinced Herbert Hemphill that folk art expression extends into the twentieth century. In fact, Hemphill and Weissman used Tolson's *The Fall of Man* as the visual centerpiece of their introduction to *Twentieth-Century Folk Art and Artists*. Tolson was the first self-taught artist in recent years presented in a Whitney Biennial (1973), demonstrating that his distinctive work could excite the contemporary art world as well. In addition to inspiring interest in two sometimes antithetical art worlds, Tolson gradually came to be seen as the embodiment of elements of his Appalachian culture rather than as an isolated and eccentric genius. Importantly, it was Michael Hall who led in this discovery. In an article published in the *Clarion* in 1987 and based on a taped conversation with Tolson from 1976, Hall allowed the artist to speak for himself concerning his environment and heritage in Kentucky, his systems of belief, and his self awareness as an artist.[13] Of the whittling traditions so common in Kentucky, Tolson stated: "Well there are differences in it. When you're carving something you've got your mind with it. You have your whole being in it. You have to. But just sitting there whittling on a stick, you ain't got nothin' in it but just a little time." Thus Tolson was clearly aware that his work

was something beyond the typical whittling and craft tradition. His observations of the political scene were pointed: "I'd tell old Nixon that he was too low down for the dogs to bark at. . . You betrayed your whole family, you lied to 'em like a hound and they finally caught up with you." And reflections of his religious belief form an insightful background for *The Fall of Man*. He says of Adam and Eve: "They didn't even know that they was naked. They were just like a two-hours-old baby. They just knowed they was here. But after this gentleman [the serpent] got through with 'em — they knowed to commit the crime." Further, "He [God] couldn't punish Adam and Eve for something they didn't know. So they very well knew it. Cain knew he was doing a murder job there — so he went off a sinner." *The Fall of Man* represents, according to Tolson, ". . . from the beginning of time — to the winding up of time. It's about the whole thing . . . that's something to think about." In these statements quoted by Hall, it becomes very apparent that Tolson was not only aware of

the standard Biblical texts and the fundamentalist interpretations of them, but also that he was attempting to make a broader, timeless statement.

Perhaps the most compelling revelation in Tolson's taped remarks is one that makes very clear his awareness of his own powers and gifts as an artist: "A man who makes those things. If you could open up his skull to see his brain, you see the sculpture there — perfect as it's made . . . You don't make it with your hands. You form it with your hands. You make it with your mind." By 1987 Hall, now fully cognizant of the approaches and methods of anthropologists and folklorists, presented the Tolson tape as his research, his field notes. By letting the artist speak for himself, Hall skirted the charge that he might infer artistic motives to Tolson that were not there. And Tolson, speaking for himself, at once acknowledged his cultural context and gloried in his artistic invention. For all the art historians and critics who had argued for years that folk art could not enter the precincts of fine art because it lacked a dialectical self-consciousness, Tolson proved them wrong. For all the material culturists and folklorists who had argued for years that the production of folk artists simply reflected the traditions handed down to them, Tolson proved them wrong as well. Here was an artist consciously using the cultural language available to him but expanding upon it to comment compellingly on the human condition.

Finally, one has only to look at *The Fall of Man* to realize that it has an essential refinement of form and a narrative focus that is equivalent to some of the greatest medieval manuscript illuminations and architectural decorations. And in the depiction of Cain in the last sculpture of the series the work rivals some of the most compelling modern narrative sculpture. Cain moving into the world, his eyes turned both outward toward the uncertainty of his future and inward toward the certainty of his guilt, has all the tragic aloneness of Giacometti's greatest sculpture. Despite the quasi-medieval timelessness *The Fall of Man* evokes, it is truly a universal statement of the situation of humanity today.

Tolson's work is certainly not the only example of the power of the objects in the Hall Collection. While the essays in this book offer a number of intriguing perspectives on the nature of folk art and the folk art field, it is finally the discussions of the individual objects that offer some insights into the biographies of the artists, the vitality of the traditions or contexts within which they work, and the formal and expressive inventions that carry their meaning and make them artists. Over a period of more than two decades, Michael and Julie Hall shaped a collection that both represented and challenged the understanding of folk art. Based on the extraordinary breadth and quality of their collection, it is our hope that a synthetic approach to interpreting it — one combining context and aesthetics — will end some of the "term warfare" surrounding folk art and provide a model for future study.

Notes

1. John Michael Vlach and Simon J. Bronner, "Introduction to the New Edition," in Vlach and Bronner, eds., *Folk Art and Art Worlds* (Logan: Utah State University Press, 1992), pp. xv - xxi. Includes bibliography of publications since 1980.

2. Christopher Knight, "Shortsighted 'Visions'," (*Los Angeles Times* Friday, October 16, 1992), Section F, pp. 1, 24.

3. See Maurice Tuchman, Carol S. Elliel, et. al., *Parallel Visions: Modern Artists and Outsider Art* (Los Angeles: Los Angeles County Museum of Art, 1992).

4. One of the best surveys of the discovery and appreciation of American folk art is Beatrix T. Rumford, "Uncommon Art of the Common People: A Review of Trends in the Collecting and Exhibiting of American Folk Art," in Ian M. G. Quimby and Scott T. Swank, eds., *Perspectives in American Folk Art* (New York: W. W. Norton & Company, 1980), pp. 13-53.

5. See Jean Lipman, Robert Bishop, Elizabeth V. Warren and Sharon L. Eisenstat, *Five Star Folk Art: One Hundred American Masterpieces* (New York: Henry N. Abrams, Inc. in association with the Museum of American Folk Art, 1990).

6. Vlach and Bronner, *Folk Art and Art Worlds.*

7. For a thorough examination of Herbert Hemphill's collecting activity and his role in the developing appreciation of folk art, see Lynda Roscoe Hartigan, "Collecting the Lone and Forgotten," *Made with Passion: The Hemphill Folk Art Collection in the National Museum of American Art* (Washington, D.C.: Smithsonian Institution Press for the National Museum of American Art, 1990), pp. 1-70.

8. Herbert W. Hemphill Jr. and Julia Weissman, "Introduction," *Twentieth-Century American Folk Art and Artists* (New York: E. P. Dutton, 1974), p. 11.

9. As early as 1981, the Halls discussed their changing perspective and noted the influence of an essay by art historian Daniel Robbins, "Folk Sculpture without Folk." See Michael and Julie Hall, in "Transmitters: A Dialogue on the Isolate Artist in America," *Transmitters: The Isolate Artist in America* (Philadelphia: Philadelphia College of Art, 1981), p. 9.

10. See the essays on folk art and artists in Michael D. Hall, *Stereoscopic Perspective: Reflections on American Fine and Folk Art* (Ann Arbor, Michigan: UMI Research Press, 1988).

11. Michael D. Hall, "The Problem of Martin Ramirez: Folk Art Criticism as Cosmologies of Coercion," *Stereoscopic Perspective*, pp. 227-236.

12. Jonathan Fineberg is but one example of a number of art historians who have dismissed folk art as inadmissible to the level of high art because its makers are supposedly not participants in a self-critical dialectic with other art. See Jonathan Fineberg, "On Art and Insanity: The Case of Adolf Wölfli," *Art in America* Volume 67 (Jan., 1979), pp. 12-13.

13. All the following Tolson quotes are from Michael D. Hall, "You Make It with Your Mind: Edgar Tolson," *Stereoscopic Perspective*, pp. 161-172.

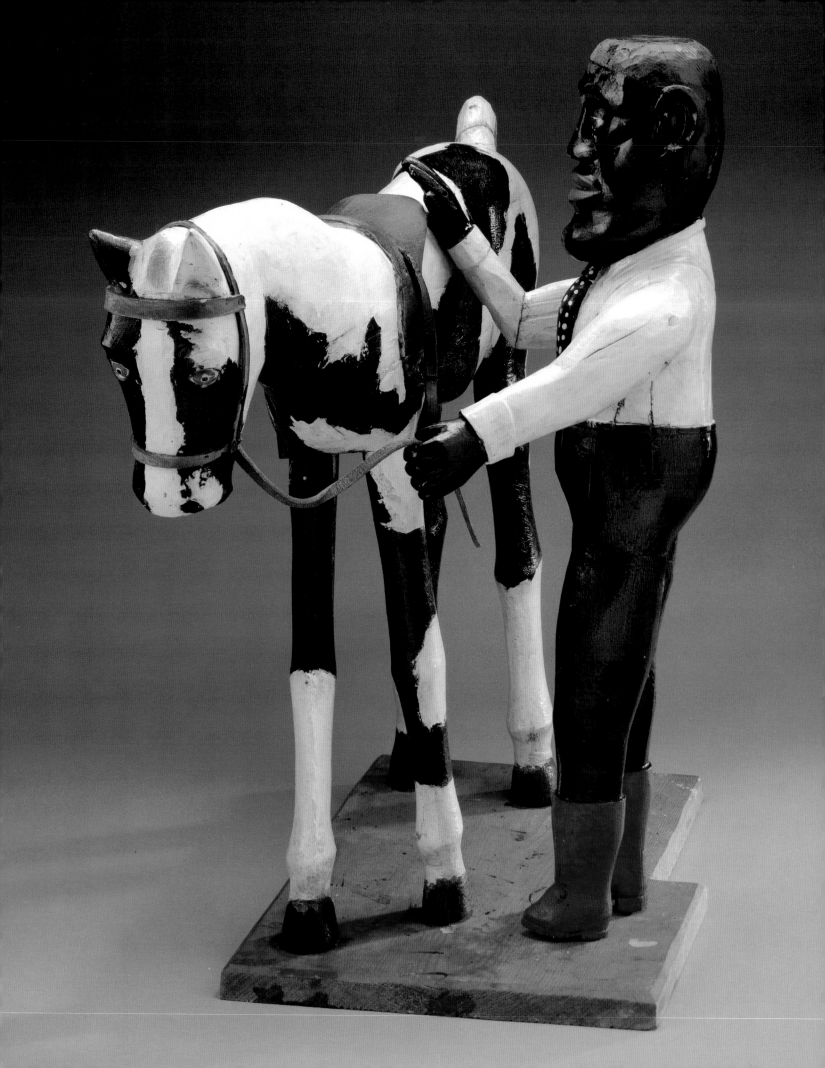

Interview with Michael D. Hall

Russell Bowman

July 16-17, 1992
Milwaukee Art Museum

RB: *How did you, trained as an artist, and Julie, with an interest in the crafts and art history, come to folk art? I mean, how did your discovery happen?*

MH: This story has been documented in a couple of other interviews, but it's probably worth repeating for this catalogue. It's a story about the happy meeting of opportunity and preparation — that convergence that Mark Twain called luck. I came from California from a strictly non-art environment. My interest in art developed around the decor at places like Trader Vic's restaurant where faux Hawaiian tikis and Polynesian masks were the backdrop for the West Coast lifestyle. I actually worked awhile as a teenager for a company called Sea and Jungle Imports, a firm that sold all manner of carvings and tapa cloths imported from the South Pacific. So I became quite taken with the art which at that time was called Primitive art — African art, South Seas art and Eskimo art. I used to go to the library and just look through the books on this stuff. I was compelled by its "primitivism" — the exuberance and exoticism I percieved in it. I started carving tikis as a teenager to make money to support my car. I carved tikis for Sea and Jungle, and I carved some masks that went to Disneyland. One of my tikis, I understand, went to the Trader Vic's in Montreal. I didn't know anything about being an artist, nor did I have any desire to be one. But I started this tiki company with a friend who did want to be an artist. We roughed our tikis out with chain saws using palm tree logs that we got from the parks and recreation department in Pasadena. We'd rent a trailer, go pick up the trunk, unload it in my parents' driveway and go to work. Using books from the library, we would copy our tiki images. And we'd get 100 bucks for them. We thought that we were making money! . . . and we were, for kids. So that's my story. That's me growing up with an attraction to primitive art and that's me emerging as a sculptor.

When I transferred to the University of North Carolina, the resident sculptor there was Robert Howard who was trained in the school of Zadkine, and a very interesting teacher. He interviewed me for acceptance into the University art program, and he asked to see my portfolio. I didn't know what a portfolio was, so Howard told me that a portfolio should represent the art work that I had done to date. I went back to my house and dug out all of my old photographs of my tikis and put them into a ring binder. And I took this scrapbook into this professor for admission. How he kept a straight face I will never know, but he did. Finally he looked up at me after a long pause and said, "Well I see that you have considerable experience in glyptic processes. Have you ever done anything plastic?" And I said, "Huh?" And that's how I became an art major. He gave me a lump of clay and sent me back out into the studio to learn the art of sculpture.

Julie, on the other hand, came from an environment that was filled with art and filled with an appreciation for it. Her mother Estelle was an interesting collector with a strong modernist affection for the primitive. The house Julie grew up in was filled with works of primitive and modern art in a complementary relationship. And because the family lived in Nashville, they also owned some carvings by Wil Edmondson. So Julie had a real introduction to art and folk art from birth. Her mother also had a good art library. Julie had an early exposure to art and artifacts and also had a natural affinity for them.

When we met, it was our shared attraction to, and curiosity about, the primitive that would make us ready for folk art. But finding folk art was another matter. The epiphany began modestly. We were in New York in the mid-sixties, and we were going to visit the Museum of Modern Art and the Museum of Primitive Art. We came uptown in a cab that let us out on Sixth Avenue. We were

Edgar Tolson, *Man with Pony*, 1958 (cat. no. 167)

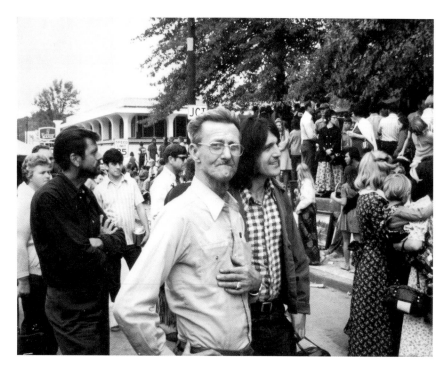

Michael Hall with Edgar Tolson and Tolson's son, Tom, Sorghum Festival, West Liberty, Kentucky, 1968.

a little bit early — MOMA wasn't open yet. We got out of the cab and walked east past the Museum of American Folk Art. The museum was featuring a show called "Collector's Choice." The show included many prime pieces from the collections of most of the early members of the Museum. Bert Hemphill had arranged the show as curator. Some of the best objects were visible in the window up on the second floor of the old museum building, and we could see them from where we were walking. We were just looking around, taking it all in, and we saw these things, and we went in — to kill time. Our folk art encounter was that simple — it was, however, powerful, and our conversion to folk art was almost instantaneous. I remember some of the pieces still — Bert's *Trapper & Squaw*; his wonderful *Stag at Echo Rock;* some of the great decoys that Adele Earnest owned; face jugs from the collection of John Gordon; some of Bert Martinson's things; and some of Isobel and Harvey Kahn's whirligigs. The show was a sampler of American folk art that went from the traditional to the non-traditional. Eccentric things like the *Trapper & Squaw* were side by side with conventional cigar store Indians. We were very electrified by the material. We came to it on an intuitive level rather than through intellectual or historical means. We just walked through

the museum and babbled — we effervesced at every turn about the stuff we were confronting.

We had been there about fifteen minutes when we noticed that we were being shadowed by this very elegant man in a white suit. He was obviously listening in on our conversation. (It was a little irritating if you want to know the truth.) Finally after about thirty-five or forty minutes, he walked up to us and put his hands behind his back and very politely said, "Do you like these things?" To which we both answered, simultaneously, "Yes, we think they're great!" And he said, "Would you like to see more?" And we said, "Sure" — and I, at least, assumed that he was going to show us some things in the museum's storage. Well, as it turned out, we had just met Bert Hemphill. He was not only the curator of the museum, one of its trustees, and a founder, but he was also (that day) the museum docent and guard. He asked us to follow him and we went over to the door, he turned on the alarm, took out a key, showed us out, closed the door and locked the place up. We went down the stairs and I still assumed that we were going into a storage area to see some more of the collection. But instead Bert took us out onto the street and hailed a cab. We got into it, and five minutes later we were in Bert's apartment.

We spent the rest of the day learning and talking about folk art. Bert entertained us wonderfully. We had drinks and food and we became friends that afternoon. In retrospect I see that Bert's place was targeted that day as a mecca for new collectors and young artists. Our whole circle of friends would soon be in and out of that place as guests.

Later that evening as Julie and I relaxed and became a little more talkative about the stuff (and a little more risk taking, I suppose), we told Bert that we knew a person who made stuff "like this" — gesturing around the room. To which he said something like, "Yeah, sure you do, and I'm the king of Siam." We were referring, of course, to Edgar Tolson. Julie and I had seen Tolson's work about a year earlier. We had only recently met Edgar and had been to his place and photographed some of his carvings two weeks earlier. I hadn't finished off the roll of film, and remembered that it was still in my camera. I jumped up, ran out on the street, hailed a cab and went to an all-night photo processing lab. I took the film in and left it, then took a cab back down to Hemphill's and said, "You'll see. We'll come back here in the morning and I'll show you what I'm talking about." He actually seemed a bit bemused by this whole performance. We continued to have a great evening and we all talked on until it was well after midnight. Julie and I went back to our hotel, and the next morning I got up early and went to get the film. It turned out that I had some pretty good prints of Tolson, his family, and some of his carvings. Julie and I went back down to Hemphill's place — I had my proof, and we confronted Bert at his front door. I whipped the pictures out of the envelope and said "Here, see!" Bert got very quiet. He went through my stack of five or six photographs, and then went through them a second time. Then he just looked at both of us and said, "I want one of these carvings." That was it. We told him that we would bring him one the next time we came back into the city. It was really flattering to have this collector who had this house filled with great folk art commit to wanting to own a Tolson. I told him, of course, that it would cost him fifty dollars for one of Tolson's Adam and Eves, and he said that he thought he could handle it. That was it — our folk art odyssey was launched.

RB: *Where did you first see Tolson, and what drew you to pursuing that work?*

MH: The credit for the actual discovery of Tolson's work goes to Julie. She had seen one or two of his carvings in a booth at a craft fair in Berea, Kentucky. I remember that one of the carvings was a very large doll, fifteen-sixteen inches tall. She came to get me and said, "What do you think?" I was somewhat nonplussed by the thing. It was unpainted, sort of folky looking . . . and I didn't know. And she said, "Isn't it great?" And I said, "I don't know." And she said, "I think it's great. Why don't we buy it?" And I said, "Well, if you think that highly of it, let's do it." So she inquired but it had already been sold. The sales booth, it turned out, was sponsored by the Grassroots Handicraft Guild which was a craft co-op in the mountains of Kentucky during the sixties. It was one of any number of craft workshops in that period attempting to generate income for mountain people, and to promote tourism in the region. Anyway, the staff that worked at the handicraft booth couldn't tell us who the maker was and we left the fair a bit frustrated because we had no clue as to who the carver of the doll was. But, over the next several months, we followed up and finally did crack the riddle. It just took a little digging into the craft guild world and finally we found somebody who knew that the carver we were looking for was Edgar Tolson — and that he lived in the town of Campton. From there it was a matter of going up into the mountains and walking through the streets of Campton and asking people if they could tell us where we could find this Mr. Tolson. We went into the local pool hall and everybody there was a bit taken aback by our appearance. I had long hair and bell-bottoms and Julie had a flowered dress on. We were the first hippies, I think, the town had seen in the flesh. So, we were regarded with a mix of suspicion and amusement. But the people were not very willing to give us explicit directions as to where we could find Mr. Tolson. They just kept passing us from one person to the next as each one would say, "Well, I don't know myself, but you ask him over there . . ." Finally one man said, "Well, I really can't tell you either, but why don't you ask that fella out there on the street." He pointed to a man out on the sidewalk leaning on a wooden cane with a serpent carved around it. So we went over and asked him if he knew who Mr. Tolson was, and he said "Yep." And we said, "Could you tell us where we could find him?" And he said, "Nope — but I'll take you to him." He started down the street and he turned the corner and went back behind the pool hall and down the alley. About twenty feet into the alley, he turned around with a big grin on his face and said, "You're a- lookin' at him." We had just met Edgar. He had strung

us along on what he thought was a great joke and we laughed along with him because we had been slicked pretty good. He took us from there up to a little building that he used for a workshop and showed us some of his tools. But he didn't have any work available at that time except for one doll that we collected on the spot. And that is the story of our meeting Edgar Tolson, and that was the beginning of the friendship. And, of course, the Tolson story is very central to our folk art odyssey, and meeting Tolson was surely the event that prepared us, I guess, to meet Hemphill. In an interesting way, the Hemphill/Tolson meeting was also important to our story. Within a rather short time after meeting Bert we were able to persuade him to come down to Kentucky to visit Tolson. When he did, he was very impressed, and had his own kind of revelation. Driving back to Lexington, Bert told us what his visit with Edgar had meant to him: "You have no idea — for my whole life I've collected objects. And they have always been on the wall, on my coffee table, underfoot . . . as things in the world, but things without any connection to life, to their actual individual makers. They were always just things to me. Today, my whole collection came alive in a new way. I realize now that there was a Tolson, or somebody like him, behind every thing that I own. And that changes the way that I understand the things I live with. Taking me to Tolson, you have given me an enormous gift. You've put a new life into my collection and you have vitalized my understanding of art." This seemed preposterous to us . . . it seemed so naïve. We had always known artists, and being a part of the art community, we knew art as things made by real people; it was second nature to us. We were amazed that Hemphill had collected for years without really contextualizing art in terms of its authorship. So he told us after the meeting with Tolson that he wanted to give us a gift that would be equal with the gift that we had given him. He proceeded to tell us that he wanted to introduce us to all of his friends, to all of the resources of his personal library, and to the rest of the collecting community. In other words, he wanted to give us a formal orientation to the field of folk art. So for the next two years every time we went to New York, Hemphill would have an itinerary for us — a whole itinerary where one day we would go down to Princeton, New Jersey and visit with Barney and Edith Berenholtz, and on to meet Barbara Johnson, and then up to see David Davies. Another time we would go out again into New Jersey, to visit Harvey and Isobel Kahn and see their collection of mourning pictures and whirligigs. Another time we went up the Hudson to meet Adele Earnest and

Cordelia Hamilton at Stony Point, and see their collection. Bert introduced us to all of the dealers in the city, George Schoellkopf, Jerry Kornblau, James Kronnen, John Gordon, et. al. Then on other trips he took us into Pennsylvania to visit the historical societies of Bucks County, Berks County, and Montgomery County, to learn the Pennsylvania folk culture through his eyes. It was a very lengthy course and very comprehensive. I've always been very grateful for the Hemphill tour. It grounded our understanding and gave us an orientation to folk art that we did not have. He opened his folk art world to us as a gift.

RB: *Michael, was your first folk piece that you and Julie acquired a Tolson?*

MH: Yes.

RB: *And, at that point, did Bert have anything in his collection that was twentieth century?*

MH: If he did he probably wasn't concerned with the fact that it was twentieth century. Hemphill's orientation to folk art came from the traditional context of "antiques."

Hemphill's original vision of folk art was gleaned from the traditional literature. When Julie and I met him he was building a collection of things compatible with the folk art in the Lipman collection, the Shelburne Museum, and the Abby Aldrich Rockefeller Folk Art Center in Williamsburg. Bert, however, would indulge his taste for the eccentric every once in a while. As surely as he would be interested in the whole tradition of trade store figures, he was still the one person who would go to the sale of the Hoffenreffer collection and buy the *Trapper & Squaw* instead of one of the Indians, race track touts, and ladies of fashion up for auction that day. He had, and still has, an eye for the unusual and the offbeat. So, I assume he had twentieth-century things in the apartment when we were first there, but it was not an issue for him.

RB: *So, did Bert's meeting you and Tolson, and learning that there was actually an artist behind the art object . . . did that lead to his realization that there was still folk art in this century?*

MH: That didn't happen initially. I think that Hemphill thought of Tolson as a phenomenon — an isolated thing. Of course, Tolson gave him a hook into his own collection in a new way, but his commitment to twentieth-century

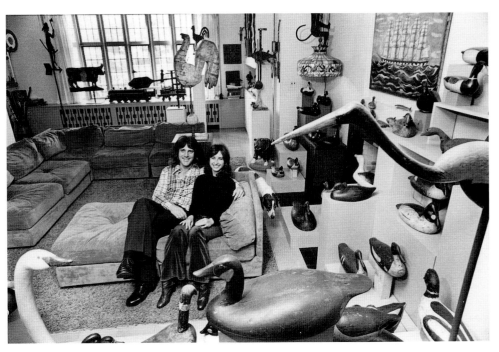

Michael and Julie Hall at home with the collection, Cranbrook Academy, Bloomfield Hills, Michigan, October 1977. Photo by Taro Yamasaki, Detroit Free Press.

folk art and to the idea that there were folk artists alive and well in our midst came over time. It was, I think, prompted by a sequence of revelations. What happened was that my group of students, first at the University of Kentucky and then later at Cranbrook, became what I have always referred to as the "army." They became a corps of folk art searchers and finders. Many of them took teaching positions at universities across the country and, because they were interested in folk art, they started seeing folk art around them. It was Mike Sweeney who had been a student of mine at Kentucky who first called me about Elijah Pierce in Columbus, Ohio. He had taken a teaching job in Columbus and had run into the Pierce material there. Lester Van Winkle, who had also been a student of mine at Kentucky, took a position in Richmond, Virginia, and with his friend Chris Sublett came across the work of Miles Carpenter. Ken Fadeley, in turn, who was a student of Van Winkle, discovered Steve Ashby. Of course, Julie and I got all the phone calls, and we would usually just jump in the car and go see the stuff if it was within striking distance. And the next person brought in was always Bert. So in rather quick succession, a number of finds came to light, mostly through the aggressive activity of the "army." After a number of "finds," Hemphill began to see that Tolson was not alone . . . and of course that's when he committed to doing the book, when he committed to turning his collection around and focusing on the work of contemporary and twentieth-century folk artists.

RB: *You've mentioned the education that he helped to give you in terms of traditional approaches to folk art. Did the collection develop along parallel lines right from the beginning — the twentieth-century material that the "army" was discovering along with the more traditional material which you were trying to learn about and absorb?*

MH: Julie and I were always working backwards, trying to find the nineteenth century and ultimately trying to complement our twentieth-century acquisitions with earlier things that would speak to the more traditional folk art aesthetic, the more traditional folk art definition. Hemphill was trying to work forward in time. He was trying to complement his traditional core collection with

more contemporary and diversified things. We were all scrambling, but in opposite directions, each coming from the opposite place to get to where the other one was already standing. That was the electricity between us during that period. Bert was all in favor of us learning the traditional and owning things that spoke to the roots of folk art and, of course, we represented for him the challenge of the new folk art and evolving definition of folk art — what would become an alternate aesthetic. In the late sixties the folk art aesthetic was expanding — the old folk art envelope wouldn't hold the new contents, and a new container had to be developed.

RB: *There are collections today that have essentially developed since the Hemphill-Hall period of the late sixties and early seventies that are entirely twentieth-century material. Your collection, along with Bert's, seems to form an interesting transition between the traditional approach and the acceptance of twentieth-century material. But why, at that time, did you have to go back and include the earlier material? What was your goal?*

MH: Well, part of your answer is inside my personality and background. I am, by inclination, a traditionalist. I was trained in the modernist tradition. And I don't believe that having a fondness for tradition necessarily limits someone's creative potential. So for me, it was important to put a foundation under the collection that would link it to some kind of art history. And of course that art history was the folk art history that Bert knew; the history he and the early collectors represented. I also want to emphatically point out that the Hemphill-Hall collaboration was not the whole thing; there were a lot of people re-thinking folk art at that time. Bob Bishop was certainly a force in all of this. He lived not forty minutes from us in Michigan at the time. He had been involved with folk art in his early years in New York as a dealer and he knew all the same people that Bert knew. He was one of the first people that Bert told us to look up. So we met Bob and he became important for us in Michigan. He was working at that time at the Henry Ford Museum. His job was dealing with decorative arts — sculpture and furniture and folk art — at the museum. So he represented tradition, but was open to challenging the very values that he himself represented. He was interested in many things, and he came on board the twentieth-century thing very quickly. He made many important discoveries himself in those years. I would also mention David and Maze Pottinger who were antique dealers in Michigan when we first came to

Cranbrook. They had a strong interest in traditional folk art. Pamela and Timothy Hill also had a shop nearby and they became very important in the seventies. As collectors and dealers they brought many important converts to folk art over a twenty-year period. There were others too, so the whole thing was an overlapping of ripples that emanated from several points.

RB: *So most of these people, certainly Bob Bishop, and you mentioned the Hills, were interested not only in traditional material but also in the expansion of this tradition into the twentieth century — they were sort of searching it out?*

MH: Precisely. I think what typified the folk art group that we associated with was an interest in historic material, but a willingness to question traditions. The Hills actually came from an interest in furniture, but once you go from a traditional form of furniture to country furniture, and get into all that paint and all of that personal expression, the step to folk art and the step then to eccentric folk art is not a very big one. So they found it their way. I am just suggesting that the times were right for some new thinking. The right people began to fall into place and a map was being drawn. It was an electric time! You asked earlier about the collections now that have moved beyond the base that we were using in the 1970s. I would like to think that in some ways we all took one base and expanded it. Today that expanded reference has been enlarged again. It would seem now, I suppose, that the Hemphill Collection and the Hall Collection form a bridge between what was wholly accepted and traditional and what was not in a historic continuum. The fact that the Hemphill Collection and the Hall Collection have both moved into public institutions is some certification of that assumption.

RB: *Well, it's also part of what makes an institution particularly interested in this collection — the range of material.*

MH: It's also what makes institutions institutional. When the Hemphill-Hall taste becomes institutionalized, it's a whole different thing than when it was sort of guerrilla and radical and on the street. Institutions, I think, are created to hold a centered position in relationship to art activities. Institutions are often blamed for not moving very quickly with art movements. But in one sense, that's not their job. It's the job of collectors and artists and galleries to be out there testing and experimenting — and it's the job of the museum to wait and watch and then, to take

a position. And this is what's taking place here. By the time two collections have gone public, the taste they represent becomes "official." I wouldn't be at all surprised to see other museums acquiring other collections of even more experimental folk art soon. You know, the radical piece of yesterday becomes the classic of today.

RB: *And it doesn't take very long — even in dealing with this material we're talking about the period from the early seventies to the now institutional period in the early nineties — just a period of twenty years.*

MH: No time at all. And in fact if you need a witness to that, the story of *The Newsboy* is perfect. *The Newsboy* was introduced in 1975 at a flea market in New England. It was brought out by a seller who dealt mostly in rare and antique books. The folk art collectors who came through the flea market that weekend thought the piece to be so eccentric that no one was ready to step up and purchase it at first. What finally happened was that several dealers got together and decided that it was interesting enough that it probably shouldn't lay there baking in the sun much longer, so they would risk whatever it took to own it jointly. The piece was bought on speculation. It's hard to imagine anyone looking at *The Newsboy* and thinking of it as speculative. But it wasn't a proper cigar store Indian, it wasn't a race track tout, and it wasn't the "right," example one could look up in a folk art book in 1975. Julie and I were the lucky beneficiaries of the hesitation over *The Newsboy* in the marketplace. We thought the piece was terrific, but it was partly because we were fairly naïve to the classic standards that were being held up against it. We thought that it was interesting and we were able to see it without traditional blinders. We got lucky. Within two years, of course, the piece was headlining the Brooklyn show, and from that show went on to become a sort of standard for American folk sculpture. There's proof of how quickly things change. It is a story that illustrates the way things go from being peripheral to being central.

RB: *In terms of your own background, did your training as an artist make you more open to the folk art you were seeing?*

MH: You have to understand that my interest was in the expressivity of folk art. My hook into what I first saw in folk art was my early affection for "primitive art" . . . I'd love to tell you that I came to it visually like Elie Nadelman, Laurent and the rest, but I really didn't. I also didn't think about folk art as a revolution either within the forming of my own taste or within the aesthetic of my culture. I was mostly challenged by the possibility that there was a raw or primitive art that was domestic — that was "ours" instead of "theirs." A certain ethnocentricity of mine, I suppose, inclined me to American folk art. I enjoyed the notion that my culture had not civilized itself to the point that it couldn't, collectively, produce things that were raw and primitive. It appealed to the collector in me that I could find exotic, wonderful stuff in my own backyard. There was a plentiful supply of it and it wasn't overly expensive. I could indulge my appetites as a collector and surround myself as an artist with stuff that I found interesting, provocative and stimulating without having to go through the mediated market that had grown up around other forms of primitive art.

I think that you have to understand that even though I had formal art training, I had an understanding of primitive art that was rather superficial. I had been told about Picasso's interest in the primitive, and about the impact of African sculpture on early modernism. But I don't think that I had made any real strong connection there for myself. But the one thing that did register strongly was an empathy for Edgar Tolson as an artist. At the time that I was in Kentucky, I was in my mid-twenties. I was as interested then, as I am today, in making my own artistic mark. Yet it seemed very difficult and uphill for me to be in Lexington teaching and dreaming about an art world that was quite far away. I wasn't in one of the centers, I was out at the edges. So I felt a bit overlooked and maybe a bit desperate. It was some solace to me, through those four years in Kentucky, to remind myself that Edgar Tolson was in the mountains seventy-five miles further away from any center than I was, making good art. I think that my connection to folk art reinforced my own idea of the artistic potential within what seemed to be a rather provincial and limiting situation. So folk art for me represented, perhaps, my own art in an art world. In retrospect folk art was a touchstone. It was a way to tell myself that things were possible rather than impossible, and a way to tell myself that art and creativity are free-floating things that are not totally tied to markets and to urban centers and their museums. So there's my best answer to your question. I came to folk art through empathy rather than through the more straightforward formalist affinity that we like to believe attracts artists to forms of art outside their own traditions.

RB: *Earlier we were talking about the collection at its begin-
nings in the late sixties, and then the traditional folk art that
you were learning about and the more contemporary things that
you were seeing and appreciating as an artist. Was there, at
that point, a plan for the collection?*

MH: I think that fairly early on a plan did begin to form.
I tend to plan formally; Julie will often plan more infor-
mally. But we communicated in such a way that it was
clear that acquisitions, given our limited means, could not
be made capriciously. I don't think that we qualify, either
one of us, as what you would call impulse buyers. And so
if you're not an impulse buyer, the whole business of writ-
ing a check to acquire something becomes a deliberate
activity. And deliberation explicitly carries the notion of a
plan. Beyond that, the plan was an evolving one, and
certainly the plan that we were working from 1969-70 was
not the plan that would have been in place in 1980. By
1980 we had seen more things. By 1980 we had become
much more sophisticated about the whole subject of folk
art. Growth was part of the real enjoyment of being
involved with this thing as collectors.

The early plan was essentially appropriated from the then-
available standard texts on folk art. I think that we agreed
that the collection would try to represent at least one good
thing (and of course the word "good" suggests a quality
issue) in each of the traditional categories of folk art —
weathervanes, trade figures, etc. And because of our "fine
arts" prejudice, we decided not to include furniture. We
also decided early not to stress utilitarian or craft-based
folk art expressions. This was deliberate. If you go
through Lipman's books and others, you'll see the painted
blanket chest called folk art right alongside whirligigs,
weathervanes and portrait paintings. But we cut to the
fine arts model of painting and sculpture. Going through
those same texts, we targeted the forms that we then
defined as "classic" — trade store figures, weathervanes,
whirligigs, portrait paintings, landscape paintings, still life
paintings . . . it was pretty easy to set up our frame for
collecting. We were attracted to the folk art history that
was already in place and it became a very convenient
guide. We could take Jean Lipman's book on *American
Folk Art in Wood, Metal and Stone* and pour over it and
speculate on what we might find that could meet one
model or another. I can remember our excitement over
Jean's piece, *Job Indian*. It's a trade store figure, but a very

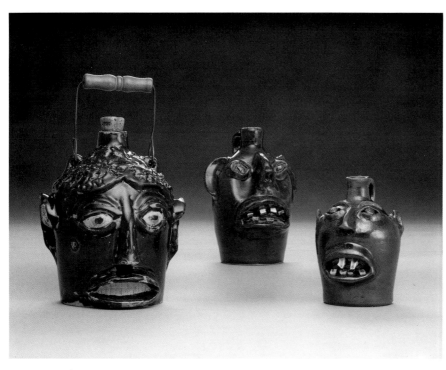

Galloway (attributed), *Face Vessel*, late 19th-
early 20th century (cat. no. 121), and Evan Javan
Brown, *Face Vessels*, ca. 1920s (cat. nos. 122
and 123)

individualistic one said to have been produced by a black slave woodworker in Freehold, New Jersey. It's in most of the literature and it's *the* cigar store Indian that's not your standard wooden Indian. It's special. It has personality, individuality, and nothing else by its maker has ever turned up. On the other hand, it also speaks to the whole language of trade store carving as an American folk art form. So the *Job Indian* inspired us to seek works of folk art that were both individualistic, unique and original and yet which were also traditional and part of a larger history.

RB: *And that direction might relate in some degree to the way Bert was approaching his collection.*

MH: I think so — very much.

RB: *The sort of eccentric examples of the standard category.*

MH: The idea of the eccentric example of the standard category was something that we learned from Bert and that idea shaped our plan in the early years. It gave us a working model right away. It let us take the whole bibliography of folk art and distill it into a map for our collecting. So the early plan was pre-set in some ways, but it was also open-ended because we were out to find the wonderful example that would meet the criteria of being unusual and original and still traditional within a category. We had both a structural and an aesthetic measure for our acquisitions.

RB: *And would you argue that, in that phase of your collecting, that your decision making in terms of quality was primarily aesthetic?*

MH: Yes, no doubt about it. Whatever aesthetic means, and certainly in those days I was more confident about what it meant than I might be today.

RB: *Aesthetic might suggest formal power.*

MH: Our early aesthetic was formal — it was visual, and was rooted in the notion of design, but it also had an expressive side. Modernist art history guided our eyes and guided our check writing if you want to be that prosaic about it. Formalism was part of the baggage that came with the whole folk art territory at the time. If you think back to Cahill's early definitions, he saw folk art as an issue of design. Lipman also saw it as such. Her arguments were always based in formal comparisons between

folk art and modernist works, particularly the art of Picasso and Matisse. So we bought that pretty much from the start. I think we got it from Bert and we also found it through the bibliography. It wasn't something that we particularly questioned. But the model would change as new things would come to light that were interesting to us, new things that we could reach out to with our definition of folk art, but which we couldn't plug back into the standard categories, or plug back into the standard history. I think the plan changed by the mid-seventies into a search for a re-definition of folk art, or an extension of the definition of folk art which would involve new categories for new forms that in some ways defied traditional categorizations — particularly those circumscribed by formalist aesthetics.

RB: *And what were some of those new categories? What were some of these new areas that you felt needed to be explored?*

MH: We were without language really. The 1981 exhibition *Transmitters* that Julie and I worked on with Elsa Longhauser at Moore College was problematic *because* it wanted to talk about works that didn't fit the categories, works that didn't have names. So we started calling certain works "isolate art." *Transmitters* featured work Dubuffet might have called "art brut" or what Roger Cardinal and others were calling "outsider art." For us Martin Ramirez was a key figure in the forcing of a redefinition of folk art. By the late seventies many folk art collectors who were looking at twentieth-century material were becoming interested in the work of Ramirez and other "outsiders." Confusing terms and definitions became part of the folk art problem, but they also became part of the challenge that started to shape our new plan.

RB: *So in the seventies this expansion of the collection extended toward what is now widely called "outsider" art?*

MH: Yes, but to cut back to your question about the plan. The shift in the plan from the early seventies into the plan of the early eighties had to do with an understanding of what we thought we were doing with folk art. Originally we were trying to create our own version of the old textbooks. By the late seventies I think we felt very much that we were part of a larger art revolution — that's maybe a little dramatic, but a larger change — something that was stirring in contemporary art consciousness at the time. We were very interested in the American side of that change. The decision to politically commit the collection, rather

than to just visually commit it, caused the big change in the plan. Now I don't want to overemphasize this or to suggest that we viewed ourselves as radical instruments for change, but we had clearly come to believe that there was some connection emerging between the world of folk art and the contemporary fine art world. Too many of my students had been too excited over too many years about this material for me to believe that folk art it wasn't impacting broadly on art thinking. Too many of the exhibitions that we had been a part of had circulated to very good venues and had met very interesting approval from a wide audience. The key proof for all of this, perhaps, was Amy Goldin's *Art Forum* review of the *Folk Sculpture USA* show. In 1976 Amy was a perceptive and interesting critic, who set up an essay that went after folk art from the standpoint of a fine arts world. Amy asked whether or not the folk art world that was knocking at the door of the fine arts world could actually qualify for admission. Her essay is still a landmark to me. She was simply saying, "Hey, you folk art people are knocking at the door. You say you want in. You are pleading a case but it seems a little scattered to me. Basically, as the keeper of the gate here, I want to ask you a couple of key questions, and you MUST answer." And she laid out the questions in that *Art Forum* piece. To me, they have never been really answered by the folk art community. I think that Amy's challenge, by and large, was ignored. I called it to the attention of a number of people in folk art — collectors, friends and curators who were all involved, and I don't think that they took it seriously. Actually by 1976 folk art was not only under the gun from Amy Goldin and her fine arts world, but from Dan Robbins and the art history world, Ken Ames and the world of material culture studies, and from Henry Glassie, John Vlach and other folklorists. All these voices were assaulting the idea of folk art as the collectors knew and defined it. The folk art collector world wasn't up to all of this. But seeing all this happening, feeling all of this coming at us, Julie and I both sensed that the collection and the field had a meaning that went beyond just our own involvement. We saw the collection turning outward to be a part of a cultural argument and becoming an instrument in an art world discourse, not just a discourse in the world of antiques. That changed the plan. The new plan, that empowered the collection critically, was the plan that ultimately brought it to public institutions. For me, the late plan was the stronger plan, the evolved plan — and it became the plan that I am still most interested in.

RB: *When you say politically, you mean making an argument for this art to be considered as seriously as other kinds of art in the art world's view.*

MH: Yes, and on lots of levels.

RB: *And so how did that then change the collection? How did that plan affect what you were buying?*

MH: Dramatically. It meant that when we considered something for acquisition, it was tested not just against what you would call aesthetic criteria, but against political criteria. "What will this really do in the argument?" "What will this say in the discourse?" So newly acquired objects were set to a task that was more vigorous than the one set for things acquired earlier.

RB: *Can you give me examples of things that entered the collection at that time?*

MH: Drossos Skyllas' paintings are the best example. We really felt that Skyllas' work knocked on a lot of doors, assaulted a lot of assumptions, challenged a lot of stereotypes in folk *and* fine art — it built and burned bridges at the same time. And there were others, but for the sake of this illustration, Skyllas is perfect. And if you look at the chronology, just about the time Skyllas' work came into the collection, the collection started showing its new plan.

RB: *When you became more aware of the material culture/ folklore point of view, did it affect your collecting?*

MH: It affected my collecting profoundly. But you have to remember that I took my college minor in anthropology and that I made my living through college and even graduate school as a folk singer. I always had a disposition to the ethnographic side of anything "folk" — folk music, folk art, folk speech, etc. I took courses in the folklore department at the University of North Carolina and I did field recordings in the southern mountains taping various folk singers, including Frank Prophet and Doc Watson.

RB: *I never knew this part of your background, Michael.*

MH: I had a real strong interest in folk music, a good music library and some academic training in folklore and anthropology. There is a part of me, the anthropologist part of me, that likes some of what folklorists see in folk

art. Julie maintained more of the aesthetic approach to the material in the collection.

RB: *But the collection's concentrations, like decoys, which have a clear functional basis, or lodge hall materials, which have a clear social connection . . . did those come in around the mid-seventies as part of an awareness of a material culture approach?*

MH: Absolutely, yes. But the date would be the late seventies and early eighties. And that would have been the time of the Winterthur conference and the time that we confronted Kenneth Ames, John Michael Vlach and then subsequently, Eugene Metcalf, Henry Glassie and others. After Winterthur we became friends with Ken Ames, who has certainly been a strong influence for me. Though Ames is not a folklorist, his interest in material culture has had enormous impact on folk art thinking. I have subscribed to a lot of the things he has argued on the subject of folk art as material culture.

RB: *An interest in this material culture side of the field is something that not many folk art collectors would have had at this point. Certainly it would not have been part of Bert Hemphill's thinking.*

MH: Never, to my knowledge.

RB: *And never part of the Jean Lipman approach to things?*

MH: Unlikely. I think you find a token reference to the "folk" of folk art in most historic writings from collectors like Lipman, but you never find scholarship. Folk art suffers, if anything, from too much mythology and too little real anthropology. A lot of the collectors who are interested in contemporary folk art will tell you wonderful, long and predictable stories about their encounters with various artists. But they tend to always tell the same stories and fabricate assumptions that fortify mythic stereotypes about the "folk." I am interested in the anthropological idea of a folk and the sociological idea of communities and of people in evolving histories. I am drawn to texts many collectors overlook because I am interested in how social factors impact on folk art. For instance, face jugs . . . At this point I am not primarily interested in them aesthetically. I think they are much more fascinating as social documents — connected to political histories, geographical migrations, stylistic evolutions and traditions of utility. Seeing them in context makes them endlessly

more wonderful for me than just seeing them as "artistic" ceramic curiosities.

RB: *When did that element come into your writing about folk art? That might have even been the late eighties.*

MH: No, early eighties. In fact, if you go back to the 1976 Brooklyn interview, you will find a naïvely expressed germ of my disposition to all of this material culture business. There I talked about Michelangelo as a provincial. That really cuts back to the idea of a community and to the idea of art as a conversation within a community. That little digression in the Brooklyn interview, beginning with some speculations on Tolson and then taking a rather preposterous leap to a discussion of Michelangelo, suggests that I was receptive to the idea of art as a social activity and cultural enterprise about the time I first began to get into the public folk art dialogue.

RB: *Given the evolving approach to the collection through roughly a twenty-year period, what do you think now that the collection is part of the museum's collection? What do you think it brings? What do you think it tells about the field of folk art?*

MH: For me, I see the collection as having achieved its political purpose in the expanded plan. For me, to see the collection come into a general art museum is to put the rest of the notes in a chord. To use an analogy, if we are talking about academic or fine art as a melody note without overtones, it is a small sound. I am interested in art as a big sound. I am more comfortable in the art museum that has folk art *and* fine art. I could even look to the day where I would want to see some popular art filling in also. Because I really do believe that if you take a material culture-based approach to art, you can identify all kinds of gestures as art.

RB: *So you are saying that the collection, brought into an essentially fine arts institution, brings that institution closer to a material culture viewpoint of what art is, and that is a healthy move.*

MH: I think it is very healthy. I am delighted to see that the Hall Collection was able to burrow in and undermine certain assumptions and stand on its own with the rest of the art around it in a museum setting.

RB: *Speaking more specifically about the collection as it stands today — other than your basic goal of having it viewed in the same context as other kinds of fine art expression — what do you think it says about the folk art field? What does the collection say about folk art in its present form?*

MH: I see that folk art, dragging the whole material culture argument with it and coming into the art museum, is going to force us to re-think fine art. I think this is very positive. We have had a fairly elite and separatist understanding of art for too long. I believe if we re-examined, say the work of David Smith, and re-measured it with an eye on things from his biography and on the political and popular culture milieu around him, we could understand it differently. Particularly if we could set it up next to other sculptural gestures made in Smith's time. We won't bring Smith down in doing this, we will just broaden our understanding of what he achieved as an artist.

RB: *To get back to a somewhat more prosaic level for a moment, do you think that the Hall Collection, as it exists today, reflects various aspects of this evolving plan? Can you see traditional forms, their more eccentric variations, the move toward an expansion of the traditional view to the twentieth-century and outsider material in the collection? And then finally taking into account material culture — do you think you can see that in the objects that we have today in the museum?*

MH: I believe it is self-evident and explicit. I think the collection has become successful as an argument on both art and culture and that this success brought about its closure for me. This completion allowed me to entertain the idea of moving it out of the house, sharing it with a larger audience, and in a sense relinquishing control and moving it into public ownership and museum care. You can see it in the example of *The Newsboy*. When we bought *The Newsboy*, we saw it primarily as a wonderful original formal expression within a tradition. We bought *The Newsboy* for what you are calling aesthetic reasons. The sculptural ingenuity and wonderfulness of *The Newsboy* were what attracted us to that carving. That was in 1975. By 1982, we were both less interested in the form of *The Newsboy*, and more interested in *The Newsboy* as a cultural sign, a cultural hero, a representation of the Horatio Alger up-by-the-bootstraps myth. When one can see that figure in isolation as a wonderful carving *and* see it as a cultural sign, one sees it through the evolving vision of the collection. *The Newsboy* can now stand in the museum and be several things simultaneously. The

Newsboy has sustained my interest through the complete mission of the collection as it went from us to an art museum and from the view of the early plan to that of the late plan.

RB: *I think one of the most difficult things to define still about folk art for those of us who approach it from the art side is the art aspect. We can find out more about the makers and we can know more about the folk or the material culture it represents. How do we define the art portion of this material today? And has that changed? Or are we still seeing it the way Elie Nadelman saw it — in relation to modernism? Can that change?*

MH: Answering this question has been a challenge for me these last ten years. It's a central question. The problem I see at the root of the question has to do with the aesthetizing of things. The notion that we can presume to aesthetize something is a difficult one, but it is a persistent one, particularly in the art world. When we talk about the Nadelman view, we are talking about being able to stand in front of something and presume to recognize that it is art and therefore beautiful. By 1984 or 1985 I had appropriated a working definition of art from the critic Donald Kuspit, who described it as "an original, dialectical treatment of commonly held cultural goods." This idea works for me because it connects material culture to the idea of art. Kuspit's description forces us to ask a number of questions when we begin to consider something as art. Is it original? In what way is it original? How do we define originality? And yet in celebrating the originality of something, how do we argue that this original thing still functions in some dialectical engagement with a community or audience as a cultural property? Kuspit's idea sets up a condition that allows a creator to be original, yet still makes the created object responsible in some way to an ongoing social conversation. And here is where we get the art/culture argument. Cultural goods are ideas, beliefs, prejudices — things that are embedded very deeply in any social matrix. And so following this avenue, we can turn right around and talk about *The Newsboy* and understand that it too is a treatment of a commonly held cultural good — the Horatio Alger stories and the idea of freedom of the press. But the carving is so original that we have to make a place for its uniqueness, we have to step back and give some pause to admire the creative impulse that gave this common thing such a unique and wonderful form. Yet to understand it as dialectical and shared is to put it right back in a cultural reference. And when we do this *The*

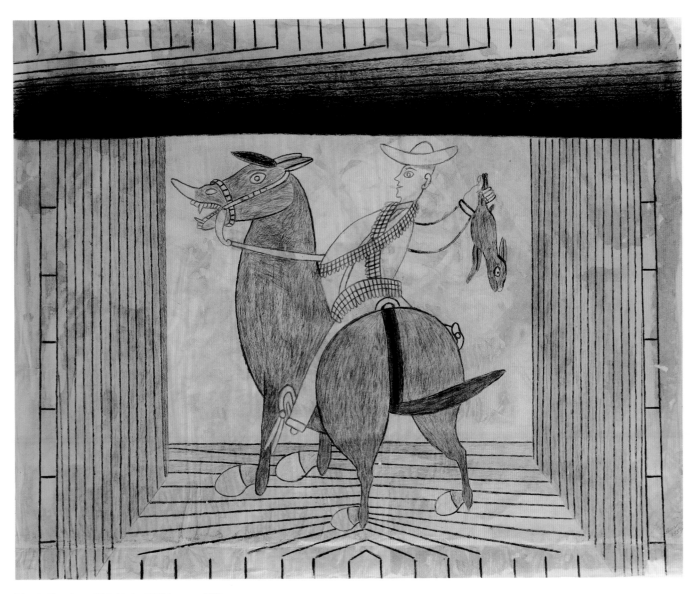

Martin Ramirez, *El Soldado*, 1954 (cat. no 229)

Newsboy becomes fine art because it meets the prescription, it answers the questions and survives the several tests built into the art definition I've just demonstrated. I like this working definition and to make it work, you must work — the search for art is an active undertaking.

RB: *Michael, where does that leave the definition of the so-called outsider or isolate artists? Some would argue that those artists are not working dialectically nor are they even, in extreme cases, a part of culture. In fact, that would be perhaps the somewhat romanticized argument that Dubuffet would have used. How do you incorporate them into the definition?*

MH: Honestly I don't try. I am of the persuasion that there isn't any such thing as an "outsider" artist.

RB: *Anything such as an "outsider"?*

MH: Only when we can fold creative gestures in and make them part of some insider conversation — make them in a sense dialectical — can we understand and appreciate the originality in them. I see art as such as a function of the culture within which it is consumed. I find myself at odds with all the romantic outsider buffs who want to believe that the best art somehow exists on Mars! I don't believe that. The best art is the art that we can consume and which is utilitarian for us.

RB: *So that the dialectic begins in our own assimilation of this art . . . but couldn't you argue it another way? That for out-sider artists, even perhaps the most extreme, there is probably an attempt to communicate? And that, second, no person is out-side of culture, and that whatever their present state of eccen-tricity or psychosis, they have a cultural background like the rest of us?*

MH: I believe this. Let's take a look at an example. I believe that the understanding of Ramirez has gone through two very distinct phases. The first phase cast him as an outsider — the whole mystification of the other that certainly grew out of Dubuffet's notion of primitivism. Ramirez was submitted to this measure and was found challenging in the early years of his discovery. By the time the Ramirez symposium convened in Philadelphia, however, several people including myself were saying that we simply did not know enough; that at that time we couldn't fold this artist and his work into anything except our own myth-making. What if this work were a form of folk art? What if it really was answerable to formal

traditions that are simply not ours? In other words, couldn't it be that the man is not incoherent, but that he simply spoke another language? That this might be Mexican art; that it might come from a Spanish tradition; and that in our Anglo ethnocentricity, we simply had refused to see, or had been unable to see, its cultural roots. In the years since the symposium, others have stepped for-ward to answer such questions and have found a lot of things. References to the Mexican revolution and certain revolutionary heroes clearly inform Ramirez's art and make it wholly compatible with a Mexican art history that also embraces Rivera, Orozco, and many other Mexican artists. So Ramirez, the outsider, becomes Ramirez the Mexican folk artist. And the book that was published on Ramirez in Mexico is entitled, *Ramirez, Pintadore Mexicano* (Mexican Painter). They don't call him an outsider. You don't have to read much Spanish to understand the cover on that book and to understand that it is the Anglo-American audience that is the "outsider" when it comes to Ramirez's art.

And I believe that even in the realm of art deemed to be the most psychotic and most displaced that much that makes art "outsider" reflects on the audience, not on the art. It is a kind of vanity to sustain all of this stuff as extra-cultural so that we can use it for our own purposes. And I would offer as proof the recent success of *The Thrift Store Painting* show, an exhibition that was generated by an art-ist from California who spent several years buying off-beat paintings in thrift shops, then circulated the collection in New York and unwittingly, I think, created the ultimate outsider. There was no biography; there was no context for any of this stuff, and all the pieces were even titled generically. Here was the ultimate outsider art and it was all dredged up from inside Salvation Army stores.

RB: *It was the ultimate romantization of the "other" created entirely from an aesthetic point of view that was essentially modernist based?*

MH: Absolutely. For my part, I place art in culture, rather than outside of it. I believe that the notion that the artist lives somewhere out on the nose of the culture animal and points the way, and sniffs around to chart uncharted courses is not a particularly interesting idea. If we put the artist in the bowel of the animal, in the stomach of culture, where digestion goes on and where nutrition is generated, we have a more flattering place for the artist and a more necessary role for art. Folk art as I see it absolutely argues

for the centering of art in a cultural process of digestion and energizing — in a way that perhaps our modernist view of a Rothko or a Nevelson will not permit. The bell jar that has been set down over high art takes it away from the center that folk art claims naturally. And folk art, now placed in an art context with high art, will hopefully shatter those bell jars and we will see Rothkos breathe again. Folk art, I think, can put fine art back in the world.

RB: *We've talked a little bit about how the collection was formed and its evolving agenda. What have we not touched on?*

MH: Well, I'd say we haven't touched on the aspect of fun. Collecting isn't just a war, it isn't all a project, it isn't all labor. We haven't touched on the aspect of the collecting activity Julie and I lived as a social and community enterprise within a circle of friends. Collectors don't function in isolation. Collecting for us was an engagement that involved a lot of comradery, at flea markets, decoy swaps and at various conferences. There's that social side of it and there's that chance to get together with people who are also on the trail searching out stuff and who enjoy their discoveries. Collecting is a way to stay sharp, it's an activity that can be competitive, but it doesn't have to be toxic. In fact, the people we met collecting all helped shape the Hall Collection in very positive ways. Bert Hemphill and James Kronnen in New York, along with the Hills and Bob Bishop in Michigan, reinforced our commitment to contemporary folk art. David Good and Roddy Moore taught us about American ceramics while Ron Swanson, Frank Schmidt and Bobby Richardson dragged us into decoys. Gene Metcalf called in our reading assignments, while Ken Fadeley and Clune Walsh beat up the highways with us "picking." And of course Julie's mother Estelle Friedman was our Nashville/Washington correspondent through the whole campaign.

RB: *What do you think the collector's role is? I think that many people right now in the folk art field would argue that the collector is the enemy; the collector is the person running around wrenching objects out of context. I would even argue that some people would say you're goal of placing your collection in an art museum, rather than another kind of museum, is a misunderstanding of the material. So what do you think the role of collectors is and how do you think they are viewed?*

MH: I respect collectors because collectors will step up to the plate and write a check. It's the collectors on the front line who scour through millions of objects. They become

Felipe Archuleta with *Lynx*, Tesuque, New Mexico, 1976. Photo by Michael Hall.

the eyes and ears for the art world. I don't mean just folk art collectors and antique collectors scruffling around flea markets, I'm talking about contemporary collectors who go to alternative co-op galleries, and a whole list of others. Collectors are sort of necessary and maybe wonderful because they are risk-takers. To bring something home is to have to go through all of the agony of wondering if it really is anything. To understand that you can't just take it back.

RB: *So you would argue that collectors in a way make the first cut in art — they're making the initial selections toward an art history?*

MH: Yes. Working from this same model you would see the museums as holding tanks that preserve, maintain, sustain (some would say kill) the hard center of an art idea. But as repositories they serve a necessary function and provide a centering for an idea of art. This is an interesting and dynamic model. Museums have a relationship to collectors. They also have a relationship to artists. Confusions arise in the art world when these relationships break down.

RB: *But what about the dangers that attend the role of discovery? There is such a premium on the role of discovery*

that one can exploit it either for financial gain or historical gain, rather than trying to advance the whole field.

MH: The whole art thing is as I see it essentially democratic. No collector that I know can do it alone. There's a collective judgment, a collective witness that interposes itself when this business of art comes up. This collectivity in the end filters and democratizes taste, which is ironic because we typically think of taste as being elite and exclusive. But in the end I should be more inclined to side with people who understand the art process as being a cultural enterprise that finally is openly aired and submitted to a kind of consensus, than with those who see it as a subversive conspiracy.

RB: *Let's talk about specialty areas in the collection, when they started, and ones that were yours and ones that were Julie's.*

MH: I would say that the ceramic side of the collection with emphasis on face jugs was my special enthusiasm. Julie always liked clay and had worked in clay herself, but my clay history goes back to my apprenticeship with Voulkos in 1964 and the workshop that I took with Shoji Hamada and with Rudy Autio even earlier in graduate school. I even taught ceramics at the University of Colorado. I never was much of a potter myself but I like ceramic things, so clay as a material speaks to me. Also I think I was intellectually inclined to clay because I liked its second class status as a craft material looking for its way into a first class art world citizenship. And I like the feel of clay, I like the look of clay, I like the fragility of it and I also like the permanence of it. I like the way that clay, in the form of both cuneiform tablets and pottery jars, has a certain enduring history. Pottery, particularly sculptural pottery, is very exciting and satisfying to me and I was drawn to face jugs because they express both a social history and the personal, artistic marks of many makers.

The decoys were an emphasis for Julie. She liked their lines, she liked their paint, she liked the decoys as sculpture. I think she was also fascinated politically with the reinterpretation of these objects, which had been so gender isolated in terms of their association with the world of hunting. It was interesting and challenging for her to collect decoys and become knowledgeable about them and ultimately to fraternize with the decoy collecting group, a group which is absolutely a boys club. She enjoyed challenging that group, besting them in trades and going to

their auctions and being a bidder and a competitor there — she liked the action. There's a lot of activity in the decoy world. It's a busier place than most other areas of folk art collecting. Decoy collectors are very knowledgeable. Julie liked the bird collector world, because it was so vigorous and smart.

The *Possum Trot* environment was an experience that was shared between our daughter Rane and myself. Rane loved *Possum Trot* from the start. It was Rane and I who traveled to California to see Larry Whiteley and to bring home the first *Possum Trot* dolls. So, there were different sensibilities brought to bear in different areas of the collection. Although there were specialties, most of the acquisitions were joint decisions. The best things in the collection came as a result of having been discovered by two sets of eyes — considered by two minds and viewed in two separate imaginations. We learned to enjoy surrendering our own prejudices and misgivings and learning to "see" something that the other person's insistence brought into your world. You become respectful and supportive of the other person's independent eye when you collect with a strong partner. A lot of the Hall Collection represents a real give and take.

RB: *Did you ever reject something because one of you felt so strongly about it as to reject it?*

MH: Yes, of course. Collector stories are always about the big one that you got into the boat *and* about the big one that got away. I suppose the classic story of the second type is the story of my problem with Martin Ramirez. The first Ramirez that Julie ever saw she loved. She understood it, she felt it, she embraced it, visually, intellectually and in every way. I, however, didn't get it. I remained very slow to warm up to Ramirez and was somewhat hostile to his work, particularly as it was represented in the argument about the "outsider." My conversion to Ramirez took time. It also took the inundation of Julie's argument. When we finally jumped in it was relatively late in the game and I must say it was a lesson to me.

RB: *One of the other things that we haven't talked about was the notion of the collection as representative of the American melting pot — and then that notion altered.*

MH: I would say that the melting pot idea as a very simple stereotype was a big part of the first affection Julie

and I felt for folk art. People in our generation grew up with the melting pot as something built into their whole acculturation. It was like the pledge of allegiance — you got it every day in school. So, when I found folk art, I found a sort of tangible celebration of the melting pot I had been taught to believe in. Ken Ames and others have commented that it is both curious and charming that this perception generated and drove the collection. Ironically the collection today suggests that the melting pot never melted. Each piece in the collection artistically argues its own specialness. In the end, I suppose the collection was talking about multiculturalism before it had a name. But I never lost my sense that the collection was a synthetic whole and represented my culture, my roots and in a sense me in an American experience. I suppose my idea grew up a little bit but I don't think that it changed so much. It just dimensionalized. My best vision looks for a broader assessment in which we would finally voice and give power to folk art and to the people who make it by celebrating their significance in bigger ways. I think that's really the project that I've been involved with as a collector and I'm just one of a number of people involved with it. Folk art is an interesting test — because there is so much uncharted water. Not many people have been asking the questions being asked about folk art in other more established areas of art. I see folk art becoming more central because of its potential to carry a load of cultural argument about what all art is or might be. Arguing the art/culture argument around folk art and setting folk art objects in conversations where they have to fight for their lives, is a way to fight for our own lives. I don't make an apology for the art idea, it seems a good one to me; I believe integrating folk art study into a cultural reassessment of the idea of art itself is the project for folk art now. If this happens — and I hope the Hall Collection can be a part of it — I think the art of folk art will take on new meaning.

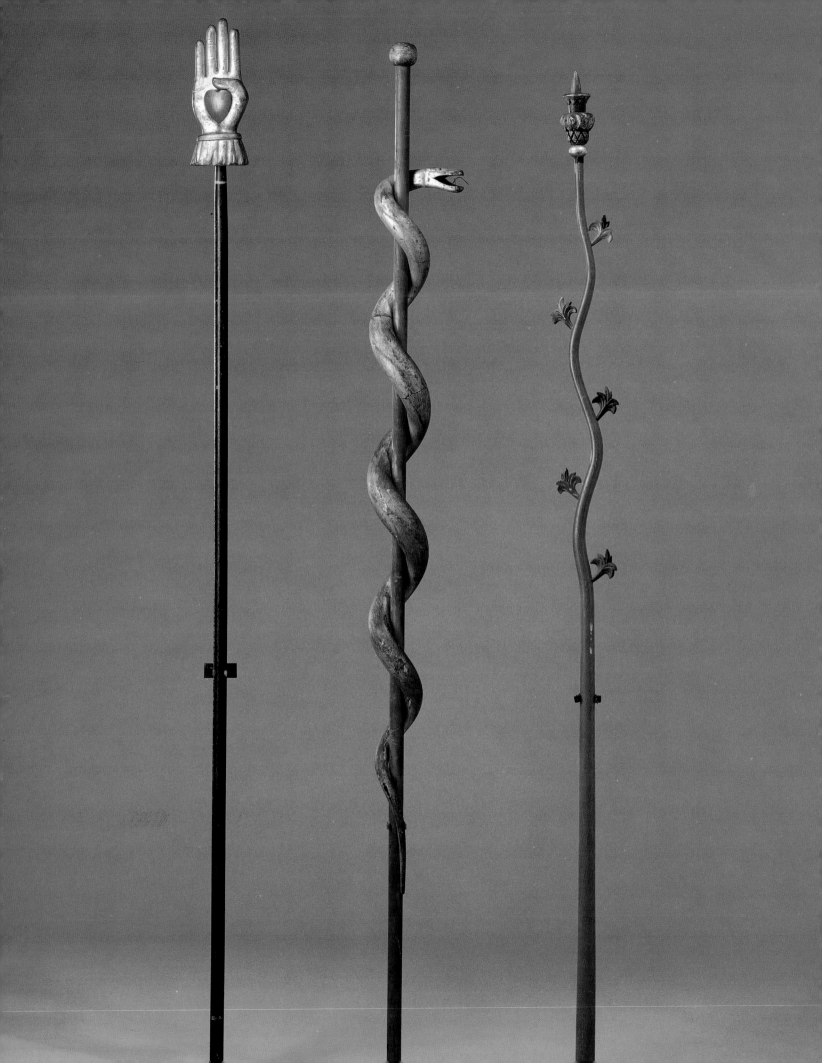

Interview with Julie Hall

Russell Bowman

July 18-19, 1992
Milwaukee Art Museum

RB: *Tell me how the collection began.*

JH: Well, it's funny, Michael was a stamp collector when he was a little boy and a Pogo comic book collector. When we moved to Kentucky we were collecting pottery. I met Michael in a pottery class (he was my pottery instructor), and my degree was in art history. With his penchant for collecting and our mutual interest in ceramics we started rather casually — almost for decorative purposes — collecting ceramic jugs, kind of a nondescript sort, nothing fancy. And I think at that point we went to the Berea Craft Fair where we discovered Edgar Tolson. Actually it was me, because I saw that carving and it just struck me, I don't know why because I had no educational base from which to come to it — it just struck me as an odd thing. So I asked around, and Tolson was being collected there by a potter at the university, but we didn't know that. Somebody finally said that the pottery instructor might know so we asked him and he said that it's an old lady that's carving those dolls and she's now dead, so we just gave it up. The next year we went back and there was another one there and I said to Michael, "That's it — I'm going to find out who is doing these," and hence the search, and finding Edgar. There was an agenda to some degree, an interest in art, an interest in crafts, Michael's penchant for collecting, and my art history interest — they all came together. We started watching Tolson and really learning from him. Here was an individual who didn't fit any of the classifications in which we were told everything fits. So we started watching him and his work and that's how the ball got rolling.

RB: *Do you think you were predisposed to noticing that work because of the collections that you knew as a child? Michael said that unlike his family, who wasn't interested in art at all, yours was.*

JH: My mother was interested in collecting and there was African art around the house. Maybe the reason that Michael was a collector was in response to the fact that his family really had no interest in anything like that. So Michael, because he had collecting sensibilities, was trying to put together a controllable area in which he could exercise those judgments.

RB: *Did you actually meet Edgar Tolson before meeting Bert Hemphill on a trip to New York?*

JH: Yes, I guess we did.

RB: *And had you already acquired work from Tolson, or had you just met him?*

JH: We had already acquired work. We bought our first piece, a doll, from Vista for $11.00. And when we went to New York and met Bert, it came together. He was showing us all this stuff and everybody was supposedly dead and then we said, "Well wait a minute, maybe there's one of these guys that is still living." For all we knew, there was only one. It was like the last of a dying species — we really had no idea. In fact I think the analogy was Schimmel — a woodcarver with an irascible temperament, carving forlorn and lonely things, occasionally selling them and trading them. I don't think we understood at first — it was like blundering in the dark.

RB: *How did things develop from there? How did you develop from one meeting with Tolson to being Tolson collectors? Was it very conscious?*

JH: No, at first it wasn't. It was just browsing around lost America. The craft fair was the same thing — just looking at stuff and then ending up at flea markets and looking at more stuff. And then meeting Bert. It seemed for me, at least, to grow out of all of these things gathering force.

Unidentified Artists, *Odd Fellows Heart and Hand Staff*, ca. 1850 (cat. no. 132), *Odd Fellows Snake Staff*, ca. 1850 (cat. no. 133), and *Odd Fellows Aaron's Budded Rod*, ca. 1860 (cat. no. 134)

And at first it was casual, and then the pace picked up as we started to realize that there was a whole body of material out there and that a lot of it had, in a sense, not been curated or understood, was misdated, or unfound. Bert helped us with that side of the question because he was always picking up things that he thought nobody could identify.

RB: *Then after you met Bert and began to learn more about the tradition of folk art, were you interested in the tradition? Or were you interested in his somewhat eccentric taste within that tradition? Or both?*

JH: Well I guess both. Coming from an interest in the crafts — community-based cottage industry with proto-types and certain forms that everyone followed — and understanding these things as cultural habits was certainly part of it. And then Bert added the other. So at that point it sort of freed us up to do both.

RB: *"The other" meaning . . . ?*

JH: The one-of-a-kind or genius thing . . . less traditional.

RB: *How did the collecting proceed? How did it become more serious? Did it become systematic in any way early on?*

JH: I think it did because Bert began to take us around and show us all the collectors that he knew, that he had entree to. I do think that Bert showed us that there was a whole body of material which was being collected, sold, bought, auctioned — a whole arena of activity around these things. And at that point, then, I think Michael's collecting habits kicked in and he thought, "Well, if there's a body of material, then we're going to find out the param-eters of it and the reference points within the circle. And we are going to make sure that we have fine examples of all of those points." And a lot of the things we had to find new. I think the exciting part was not having the tradi-tional whirligig, but finding out that there were other things that were undiscovered at that time that might have their own place within the fine art field. Like the *Possum Trot* doll theater. In a sense it is environmental, and there were a lot of people doing that. But the way that Calvin Black did it was his own kind of thing. It wasn't trained art but it wasn't traditional folk art either. That was redefinition.

RB: *At what point did you become interested in that redefini-tion of what the standard categories or types were — very early on or a little later?*

JH: In the beginning we really didn't know what points were already there and what points were not there. It came with a certain maturity to become really cognizant of what we were doing and be aware that there were so many environmental pieces and that each one was very different — so I think originally we were looking at the whole thing and some of those reference points pretty much stayed the same. Whirligigs were already whirli-gigs, and most of the great ones were already owned. Weathervanes were already weathervanes and most of the great ones were owned. But in certain areas, like the environmental pieces or the ethnic things from the twen-tieth century, there was still great stuff to find — and that changed the shape of the known body of folk art.

RB: *But you still, in the early phase of your collecting, went back and looked for the traditional nineteenth-century types as well as more individual twentieth-century pieces. Were you doing that consciously — trying to bring those two parts of the equation together?*

JH: I don't think that at the beginning, consciously. In the beginning, with Michael being the collector, we realized that all these things were loosely categorized as folk art and if we were going to collect it, we ought to have one of these, i.e., as good a weathervane as we can. And when we found that wooden rooster, it was very early and primi-tive, not sought after in the market, so we got the best we could afford in the traditional category. I really don't think we understood that there were whole groups of those things that were worlds of their own, like weather-vanes, and that they could be redefined and collected in their own right. You could start making your own categories, because there was a whole world of things out there that didn't fit into the old ones.

RB: *Did your willingness to accept what some people would consider the crude aesthetic within folk art — the things that were more surprising or eccentric — did that come from your art and art history background?*

JH: Some of it yes, definitely. It freed it from the design, decorative arts or crafts background.

RB: *Or was it the sense of knowing that art was about breaking the rules sometimes, pushing forward and expanding understanding?*

JH: Yes, that was part of it. This is a good story because it shows how sophisticated, yet how innocent we really were. Michael found a goose, a big wooden goose. It was an H. H. Ackerman we found out later, but we didn't know anything about decoys and he brought it home and said this is a neat carving. I remember that he said, "Julie you won't believe this. I just found one goose that's exactly like another one." And I remember yelling from some other room, "Don't be ridiculous! That's absurd!" And I came out and he had them on the floor of the living room and we said, "My god, why are there two of these?" We had no idea there are always two, there may be two hundred, there may be two thousand. That's the way they're made, but then we didn't know. So some of it was discovery and some of it was because our art backgrounds made us understand the barriers and borders that have been erased and moved around.

RB: *At what point did you become aware of another way of looking at this material? Other than the aesthetic approach which I perceive to be the way, say, Bert viewed this material, or that, in the early twentieth century, certain artists looked at folk art for formal qualities that echoed modern art. When did you become aware that there were other people — like the material culture/folklore group — looking at this material in other ways?*

JH: Well, the material culture/folklore perspective came way late in the game, in the 1980s.

RB: *Was the collection significantly formed before that?*

JH: Yes, absolutely. I don't think the material culture viewpoint was very transformational, it was so late that by then all the pins were set.

RB: *What about the collections like the decoys or the ceramics which fall more clearly into a material culture category? Did you start those collections well before you were aware of the material culture approach?*

JH: The material culture approach assumes that all objects can teach you about the culture in which they were made. I don't think that we ever looked at it that way because we weren't really looking in the end to understand the culture. The objects weren't vehicles toward an under-

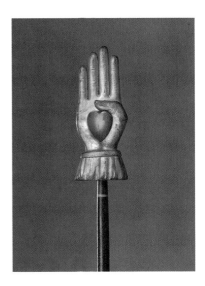

Unidentified Artist, *Odd Fellows Heart and Hand Staff*, ca. 1850 (detail of cat. no. 132)

standing of the cultures that produced them. The things that we learned were often second hand, and it was interesting to know about them because it taught us more about the objects. But in the end the objects were more important than the culture for us.

RB: *What made you undertake the collections within the collection, like the decoys or the lodge hall things?*

JH: I think that the objects led us. I think that the decoy story is probably repeatable in terms of those other things. All of a sudden we found out there were two geese, the rig probably included twelve, the man made more than one rig, and was a Michigan carver. There are other carvers in other areas. You buy another decoy and look at it and you realize it's totally different. So there must be regional differences — maybe there are differences in technique, numbers, or species. The objects lead you at that point. And so you go to the decoy convention groups and you look at everything — undifferentiated initially to your eye — and see that they start to fall into patterns and the patterns they form tell you what to do.

RB: *People think of the Hall Collection as certainly embracing the twentieth century and it is one of the earlier collections to do that. The collection also takes a more formal point of view*

emphasizing painting and sculpture and excluding furniture, textiles and so forth. And eventually, it embraced outsiders and visionaries. It seems strange to me that you were also collecting in an area that was as traditional as the decoys. Most folk art collections today, and probably even most of them twenty years ago didn't go into decoys. Why did you?

JH: I wish I knew. I think at that point it gets personal and the talk diverges from the *we* into *my* view. There is something ritualistic about those things. I always felt that within these objects there was some belief in magic. I really felt that hunters believed somehow that these things draw the birds in from the sky. When they were carving them, I almost felt that there was a kind of mystery about them, like studying old church objects. The birds had a kind of weird, brooding quality that attracted me particularly and that's why I'm attracted to the lodge hall things too.

RB: *I don't think that's the way that most people would describe decoys.*

JH: Well, you're right I suppose. But to me there is something about them. There is a fascination with birds in general with people. The fact that we can't fly and they can. I think I was attracted to them because they have a votive quality, like cave paintings. No one knows what the cave paintings were, but I think that they were to ensure the success of the hunt. If you could draw the horse on the wall with an arrow on it, somehow there would be some magical means through which this need might be imparted to a higher power to make it happen. I always felt that there was an act of devotion or metaphysical activity in making these decoys. Hunters never talk about it and no one ever explains it, but I think that the objects kind of reverberate with that — and that is what attracted me to them.

RB: *You have told me before that you got involved with the whole world of these hunters and collectors, and that it was and probably still is very much a man's world. Was that an interesting challenge for you?*

JH: Yes, I did enjoy wheeling and dealing in a man's world. But there were things about it that were really disgusting to me. I really hate killing.

RB: *You mentioned before your repulsion for hunting or killing animals. How does that fit into this whole equation?*

JH: I really hated the activity but I loved the object.

RB: *Did you ever go along on a hunting excursion to see what the whole thing was about?*

JH: No, but they wanted me to, because they said that I couldn't understand the genre without having experienced the function of it. And of course being the wise-cracker that I am, I said that I don't have to cut off my hand to know I won't like it. I see objects as having two functions when they come from a craft base or a folk base: The first function is with the society that made it, the second function is as symbols for things that we need in the current social mode. In filling our needs, it functions dually. Initially it has a function for the first culture, and secondarily it is an icon of something imagined or real from the other culture.

RB: *Of course the folklorist would say that you are decontextualizing the object and turning it into something that it is not.*

JH: I appreciate the material culturist's desire to get as close to the original thing as possible, but the older I get the more suspicious I become of words like "authentic" and "original." I am beginning to think that change is elemental.

RB: *Do you mean change is a constant in terms of culture and objects — that they are always changing meaning?*

JH: I mean there are people who want to go back in history. There are people who want the good old days, especially now in our political situation. They tend to be extremely despairing of the future. I think that the desire to get back to the original culture — I mean, I appreciate it and understand it, and I even sometimes long for it and would like to believe that with the proper tools a scholar can really understand another period — but deep down I think that we have to invent some of history because we were not there. We are one culture looking at another culture. We try to reconstruct their world, and then if we are not trying in the way that a particular field wants us to, they say we are deconstructing. But I have a feeling that we are always deconstructing. I don't think that you can ever go back and completely understand the minds of people.

RB: *Tell me about the lodge hall things and your fascination for them. I understand that was primarily your direction within the collection.*

JH: One of the things I like a lot about them is that they don't fit any categories. But they follow a prototype, there are a lot of them made. They are not crafts; they are not art. They stretch the definitions of our investigation because they don't fit anything. They do have an aura, again; they have a mystical streak. The makers are trying to make them look peculiar and strange and compelling and ritualistic.

RB: *They did have a mystical presence just in being a part of bringing those fraternal groups together.*

JH: I think the groups got together because the nineteenth century in America was a very tumultuous period and lodge halls provided the artificial stasis that otherwise wasn't there. As I said, I think change is a normal element of culture, although sometimes it's faster than at other times. The nineteenth century happened to be a time when it was really fast. All kinds of stuff was happening in the culture — industrialization, urbanization and immigration — and I think that people thought that the world was in too much flux. I think that they needed this group of brothers. Those words come up in their literature over and over; every third sentence is "my brothers and I" — fraternalism. And all that business is really important because it suggests that these are people "like unto yourself."

RB: *A lot of the lodges also offered financial security, right?*

JH: Yes, that too. Emotional security and financial security. I divide the lodges into two groups. This is not about our collection per se, but my research has led me to believe that some of them were very low on the ritual and high on benefits; they called them benefit societies. Their primary considerations are widowhood, orphans, disabilities incurred during work, bad illnesses, time off of work, burial funds, etc. Then there are others that are much higher on ritual.

RB: *Most of your lodge hall material is Odd Fellows.*

JH: I've found that the bulk of material out there is Odd Fellows. They were the poor man's Masons and they couldn't afford a lot of fancy stuff. So they had the local townspeople making things from catalogue prototypes.

You can go to New York or Indiana and you can find Odd Fellows hand-carved things. You can find Masonic things but they are usually not handmade, they are mass produced — they don't have as many interesting, peculiar objects.

RB: *Were there other areas of the collection that were your particular interest?*

JH: There were certain things I know I was not as interested in; Michael liked the weathervanes better than I did. I never would have had to own a weathervane, but then I suppose he might never have had to own any ducks. I like whirligigs, but not as much as he did. I love painting but a lot of times we couldn't afford it, unfortunately.

RB: *How did you and Michael make decisions? Did you always make decisions together, did you always agree?*

JH: We didn't always agree. Sometimes one person would be in one place and spot something and I would call him up and say, "I found this and I really like it." And he would say, "Do you really like it?" And I would say, "Yeah, I really like it." And then he would say, "Okay then, if you think you should get it, then get it." So you built your confidence by hearing that voice on the phone as much as anything else. As you described the object, you clarified your own feelings about it. So we worked a lot of it out long distance, but sometimes we would be

A. Elmer Crowell, *Preening Black Duck*, ca. 1890 (cat. no. 44)

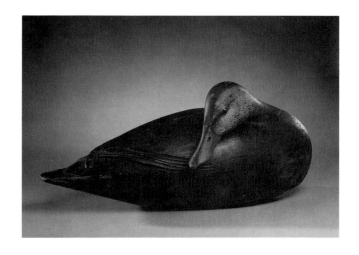

together and then we had a little code because we didn't want to be too enthusiastic about a piece in fear that the dealer would withdraw it or raise the price. Better they raise the price than withdraw it from the possibility of acquisition. We learned to say things like, "I think this is very interesting," which meant, "I'm going to die if I don't have this in ten minutes." Then the dealer didn't know what you meant and you could communicate and make a joint decision.

RB: *There is another thing that I am curious about. How hard did you work on this? Were you out every week? You talked about traveling . . . did you travel to collect? How did you do it?*

JH: We did it all. We got books, every book we could lay our hands on. When we couldn't see the material in person we went through books. We went to see collections. We made lists of all the whirligigs we knew and then we would try to rank them in the top ten. Then we would figure out which one was the best and if we couldn't get it what would be next on the list. Then as we were looking, if we found something we thought was of the highest quality we had seen, we would grab it.

RB: *So you were very systematic in that way.*

JH: Yes, the lists were in file folders. It was a game too, it was fun. We would sit around and say, "Well if you could have any weathervane in America, which one would you have?" I would say "I like that cow owned by Greenspan." And Michael would say, "Yea, what about Bert's peacock?" And we would go on like that. Then we would say, "Well you know, the cow is three-dimensional and the peacock is flat. So maybe that is two different ways of looking at weathervanes. So, I guess we ought to get one in the round, because that's a wonderful thing, and we also ought to get a flat one." Then we would go about trying to get the best of the type as we could find.

RB: *So you looked at all the books, you looked at all the collections, you made lists, you thought about rankings and then you thought about going out and looking for things that would be the equivalent of those — if those things were unattainable.*

JH: Yes, and we drove everywhere. Everywhere we went if we saw any sign — antiques, junk, anything — we would pull over. It took forever — it seems like we were always driving somewhere. I remember one time saying

to Michael, "If we pull over one more time, I really will be sick" because we had made it only twenty miles in two days. That's an exaggeration, but you don't get anywhere fast. But mostly the chase was really fun.

RB: *You must have arrived late a lot.*

JH: Absolutely. Because I would say, "There is a sign over there and it's an antique show." Even if it was a little barn, we would stop.

RB: *And where did you find things?*

JH: Everywhere.

RB: *You mean you found things in little junk stores?*

JH: Did Michael tell you the story about Bert and the blue-eyed doll? That was a learning experience. We were some-place — I don't know where. We used to take trips with Bert sometimes and go antique picking. We'd call and just say, "Let's go through Indiana." We all three went into this antique shop and we had a friendly competition, which was whoever finds first, gets — we're not going to quibble. We had been in a couple of really bad shops, so I wasn't as keen, and I didn't expect to find much anyway. And Bert, I don't know how he did it but he saw this toe sticking out of a box underneath a very unattractive stack of Persian rugs. I wouldn't get near this pile of stuff, but Bert reached down and he pulled out the most wonderful doll I have ever seen. It was this huge, natural wood carving with blue eyes — this wonderful carving. After that I realized with deep foreboding and fear that it could be anywhere. You might find something ANYWHERE. So after that we became scared *NOT* to stop. I mean if there was a gas station and we looked behind it and there was a shack full of old wooden stuff, we would be tempted to go poke around in it. Because if he could pull that beautiful doll out of that stack of rotting rugs . . . it put the fear of God into us and we looked everywhere, and with success.

We went to dealers all over the country. We went to Madison Avenue and we went to Fairview, Ohio. If there was a dealer and we liked their advertisement or it looked like something interesting, we wrote them. We would start contact with them. We'd write back and forth asking if they had anything, asking for pictures.

RB: *Some people would find this rather obsessive behavior.*

JH: It was fun! You got tired, but we had fun. I remember when we finally bought the *Pair of Black Figures*. We weren't going to leave them in the car, and we were in a motel in Ohio. We had them wrapped in blankets and we took them into the hotel room. And by the time we got the second one in there, we looked out and the motel owner was sneaking around our cabin. He thought we had two bodies with us. Sometimes it was stressful or bad, but a lot of times, it was just downright fun.

RB: *When Michael talks about the collection, he talks about wanting to redefine folk art. So have you. Then he talks about wanting to recast the appreciation/understanding of this material. It was as if he wanted to make this redefinition and then have it accepted by getting the collection into an institution. Was it always your goal that this collection would go to an institution?*

JH: That's Michael. I hate to be an armchair psychologist, but I think in a sense Michael wanted and wants his own work, although created outside of New York and thus always difficult to get noticed, to be accepted in art circles. And I think he felt a kind of projection, a kinship to some of the artists we collected. These artists who are born on the periphery, either in terms of their education or socio-economic status or geographical location, are not privy for one reason or another to the venues that other people have for success and fame. I think he felt for them that it was appropriate, that they deserved a wider audience. So he had more of a mission than I did.

RB: *But it was never your goal to create this collection to pass on to an institution. You simply were enjoying living with it.*

JH: Absolutely. I just enjoyed getting great stuff and living with it. To be able to walk in your own living room and say, "I forgot how wonderful that is." or "Wow, that's really great." I'd look at those *Possum Trot* dolls and think what unique, marvelous objects they are. In a world full of things, there is nothing like them. Nothing. And here is this man sitting there with a carving knife and some pots of ugly acrylic paints, some old clothes and some used wigs, and he created something which is a marvel on this earth.

RB: *Do you remember artists or objects that you had an immediate aesthetic response to?*

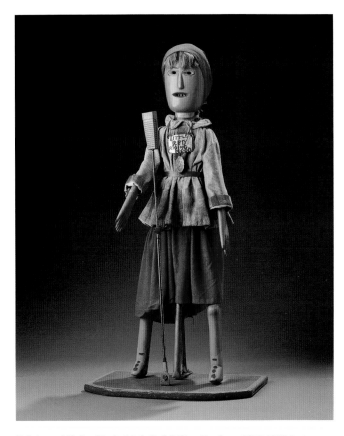

Calvin and Ruby Black, *Little Red Riding Hood*, ca. 1950-1972 (cat. no. 165b)

JH: The *Pair of Black Figures* I did right away. Michael saw those first. There was this woman named Murphy who was an antique dealer in Hamilton, Ohio. Let's see, how did Michael happen on her? I think Clark Garrison mentioned this woman down the road. Michael drove there and she had them up in the attic of this barn, from what I understand. They were on their backs and Michael saw them and he loved them. If I have the history right, he took Bert there to look at them. And Bert was doing one of his cranky acts where he said, "I have the two greatest figures . . ." Well Michael really didn't know how great they were. In fact, I think he was almost overwhelmed and felt, as junior collectors, we should show this to the big collectors and maybe even they ought to have them. Now that I look back on it, it's like he bought his folk art mentor in to take a look at them, and if his mentor wanted them, he knew they should be bought.

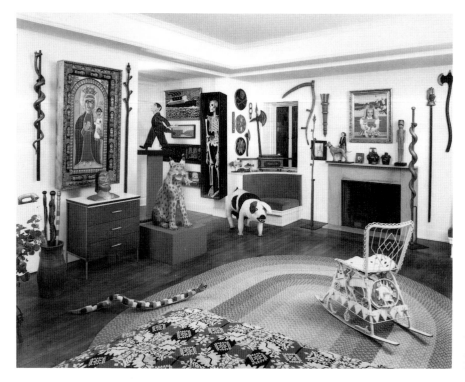

The collection in the Halls' home, Cranbrook Academy, Bloomfield Hills, Michigan, 1989. Photo by Steve Benson.

Somebody should have them. And Bert looked at them and said "I already have the two greatest figures, why would I want two more?" And he shook Michael's confidence in him as a young collector. And so then Michael came and got me and asked me to look at them and tell him what I thought. And by then, he was pretty shaky. We drove up and looked at them. I couldn't even talk . . . I remember that I could not talk. Michael got in the car and we were driving away and he gave me this sheepish look and he said, "Well, I guess you don't like them, do you?" When I got my breath, I said "BUY THEM." Just like that, it's all I said. "Buy them." He said, "Well how can we afford them?" I said "I don't know, but we have to have them. They are the greatest things I ever saw." But he had interpreted my silence as disapproval. I was staggered by the sight of them. They were so magnificent. I have never seen anything like them before, and I'm not sure I ever will again. And we went scooting back down there, and got them and put them in the car and drove back.

RB: *Michael and I talked a little about the whole outsider art thing. He said you were always more open to those artists than he.*

JH: Yes, I suppose so. Well, I like the peculiar. I like the decoys and lodge hall paraphernalia because they are kind of weird and ritualistic and there is a kind of obsessive quality to outsider stuff too. I didn't know it at the time — that peculiar obsessive patternization that they do over and over — like a zig-zag motif 4,000 times — that's crazy. And I like that. I'm drawn to that kind of weirdness. So maybe that's it.

RB: *He said he was slowed down because he couldn't "fit" outsider art into a category at the onset. In fact at that time it didn't have that name. And so he said he was hesitant while you were not.*

JH: Well it was because he had a more methodical mind. He always had an inclination to find out what the categories were and fill them. I think his background in stamp and comic book collecting helped him to think that way. And since I had never been a collector, it was easier for me to walk up to something and (to use Ames' terms) "immerse and tingle." Of course, I would like to think that my immersion and tingling had to do with a point at which my intellectual understanding kicked in with my sensibilities and went hand-and-hand so that I made a

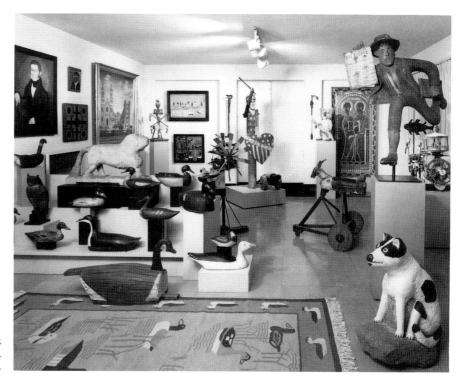

The collection in the Halls' home, Cranbrook Academy, Bloomfield Hills, Michigan, 1989. Photo by Steve Benson.

choice that was intellectual as well as emotional. I wasn't worried about the categories as much.

RB: *How was it to acquire an Edmondson when you had grown up with Edmondsons?*

JH: A little dull for me. I would never admit that before.

RB: *There wasn't any sense of coming full circle?*

JH: No. Another reason possibly that I wasn't so worried about the categories — I was thinking today, here we have all these art historical types who are working like hell to try to figure out how things fit together and they are happy because there is a group of things called Impressionism and there are definitely some characteristics that those artists share in common. And then when Van Gogh and Gauguin come along, historians realize that they are not Impressionists, but they don't know who they are, so they grope around for a term and they find it. And they call them Post-Impressionists — that just means after Impressionism. Obviously they couldn't find any stylistic analogues in there anywhere. These stylistic categories are always slipping and changing or are not very real to begin

with . . . Having some understanding of the caprices of art history too, rather than being a collector like a stamp collector — I already knew that the categorization of the things we were collecting could be slipping around. You can certainly look at those things and find a way to open up to them without worrying where they fit.

RB: *It seems to me that you have talked about the collection being put together with two complementary viewpoints and that these seem to synthesize into one whole. Is that still your view of the collection today?*

JH: I think that it was a constant conversation and I really think that we learned from each other in an interplay or a kind of resonation that was an ongoing evolution for both of us. And I can remember Michael bringing home something or me bringing home something that one or the other of us liked and that the other person had never thought about. And later on, the other person saying "My gosh, that really is interesting. I really hadn't thought about it." And the next purchase would indicate their understanding of the potentials or the expressive possibilities of the piece that was brought home.

Interview with Julie Hall

RB: *Do you think that collections come to a closure — that they complete their statement?*

JH: I think so. That would be true of any kind of collecting. You make a decision that you're going to collect all of these different things — say weathervanes or decoys. The decoys took a long time to finish because there are a lot of different construction methods, a lot of different areas that should be represented, a lot of different species that were carved. So, there are a lot of interesting carvers and you may decide whether or not you want them represented. You kind of get a scheme for it, and realize that you want a carver from every state, or any area that carved a different kind of decoy, and you've got all those. And then you get all the species. And then you sit around and figure out which maker made the best wood ducks, and you figure out whether you can get one, and you get one that's not very good, but you'll never get a great one because there's only about three others and they're in private collections, and you say," Well, Massachusetts wood ducks are pretty much done." And you upgrade constantly, and finally in the end you have the best example of the Ward Brothers work, or the best example of William Bowman's shorebirds. And you decide that in Massachusetts they did golden plovers, and Bowman did great golden plovers, so the epitome in that area would be to get a Bowman plover, because he is one of the best Massachusetts carvers. And you get a really fine one, in wonderful condition, and what else do you need?

RB: *Do you think that the Hall Collection, as it has now come to the museum, essentially represents that kind of statement . . . of completing a lot of the categories and representing those categories with primary objects?*

JH: Yes, except for some of the paintings, and I am delighted to say that you have a large and significant group of paintings [in the permanent collection] which will complement the things that we didn't have, that we frankly couldn't afford, to be honest. Everything that we could do from our financial position, our aesthetics, our intelligence and our energy level, we did do.

RB: *Do you think that your notion of quality is still formally based or aesthetically based, and that this had something to do with your background as an art historian?*

JH: I think aesthetics are all culturally based, and we can only come out of our culture. We couldn't have looked at

African sculpture before we had modernism, for instance. So when you look at African art and say that it's beautiful, I think it's all absolutely relative. But in the sense that we do get certain ideas about what is beautiful from our culture, you always have to deal with masterpieces.

RB: *So we look at folk art then with the eyes of our culture and even our own definitions of what's beautiful or powerful based on modernist ideas . . . that's the only way we can look at them.*

JH: That's what I think. Marxists would say that's just a manipulation of the upper classes or the elite to get people to pay money and act a certain way concerning these objects. I don't think that. I think that mankind has a natural disposition to rate things higher or lesser. We are all cultural, social beings, and we look to other people and work on our ideas of what's good, better, best . . . That's what man does — animals can't do that. It's a natural human condition. So to discuss it in terms of manipulation or of one class over another I think is very insignificant when you look at how people operate. Of course you're looking for the best one — because you are a cultural being. Material culture people are looking for the best one, but the best one for them is the one that has the most information in it. When they see a chair that they're most interested in, they believe that chair manifests more elements that express the society from which it came. But since they are bound to be looking at it from a different position than the person who made the chair, they too are manipulating and being arbitrary about what is the best. So, coming from an art background, I'm going to assess it with some of the aesthetic criteria taught to me.

RB: *Wouldn't material culturists argue that there is no best? That all chairs are equal in terms of the information that they give us about the culture in which they were made.*

JH: They might argue it. But when they sit down and decide to write about it, it's because they think that object is more telling, has more information about a group of people or a period we don't know much about.

RB: *Do you think that these points of view, i.e., our cultural standards about quality, or the information about the culture that can be derived from an object . . . do you think that those two points of view can be synthesized?*

JH: Yes. All of these things are interlaced — to talk about aesthetics is to talk about a lot of things.

RB: *In terms of the social conditions, political changes, understanding of roles . . . how do you think that those changes as you lived them in the period from the late sixties through the eighties affected your ideas on collecting?*

JH: I think that the collecting effort, like all of our efforts, is linked to our understanding of American society. I think that when we were first collecting that the melting pot probably was our guiding principle. There were times politically in which we thought that the similarities among Americans were more important than the differences. And politically, Johnson's Great Society assumed that the similarities were going to bind us. And then we became dismally aware that Americans did not all agree on how things ought to be. I think that the collection reflects the different political climate, and later on we were looking for things that reflected a strong ethnic influence.

RB: *You started off thinking that the collection was going to show how the diversity of America comes together. As political sentiments evolved, you began to see that maybe that wasn't happening. So the collection's diversity you began to see in another way, as expressing the diversity of American life, sort of emphasizing these individual statements.*

JH: It became more important to make sure that you covered all the divergent points of American mixture, because we were more aware politically that those points were defined and weren't melting together.

RB: *This leads me to another question that Ken Ames mentions in his essay. He expresses surprise that you, as a co-participant in this collection, didn't represent more women artists. How do you respond to that?*

JH: I think of myself as a person beyond my gender. Gender wouldn't be guiding my decision making in terms of what I was interested in collecting. Secondly, I don't think that making art or collecting art has to have a hidden agenda. I don't believe that is the nature of art.

RB: *Some people would argue, though, that the choices you make, whether you intend them to be or not, are political.*

JH: Well that's fine then, because we are part of a culture and we have to reflect the political culture. If I had been a real card-carrying feminist over and above other things, then I suppose I would have collected quilts over decoys — and that would have reflected me and the culture that I

was responding to. But, although I am a feminist, I don't operate in that way, and it wouldn't have been right for me to have to do that.

RB: *What about your relationship to living artists, be it Tolson or someone else. What do you think the meaning of that was to you and does it affect the artists?*

JH: I think the first thing that happened for us, personally, was that these people were a revelation. The Tolsons had eighteen children. The Tolsons didn't always have running water. They often didn't have food. They lived a life that was very close to the poverty level, or in the poverty level. So watching these people survive in these conditions, and in Edgar's case still be a creative artist, was really quite amazing. It made it clear that artists didn't have to work in lofts. The impulse to make things was absolutely universal. For middle class people who had been to art schools and universities, to see the way these people lived and survived in this very depressed economy, in a very peripheral geographic area, and still get up and take a carving knife and try to make something that the mind had conceived — that was really fascinating and exciting and tremendously broadening.

RB: *Do you think that your discovery of Tolson, and to a degree I would even argue your promotion of Tolson, changed him as an artist, and do you think that's inevitable?*

JH: In Tolson's case, he really didn't change as much as one would think he would. I can't imagine that he wasn't changed in some way — my basic philosophy is that in visiting a place, even putting your foot on the soil, you change in some way. So the increasing amount of people who went to see Tolson, write Tolson, had to change him in some ways. But I think that in his particular case he became more prolific. Before he was an extremely discouraged person, the kids would come in and take things, throw them away — they weren't a valued object in the community at all. And by the time that it was all over, Tolson was a valued individual, and his work was valued. So he made more things, and of course his situation changed economically. The Tolsons moved up in social rank and economic security.

RB: *Did that happen for him before his death?*

JH: Absolutely.

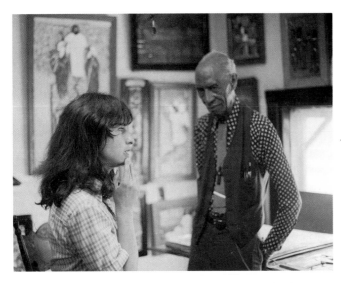

Julie Hall with Elijah Pierce in his barbershop gallery, Columbus, Ohio, July 1978. Photo by Michael Hall.

RB: *Both in economic terms and social approval based on his work?*

JH: Dramatically. When we came into town and were trying to find him, I remember that the woman we stopped at the luncheonette immediately responded negatively — "Why were we looking for him? He drinks too much and makes naked people." That's what she said. And she really didn't want to tell us where to find him, but she said rather scathingly that, "If you're going to find him, go look in the pool hall." By the time we left, the Tolsons were well respected. Of course no one really understood it, but they knew that he was famous, made money, and was accepted in other places. Without putting a value judgment on it — like determining what it means to sell out or lose integrity — certain artists will change much more rapidly. Tolson seems to have had a natural immune system to anything but what he was doing, and he pretty much stayed the way he was. And when he died, he was very much the same man, the carvings were pretty much the same as when we had met him. However, it did inspire a whole bunch of entrepreneurial types in Campton to make a cottage industry out of folk art.

RB: *What's interesting is that, based on a certain modernist impulse toward originality of thought or creation, we take the cottage industry offshoot as indicative of decline. While if*

you take the traditional definition of folk art, passing on tradition is indicative of authenticity.

JH: Right.

RB: *They're producing something within a system of aesthetics and values that their community understands, and it's part of the way that they live and work.*

JH: You're right. For the material culture people, that should be more significant than the other.

RB: *Exactly.*

JH: Because its indicates a whole economic and philosophical and aesthetic group of things going on in a community. For them it would probably be the more important thing to look for. And for others, who have a bohemian model for artists, they'll be looking for Tolson to be the individual, the innovator.

RB: *The untouched original.*

JH: Yes, the authentic innovator. It just depends on which viewpoint you're coming from — which one you value.

RB: *But is still indicates that there is a difference in approach between the art-based faction and the material culture faction. As much as we try to synthesize them and try to learn from each other, there is still a basic difference of value there.*

JH: And this is a perfect way to talk about it, too. People who come from the first model, the art model, would say that Tolson is an innovative individual, a staunch American, a self-reliant Natty Bumpo and an aesthetic innovator, a man of integrity and independence. And that the Campton School is a bunch of copy cats and entrepreneurs. And the material culture people would say that Tolson is an interesting, idiosyncratic occurrence.

RB: *But not the real expression of this culture.*

JH: The real expression of the community and the interesting thing for material culturists would be to study the guys who were copying or taking their own liberties with Tolson's model.

RB: *One of the questions that has always dogged folk art from the beginning is the uniqueness of its expression and how it is*

indigenous to America . . . the whole question of "what is American in American folk art?"

JH: I think that what might be American in American folk art is our belief in individualism. The whole idea of looking for the "one man, one pocketknife" idea is very American — we're looking for it. I don't know whether individualism is reflected in American folk art, but our desire for it may be. I think there is an individual aspect to it because, as much as I've gone around this country, I've never seen anyone make anything like Tolson, or the *Possum Trot* group. Nothing is like it in the world. So I have to believe that there is something to this individualism in America that does affect peoples' ability to follow their own star, so to speak, and follow their own ideas.

RB: *That very emphasis on individualism again comes closer to the artistic definition of art than the folk definition of art.*

JH: Yes. And I'm one of those people who believes that America did invent the idea of individualism. And I think it is American, whether it resides in Tolson or in the constituents of Ross Perot. We believe in it, we want it, and we enact it. We would like to believe that our destiny is in our own hands. That probably affects everybody in our society, whether they are living in Appalachia or running for president.

Crossing into Uncommon Grounds

Lucy R. Lippard

I live in layers of familiar objects, some made by well-known and some by unknown artists, while others, equally exquisite, are created by nature alone. One of my favorites is a human/natural collaboration — a circular root snake that kicks around on the crowded bookshelves above my desk. It irritates me that I can't remember where I got this handsome object — a flea market, a junk store, perhaps a gift, years ago. It is about four inches high. The wood is black and hard with a natural patina. It curves twice, then the head turns back toward its triple tail, which resembles three new and finely writhing snakes born of the stronger body. A small knot in the wood forms a kind of topknot or headdress behind the eyes. Winding three times around, it could be a bracelet for a wrist smaller than mine. One eye is a tiny lump in the smooth, dark wood, and the only human-made emphasis is the other eye and a groove carved for its delicate mouth. It is fragile, graceful, and tough. It feels as though it could be African American, from the South, where I was raised for several childhood years, ignorant of the spirits around me. But it could also be from some other continent, the intricate curling branch of some plant I've never seen. Although I was once trained as an art historian, and now and then feel a tinge of curiosity, I don't ultimately care where it comes from and I've never gotten around to showing it to anyone who might know. Its beauty and resilience reassure me; it belongs to some place where little distinction is made between "natural" and "artificial," a place where humans and nature are not antitheses, where continuity between the two realms is taken for granted. I like to think that the root called and some artist responded, with a single word. Was the artist woman or man? Brown or pink? Here or there? Sooner or later I will know more about the snake's origins. Will it matter? What if it turns out to be something I'm not supposed to have? Something unownable? To whom should I return it?

A second object from my daily life: Bessie Harvey's *Rider* is also made of roots. Although I have never met the artist, I have seen a lot of her work over the years and finally found one I could afford in North Carolina. A wide-eyed black figure, whose horns are also hands holding the reins, does not control the runaway "nightmare" it rides. The steed has a giraffe-like neck, several horns, buck teeth, and eyes like its rider. The rider could be the artist, any artist, being "carried away" into unsuspected, desired or dreaded realms. Harvey, an African American woman from a small town in Tennessee had seen the images since childhood, but only began to bring them out of the wood and roots after she had raised eleven children. Her materials call out to become her visions. "It's somethin' like a torment," she has said. "Just about everything I touch is Africa . . . and I must claim some of that spirit and soul."[1] Robert Farris Thompson, citing Harvey's "formal plenitude," says she "vibrates" her wood with the addition of paint, sparkling glass, and foil. He also notes that her figures can be regarded as incarnations of *bisimbi* — powerful local spirits in the Kongo that are twisted like roots:

> Forked branches, held to be remarkable counters of the presence of the spirit, are such a strong element of the Kongo religion in Cuba that the faith has come to be termed *palo* (stick, twig, branch from the forest).[2]

A third object near my desk — a tiny armadillo skull, its mosaic scales painted in orange, turquoise, black — once had a life of its own on a Texas prairie. It was resurrected, and given new eyes — a shell and an agate, "for seeing in all directions" — by Cherokee artist Jimmie Durham, who is self-and-family-taught as a carver, and school-taught as an "artist." "A 'savage' can't, or won't, make 'fine art,' " he says.

> .Back home we have old people who have the most amazing power — it shines and vibrates, and

Bessie Harvey, *Pregnant Woman*, ca. 1985 (cat. no. 175)

Ben Miller, *Snake Cane*, ca. 1985 (cat. no. 107)

I think that it comes from their goodness and generosity of spirit . . . I'd like to achieve that.[3]

And one last piece close to me: an old dark wooden plane was given to Peter Gourfain by an old man he befriended in Brooklyn. He then transformed its surfaces with a rich frieze of Romanesque-like figures that seem to be rising up in revolt against their confinement. The tool, already venerable, already a handsome object, has been given a second life as "art." The artist, whose training and sophistication is extensive, but who has always been able to keep his feet on the "common ground," has recalled or responded to pre-industrial roots.

These four objects, found and altered by artists — which I've chosen to begin with because I know them better than the pieces about which Michael and Julie Hall feel the same way — run a gamut of "outsiderness." Harvey, Durham, and probably snake-maker qualify (problematically) as outsiders because they are people of color, while Gourfain, the white male, has been a formal and political resister against (and at times within) the mainstream. But only snake-maker and Harvey qualify as outsider artists if artworld definitions are applied, and Harvey has now exhibited so often in high art venues, an argument could be made for her having escaped the fold and become a "black artist," waiting like so many of her African American colleagues to cross the artificial border into just plain "artist." Durham, whose savage post-modernism is a protest against the exclusion of native American production from universal art, is trying to carve out a place where the two can coincide. Gourfain — committed to social change through left politics, teacher at both art schools and senior centers — moved years ago from "inside" minimalism to "outside" maximal art; he scorns the commercial milieu even as he sometimes makes a living as an artist. Snake-maker, who may be long gone, doesn't care what s/he is called.

The term "outsider" art, fairly new and already discredited, is as confusing as the range of works it tries to incorporate. The Halls have called the artists in their collection "isolates" (isolated in urban and remote rural environments or by states of mind, mental disorder, religious preoccupation) rather than outsiders, although both terms seem to contradict another common definition of folk art as communally based. These artists are outside or isolated from what? Their own social contexts? Some-times. The mainstream? Usually. They are outcasts only in the sense that those who live in their head tend to be ignored in a society that primarily decorates the pocket and the outer self. Their isolation is actually a perceived but unacknowledged class difference. From an existential position, they are no more isolated than most modern souls. So it is a matter, once again, of an ethnocentric society's negative naming process — based on what is not, rather than what is; the margins are defined by the center.

The high-cultural bias with which folk artists of color are viewed is itself a problem of context — not just the white-walled elegance in which a painted tin bucket or a beaded watch band or a carved religious figure may be set off, but the surrounding, pervasive, invasive social

constructions of art which influence the folk artist as well as the fine artist of any color. When and if the categories blow away, we will be able to go back and look at the work of each artist in real particularity, in terms of her or his life, place, family, community, education, influences, beliefs, values and the longings and visions that never entirely transcend the specific, the "ties that bind" us to the earth. *Common Ground: Uncommon Vision*? Maybe it's the other way around, and the visions are more common, more universal than we suspect, while the uneven ground of a class society is not so common after all. While it is true, as African American poet Estella Conwill Majozo says, "We're all breathing each others' breaths,"[4] we breathe from different places. According to art dealer and folk art scholar Randall Morris:

> Entire bodies of work have disappeared from our knowledge banks because the art establishment did not have the right word to describe it. Environments both sacred and secular are destroyed every week because their importance in this universe has never been understood . . . We are the outsiders. We are dominating and invading entire ways of life and giving them our names. By naming it we think we own it.[5]

I prefer the term vernacular, or home-made or self-taught, though of course all good art is to some extent self-taught and the studio is home to many, just as home is the studio to many. "Perhaps if we started seeing the homes of the Southern artists as studios," says Morris, "we would stop treating them as factories."[6]

This statement recalls parallels with feminism in the early 1970s, when women artists, often lacking the big white lofts where men worked, demanded that kitchens, bedrooms and card tables be seen as studios. Perceived as well as actual context determines how the product is seen.

It seems both inane and inevitable that I have already opened that can of worms I had meant to let alone: "What is folk art and what isn't?" I am torn, as I write for the first time at any length on vernacular art, between the scholar's temptation to name, to divide and divide again, and a contrary urge to decategorize forever. Who are the folk? Who is the "common wo/man"? Yet the ground is shifting even as we try to pin down the categorizations. And in the field of ethnic aspirations, naming is of extraordinary importance. Since *all* defini-

tions of art tend to be intellectually pretentious, romantically vacuous, or wishful thinking, I yearn, probably naïvely, for a day when the categories will disappear and unconfined experience will become paramount. Destruction of irrelevant and misleading nomenclatures shouldn't affect the way the objects are seen, but we have learned enough about representation over the last decade to recognize the way vocabulary constructs the hierarchies on which the market and imposed notions of Quality are based.

Like most people whose lives are committed to looking, I have always been pleased by serendipitous encounters with vernacular art. But I have been forced to confront this growing pleasure directly in the last fifteen or so years in which I have become jaded by the art scene and often disaffected by the fine art that used to affect me deeply. The absence of meaning in many of the most beautifully made or cleverly stylized objects within the art world has sent me — and others — back to what I emotionally, if not intellectually, perceive as the sources of creativity. This return need not mean a regression to the kind of aestheticizing that has characterized past study of folk art. On the contrary, perhaps by expanding — going further out on both sides of the formalist/contextual debate — some actual common ground can be discovered. Strategies might include unexpected collaborations and dialogues decontextualized by moving out of the art worlds and into less rarified territories.

The range of complex situations displayed in the four objects around my desk is not that rare. While the so-called art world mainstreams (there are several of them, which overlap in the market) still hold the center, the so-called margins are occupied by a great diversity of art and artists and have been the most interesting place to Look and See for well over a decade. Some of this divergence, and rebellion against market control and categorization, began in the early 1970s with the feminist movement's rehabilitation of so-called craft mediums — from fiber arts and quilting to china-painting, hobby arts, even baking. Fourteen years ago I wrote that perhaps only in a feminist art world:

> will there be a chance for the 'fine' arts, the 'minor' arts, 'crafts,' and hobby circuits to meet and to develop an *art of making* with a new and revitalized communicative function . . . [when] our visions are sufficiently cleared to see *all* the arts of making

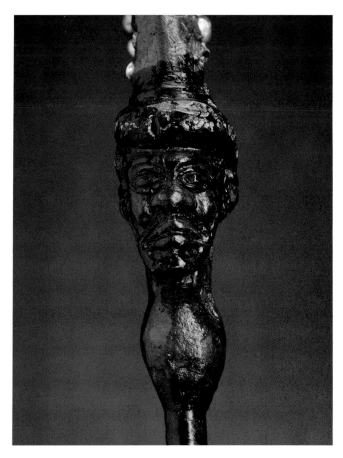

"Stick Dog" Bob, *Golf Club Cane*, ca. 1970s (detail of cat. no. 103)

as equal products of a creative impulse which is as socially determined as it is personally necessary . . . [7]

Through the 1970s and 1980s, the sources, content, and materials of new art continued to expand, but the contexts usually remained inside the art world. On the margins, however, a new genre public art, often involving performance, was developing out there in the world itself, where the audience or participants — true outsiders — become part of the mix, the form, the artist's work. As it expands the view of art itself, this kind of avant-garde community art indirectly expands my view of vernacular art. Deliberate mixtures, even confusions, of "high" and "low" cultures invaded the fine art context in collective forms like Group Material's shows (such as *Arroz con Mango* in which each inhabitant of the gallery's block

contributed her/his own favorite art object), Judy Baca's and Tim Rollins' work with unprivileged kids, Suzanne Lacy's communally constructed performances with older women, John Malpede's Los Angeles Poverty Department work with homeless people, and many others.

By the mid-1980s a second tributary met the mainstream — the presence of an increasing number of innovative and culturally rooted artists of color. From the dual directions of conservative nostalgia and radical challenges to conventional history, the idea of personal and political roots has inspired a great number of contemporary artists. While some have warned against the dangers of "getting tangled up in roots," others have felt the call of real or imagined homelands. Today, for instance, David Hammons' African-inspired street (and gallery) art that pays homage to black vernacular art, is welcomed into the artworld. Faith Ringgold's quilt stories and Joyce Scott's beaded sculptures — both learned from their sewing mothers — are finally also considered high or inside art. At the same time, as Randall Morris points out, biography is more important than aesthetics in the evaluation of vernacular art: the artists have to be poor, crazy, criminalized, non-white, uneducated, young, old . . . [8] In a recent exhibition organized by the Southeastern Center for Contemporary Art — *Next Generation: Southern Black Aesthetic*, which admirably incorporates vernacular artists Hawkins Bolden and Lonnie Holley (whose work is arguably the best in the show) — only these two artists are described in the catalogue's biographical section by paragraphs about their lives, not their careers; the professional artists are represented by long resumes listing exhibitions and honors. Such inclusion, if not yet seamless, is a step in the right direction. But it is unlikely that black vernacular artists, like their professional counterparts, will often be able to make the leap over "Black Art" and into "Art." One reason is that vernacular artists are rarely given the chance to speak for themselves. Interviews and artists' statements are hard to find.

Eugene Metcalf, in a ground-breaking article written almost a decade ago on "Black Art, Folk Art, and Social Control," has written that the Harlem Renaissance marked first-time white support for black arts, while at the same time, there was "a hardening of caste lines and a resurgence of racism resulting in bloody riots and the rebirth of organizations like the Ku Klux Klan." This sounds very familiar today as the right wing attacks all

moves towards multicultural cooperation as divisive threats to state unity. Similarly, Metcalf again on the 1920s:

> . . . the new popular stereotypes of black primitivism were remarkably similar to the old racist stereotypes of black self-indulgence and irresponsibility. Before the 1920s blacks were condemned for being childlike and shiftless. After the war they were applauded for being spontaneous and free. The image had not become more accurate; rather, white society's view of itself had changed, and whites now used blacks to justify their own rebellion against the discontents of civilization . . . Generally, it was hard to tell the difference between the derision and the praise.[9]

Today white people remain the gatekeepers. Whenever we pick and choose from other cultures, we are validating values and tastes that may not be shared by those who made the art. We tend to select that which either validates our own values or at best, that which provides intellectual challenges to our assumptions.

Commercially, the main thing that separates folk art and "black art" is that Southern African American vernacular artists don't usually have agents; their work is netted through sharecropping situations, in which, according to Morris, "all their output is picked up for relatively small stipends by agents and pickers and then farmed out at huge markups around the country . . . And to this day no one has called the concept racist in public."[10] The same of course can be said of Appalachian, native American, and Latino craftspeople, whose work is intended for fairs, church sales, flea markets, or airports.

Eugene Metcalf has written that definitions of art are highly political. The fact that most of these artists don't give a damn which kind of artist they are called shouldn't negate the weight of this process. The makers of things *are* often pleased that they are perceived as *artists*, aware, like the rest of us, of monetary benefits and prestige accompanying that glorified position. It is romantic to think that in this day and age folk artists can be rigidly separated from the values and society in which the rest of us live. That used to be the myth about artists in general, that they somehow escaped their social context and were "freer" than the rest of us, above it all, or below it all.

Poverty separates in other ways. To consider context is to consider class and economics. There is a pervasive

and paternalistic tendency, even among the most progressive onlookers, to assume that folk art is spoiled by contact with the (true) outside, that sophistication will destroy rather than enrich authentic vernacular output. (And of course sometimes this is true, as it is true for high artists who lose their way.)

Have things really changed since Holger Cahill wrote in 1932, "Folk art cannot be valued as highly as the work of our greatest painters and sculptors, but it is certainly entitled to a place in the history of American art?"[11] This is the kind of guarded reception so-called multicultural art has received in some quarters since the late 1980s. The confrontations, co-optations, and conflicts that have characterized the meeting of margins and mainstream in recent years have been seen as primarily transformative by some (myself included) and as primarily assimilational by others. The latter view has been expressed by critic Donald Kuspit, with a certain realism tinged by a certain cynicism:

> The appropriation of the marginal by the mainstream is dialectical in that the marginal is legitimated by the mainstream and the mainstream acquires the aura of authenticity and integrity supposedly innate to the marginal . . . Once appropriated by the avant-garde, the artifacts that embody marginality slowly but surely become mainstream, eventually acquiring the status of high art even though they were initially valued because they had nothing to do with its conventions. In its turn the avant-garde acquires the exotic look of being at the limit of civilization . . . that marginal art affords.[12]

Since the 1960s, an underground battle has been waged over the extent to which art and life can and should merge. Kuspit concludes that marginal artists once assimilated into the mainstream become minor artists, in part because objects too closely entwined with the real world are not accepted as art, and the nameless makers of folk art have long been defenseless against such charges. They are named in and out of categories at the will of those who love their products and those who exploit them (often the same people). This is only the case, however, when the process of naming from above overcomes direct experience.

All folk art (although that by people of color is assumed to be doubly "primitive") has long played the

role of the other for a hierarchical dominant culture that is in fact a non-culture. Those who maintain a sense of culture are oddly envied by those who have bought into the cultureless dominant culture, even when or perhaps because they live in unenviable economic circumstances. It is culture — often a euphemism for class — that separates middle-class and avant-garde art from vernacular art. White people in the U.S. often see themselves as without culture, without past, whereas vernacular art (like native American art) is seen as permanently located in the past, despite the fact that much of it looks to the future with a certain visionary optimism. James Pierce, a Kentucky/Maine artist and teacher who is a longtime supporter of outsider artists, has noted wryly that "socialized and inhibited university-trained artists . . . pursue the work of these natural artists as they would their own lost youth and innocence."[13] Lukacs' notion of a "transcendental homelessness" that characterizes the modern Western mind, has been summed up by Marianna Torgovnick as

secular but yearning for the sacred, ironic but yearning for the absolute, individualistic but yearning for the wholeness of community, asking questions but receiving no answers, fragmented, but yearning for 'immanent totality.'[14]

From the security of educated whiteness, it can be difficult to realize that change is not change unless it crosses the board.

In a splendid diatribe about everything that's wrong with the context in which folk art is held captive, Randall Morris says that outsider/self-taught art has

little or no contextualization into the art world at large; and worst of all it has become a secret hiding place for the last bastions of cultural elitism, imperialisms and out-and-out racism . . . We seem to need to believe that the 'noble savage' still exists. We need to believe it so badly that we will even cut off part of our own everyday world and exoticize it to create an 'other' we can collect, embellish with theory, and still seek to control.[15]

It was interesting to learn that Michael and Julie Hall first envisioned their collection as a reflection of the mythic American melting pot, but ultimately saw it as more indicative of enduring cultural diversity. This

altered perception is a sign of the times, as well as of raised consciousness. As Michael Hall has said,

the worth of any given work of art is continually being adjusted as its impact on our collective definition of ourselves is reassessed. The artists among us give us a composite image of ourselves in which we perceive our identity.[16]

Commodities in a capitalist society are seen as isolated objects; associations with lived experience are seen as irrelevant to art objects. As we enter a period of intensely hybrid cultural activity in which categorization and divisions are breaking down but not melting down, perhaps the most crucial element at this cultural crossroads is the need for a relational, and reciprocal, theory of multiplicity. As James Baldwin once wrote, rejecting imposed identities, "If I'm not who you thought I was [a "nigger"] . . . you're not who you thought you were either. And that is the crisis."[17]

It is a crisis for the white collector, critic and audience as much as it is a crisis for those who are misnamed. This is not to say, however, that naming is the sole cure, that we will ever understand everything about each other. The vitality of the intercultural process is maintained by difference. New alliances, new mixtures are being formed in contemporary art and the (relatively) unselfconscious creativity of vernacular art seems a good place to look for them. The mixture of kitsch and commitment, synthesis and sincerity, is typical of the new hybrid art, which may be born of cultural specificity, but ends up living in the domain of cultural generality — a national or even global common ground. Instead of seeing folk art as potential high art and separating it from its uncommon ground, why not see its deep roots as something that could be emulated (rather than ripped off) by high art?

Vernacular art is simultaneously strange (mysterious) and universal — it sounds contradictory but is in fact simply expressive of an integrated dualism that surfaces in much of the writing about it. To whom is it strange? To whom is it familiar? In view of the power (and empowerment) embodied in so much vernacular art, it is appalling that the term "primitive" is still used to describe the products of the self-taught, albeit less and less frequently and often in face-saving quotation marks. It is a word that acts like an ecological indicator to our own art environment, a word that is especially objectionable when applied

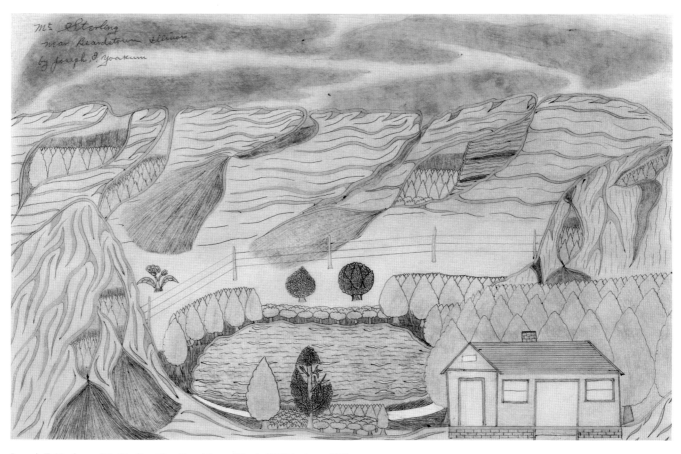

Joseph E. Yoakum, *Mt. Sterling Near Beardstown Illinois*, 1972 (cat. no. 225)

to the vernacular art of people of color. Paraphrasing Jean-Jacques Rousseau and Claude Levi-Strauss, Torgovnick writes that there are not authentic primitives, no nature/culture dualism because "all cultures construct natures."[18] For Euro-Americans, she says, "to study the primitive brings us always back to ourselves, which we reveal in the act of defining the Other."[19]

If any white writer manages to ignore the concept of the Other, it is Robert Farris Thompson, whose twenty-five years of work on the African sources of African American art blithely approaches utilitarian objects, yard art, vernacular art and high art with equal scholarly fervor. He has demonstrated how vernacular art acts "upon black artists like an invisible academy, reminding them who they are and where they came from, an alternative classical tradition."[20] But I am struck by the ambivalence that charac-

terizes so much writing on folk art. Perhaps it is endemic to scholarship to be torn between categorization and imagination. Randall Morris calls for art historians and folklorists to combine efforts towards a "fascinating examination . . . of the process that begins with a folk cultural product and ends as a work of individual genius." At the same time he says he is personally

glad to hear that Frank Jones is not in the same category as an applehead doll . . . There is no line drawn between illustration and art. Royal Robertson and Grandma Moses romp in the same Elysian fields even though they never had and never will have anything in common.[21]

Similarly ambivalent and sometimes contradictory distinctions (or, more harshly, nitpicking) characterize even

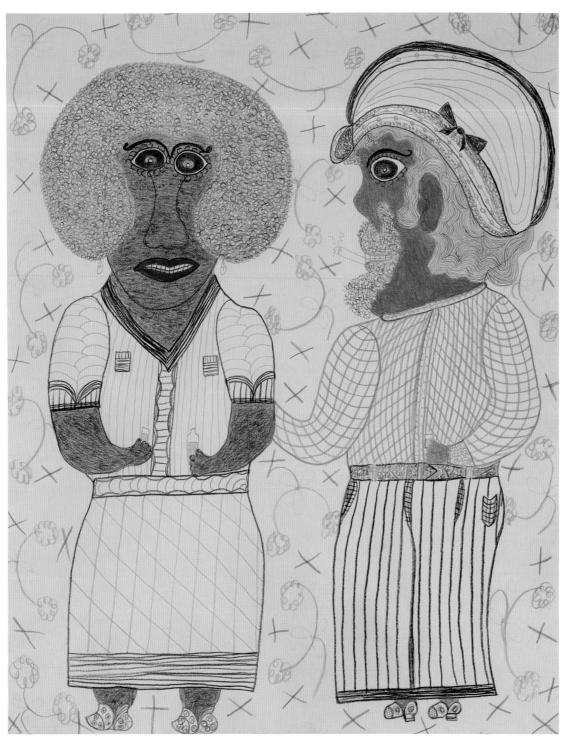

Inez Nathaniel-Walker, *Stylish Couple*, 1977 (cat. no. 216)

the best academic writings on the subject. Eugene Metcalf distinguishes between black art and folk art, while criticizing Jane Livingston for identifying folk art as "an aesthetic paradoxically based in a deeply communal culture, while springing from the hands of a relatively few, physically isolated, individuals."[22] Metcalf took exception to the perception of that work as "neither folk art nor fine," but in so doing, he created his own contradictions. Folk art, he argued, is communal, and black art is the occupation of isolated/individual African American artists; the "much more independent and improvisatory" aspects of the artists in the exhibition should deliver them into what I see as an equally confining category of black art. ("Black art" is by definition still separated from "art," i.e., "white art.") An artist like James Hampton (whose *Throne of the Third Heaven* was in the Corcoran show), wrote Metcalf, is not a folk artist — making art that functioned as a connection to society or tradition — but a high artist (drawn "apart into a private universe").[23] I'd argue that a high artist is not just romantically defined by her or his isolation, but by the commercial hierarchies that affect the art once it leaves the studio.

"Real black folk art," such as baskets, gravestones, and musical instruments, writes Metcalf, is overlooked or dismissed, while social and aesthetic status is conferred upon the idiosyncratic works that resemble mainstream art and can be connected to various modernist movements. Pushed into categories that do not fit it and stigmatized by a questionable — possibly pejorative — aesthetic that does not describe it, this black art is celebrated precisely for what it is not. Its truly unique qualities become, therefore, more difficult to understand and value . . .[24]

Knowing as little as I do about the history of the naming of folk art, I am not clear about why it took so long to include a large number of black artists even in a folk art context; was it seen as a stepping stone to high art and therefore an invasive tactic by masses to storm the palaces of art? Metcalf identifies, and perhaps exaggerates, a xenophobia within the art market that implies just that:

One of the ways by which the notion of folk art preserves the status and power of the leisure class is by serving as a dumping ground for unusual forms of expression that might challenge the artistic and social status quo. Produced by artists uncommitted to the high-art tradition and the values and society that support it, these works pose a potential social threat. This art is at times the product of a world view antagonistic to the leisure class. To admit that it is as complex and significant as academic art suggests the validation not only of the art itself but of the culture, the attitude, and the people it represents as well.[25]

With the introduction of many more African American artists into the peripheral center, things have changed since that article was written, and Metcalf himself may well have rethought some of his more finely-shaved definitions. But the problem of individual versus communal remains a red herring, furthering the kind of "either/or" thinking that characterizes the art world in almost every aspect of its existence. Metcalf says that to neglect a sense of community is to deny the very essence of folk culture. If that's so, then all the more reason to erase the categories. In many cases, the focal point is not so much community as place, or memory of place. In addition, an individual can express communal beliefs and longings even if s/he is isolated, and even if s/he is wallowing in the art context. However, the chances of these beliefs and longings being identified in the sterile commercial context are not great.

Theoretical insistence on the distinction between high art and folk art, while demanded by current methodologies, can be insidious and double-edged. On one hand, it is crucial to acknowledge the invisible ways in which social control is abetted under the guise of aesthetic standards. In the battle around Quality, these machinations operate still more dangerously within the fine art world itself in regard to artists of color and other groups struggling to release information and emotions from unfamiliar territory. On the other hand, it is important to convince those who mediate art that quality is relative rather than absolute, differing among communities and cultures. The binary naming process itself — folk art versus real-art — is inevitably imposed from above and beyond the world of the practitioners.

Lonnie Holley, the extraordinary self-taught artist from Birmingham, Alabama, speaks from a place that transcends external definitions:

Time, for me, works like a door. You have to go through time in order to be in it. It seems like one big cycle from within, like a spring. You start at

the inner most part of the spring and you move outward as you grow. And, as you grow, this materialistic body, which is flesh, takes its place and acts; then it falls back to the beginning to recreate itself . . . This is what the Spirit have gave me: Man was supposed to know all about the things that had been created on earth, from one time period all the way to another . . . Time is standing still if one is not moving in it; and, if one is moving in it, time moves so fast that we cannot keep up with it.

So I'm sure that everything that has happened, all the ancestors that have had to pass away in order for the earth to be as it is, they was playing a part, like I'm playing a part in life today, just living and creating. Then I'll fade away and kind of fertilize the soil around my children.[26]

We increasingly recognize the link between professional artists and the outside world and the ways both are unnaturally confined to a narrow concept of art which permits even white male artists to understand alienation. Truly new art of all kinds brings new information into the incestuous isolation native to high art. Once inside however, it tends to be redesigned. As Michel Thevoz has said in a discussion of *art brut*, "like Orpheus, who by looking at her, killed the woman he loved, western culture seems doomed to destroy any other form of expression by the mere fact of taking advantage of it."[27]

So-called folk artists tend to be more relaxed than so-called fine artists with crossing back and forth over the borders between life and art, and with the idea that both art objects and art-making have healing powers. "Art as therapy" is denigrated in the art world market because it is seen (perversely) as a denial of the incredible amount of hard work it takes to be an artist in this society. Nevertheless, the best artists, like traditional shamans, consciously and unconsciously take risks for the common good outside of the circumscribed boundaries of professionalism set for a politely outrageous art that sits safely in galleries and museums, usually revealing little but the surfaces of the modern malaise. A good deal of the most interesting art found today in galleries and museums has been influenced by the strength of objects made for religious, political, or therapeutic reasons. Ralph Griffin, for instance, finds his roots in water, associates water-shaped wood with antiquity and power, unconscious embodiments of Kongo religion,[28] that add the global colors of shamanic vision.

I go to the stream, I read the roots in the water, laying in clear water. There's a miracle in that water, running cross them logs since the flood of Noah . . . This is the water from that time. And the logs look like Old Experience Ages . . . I paint it red, black and white to put a bit of vision on the root.[29]

The dilemma posed (and accepted by writers about folk art rather than by the artists themselves) is still one of ghetto versus assimilation, autonomy versus co-optation. There are still a thousand questions to answer and they will spawn others. Is the power and spirit of a work made from roots found in the Tennessee woods permanently or temporarily (or not at all) stolen when it is exhibited in a foreign milieu and exposed to misunderstanding eyes? Do objects ripped from their contexts become merely beautiful, their richness forever impaired? Or is that power latent, waiting until a Robert Farris Thompson, or a new group of young artists who can see through glass cases, comes along to open the windows?

In fine art, the everyday is for the most part dismissed (except in still lifes and portraits, and even then, formal values tend to overwhelm the quotidian information). In vernacular art, the everyday is the container of meaning, of the political and spiritual currents that spark life itself. I suspect that few of the artists in the Hall Collection have worried about their alienation from the dominant culture. (And the indifference is mutual.) "Visions or dreams are generally highly personal experiences; to become legitimate parts of a folk aesthetic they must be shown to be responsive to communal dictates," writes Metcalf.[30] Community is too narrowly defined here. The visionary process does not only occur "within strong traditional cultures." The emphasis on memory, place, dreams and visions provides an unrecognized common ground between vernacular and high art. In popular opinion, all artists are assumed to work on this spiritual level, even though many do not. William Ferris says that domestic arts frame the artist's culture "into recognizable units," providing a way of coping with daily life and memories, and that the images emerging from the dreams of Southern African American artists often

follow patterns consistent with each other and with traditional Afro-American folk art through which the artist recreates images of his [sic] past, and this dimension of Afro-American experience helps explain how artists hundreds of miles apart can create

similar images and even use the same language to describe their 'futures.'[31]

Fantasies of Africa are often built upon psychic insights and memories. Storytelling and narrative art guarantee continuity, which is what so many of us in this society have lost.

The rules for folk art appear to shift when Latino or especially native American art is being discussed. Aside from the *retablos*, *bultos*, and *santos* of the Southwest, Latino folk art — ironwork, cement work, the yard art of *capillas* and *nichos*, is often relegated to the craft or utilitarian category, while walking sticks by both white and African American artists are, for some reason, permitted into the sculpture salons. Nowhere are these arbitrary distinctions more obvious than in the history of native American art, which has been winnowed out of a common category that had as much to do with life as with anything resembling what we call art.

In the early part of the century, ethnographic collections were summarily divided between art and artifact, between art museums and natural history museums. The division itself was part of a grudging acknowledgment of Quality in "savage" aesthetics. Curiously, one rarely sees "native American folk art" — or rather one sees it, but not under the rubric. Ironically this is one place where boundaries between folk and fine art are sometimes crossed, although not necessarily for the right reasons. Even while some native American religious art from the past has been elevated to high art, Indian folk art is seen as an imitation from a functional past. Indian artists have been confined by their markets, although in the last few decades, some — like some folk artists — have escaped into the avant-garde.

Given the false distinctions between utilitarian object and "useless" art that haunt the vernacular arts in all communities, I particularly admire two recent folk art compendiums: the Texas Folklife Center's *Art Among Us* — Pat Jasper's and Kay Turner's 1986 investigation of Mexican American vernacular art in San Antonio; and *We Came to Where We Were Supposed to Be* — the 1984 exhibition of Idaho folk art curated by Steve Siporin. (The title is a quote from the Shoshone-Paiute on the Duck Valley Reservation.) *Art Among Us* includes cement park sculpture, wrought iron ornament and furniture, religious shrines and paraphernalia, murals, yard art, signage, and grave decorations. *We Came . . .* has an even broader range,

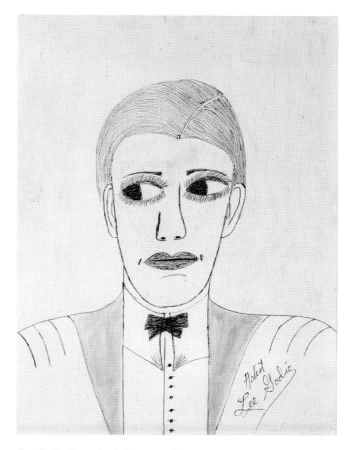

Lee Godie, *Portrait of a Man*, 1983 (cat. no. 4)

encompassing the Coeur d'Alenes, Nez Perce and Shoshones along with Mexican American, Basque, Finnish American and Mormon communities. Their products include buckaroo saddles, quilts, rugs, parfleches, belts, embroideries, waxflower ornaments, cradleboards, wagon-wheel fences, whittled fans, baskets, mailboxes, miniature machines, tools, fishing flies, branding irons as well as the more conventionally accepted whirligigs, sculptures and pictures.

Such an expansive approach harks back to the native and rural Latino tradition of inseparable life, religion, land, politics and things made within that same embrace, which also constitutes a possible model for the future. *We Came . . .* is a grassroots history of Idaho, and as such it does not divide the people who live there. As Siporin says, they don't often express a sense of self so rashly as to

declare themselves "artists." They consider themselves housewives, ranchers, or blacksmiths whose art is part of their work and leisure.[32]

The audience for these arts may often be a consumer, but the relationship is more integrated than that of buyer and seller in the artworld. Jasper and Turner talk about "aesthetic loyalty" and cite Clifford Geertz's suggestion that traditional art forms and cultural realities are interwoven, simultaneously creating each other.

This idea of art *creating* community cultural realities challenges our usual notion of art — especially folk art — as a static reflection of societal values. It allows us to see that Mexican American folk art in San Antonio exemplifies the very way in which art-making may constitute strategies for affirming and recreating loyalties in the family, the neighborhood, and the community at large.[33]

So why can't we see all of these very different arts (and I haven't touched on many, such as those made by the ill, the old, prisoners, or from an Asian American tradition) as a series of interfaces, between urban and rural, old and new, this and that culture, art and non-art? As multiculturalism mixes it up on the art scene, barriers between disciplines, mediums, and hierarchies are falling too.

Notes

1. Bessie Harvey, quoted in *Black Art — Ancestral Legacy, The African Impulse in African-American Art* (Dallas: Dallas Museum of Art, 1989), p. 270.

2. Robert Farris Thompson, "The Circle and the Branch: Renascent Kongo-American Art," in *Another Face of the Diamond: Pathways Through the Black Atlantic South* (New York: INTAR Latin American Gallery, 1989), p. 42.

3. Jimmie Durham, letter to the author, 1991.

4. Estella Conwill Majozo at "Mapping the Terrain" conference, Oakland, California, November 1991.

5. Randall Morris, "A Question of Authenticity," unpublished paper, New York, 1990.

6. Morris, "A Question of Authenticity."

7. Lucy R. Lippard, "Making Something from Nothing (Toward a Definition of Women's 'Hobby Art')," *Get the Message?* (New York: E. P. Dutton, 1984), p. 105. Originally published in *Heresies*, no. 4 (Winter 1978).

8. Morris, "A Question of Authenticity."

9. Eugene Metcalf, "Black Art, Folk Art, and Social Control," *Winterthur Portfolio* vol. 18 no. 4 (1983), p. 277.

10. Morris, "A Question of Authenticity."

11. Holger Cahill, "Folk Art," *Art Digest* (15 December 1932), p. 14.

12. Donald Kuspit, "The Appropriation of Marginal Art in the 1980s," *American Art* (Winter-Spring 1991), p. 134.

13. James Pierce, *Unschooled Talent* (Owensboro, Kentucky: Owensboro Museum of Fine Arts, 1979).

14. Marianna Torgovnick, *Gone Primitive* (Chicago: University of Chicago Press, 1990), p. 188.

15. Morris, "A Question of Authenticity."

16. Michael Hall in *Transmitters: The Isolate Artist in America* (Philadelphia: Philadelphia College of Art, 1981), p. 9.

17. James Baldwin, "A Talk to Teachers" (1963), *Graywolf Annual Five: Multicultural Literacy* (St. Paul, Minnesota: Graywolf Press, 1988), p. 8.

18. Torgovnick, *Gone Primitive*, p. 222.

19. Torgovnick, *Gone Primitive*, p. 11.

20. Robert Farris Thompson, *Black Art — Ancestral Legacy*, p. 131.

21. Morris, "A Question of Authenticity."

22. Jane Livingston, "What It Is," in *Black Folk Art in America 1930-1980*, by Jane Livingston and John Beardsley (Jackson: University Press of Mississippi and Center for the Study of Southern Culture for The Corcoran Gallery of Art, 1982), p. 11.

23. Metcalf, "Black Art," p. 283.

24. Metcalf, "Black Art," pp. 288, 287.

25. Metcalf, "Black Art," p. 287.

26. Lonnie Holley, in *Another Face of the Diamond*, p. 63.

27. Michel Thevoz, *Art Brut* (New York: Rizzoli, 1976), p. 14.

28. According to Robert Farris Thompson in *Another Face of the Diamond*, p. 47.

29. Ralph Griffin, quoted in *Another Face of the Diamond*, p. 48.

30. Metcalf, "Black Art," p. 282.

31. William Ferris, *Journal of American Folklore* Vol. 88 (1975), p. 116.

32. Steve Siporin, introduction to *We Came to Where We Were Supposed to Be* (Boise: Idaho Commission on the Arts, 1984), p. 3.

33. Pat Jasper and Kay Turner, *Art Among Us/Arte entre nosotros* (San Antonio: San Antonio Museum Association, 1986), p. 10.

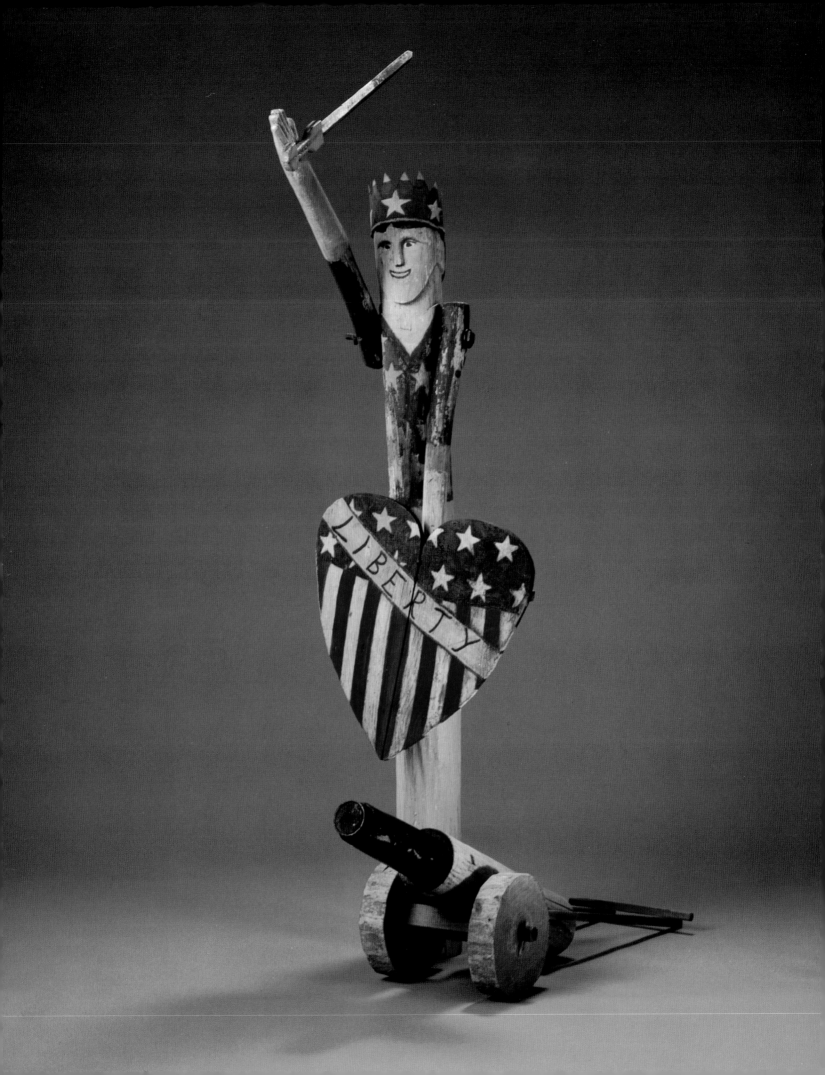

De-Fining Art History
The Hall Collection of American Folk Art

Jeffrey R. Hayes

> *Much [folk art] may be called primitive in the sense that it is the simple, unaffected and childlike expression of men and women who had little or no school training in art, and who did not even know that they were producing art.*
>
> - Holger Cahill
> *American Folk Art* (1932)

Folk art — whether defined traditionally as the craft production of discrete communities or more loosely as the creative output of various nonacademic, self-taught, or "outsider" artists — is largely overlooked in histories of American art. A review of the attitudes and circumstances that have shaped major surveys explains that neglect,[1] and an alternative approach illuminated by selected works from the Hall Collection indicates that fuller notice and incorporation of folk art would profoundly enhance American art history.

Historiography

The first histories of American art were written by art world insiders rather than scholars, and for that reason painter William Dunlap's *History of the Rise and Progress of the Arts of Design in the United States* (1834), and critic Henry Tuckerman's *Book of the Artists* (1867) could claim immunity from the professional historian's presumed code of objectivity. Nevertheless, similarities in method and viewpoint link their accounts, and to some degree, those similarities endure in many later, academically sanctioned histories. Dunlap and Tuckerman both wrote from and for an urban, middle class perspective; both used a series of ascending, individual biographies to build their chronicles; and both saw American art as a new branch stemming from the tree of European fine arts that had steadily developed since the Renaissance. Thus, Dunlap began his survey by reiterating basic Enlightenment distinctions

between the arts of "time" (poetry, music) and those of "design" (sculpture, painting, engraving, architecture).[2] Tuckerman traced "our earliest art" to London-trained John Smibert and conceded: "To one familiar with the Art of Europe, or even with the criticism thereof by eloquent modern writers, there may be little attraction in the earliest production of pencil and chisel on this Continent."[3] Moreover, each expressed typical nineteenth-century faith in historical "progress," which in art meant primarily *aesthetic* advancement. Dunlap consequently honors more recent American artists by surmising that "many of the pioneers who . . . opened a path for the arts in our country had little merit" and bemoans the "degraded state [of] art" here where portraitists once had to double as sign painters.[4] Tuckerman likewise finds that commercial expedience "often degrades . . . Art in America as a social and aesthetic element" and reserves hope only for the professional fine artist, writing: "A 'knack at catching a likeness' has often been the whole capital of a popular limner, whose portraits, in many instances, are the sole memorials of endeared progenitors . . . and, as such, cherished despite the violations of drawing, and absurdities of color, apparent to the least practised eye."[5]

Turn-of-the-century historians who followed Dunlap and Tuckerman maintained their essentially bourgeois outlook, biographical approach, and tight focus on the fine arts. In addition, greater recognition of institutional forces came, not surprisingly, from two respected professional painters. S. W. G. Benjamin's *Art in America: A Critical and Historical Sketch* (1880) recognized the growth and power of the New York-based National Academy of Design, and academician Samuel Isham's *History of American Painting* (1905) mixed detailed reports on individuals with broader commentary on patronage, publicity, art schools, artist organizations, and other evolving systems of influence. However, Isham's aesthetic priority ("the great majority of our painters [aim] for purely artistic qualities . . . for

Unidentified Artist, *Miss Liberty*, early 20th century (cat. no. 195)

Bruno Podlinsek, *The Greeter*, ca. 1982 (cat. no. 33)

beauty of line or form or composition or tone"),[6] coupled with his low estimate of popular taste ("the delight which the average man takes in the minute and literal reproduction of familiar objects"),[7] left little room for folk art beyond a brief opening chapter on the early "Primitives." Although Erastus Field, Ammi Phillips, and a host of other prolific nineteenth-century "plain painters"[8] go unmentioned, Isham acknowledges the rise of a "Native School" of portraiture led by itinerant Chester Harding which he judges "deadly uninteresting. Its very competence condemns it. They did completely what they tried to do, and except occasionally there is no grace, no nobility, no decorative feeling or beauty of handling, but instead a petty insistence on every trivial detail."[9]

Suzanne LaFollette's *Art in America* (1929) was the first genuine social and intellectual history that addressed broad issues such as nineteenth-century representations of women, the economic impact of imported art, and the aesthetic effects of industrialization and westward expansion. Her subject matter also surpassed earlier surveys to include illustration, furniture, and other decorative arts, but folk art — unless two paragraphs on the commercial threat to "American Indian" art qualify — finds no place in a lofty critique that laments "the poverty of the American environment" and attributes our "retarded cultural development" to native "forces of materialism and greed."[10] In her closing chapter on modern artists and their tendencies, she further notes (with evident internationalist disdain) the "frequent complaint, especially since the overstimulation of patriotic sentiment during the War, that American art is not sufficiently American, and that the artists must cut off from European influences"[11] if they hoped to achieve a distinct, national style.

Despite LaFollette's reservations, that "frequent complaint" and its potent political underpinnings were already affecting contemporary American art in general and historical attitudes toward folk art in particular.[12] Attitudes had begun to change in the late 1910s when a number of American modernists, reacting against charges of slavish European imitation and aesthetic anarchy, claimed folk art as a respectable indigenous precedent for their mostly reductive, semi-abstract, idiosyncratic styles. Their identification with such work was primarily formal, of course, as Charles Sheeler explained: "My paintings have nothing to do with history or the record — it's purely my response to intrinsic realities of forms and environment . . . [like] the bones of something that was original."[13] By the

troubled 1930s, however, folk art had assumed much broader significance as Americans, already stung by war and depression which many blamed on Europe, struggled to adjust to the increasingly urban, mechanized, and socially fragmented complexion of modern life. As codified by curator Holger Cahill in a series of exhibitions in Newark (*American Primitives*, 1930; *American Folk Sculpture*, 1931) and New York (*American Folk Art: The Art of the Common Man*, 1932), folk art served to moderate tensions by recalling an "authentic" national past that infused the present with the enduring practical and democratic virtues of America's "common" people. Cahill's writings and standard museum displays upheld the high modern emphasis on paintings and carved, cast, or modeled figures that "had esthetic value of a high order,"[14] and although he paid little attention to original context, his overriding *cultural* advocacy of this material brought greater recognition in Oskar Hagen's *The Birth of the American Tradition in Art* (1940), John McCoubrey's *American Tradition in Painting* (1963), and other studies that propounded the evolution of a unique "American style" based on milieu and temperament.

Holger Cahill effectively championed folk art at the same time that he firmly subordinated it. "Folk art cannot be valued as highly as the work of our greatest painters

Unidentified Artist, *Found Object Rocking Chair*, mid-20th century (cat. no. 130)

and sculptors," he concluded, "but it is certainly entitled to a place in the history of American art."[15] The first and arguably still the most insightful history to heed Cahill and give folk art a substantial "place" within the full sweep of American art was Oliver Larkin's *Art and Life in America* (1949). Devised as a study of the major and "so-called 'minor arts'," Larkin sought to "show how these arts have expressed American ways of living and how they have been related to the development of American ideas, particularly the idea of democracy."[16] His synthetic approach to art and life, despite ongoing emphasis on traditional pictorial and sculptural forms and assignment of most folk material to a single chapter, raised a number of important issues, including the problem of *misnaming* artists ("Sunday," "self-taught," "popular," etc.) and the question of whether earlier comprehensive definitions of folk art could remain viable in a "country of many racial origins, of enormously varied geography, of rampant individualism, of railways, camera, and cheap manufactured articles." He refers, for example, to black artists who have produced canes that reflect African sources as well as portraits that differ "in no way from the hard effigies of his white contemporaries." He also challenges two basic, closely related modernist postulates about folk art — its "primitive" quality and its "abstract" tradition. The first he ascribes to the "modern aesthete's . . . unsound assumption that learning is a dangerous thing, and the child is wiser than the man." The second he accepts as superficially true in relation to academic illusionism, but further assesses as either "involuntary" with certain media such as theorems, or optional under often varied circumstances. "The 'primitive' simplifications were not always the mask of ignorance," he wrote, "[For William Prior] they were an adaptation to the customer's pocketbook. This New England itinerant announced his willingness to supply a flat portrait for one fourth the price of a shaded one, and was competent on both levels."[17] Moreover, Larkin denied the common notion that folk art was confined to the pre-industrial past and endorsed "interest in contemporary work which preserved that tradition." His remarks on the "discovery" of black painter Horace Pippin were especially astute, for their lack of condescension anticipates more recent critiques of ethnic, class, and other stereotyping in folk art literature:

> But "primitive" was an inadequate word for this veteran of the First World War who worked all day and far into the night . . . his injured right hand gripped by his left to steady the meticulous brush.

There was a grave eloquence in his three tributes to John Brown which no other version of that much-painted subject could equal, and a searing intensity which was the projection of a sure intelligence.[18]

Beyond identifying key theoretical and historiographic concerns (he also noted the tie between rising nationalism and folk art studies),[19] Larkin's expansive view of American material and intellectual history required that folk art's aesthetic appeal be balanced by an appreciation for its original context and purpose.

Thus, the sharp silhouette of a pre-Revolutionary weathervane is viewed against a political setting; patchwork details in a landscape mural are linked to popular prints and travel books; richly decorated Pennsylvania German *fracturs* are recognized as family documents and moral texts; spare Shaker furniture reflects the practical rules of that distinct society; and Morris Hirshfield's flatly painted, stylish-looking figures stem from his years of working with garment patterns. By recognizing both the physical beauty and social moorings of what he preferred to call "people's art," Larkin concluded emphatically:

> One knows that a vast reservoir of artistic strength is in the country, and that the urge to externalize experience is continuous and irrepressible. One learns that professional training may or may not improve a man's power of expression, depending on the strength of his conviction and his will to communicate. One realizes that the gap between artist and layman has been too often bridged to be as wide as one has supposed. A highly "civilized" people whose aesthetic life is the special privilege of a few is in no true sense a highly artistic people.[20]

The prospect of more fully incorporating folk art into overviews of American art has progressed very little since Larkin. Daniel Mendelowitz's *A History of American Art* (1960), auspiciously dedicated to "thousands of forgotten artists, artisans, and craftsmen who have helped shape the face of America," includes sections on the "household" arts, religious carvings and paintings, figureheads and shop signs, rural crafts, and the modern "primitives," but most of his material is appraised from a contemporary modernist perspective that reduces Wilhelm Schimmel's carved animals to "animated silhouettes . . . enlivened by vigorous conventionalized patterns" and an embroidered mourning picture to "an astonishing variety of stitches, a

nice sense of design, and an unusual ability to express sentiment in . . . a medium somewhat unsuited to such sober purposes."[21] Worse still, a quaint rhetoric still found largely in folk art criticism trivializes many examples; hence, a New Mexican *bulto* is "doubly touching because of the humble naïveté with which the forms are developed" and Erasmus [sic] Field's *Historical Monument of the American Republic* is extolled because "only a simple-hearted folk artist would attempt such an elaborate expression of patriotic fervor after the tragic episode of the Civil War."[22]

Although specialized literature on American folk art first appeared in the 1930s and has flourished since the 1970s,[23] integrated studies of folk *and* fine art have remained scarce and, for the most part, methodologically cautious. Three surveys, all published in conjunction with the United States Bicentennial, reflect those limitations. John Wilmerding's *American Art* (1976) is a chronological history of painting and sculpture with an emphasis on period styles and a brief, conventional estimate of folk art as a reflection of Jacksonian populism: "The nineteenth century's association of art with national well-being encouraged artists of all persuasions . . . [thus] for the first time we see a groundswell of art produced not just by the trained and traveled artists, but by the untutored and self-taught amateur as well." Whirligigs, weathervanes, trade figures, and other distinctive modes of folk art production are listed but not discussed, and although pertinent theories of "functional beauty" and the "not so sharp . . . line separating folk and academic art" are cited, modernist assumptions about the "abstract perception" of painters such as Edward Hicks and Thomas Chambers persist.[24] Tom Armstrong, in the Whitney Museum catalogue *200 Years of American Sculpture* (1976), also devotes one chapter to mostly vintage folk sculpture which, despite only "token" recognition in past surveys, he feels "surpasses the accomplishments of fine artists" because "it is most closely related to the life of the people."[25] Nevertheless, his essay actually minimizes history and stresses the "aesthetic merits" of objects which have become "detached" from their original makers and context. Reprising Cahill and others, he argues that folk art is best "understood" in terms of modern art and that "the intuitive ability of the folk artist to abstract an observation or emotion inspired by nature . . . is the core of American folk art."[26] Thus, weathervanes show "pure form," decoys become "abstract sculpture," and more "eccentric" twentieth-century works such as Simon Rodia's *Watts Towers* — already modern

Unidentified Artist, *Ship Vitrine and Diorama*, ca. 1890 (cat. no. 126)

and "apart from society" — amount to "gigantic personal fantasy."[27] Joshua Taylor in *America as Art* (1976), another ambitious exhibition catalogue that examines "ways in which . . . ideas and attitudes about America became inseparable from [our] art," traces interest in folk art to 1920s-1930s cultural nationalism and explains how that interest functioned for a diverse group of intellectuals, collectors, early modernists, and later "regionalists." Although edifying from the standpoint of intellectual history, illustrated examples of folk art are not discussed except as *references* to fine art.[28]

Definition

Thinking positively about our culture . . . and knowing little about folk artists and their worlds, we demean folk art as the dull result of inertia or as the happy innocence of unimportant people.

- Henry Glassie
The Spirit of Folk Art
(1989)

Most art historians assign certain criteria to folk art — simple forms, fixed subjects, plain media, practical intent, provincial origins, "common" makers — even though these characteristics are vague, highly subjective, and confounded by many exceptions. Scholars of folklore and material culture further assert that such criteria function as just one side of a larger dichotomy that defines "folk" art entirely in terms of what "fine" art is *not*. If

what is deemed "fine" art is refined, original, complex, aesthetic, worldly, and unique, then what is deemed "folk" art must lack or oppose these traits. While questioning the plausibility of so neat a division, Michael Owen Jones summarizes the rationale for this historical norm:

> Supposedly, there is an "avant-garde" or an "elite" . . . consisting of "creative" people who are conceived of by some others and by themselves as "artists," whose goal is to produce "major monuments" and "great works"of "art" which evince "stylistic trends" and generate an "aesthetic" experience in the percipient. Objects and people are contrasted, often intuitively and on the basis of limited information, to this standard of measurement . . . When an insufficient (but not articulated) number of correspondences seem to obtain, the objects or people are designated by the catch-all category "folk" or "popular" or "non-academic."[29]

Within this essentially negative framework, folk art serves at best as a foil for fine art's primacy. At worst, it is used as a "critical weapon" by cultural reactionaries and sentimentalists, or it is reduced to a "corrective concept" that supplies the modern world with a reassuring fix of tradition, innocence, and spirituality.[30]

A more positive, alternative approach to art history would de-emphasize prejudicial constructs such as fine and folk (which elude clear definition anyway), and address art as "a message about the wonders of impurity" and artworks as ubiquitous, intersecting signs of widely varied human intention and circumstance.[31] Such an approach promises to have a "democratizing impact" on art scholarship and criticism, which has long understated the true plurality of American culture.[32] Two recent surveys, Michael D. Hall's *Stereoscopic Perspective: Reflections on American Fine and Folk Art* (1988) and Lucy R. Lippard's *Mixed Blessings: New Art in a Multicultural America* (1990), take important steps in this direction. Lippard restricts her focus to contemporary art, but her many examples cut across racial, regional, and class lines without regard for the narrow "notion of Quality that . . . is identifiable only to those in power."[33] She acknowledges the distinct and influential work of Asian, Latino, and African American artists, several of whom are self-taught and transcend pat boundaries between fine, folk, and "other" art. Hall's volume of essays is more conventionally divided between fine and folk art topics, but includes in interrelated section

on collecting and an opening chapter that argues against "an elite [view] which presumes that anything art-like found outside of the embrace of high culture is little more that a 'knock off'." Recognizing all art as vernacular, adjoining "things in the world" with at least as much artifactual as aesthetic value, he proposes that we "visualize high- and low-end culture in conditions of interchange rather than in . . . opposition," and contends that a "new and broadened survey of American art must ultimately describe the ways in which diverse art productions . . . reciprocate within a unified cultural context."[34] Hall's subsequent essays amplify his thesis that *all* artists operate within and represent culture/s, and that "when great folk works are placed side by side with. . . high art, they do not come off as second class."[35]

Multiple Perspectives

Hall's critical respect for American folk art is complemented by his own experience as a trained sculptor and substantiated by the collection that he and Julie Hall began to build in the late 1960s and passed to the Milwaukee Art Museum in 1989. Midway through that span, he spoke as a collector about folk art's significance on several levels that converge with fine art and provide the framework for fuller art historical inclusion: "The value of folk art may be in its affirmation of the self in the very individual sense, in the local sense of community, in the regional sense of maybe an ethnic group or a locale, and then, of course . . . in the national sense."[36] All five of these "value" levels are variously marked and often bridged by works in the Hall Collection.

Individual. It is commonly assumed that fine art is unique and independently created while folk art is typical and communally generated, a simple polarity that reinforces the latter's lesser status in art history. However, much as recent scholarship on several historic fine artists has shown their originality to be securely framed by popular concerns,[37] so too the Hall Collection (due largely to the Halls' own *fine* art training) includes many works that admit great individuality within a system of shared purpose, form, or meaning. A nearly lifesize, late nineteenth-century *Pair of Black Figures* (cat. no. 194) epitomize this conjunction despite its unknown authorship. Formal poses, fixed gazes, and missing props (a staff and book?) suggest an institutional function, probably in lodge hall or funerary ritual. Moreover, their strict frontality, masklike visages, mixed media, and noble demeanor

link them to an inclusive African aesthetic tradition which counters mainstream black stereotypes of the period. Nevertheless, such strong cultural connotations still do not fully account for the *sculptural invention* — the exacting design, bold construction, and spatial magnitude — of this historically unique and formally compelling pair of objects.

More recent if less conspicuous examples sustain this quotient of individuality without denying a broader context: *The Greeter* (cat. no. 33) is a conventional "tin man" long used as a sign in the heating and cooling business, yet his singular hands were consciously traced from those of the proud artist who made him; the *L & N Engine and Tender* (cat. no. 155) and *Found Object Rocking Chair* (cat. no. 130) variously portray the necessary tools of nationwide industries, yet both were assembled by imaginative makers who transformed sundry materials into novel wholes; and the many drawings of self-taught Bill Traylor (cat. nos. 213, 214, 221) and Joseph Yoakum (cat. nos. 225-227) appear to inventory familiar people, places, and things with line and color that are utterly their own.

Personal and extrapersonal dimensions also merge in Calvin and Ruby Black's *Midget Doll Theatre* (cat. no. 165), once part of *Possum Trot*, a roadside attraction built in the Southern California desert over the course of more than two decades. The more than fifty highly individualized dolls which Calvin crafted and Ruby dressed from scavenged materials were each named after close friends or favorite celebrities and functioned much like a surrogate family for this childless couple. From an autobiographical standpoint, these hand- and wind-animated dolls may have further recalled Calvin's adolescence spent caring for his siblings and mother, and early jobs with the carnival, circus, and puppet shows. Beyond this private dimension, the dolls' manufacture called for wood and cloth working skills endemic to the Blacks' rural Southeastern origins, and their mechanically induced singing and dancing capacities reflect an array of likely sources that range from Scottish American country music and Nashville's *Grand Ole Opry* to vaudeville and burlesque, classic radio voice skits, and early television variety programs. Despite its apparent eccentricities, the theatre and park, which only slightly predate nearby *Knott's Berry Farm Ghost Town*, should also be viewed in broader relation to the mid-century boom in American travel, vacation, and family entertainment industries.[38]

Community. Virtually all artists are shaped by and depend upon communities. Fine artists, despite their post-nineteenth-century aura of personal autonomy and cultural vanguardism, come from specific socioeconomic backgrounds, receive certain training based on prevailing values, and enter a field governed by established systems of reward and recognition that mediate between individual and collective desires. The communitarian basis for folk art — from early Pennsylvania German *fractur* to Amish quilts, Ohio basketry, and contemporary Eskimo dolls — is more readily acknowledged, although this work also allows for substantial creative independence within traditional boundaries. For example, ceramic face vessels made in the Deep South by eight generations of the Brown family (cat. nos. 122-124) have remained generally consistent in form and technology for more than a century, yet each potter has perceptibly varied the scale, surface, color, or features of this product according to his own sensibilities and those of a changing audience/market.[39]

The very notion of *community*, beyond customary family, ethnic, and geographical confines, should also be applied as flexibly to folk as it is to fine art. Indeed, the Hall Collection's rich assortment of mid-nineteenth-century men's lodge hall staffs, arks, symbolic plaques, axes, and other implements connoting power and authority (cat.

Unidentified Artist, *"Root Head" Black Brant Goose*, ca. 1930s (cat. no. 77)

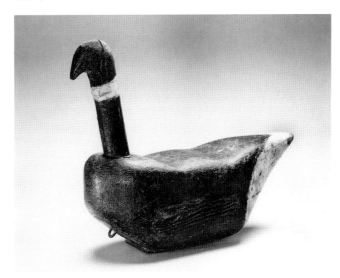

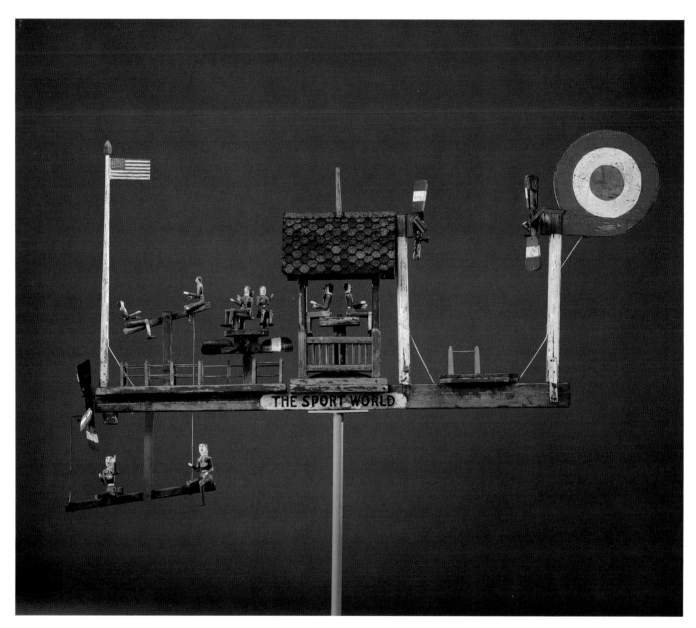

Unidentified Artist, *The Sport World*, ca. 1920s (cat. no. 163)

nos. 132-147) accrue from the same *social* community and setting that produced the decidedly "masculine" genre paintings of William S. Mount, George C. Bingham, and their peers.[40] Other significant "communities" amply represented by folk art include the common *economic* interests often marked by bird, bull, fish, and other animal weathervanes (cat. nos. 34, 37, 38, 39); popular *intellectual* models evidenced in works as varied as the Spencerian penmanship drawing (cat. no. 220) or Fred Alten's quasiscientific sets of animals (cat. no. 181); and closely shared *moral* standards ranging from Erastus Field's subdued New England merchant class sitters (cat. no. 1) to Elijah Pierce's evangelical Christian "sermons in wood."

Region. Thomas Hart Benton, Grant Wood, and other "regionalists" were among the first fine artists to valorize folk art for its egalitarian and indigenous qualities, yet like most of their professional colleagues they maintained close, necessary ties with the Eastern art establishment. While fine art and official art history long remained under the purview of New York (and later Los Angeles or Chicago), folk art flourished in the seams that cut between those capitals. Left out of the race to be recognized as *the* American art, folk art also retained many local characteristics which the Halls appreciated and sought to include in their collection. Thus, contrary to longstanding "melting pot" theory, Eugene Metcalf finds that "the collection represents, as a whole, not a coherent image of a unified democratic nation . . . but instead the possibility of an America unable to accept, or come to grips with, its multiplicity and fundamentally divided by issues like class, race, ethnicity, and region."[41] Nor is this manifold identity evinced in any one way — for example, *subject* ensures that the maritime paintings of James Crane (cat. no. 18), like the small anonymous *Ship Vitrine and Diorama* (cat. no. 126), bear respectful witness to New England experience; *material* proficiency marks the deft wood carvings of Ben Miller (cat. no. 107) and S. L. Jones (cat. nos. 174, 212) with a distinct if varied Appalachian aesthetic, as does Edgar Tolson's *Fall of Man* series (cat. no. 205) which integrates mountain craftsmanship with a "broader historic and symbolic" portrait of human nature;[42] and *idea* governs Jim Lewis's deliberately symmetrical, technicolor oils (cat. nos. 26 and 27), which reinforce "Old West" myths and heroes rather than recognize messier frontier truths.

Above all, multiregional forms and how they interact with other functions and effects are most fully revealed through the Hall Collection's rich assortment of duck, shorebird, goose, confidence, and fish decoys. As an artifact-tool-portrait, Gus Wilson's *Preening White Wing Scoter* (cat. no. 47), a sea duck which flourishes in the North Atlantic flyway, is convincingly shaped and posed, well-built with the maker's characteristically broad "inletted" neck, and endowed with good weight, overall balance, and a flat bottom to withstand the rough coastal waters of Maine and Nova Scotia. As art-sculpture-abstraction, the object's formal stability, unified shape, and minimal surface pattern make a wholly satisfying impression *in itself*. Likewise, Nathan Cobb's hallmark *Brant Goose* (cat. no. 70) represents a prime game species once coveted by those who used this carver's remote Virginia barrier island hunting lodge. Cobb's decoys couple exceptionally lifelike features, such as the imported black glass eyes, notched tail and precisely weighted "feeding" effect, with fluent contours and an exquisite natural patina. In the Midwest, where an array of puddle ducks predominate, Tom Schroeder's St. Clair Flats *Redhead* (cat. no. 59) and Robert and Catherine Elliston's Illinois River *Blue Winged Teal* (cat. no. 42) also combine practical local effects with each maker's particular aesthetic qualities. Schroeder's emphatically modeled decoys included a hollow, skirted base to increase stability while preserving movement on shallow, wind-swept waters, while Robert Elliston employed a long, smooth, flat-bottomed design to prevent rolling and accommodate Catherine's painterly finish. Alternatively, the sheet metal *Silhouette "Stick Up" Goose* (cat. no. 75), commercially made and primarily used in the Upper Mississippi Valley, simulates larger Canadian waterfowl, folds for easy transport and storage, and appeals more to mechanical taste. Finally, the painted plumage of the *"Root Head" Black Brant Goose* (cat. no. 77) represents a bird especially plentiful in the Pacific Northwest, although its appropriation of "found" material for depictive purposes denotes a semi-abstract aesthetic standard more widely explored by formally trained early modern artists.[43]

Ethnicity. Years ago, social critic Harold Stearns — a contemporary of Holger Cahill — declared "that whatever else American civilization is, it is not Anglo-Saxon, and that we shall never achieve any genuine nationalistic self-consciousness as long as we allow certain financial and social minorities to persuade us that we are still an English colony. Until we begin seriously to appraise and warmly to cherish the heterogeneous elements which make up our life . . . we shall make not even a step toward true

unity."[44] Despite this bold admonition, most histories of American art have remained ethnically flat. The controlling influence of white, English-speaking culture long ensured that diversity — if acknowledged at all in works like William Fuller's *Crow Creek Agency Dakota Territory* (1884),[45] Alfred Stieglitz's *The Steerage* (1907), and Thomas Hart Benton's *Social History of Missouri* (1936) — it was perceived primarily in terms of assimilation rather than profound or enduring difference. Even where reputed realists such as Jacob Riis and George Bellows have specialized in images of ghetto and immigrant life, we find much of their imagery laced with stereotypes, exaggeration, or a paternalistic "otherness."[46]

Folk art, often defined as well as downgraded by its *evident* ethnicity, expands and humanizes our cultural perspective, as Michael Hall notes in an essay detailing his own critical interests: "I continually find ties that bind it to my own experience and . . . to the pluralistic world all Americans share politically, economically and ideologically."[47] That plurality, despite the strategic omission of native American material and an emphasis on twentieth-century examples, is reflected in the Hall Collection, where works by John Scholl (cat. no. 152) and J. C. Huntington (cat. no. 224) uphold Pennsylvania German decorative tradition; the strong graphic styles of Lawrence Lebduska (cat. no. 7) and Anna Celletti (cat. nos. 15, 16, 21) as well as an elaborately fashioned "church model" (cat. no. 129) suggest various Eastern European vernacular sources; and the emblematic paintings of Drossos Skyllas (cat. no. 2) and iconic bas-reliefs of John Perates (cat. nos. 201, 202) recall Greek Orthodox precedent. Mexican American cultural expression is also found in Luis Tapia's small contemporary *santos* (cat. no. 209), Felipe Archuleta's far more sensate but traditionally constructed and polychromed carvings of Southwestern fauna (cat. nos. 191, 192, 193), and Martin Ramirez's fluently composed, contextually evocative *banditos* (cat. no. 229).[48]

Begun at an important juncture in Civil Rights history, the collection's most conspicuous ethnic component is African American. The formally attired figure of a *Black Man* (cat. no. 166), Elijah Pierce's *Pearl Harbor and the African Queen* (cat. no. 199), Bill Traylor's *Gentleman with Top Hat and Cane* (cat. no. 214), and Bessie Harvey's *Pregnant Woman* (cat. no. 175) all impart a fundamental dignity and self-respect. Colorful, richly textured staffs by David Butler (cat. no. 104) and "Stick Dog" Bob (cat. no. 103) reprise an additive African aesthetic that differs

from other, precisely engraved canes in the collection. More specifically, the vital social and historical role of religion in the African American community is clearly displayed in the miracle themes of Pierce (cat. nos. 197, 198) and Josephus Farmer (cat. no. 211), Wil Edmondson's majestic *Lion* (cat. no. 196), Sister Gertrude Morgan's ecstatic *Heaven* (cat. no. 230), and Mose Tolliver's impassioned Christian as well as more exotic, supernatural imagery (cat. nos. 24 and 25).

Nation. All art produced within a nation says something about that nation's physical, political, or spiritual makeup — a modestly initialed *Coast Scene* (cat. no. 10) no less than a signed Hudson River School landscape; a group of presidential whirligigs (cat. nos. 156, 159, 162) no less than officially commissioned statuary; votive paintings by Nazarenus Graziani (cat. no. 11) or Howard Finster (cat. no. 23) no less than those by Albert Ryder or Mark Rothko. If anything, folk art's longstanding formal and functional multiplicity vis-a-vis fine art makes it the *principal* facet of American art history. Created outside the exclusive, well regulated corridors of professional art, it often affords more direct access to basic issues and tensions underlying American life. For example, a rich cross section of animal imagery that includes "working" decoys (cat. nos. 40-91), Alten's caged *Menagerie* (cat. no. 181), and Archuleta's wary *Lynx* (cat. no. 193) illuminates contrary historical attitudes of pragmatism, dominance, and veneration toward our natural environment. Likewise, *Miss Liberty's* (cat. no. 195) upraised, bloody sword and heart-shaped shield below mark the poles of engagement and isolationism that divided early twentieth-century American foreign policy, while apparent "whimsies" such as *Fighting Cats* (cat. no. 160), *The Sport World* (cat. no. 163), and *The World of Work* (cat. no. 154) trace the competing socio-economic interests of labor and leisure. More recently, Calvin Black's pampered troupe of "birdcage" dolls (cat. no. 165) and Denzil Goodpaster's *Cane with Woman and Jaguar* (cat. no. 105) reiterate popular, profoundly conflicted feelings of adoration and subjugation toward women. Much like Edgar Tolson's poignant *Man with a Pony* (cat. no. 167), where the human ("vertical, painted crisply, showing dignity and intelligence") and the beast ("horizontal, painted unevenly, simple and toy-like") are joined more by existential *contrast* than by simple physical proximity,[49] American folk art mirrors the vivid, often essential contrasts that comprise our national identity and heritage.

Conclusion

Viewed as a whole, the Hall Collection strongly suggests that there is little if any *significant* difference between folk and fine art in nineteenth- and twentieth-century American culture. Both are created by highly informed and practiced individuals, the former through family or local tutelage, traditional apprenticeships, related employment, or self-training, the latter through formal education and subsequent professional experience and associations. Both serve basic human needs to record the past, express the present, or envision the future, just as both reflect aesthetic choices which are thoughtfully made, open to revision, and remarkably mixed within a spectrum which ranges from precise representation to utter subjectivity. And despite social and economic disparities which still generally privilege fine art over folk art production, both issue from communities with substantial regional, ethnic, and spiritual values which co-determine the *full* national character. Cutting across this common ground, Michael Hall further contends that all art is essentially a "declaration . . . of self in time [when the artist] recognized that he existed and recognized that he existed within a context." Ultimately, Hall finds that the only real distinction between folk and fine art is that folk art isn't *identified* by the fine art "system" of dealers, collectors, critics, and others as fine art.[50] Henry Glassie sees this partition being reinforced by art historians (inside the system) and folklorists (outside the system) largely on the basis of deeply entrenched academic methods and conventions. He denies this artifice and wisely proposes an alternative path:

> If scholars could strip away their prejudices and learn to approach all art in the same mood of disciplined passion, they would learn that it is all competent, that it all blends the individualistic and the traditional, the sensual and the conceptual, that it is all historical, the product of human beings who live in societies beset by problems conquered by fun and serious work.[51]

Prejudice still divides the history of American art into fine and folk art camps. A superficial sense of social or aesthetic order is thereby imposed, but at the expense of recognizing the intersecting tensions, drives, and achievements that have truly defined and continued to shape our complex culture.

Notes

1. Especially useful historiographies of American art are Elizabeth Johns, "Histories of American Art: The Changing Quest," *Art Journal* vol. 44, no. 4 (Winter 1984), pp. 338-344, and Wanda M. Corn, "Coming of Age: Historical Scholarship in American Art," *The Art Bulletin* vol. LXX, no. 2 (June 1988), pp. 188-207. Corn warns that although recent art historians have shown an increased interest in folk art, their "decontextualized [views] . . . are so different from those of other scholars of folk art that the two groups might as well live on separate planets."

2. William Dunlap, *History of the Rise and Progress of the Arts of Design in the United States* vol. I (New York: Dover Publications, 1969), pp. 9-10.

3. Henry T. Tuckerman, *Book of the Artists* (New York: James F. Carr, 1966), p. 7.

4. Dunlap, *History of the Rise and Progress of the Arts*, pp. 17, 98.

5. Tuckerman, *Book of the Artists*, p. 23.

6. Samuel Isham, *History of American Painting* (New York: The MacMillan Co., 1905), p. 561.

7. Isham, *History of American Painting*, p. 361.

8. This term has been used recently to describe a style of painting that is primarily linear and lacking in full three-dimensional illusionism. Opinion differs over whether this style served the expressed aesthetic wishes of a particular class of patrons or resulted from the technical limitations of its practitioners. Compare, for example, Charles Bergengren, "'Finished to the Utmost Nicety': Plain Portraits in America, 1760-1860," in *Folk Art and Art Worlds*, eds. John Michael Vlach and Simon J. Bronner (Ann Arbor: UMI Research Press, 1986), pp. 85-120, and John Michael Vlach, *Plain Painters* (Washington, D.C.: Smithsonian Press, 1988).

9. Isham, *History of American Painting*, p. 179.

10. Suzanne LaFollette, *Art in America* (New York: W. W. Norton & Co., 1929), pp. 238-9.

11. LaFollette, *Art in America*, p. 326.

12. See Eugene W. Metcalf Jr., "The Politics of the Past in American Folk Art History," in *Folk Art and Art Worlds*, eds. John Michael Vlach and Simon J. Bronner (Ann Arbor: UMI Research Press, 1986), pp. 27-50.

13. Quoted in Frederick S. Wight, *Charles Sheeler: A Retrospective Exhibition* (Los Angeles: UCLA Art Galleries, 1954), p. 35.

14. Holger Cahill, *American Folk Art: The Art of the Common Man in America 1750-1900* (New York: Museum of Modern Art, 1932), p. 27.

15. Cahill, *American Folk Art*.

16. Oliver W. Larkin, *Art and Life in America* (New York: Holt, Rinehart and Winston, 1949), p. vii.

17. Larkin, *Art and Life in America*, pp. 224-5.

18. Larkin, *Art and Life in America*, pp. 427-8.

19. Larkin, *Art and Life in America*, p. 408.

20. Larkin, *Art and Life in America*, p. 231.

21. Daniel M. Mendelowitz, *A History of American Art* (New York: Holt, Rinehart and Winston, 1969), pp. 410, 265.

22. Mendelowitz, *A History of American Art*, pp. 335, 417.

23. Besides Holger Cahill's seminal essays, other important early publications included: Allen H. Eaton, *Immigrant Gifts to American Life* (1932); Sidney Janis, *They Taught Themselves* (1942); Jean Lipman, *American Folk Art in Wood, Metal and Stone* (1948); Erwin O. Christensen, *The Index of American Design* (1950). Notable among the more comprehensive post-1970 surveys were: Jean Lipman and Alice Winchester, *The Flowering of American Folk Art* (1974); Robert Bishop, *American Folk Sculpture* (1974); Herbert W. Hemphill Jr. and Julia Weissman, *Twentieth-Century American Folk Art and Artists* (1974); Kenneth Ames, *Beyond Necessity: Art in the Folk Tradition* (1977); John Michael Vlach, *The Afro-American Tradition in Decorative Arts* (1978); Jean Lipman and Tom Armstrong, eds., *American Folk Painters of Three Centuries* (1980).

24. John Wilmerding, *American Art* (New York: Penguin Books, 1976), pp. 100-4.

25. Tom Armstrong, "The Innocent Eye," in *200 Years of American Sculpture* (New York: Whitney Museum of American Art, 1976), p. 75.

26. Armstrong, "The Innocent Eye," p. 86.

27. Armstrong, "The Innocent Eye," pp. 98-100.

28. Joshua C. Taylor, "The Folk and the Masses," in *America as Art* (Washington, D.C.: Smithsonian Institution Press, 1976), pp. 219-39.

29. Michael Owen Jones, "L.A. Add-ons and Re-dos," in *Perspectives on American Folk Art*, eds. Ian M. G. Quimby and Scott T. Swank (New York: W. W. Norton & Co., 1980), p. 353.

30. Henry Glassie, *The Spirit of Folk Art* (New York: Harry N. Abrams, 1989), p. 254.

31. Glassie, *The Spirit of Folk Art*, p. 258. See also Michael Owen Jones, "Modern Arts and Arcane Concepts: Expanding Folk Art Study," in *Exploring Folk Art* (Ann Arbor: UMI Research Press, 1987), pp. 83-6.

32. Kenneth L. Ames, "Folk Art: The Challenge and the Promise," in *Perspectives on American Folk Art*, eds. Ian M.G. Quimby and Scott T. Swank, pp. 320-1.

33. Lucy R. Lippard, *Mixed Blessings: New Art in a Multicultural America* (New York: Pantheon Books, 1990), p. 7.

34. Michael D. Hall, "American Sculpture on the Culture Mobius," in *Stereoscopic Perspective: Reflections on American Fine and Folk Art* (Ann Arbor: UMI Research Press, 1988), pp. 3-4.

35. Hall, "The Bridesmaid Stripped Bare," p. 238.

36. Michael D. Hall, "A Sorting Process: The Artist as Collector," in *Folk Sculpture USA*, ed. Herbert W. Hemphill Jr. (New York: The Brooklyn Museum, 1976), p. 35.

37. See, for example, Elizabeth Johns, *Thomas Eakins: The Heroism of Modern Life* (Princeton: Princeton University Press, 1983); Peter H. Wood and Karen C. Dalton, *Winslow Homer's Images of Blacks: The Civil War and Reconstruction Years* (Austin: University of Texas Press, 1988); Elizabeth Broun, *Albert Pinkham Ryder* (Washington, D.C.: Smithsonian Institution Press, 1989); Nancy K. Anderson and Linda S. Ferber, *Albert Bierstadt: Art and Enterprise* (New York: Hudson Hills Press, 1990).

38. The best source for *Possum Trot* is still the film by Allie Light and Irving Saraf, *Possum Trot: The Life and Work of Calvin Black* (San Francisco: Light-Saraf Films, 1976).

39. John Burrison, *Brothers in Clay: The Story of Georgia Folk Pottery* (Athens: University of Georgia Press, 1983), pp. 196-8; see also Michael D. Hall, "Brother's Keeper: Some Research on American Face Vessels and Some Conjecture on the Cultural Witness of Folk Potters in the New World," in *Stereoscopic Perspective*, pp. 218-9.

40. See Elizabeth Johns, *American Genre Painting: The Politics of Everyday Life* (New Haven: Yale University Press, 1991), pp. 68-91, 142-47.

41. Eugene W. Metcalf, "Afterword," in *Stereoscopic Perspective*, p. 256.

42. See Michael D. Hall, "You Make It with Your Mind: Edgar Tolson," in *Stereoscopic Perspective*, pp. 161-72.

43. For an especially informative study of North American decoys with an emphasis on leading carvers and principal regional characteristics, see Joe Engers, ed., *The Great Book of Wildfowl Decoys* (San Diego: Thunder Bay Press, 1990).

44. Harold E. Stearns, ed., *Civilization in the United States* (London: Jonathan Cape, 1922), p. vii.

45. See, for example, Julie Schimmel, "Inventing 'the Indian'," in *The West as America*, ed. William H. Truettner (Washington, D.C.: Smithsonian Institution Press, 1991), pp. 149-89.

46. See Marianne Doezema, *George Bellows and Urban America* (New Haven: Yale University Press, 1992), pp. 123-99.

47. Michael D. Hall, "The Bridesmaid Bride Stripped Bare," in *Stereoscopic Perspective*, p. 241.

48. See Michael D. Hall, "The Problem of Martin Ramirez: Folk Art Criticism as Cosmologies of Coercion," in *Stereoscopic Perspective*, pp. 227-36.

49. Michael D. Hall, "You Make It with Your Mind," in *Stereoscopic Perspective*, p. 169.

50. Michael D. Hall, "A Sorting Process: The Artist as Collector," in *Stereoscopic Perspective*, p. 111.

51. Henry Glassie, *The Spirit of Folk Art*, p. 228.

Folk Art and Cultural Values

Kenneth L. Ames

There are many paths in life. If we are fortunate, we find one that is right for us. But exceptional people are not content to follow old or familiar paths. They make their own.[1]

Michael and Julie Hall are two exceptional people who have made their own distinctive path. They have laid out a new trail across the landscape of art. Over a period of many years they have created a kind of mega-artwork — the Michael and Julie Hall Collection of American Folk Art — an enduring record of the path these two gifted and committed people have blazed. Constructing such an exceptional artifact is a complex and demanding task that requires vision, imagination, resourcefulness, unfailing energy, a willingness to take risks, belief in oneself, and nearly obsessive devotion.

Collections are intensely deliberate and purposeful creations, the result of continuous searching, evaluating, refining.[2] New additions to the evolving collection, like new lines added to a drawing or engraving, change the overall effect and require corresponding adjustments, some-times reductions, to the entire composition. Like novels and scholarship, collections are often deeply autobiographi-cal. A collection cannot be fully understood without know-ing something about its collectors. And collections are usually deeply revealing about the people who create them. Collections record or objectify personal journeys or sagas; they are the tangible expression of intellectual, emotional, or spiritual growth and development. A collec-tion is a biography without words, in which individual objects may be places visited, significant experiences, or personal epiphanies.[3]

The biographical dimension of any major collection is significant. But collections yield evidence that transcends individual lives. All people — and the Halls are hardly exempt — live in the greater society and are social activists, knowing or otherwise. All people respond to their society's culture and shape it in some way. Because collections are little worlds, they are necessarily configured in response to the larger world that impinges on their creators. I find the Hall Collection wonderful as a total artifact, as an assemblage of extraordinary individual objects, as a source of insight into the lives of two sensitive and fascinating people, *and* as a mirror of late twentieth-century life. It is that last dimension of the collection that I want to focus on here.

Some of the most prominent and painful features of contemporary life are confusion, controversy, and conflict over core cultural values. The degree to which the Hall Collection serves as a lens for focusing on problematic areas of contemporary cultural life is remarkable. In this collection of deceptively simple-looking goods lie complex and perplexing questions, questions that ultimately push us to examine our most fundamental values. And that is precisely why the Hall Collection is not "merely" an aesthetic feast. Put in other terms, a collection that only provides visual delight has value, but that value is modest compared to a collection that sets people off on explora-tions of their own inner thoughts and beliefs, that asks difficult questions about social responsibility. To me, the realization that we can find reflections of the larger world in the Hall Collection increases its interpretive value.

There is more to life than seeing, more to life even than feeling. For we are only complete human beings when we also think. And we are most responsible human beings when we think about the ramifications of our ideas and beliefs. The Halls have put together a collection that invites us to look, urges us to feel, and compels us to think.[4]

Folk art has always provoked controversy and con-tention, and it still does.[5] Today, even mainstream art and

Bill Traylor, *Talking Couple*, ca. 1940 (cat. no. 213)

Josephus Farmer, *Tribute to the Kennedys*, 1970s
(cat. no. 210)

mainstream art history have become contentious. The comfortable art universe that seemed secure two decades ago is being dismantled on all sides: old hierarchies and the assumptions that supported them are under attack. Canons and pantheons are contested and deconstructed. Like American demography and values, art and art ideas are shifting, changing, becoming increasingly confusing and to some, threatening. Consensus has disappeared. Where some see lofty visions, noble ideals, and good intentions, others see posturing, self-indulgence, solipsism, elitism, condescension, racism, sexism.[6]

American society is deeply conflicted, and understandably so. Injustices and inequities stand out in high relief. Greed, racism, and sexism seem to be the American trinity of the late twentieth century. To protect ourselves from reaction and repression we need to look hard at the institutions around us and ask whether they promote a just and equitable society, or serve the forces of repression. We need to look closely at the reigning concept of art and ask if it truly benefits American society. And we need to ask some hard questions about folk art.

I wonder, for instance, whether folk art democratizes our concept of art. Does folk art further mystify art and museums? Does it advance positive social values? Does it promote fundamentalism? Can it really promote empathy by putting us in touch with universals of human experience and human nature?

I ask these questions because as I understand it from conversation with the Halls, they set out to expand the idea of art. They hoped to use folk art as a lever to pry open the ruling concept of art and to bring greater

democracy to art and, by placing the collection in a museum, to art museums. In the end, I think they were only partially successful. Their limited success has less to do with their abilities than with the concept or construct of folk art itself. When it comes to significant change, folk art simply promises more than it can deliver. I believe the Halls worked within a flawed or limited structure that ultimately hindered the full implementation of their vision. Folk art was the wrong lever.

While I agree that the goods called folk art are legitimately and authentically fascinating and of aesthetic merit, I disagree with some authors in that I find the ramifications of folk art deeply problematic and troubling. Let me explain by exploring the five questions I just raised:

Does folk art democratize our concept of art? Democratizing art — taking into account more people and more diverse artifacts and performances — also means accepting multiple definitions of art and multiple purposes and functions for art.[7]

On the surface, the response to the question would seem to be positive: Folk art has to be democratic.[8] But the matter becomes less clear when we look carefully at the objects, their uses, and what is said about them. And we learn a great deal when we look at the dominant fine arts world of today.

It should not be surprising that the understanding of art *inside* the art community differs from the perceptions of the outside world. To people who share the dominant fine arts culture, art is about personal vision, innovation, creativity, self-expression, and personal problem-solving.

True art, from this perspective, has no function other than contemplation, no function other than being. Art is its own reality and the artist is the godlike creator of that reality.

To people outside art circles these are quaint conceits. While these ideas may apply to contemporary studio artists, they do not describe conditions, values, or beliefs that prevail in other societies, past or present. Historians, anthropologists, and others recognize that this contemporary vision is not a universal norm, but an aberration. Throughout world history and still today in most parts of the world, art is for something else: In traditional contexts art is often associated with mythic and ritual phenomenon. It can be playful or part of a game. Art can be body decoration. It can celebrate, ceremonialize, persuade or convince. It can also help to bond or unify a society. Yet art can disrupt; sometimes it subverts. Art is not monolithic; many arts serve many ends.[9] But only rarely is art just for itself. That is an innovation of modern Western capitalist, materialistic societies.

It is helpful to recognize that art in our society is not like art elsewhere. For us, art has become a narrow specialization. It has become professionalized, and with that professionalization has come the elevation of its own concerns, values — even its own jargon. Within high art circles, professional artists talk to other professional artists. The public, to whom most artists around the world have always talked, is left out of the conversations.

Where does folk art fit into this situation? For the most part, folk art has been discovered — or invented — and defined by professional artists within the dominant fine arts sphere. And for the most part, they have brought to their definition the prejudices and preferences of their guild. While many folk art objects in the Hall Collection (and elsewhere) originally had utilitarian functions, those functions have been minimized: emphasis is on aesthetics, not utility; on form, not function. Yet the variety of functions performed by these objects is remarkable, ranging from the obvious (in the case of weathervanes, decoys and containers), to the less obvious (objects that celebrate, commemorate or express group and individual faith, or self-therapy).

So the news is both good and bad: on the good side, we can see that the Hall Collection has expanded the concept of art by including a remarkable range of goods not (traditionally) considered "art" — trade signs, ceremonial figures and paraphernalia, advertising props, toys, dolls, games, whirligigs, weathervanes, decoys, ceramics, canes, and a great variety of drawings, paintings and sculpture.

But from another perspective, all we really have are drawings, paintings and sculpture. All the objects in the collection fit into one of these three very traditional categories. Why is this a problem? Because orthodoxy triumphs; the reigning narrow definition of art is still intact. Many new things pass through the gates of art, but it turns out that all of them have some covert link to goods already inside.[10]

The Halls deserve credit for prying apart traditional categories of art far enough for these nontraditional drawings, paintings and sculptures to pass through. But sharing or at least constrained by many of the values of the art society, they accepted its claims for the validity and superiority of those traditional categories. And so this collection contains no ikebana, no knitting, no quilts, no flower arranging, no foods, no silverware, no clothing, no body art, and no jewelry. In fact the list of what it might contain runs to the hundreds of categories.

The situation becomes more problematic when we recognize that other limiting factors were also at work here, determining which objects could appropriately become part of the collection. Some of these were aesthetic, objects being selected on the basis of a personal taste shaped by a very knowing dialogue with evolving art culture of the twentieth century. And some were definitional — art continues to be defined as a unique object, preferably the work of a single individual, created by traditional low-technology processes. But these restrictions exclude most of the modern world. They exclude group products, work formed by high technologies, and objects intentionally made as multiples. These restrictions seem rigid, archaic, anti-democratic, and oddly hypocritical.

When these limitations are taken into account, folk art seems as reactionary as it is progressive, trading new kinds of objects (and most assuredly new kinds and classes of people) for a very orthodox reading of art. Fostering both artistic and cultural diversity means giving up more control than we have been able to do so far. To be fair to all people who make things, to be fair to their societies, we must let the goods be what they are. We must let them have their own functions. We must accept

goods that do not fit our preconceptions and allow other layers of meaning and intention to abide. Then we can begin to democratize art.

Does folk art mystify art and museums? The kind of art we find in museums is distant from the lives of most people: it is simultaneously viewed as impractical, inaccessible, insignificant, unattainable, incomprehensible. Abstract art in particular lies beyond the realm of many, a mystery only understood by the "initiated." The distance between the public and fine art is considerable, for while various forms of modernism have signalled the triumph of the artist's or producer's values over those of the patron, the community, or the market, they have also marked stages of art's gradual retreat from meaningful engagement of the public in dialogues about social, cultural, and political values. Fine art may seem to be prospering today, but it does so at the cost of its soul. It has become mystified but has lost its vital link to the society that once understood and supported it.

Mystification is usually purposeful. Injustices or inequalities that become institutionalized depend on mystification or ideology to conceal and sustain them. Both art museums and the highly inflated price of art need justification, since rational grounds for their elevated status are hard to find. In art and in art museums, inequality and injustice are often mystified as quality, although just how that quality is determined is also mystified. The rules are known only to insiders, who may divulge their judgments but not the full basis on which those judgments rest.

I have spent much of my life contemplating the wonders of the visible world, and I have found profound satisfaction. But no sane person can believe that art is the crowning achievement of humankind. Peace; an end to violence and the threat of violence; the elimination of tyrannies, destructive ideologies and xenophobia; social and political equality; the equitable distribution of resources; the gift of self-esteem; broader tolerance for diversity; the chance for all people to discover and develop their true strengths — these would all be greater achievements than any work of art. Each would benefit more people in deeper and more enduring ways. Art matters, less than some things and more than others, but we serve no good ends by making pretentious or pious claims for its power or value. It is part of human life, but for most people, neither the goal nor the culmination.

Any unbiased critic who looks carefully at what is considered art or great art and what is considered lesser art — or not art at all — will be hard-pressed to come up with a rational defense for the current hierarchy. It becomes all too clear that fashion, caprice, accident, and some people's need to control, play large roles in the art game. Indeed, the fact that pantheons change only reveals their artificiality. Consider one example: At one point, nineteenth-century academic art was dominant. Then it gradually fell into disregard, and was set up as the enemy by modernists, who defined themselves and their work in opposition to it. But now we look with renewed delight at academic pictures and are greatly pleased that, for instance, the Milwaukee Art Museum has such a wonderful collection of them and displays them as one chapter in the multi-chaptered history of the arts.

The story of folk art has similarities. Once, in the not-too-distant past, many of the aesthetically powerful things the Halls collected were not allowed in art museums. Today they are not only allowed but proudly presented. Have we been fools all along, unable to see treasures in our midst? Or are we witnessing the outcome of power struggles within the art community, with different factions and different agendas assuming the upper hand? The answer to both questions is yes. And if one ideology blinded us, the other pushes us to over-respond.

The very notion that some things are allowed in art museums and others are not brings us closer to understanding how the dominant concept of art and art museums that adhere to that concept promote injustice. Like the diamond market, this concept of art rests on artificial scarcity. In fact, the world is full of wonderful, artful things. But the value of art, like the value of diamonds, would decline if too many of these objects were on the market: One way to control the amount of art is to control the definition of art. For unlike diamonds, which are geologically produced, the category of art is culturally produced. People invented the category and people control its application.

One way of controlling the concept of art is to control what goes into art museums. Although some museums are enlightened, as a group, art museums have been exclusionary: conventional notions of art and democracy do not seem to mix easily. Art society is one of the most resistantly elitist arenas of American life. Think of other fields of endeavor: consider popular music, amateur

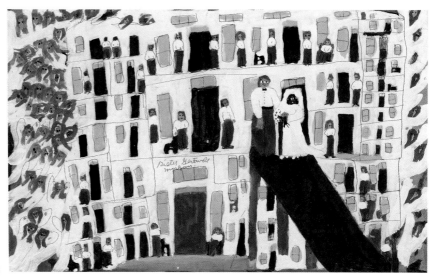

Sister Gertrude Morgan, *Heaven*, ca. 1965
(cat. no. 230)

athletics or academic scholarship. While other realms of life are accessible through merit, art seems particularly resistant to such openness.

What are the rules for rising to the top of the art field? What are the external, objectifiable criteria on which one will be judged and against which one can measure oneself? It is hard to say. Some will argue that this is rightfully so, because art deals with a certain indefinable, magical, mysterious "something" that transcends the crude business of quantifying. And I say that is *exactly* what mystification is all about: a smoke screen to conceal the arbitrary and capricious pattern by which some things get dubbed art and others do not.

Consider the plight of folk artists who want to succeed. They are caught in a double bind. First, how do they study to become folk artists — especially when current artistic ideology stresses personal vision? Where do they look? What do they read? With whom do they apprentice? The preferred answer is that they do not look, read, or apprentice. Folk art is grounded in innocence and cannot be learned — at least according to its twentieth-century modernist-inspired definition.

Secondly, if they actually do succeed commercially within their own society, there exists the distinct possibility that this success will count against them. Success is often interpreted to mean that their work is too ordinary,

too banal, too trendy, too modern. Besides, commercial success undercuts the notion that *authentic* folk art is not really made for financial gain: money somehow sullies and tarnishes when spent within the folk art community.

What kind of messages do we send when we maintain that self-awareness and education produce loss, not gain? When we maintain that success and recognition depend on a chance encounter with those within the art power structure? Folk artists must wait to be discovered, anointed. Thus the power in this relationship always remains in the hands of the art ruling class. This power relationship is underlined by the fact that there are few major folk art presences in American museums not associated prominently with collectors, who have taken objects out of closets, gutters, trash cans, off shelves, walls and porches, and brought them into art museums. In folk art, collectors have been the agents of magical transformation, and share billing with the artists.

This elevation, this transfiguration, this sanctification, as once mundane objects enter the museum, constitutes a sort of artifactual conversion experience. In religion, conversion experiences — the phenomenon of being reborn — are accorded heightened significance. A similar heightened significance occurs in the object world and is reified in the object's rise in economic value. When it enters a museum, the converted object joins the society

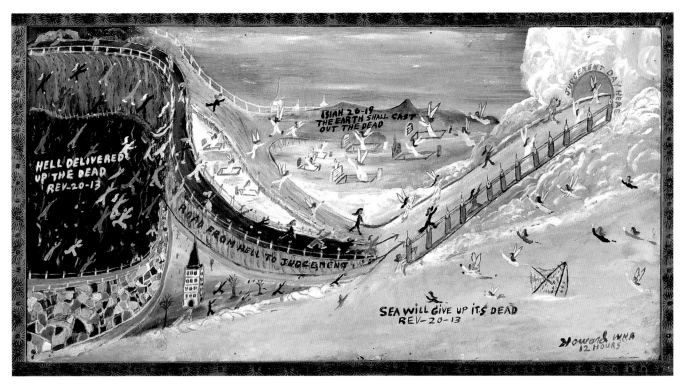

Howard Finster, *Sea Will Give Up Its Dead*, ca. 1977 (cat. no. 23)

of the elect through the agency of a savior, in this case, the collector.

Along with being reborn comes the stripping away of old associations and meanings and the imposition of new associations and meanings. It is no accident that we know so little about the original contexts of folk art objects, and even less of an accident that we often expurgate virtually all references to those contexts when we exhibit the objects in a museum: this sweeping away of the past is part of the process of mystification.

Does folk art advance positive social values? What positive social values can we find in folk art? The most obvious argument is that folk art makes museums more pluralistic, that it brings greater diversity to their collections and exhibitions. American folk art is the work of people of many ethnicities, from many parts of the country, and from under-represented, usually lower, social classes.

The diversity in the Hall Collection advances the emerging vision of America as what some have called the great tossed salad. Unlike the old melting pot metaphor in which all peoples were assumed to lose their ethnic identities and merge into one great American amalgam, in the tossed salad metaphor, distinctive values and behaviors are retained. While people of many different backgrounds co-mingle in the same great salad bowl, they retain and nurture parts of their culture that matter to them.

Gathered together in the Hall's extraordinary assemblage are objects produced by people from at least twenty-eight states and representing at least eight different ethnic and as many American regional traditions. The Hall Collection provides a remarkable survey of certain kinds of creativity by Americans of diverse ethnic and cultural orientations. This is all to the good.

Yet what remains intact beneath this diversified surface is a totally undiversified power structure. Entry

into this collection has been by invitation only; self-nominations were not encouraged; the collection was not formed as the result of open competition. Objects came from many different cultural and ethnic groups but they were not selected by those groups. In fact, there is little reason to believe they would have been, or that those groups would have selected these artists to represent them.

This is in part because the artists have more frequently articulated personal rather than communal values; because they have addressed issues meaningful to themselves but not necessarily to others in their community. And in part it is because the objects selected represent the Halls' particular variant of the current high art aesthetic, rather than the aesthetics of other cultural groups. What holds these objects together as a collection is the Halls' own distinctive vision.

Powerful as that vision is, we delude ourselves if we think we learn much about alternative aesthetic traditions in America from this collection. Ultimately we learn most about the taste of the Halls. These objects provide only partial understanding of communally shared conceptions. Diversity, then, turns out to be largely a matter of surface.

Yet even on the surface, that diversity is only partial. Think about gender.[11] Why is it that so few women are represented in this collection, even though half of the collecting team was female? By my tabulation, only about 11% of the objects in the Hall Collection were made by women — the collection perpetuates the sense of male domination in art.

Defenders of the gender imbalance might argue that males predominate because in traditional societies, or at least the traditional societies represented here, males produced most of the art. Maybe so, but many of these same societies also repressed women. We need to balance the alleged positive features of those societies with the very real negative features they also possessed. We need to move beyond misty-eyed and uncritical affection for traditional societies and acknowledge that they also had their costs.

But what about the present? Why isn't there greater balance? Are the particular qualities the Halls sought in the things they collected more prevalent in the work of males than of females? Did the Halls, consciously or unconsciously, emphasize categories of goods typically made by males and ignore those in which women predominate? Whatever the answer, the fact is that the collection perpetuates male domination of art. Is a definition of art that excludes so many people justified? Is it justifiable to enshrine gender bias in art museums?

These are basic questions of equity. The answers affect the world we live in and the world our children will live in. I think it is time to take our ideas of art, along with many other commonplace assumptions, back to the drawing board. A few revisions are in order.

Does folk art promote fundamentalism? In a recent essay in *American Quarterly*, Steven Watts wrote about what he called the "idiocy" of the discipline of American Studies as it is currently practiced. One of his major criticisms is that contemporary scholars pay too little attention to the content of cultural products. The same can be said of the art community — and we might wonder if "idiocy" is the right word in this context as well.[12]

Artists sometimes assume, because their art is primarily about form, that folk art is primarily about form. This is a critical fallacy. For while every creation has form, form is not necessarily its purpose. To paraphrase Ben Shahn, form is the unavoidable shape that content must take.[13] For most artists outside the circles of modern art, including folk artists, content is an important part of their message. Yet that content usually gets overlooked. In the case of folk art, that strikes me as particularly problematic because that content is fundamentalist; by fundamentalist I mean both that it adheres to the ideology of conservative Protestantism and that it is generally reflective of a narrow, rigid and restrictive view of the world.[14]

Some of the people who have made the things we call folk art are people on the edges of the predominant society. Those we know about frequently inhabit bleak or severely restricted worlds; they are often quite poor and not from the priviledged classes. They have little in life and fear that change will leave them with even less. Not surprisingly, many of these people find refuge and solace in fundamentalist Christianity. Think about some of those whose works are included in this collection: Elijah Pierce, S. L. Jones, Howard Finster, Bill Traylor, Gertrude Morgan, John Perates, Josephus Farmer, Edgar Tolson. All produced visually interesting works grounded in conservative constructions of reality.

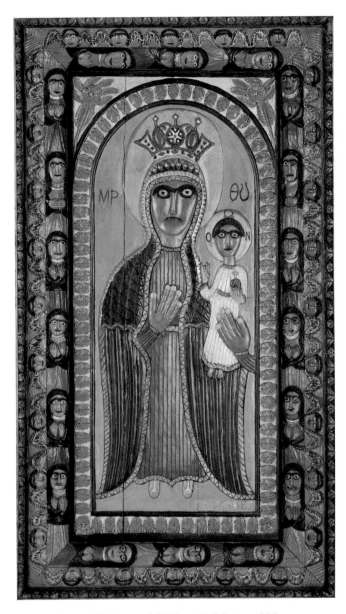

John W. Perates, *Madonna and Child*, ca. 1940 (cat. no. 201)

How can we respond to images of the head of Christ, of saints, of biblical tales, and visions of heaven? One response is to recognize that the people who created them are part of the diversity of America and that their culture is part of the pluralism we prize. Another is to recognize that these people are in many ways victims of social inequality, of limited and limiting perspectives and ideologies.

We have to acknowledge that some folk artists express values and beliefs that some people find repugnant. Ask yourself if you really want to endorse orthodox patriarchal Christianity, often repressive of gays, and of differences of many kinds. Do you want to endorse simplistic views of reality — views that in some ways are the most limited? Yet how often, in discussions of folk art, do we find questions about the content and the ramifications of that content? We need to acknowledge that even if it does not advance or promote them, some folk art presents fundamentalist views. We are more just to these people and to ourselves if we acknowledge what lies before us.

Ultimately we have to ask where folk art fits into contemporary discussions of values and what roles its promoters want it to play. Is folk art a way to say reactionary things and still keep liberal company? What are the ramifications of putting folk art, particularly folk art by fundamentalists, into American museums? Are we comfortable with those ramifications?

Does folk art put us in touch with universals of human experience and human nature? To this question I think answers are less equivocal. Folk art offers valuable lessons about humanity and about strands that bind all of humanity together.

Art really is a human universal. Although it goes by many names (or sometimes none at all), and although it performs many functions, all people have something that can be called art. And all the world's people have what Michael Owen Jones has called a feeling for form.[15] It is a major component of acknowledged art everywhere. But Jones also finds it in the commonplace activities of everyday life and even on industrial production lines. He sees it in the ways in which people arrange objects on the tops of desks and tables; in the ways they decorate their offices — sometimes even in the ways they arrange their trash along the curb. He finds people enjoying the rhythm of production line work, the shapes, colors, and textures of

the materials they work with. Sometimes they become one with the form in what are called flow experiences.

The same feeling for form has been recognized by others for years, whether it is Hamlin Garland admiring long, straight furrows of prairie soil being turned over by a horse-drawn plow, or Garrison Keillor intoning about cutting long, slow, graceful arcs across the ice while skating at night on a frozen pond near Lake Wobegon. Anthropologists have recorded this feeling for form in hundreds of societies around the world.[16]

We see this feeling for form in both the highly worked objects and in the least, in the extraordinary *Newsboy* and in the Wil Edmondson *Lion*, in the *Pair of Black Figures* and in the *Rooster Weathervane*, in the lures, the decoys, John Perates' *St. Nikolos*, and throughout this collection. We see it in the marvelous *Root Snake*, where form is more discovered than created. All these objects are grounded in the universal feeling for form and when we experience that feeling we share in a panhuman, or universal phenomenon.

Some of these objects are doubly affecting because they draw on the other human universal: empathy. All people have the capacity — not always exercised — to feel what others are feeling. Indeed, we could argue that most of the world's evil is done when humans suppress empathy and refuse to feel what others are feeling.[15]

In the objects the Halls have collected, empathy is encouraged by the inescapable predominance of figural forms, both human and animal. Almost 90% of the collection is made of human or animal evocations in two- and three-dimensions. This is an unusually high proportion that results in a collection that is unparalleled in its accessibility. The claims that folk art represents a kind of everyperson's art has validity: much of it is immediately accessible to people of all sorts, classes, ethnicities, nationalities. In responding to a sad or joyous face, we really are in communion with all humankind. There is profundity, even sublimity, in this realization.

Folk art may then be a way of compensating for the relative aridity and aloofness of much twentieth-century art. For folk art's greatest virtue is its accessibility. There are few barriers between objects and viewers, between objects and emotions. Michael Hall once made a comment that puzzled me; he said that folk artists were insiders, but

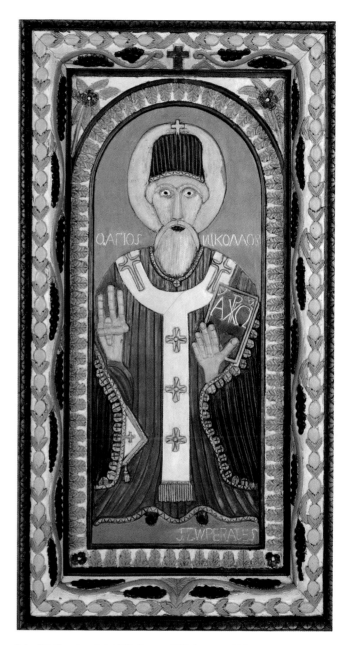

John W. Perates, *Saint Nikolos*, ca. 1950 (cat. no. 202)

that we were outsiders. Perhaps what Hall meant was that folk artists seem to be genuinely inside their own lives, inside their own feelings. By comparison, contemporary fine artists often seem abstracted from reality, playing too hard at obscure and rarified games that lack the compelling quality of folk art. Perhaps folk art teaches us that twentieth-century society often stands too far back from emotion.

So it is true that folk art can put us in touch with universals, both the ubiquitous feelings for form and empathy. And both are valuable. Greater respect for our own feelings for form can help us improve the aesthetic quality of our own environments and recognize and enjoy feelings for form that others around us have expressed. And empathy is the key to seeing the human in another human being. Empathy is a necessary first phase in resolving solution of social and international problems and conflicts.

In this discussion, I have tried to suggest some greater problems inherent in the Hall Collection. I have said some strong things in order to be provocative but also because I believe them, and believe they can challenge viewers to experience, to reflect, to learn, to grow. I have deliberately ignored the usual path of folk art histories and appreciation, believing that it led in directions that would be neither productive nor responsible. I have been guided by my belief that art is more than something to like.

Notes

1. On making original paths, see Denise Shekerjian, *Uncommon Genius: How Great Ideas Are Born* (New York: Penguin Books, 1991); Denis Waitley, *Seeds of Greatness* (Old Tappan, New Jersey: Fleming H. Revell, 1983); and Sam Keen, *Fire in the Belly: On Being a Man* (New York: Bantam, 1991), pp. 125-185.

2. On collecting, see Russell W. Belk, et. al., "Collectors and Collecting," *Advances in Consumer Research* 15 (1988), pp. 548-553.

3. A partial verbal account of Michael Hall's personal journey appears in his *Stereoscopic Perspective: Reflections on American Fine and Folk Art* (Ann Arbor: UMI Research Press, 1988).

4. On thinking through ramifications, see Daniel Yankelovich, "A Missing Concept," *Kettering Review* (Fall 1991), pp. 54-66.

5. See, for example, Kenneth L. Ames, *Beyond Necessity: Art in the Folk Tradition* (New York: W. W. Norton for the Winterthur Museum, 1977), and John Michael Vlach and Simon J. Bronner, eds., *Folk Art and Art Worlds* (Ann Arbor: UMI Research Press, 1986).

6. For comments on changes in art history, see observations of Wanda Corn, Gerald Silk, and Albert Boime in "Scholarship in American Art," *Smithsonian American Art Network*, Supplement to 4 (Fall 1991).

7. For diverse readings of art in contemporary American society, see Stephen Benedict, ed., *Public Money and the Muse: Essays on Government Funding for the Arts* (New York: W. W. Norton, 1991).

8. For orthodox interpretation of folk art, see Jean Lipman and Alice Winchester, *The Flowering of American Folk Art* (New York: Viking Press, 1974).

9. Ellen Dissanayake, *What Is Art For?* (Seattle: University of Washington Press, 1988); and Dissanayake, *Homo Aestheticus* (New York: The Free Press, 1992). For a historical view, see Alan Gowans, *Learning to See: Historical Perspectives on Modern Popular/Commercial Arts* (Bowling Green: Bowling Green University Popular Press, 1981), pp. 2-36.

10. On pain caused by the dominant ethnocentric definition of art, see Gerald D. Yoshitomi, "Cultural Democracy," in Benedict, ed., *Public Money and the Muse*, pp. 195-215.

11. The literature on sexism and art is extensive. For an overview, see Thalia Gouma-Peterson and Patricia Matthews, "The Feminist Critique of Art History," *Art Bulletin* 69, no. 3 (September 1987), pp. 326-57. A major historical study is Germaine Greer, *The Obstacle Race: The Fortunes of Women Painters and Their Work* (New York: Farrar Straus Giroux, 1979).

12. Steven Watts, "The Idiocy of American Studies: Poststructuralism, Language, and Politics in the Age of Self-Fulfillment," *American Quarterly* 43, no. 4 (December 1991), pp. 625-660.

13. Ben Shahn, *The Shape of Content* (Cambridge: Harvard University Press, 1957).

14. For an analysis of contemporary Protestant fundamentalism, see S. J. D. Green, "The Medium and the Message: Televangelism in America," *American Quarterly* 44, no. 1 (March 1992), pp. 136-145.

15. Michael Owen Jones, *Exploring Folk Art: Twenty Years of Thought on Craft, Work and Aesthetics* (Ann Arbor: UMI Research Press, 1987), pp. 119-131.

16. Dissanayake, *What Is Art For?* and *Homo Aestheticus*. See also Donald E. Brown, *Human Universals* (Philadelphia: Temple University Press, 1991), pp. 130-140.

17. Brown, *Human Universals*, pp. 139, 159. On the costs of suppressing empathy, see Myriam Miedzian, *Boys Will Be Boys: Breaking the Link between Masculinity and Violence* (New York: Doubleday, 1991).

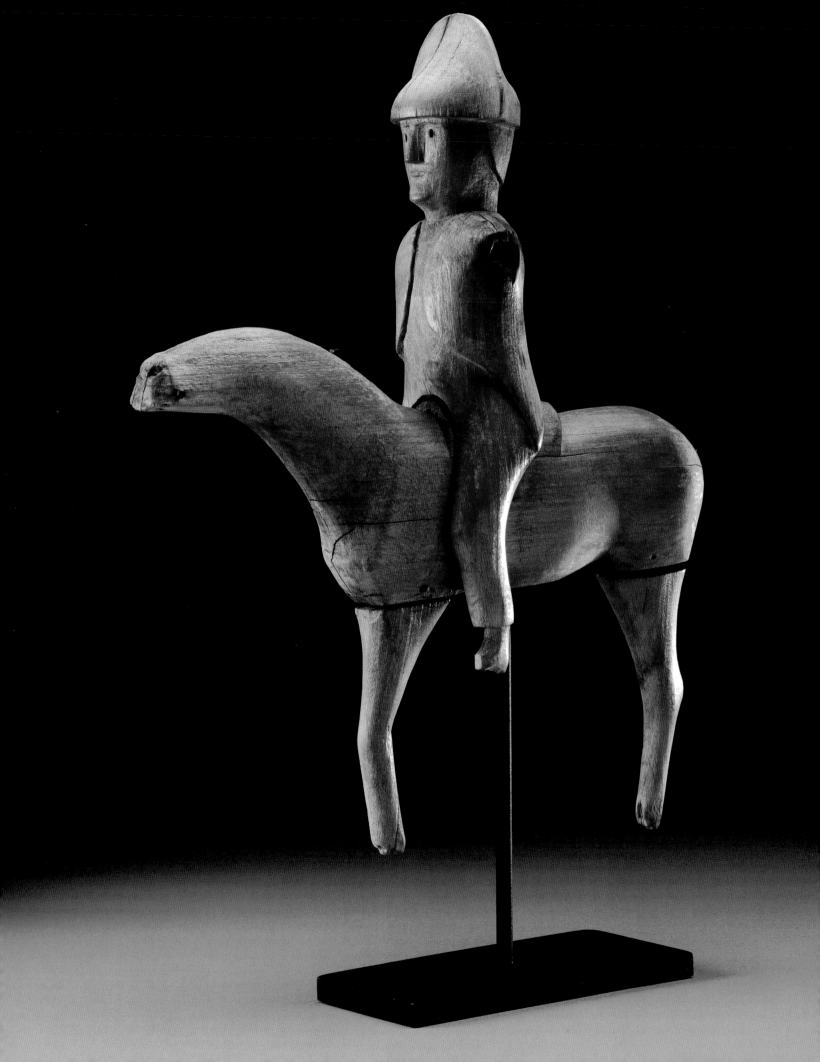

Catalogue of the Collection

The catalogue is divided into three categories: *Paintings*, *Sculpture*, and *Works on Paper*. *Paintings* and *Works on Paper* are subdivided into: Portraits, Animals, Still Lifes, Views, and Religion & History, reflecting a progression from descriptive works to those which address more conceptual concerns. *Sculpture* is further subdivided into functional and subject categories. Entries include a heading which states artist's name, location, title of work, date, materials, dimensions, provenance, date of acquisition, and Milwaukee Art Museum accession number. If two works by the same artist appear in sequence, the artist's name and location are not repeated. Dimensions are stated in inches, with height preceding width, preceding depth; metric dimensions follow in parentheses. Those works included in the traveling exhibition are indicated with an asterisk beside the entry. Authors of the catalogue entries are identified by their initials:

Margaret Andera	(MA)
Kathleen Battles	(KB)
Russell Bowman	(RB)
Debra Brindis	(DB)
Suzanne Ford	(SF)
Julia Guernsey	(JG)
Jennifer Hachemi	(JH)
Jeffrey R. Hayes	(JRH)
Gina Kallman	(GK)
Katharine Malloy	(KM)
Mary Plaski	(MP)
Daniel Shyu	(DS)
Barbara Urich	(BU)
Linda Van Sistine	(LVS)

Unidentified Artist, *George Washington on Horseback*, ca. 1850 (cat. no. 156)

Paintings

Although painting dominated many early collections and was once considered a premium folk art medium, its historic ties and key place within the fine arts has prompted one leading scholar to contend: "To see pictorial works as representative of American folk art tradition ignores the very social and formal considerations which distinguish folk art from academic art."[1] This section of paintings, which ranges from conventional nineteenth-century portraits to extraordinary modern narrative subjects, reflects a more inclusive, moderate view that discounts media or category of production as essential criteria for defining folk art and denies that such art must always issue from close-knit, custom-bound communities. Rather, folk art — including painting and other nearly universal modes of expression — is created by thousands of people in a wide variety of styles and contexts. These "folk" have little formal training and seldom think of themselves as professionals, but they do value (and wish to be valued for) what they make, often as much from an aesthetic as from a practical standpoint. In theory, socioeconomic and educational factors combine to distinguish folk from academic art, but in truth the dynamics of American culture rarely permit any one side of that formula exclusive impact. (JRH)

1. John Michael Vlach, "The Wrong Stuff," *New Art Examiner* 19 (September 1991), p. 23.

Drossos P. Skyllas, *Young Girl with a Cat*, detail, ca. 1955 (cat. no. 2)

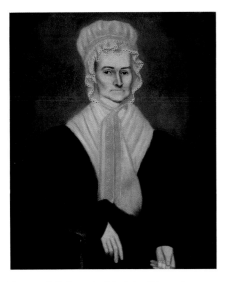

Erastus Salisbury Field, *Pair of Portraits (Woman and Man)*, 1833 (cat. no. 1a, b)

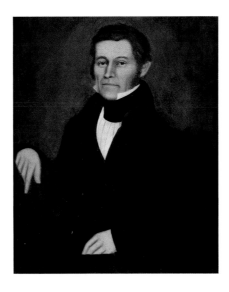

1a & 1b*
Erastus Salisbury Field
Connecticut
Pair of Portraits (Woman and Man) 1833
Oil on canvas
35 ⅛ x 29 ½ in.
(89.2 x 74.9 cm) each
Acquired from Kennedy Galleries,
New York, 1981
M1989.202.1,2

These two unidentified portraits were most likely among the more than thirty that itinerant artist Erastus Salisbury Field completed in 1833 during stops in Winchester, Winsted, and other thriving Connecticut towns. His recent marriage and the birth of daughter Henrietta undoubtedly encouraged Field to seek additional commissions beyond his native Massachusetts. The heavy grade canvas, black panelled frames, and handwritten inscription ("taken 1833") on the reverse of the man's portrait all point to this period, as do the elongated three-quarter poses, grey-green nimbi, and limited accessories such as the woman's perfume bottle and red "snail shell" armchair.[1]

Field — with Ammi Phillips, Rufus Porter, William M. Prior and other so-called "Plain Painters" — have elicited diverse, sometimes opposing critical estimates. One historian contends that "Field never became a fine artist largely because he lacked the required skill . . . his New England clientele generally accepted his work regardless of its flaws, enabling him to remain content with a stunted level of development."[2] However, another scholar finds sound practical reasons for the rise of a "rural artistic idiom" and concludes that "itinerants like Field became innovators in a village vernacular to meet the demand (and lower the price) for their offerings. [They] experimented with the rapid . . . manufacture of likenesses with stylized designs which standardized their products, but they distinguished their subjects by the inclusion of personal items."[3] A third scholar further argues that Field's early style had less to do with technical or economic factors than with the "contradictory" cultural complexion of his patrons:

The flatness and frontality of the paintings . . . are the result of a social reticence in the presentation of self in egalitarian communities, rather than an unconscious abstraction resulting from . . . either bold innovation or technical short cuts, nor yet from ineptitude . . . Plain paintings are simultaneously responsive to modern bourgeois and traditional values; they express both the pride in individual accomplishment and claims to a new class status . . . while also restraining these impulses with the moral caution of a communal aesthetic.[4]

(JRH)

1. Mary Black, *Erastus Salisbury Field: 1805-1900* (Springfield: Museum of Fine Arts, 1984), pp. 16-19.

2. John M. Vlach, *Plain Painters* (Washington, D.C.: Smithsonian Institution Press, 1988), p. 25.

3. David Jaffee, "'A Correct Likeness': Culture and Commerce in Nineteenth-Century Rural America," in *Folk Art and Art Worlds*, eds. John Michael Vlach and Simon J. Bronner (Ann Arbor: UMI Research Press, 1986), p. 55.

4. Charles Bergengren, "'Finished to the Utmost Nicety': Plain Portraits in America, 1760-1860," in *Folk Art and Art Worlds*, eds. John Michael Vlach and Simon J. Bronner (Ann Arbor: UMI Research Press, 1986), pp. 85, 108, 116.

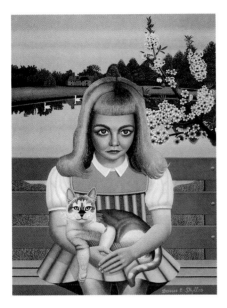

Drossos P. Skyllas, *Young Girl with a Cat*, ca. 1955 (cat. no. 2)

2*
Drossos P. Skyllas
Chicago, Illinois
Young Girl with a Cat ca. 1955
Oil on canvas
26 x 20 in.
(66 x 50.8 cm)
Acquired from Phyllis Kind Gallery,
New York, 1980
M1989.211

Although Drossos Skyllas's "sweetest dream [was] to do a large painting of the Last Supper for the American people,"[1] it was the image of woman that figured most prominently in the work he actually produced. His varied treatment of this subject — young and old, nude and formally attired, indoor and outdoor, shy and aggressive — amounts to a physical and emotional composite linked by an eerie stillness, often identical accessories, and common features such as her conspicuous reddish blonde hair. That particular trait, along with the limits of a modest income, suggests that Skyllas's wife and sole supporter (*Iola*, Roger

Brown Collection) may have been the "model" behind these riveting portraits.

Young Girl with a Cat features a child who appears to have passed beyond traditional feminine contexts of domesticity (estate), innocence (swans), and motherhood (cherry blossoms) to confront her fate from a hard bench that bars past illusions. Her demeanor is both devilish and disarming, and like the Pre-Raphaelite or Symbolist maidens that Skyllas may have had in mind, she affirms that "flowing and abundant [hair] is part of woman's mystery. Like her eyes, wide open and profound . . . it contains something of her ideal essence, a symbol at once pure and dangerous."[2] Ordinary girlishness is further subverted by the cat in her lap who echoes her unmitigated gaze. Female and feline elements combine to impart a Sphinxlike impression of passion, pain, and "an ultimate meaning which must remain forever beyond the understanding of man."[3] (JRH)

1. Drossos P. Skyllas, "Last Supper" (Typescript, Phyllis Kind Gallery, Chicago, Illinois).

2. Robert Goldwater, *Symbolism* (New York: Harper & Row Publishers, Inc., 1979), p. 60.

3. J. E. Sirlot, *A Dictionary of Symbols* (New York: Philosophical Library, 1962), p. 289.

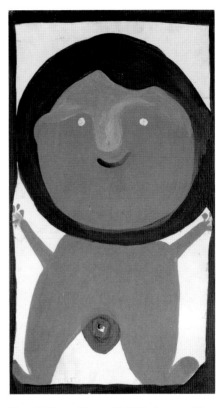

Mose Tolliver, *Man*, mid-1970s (cat. no. 3)

3
Mose Tolliver
Montgomery, Alabama
Man mid-1970s
Housepaint on board
25 ½ x 14 ¼ in.
(64.8 x 36.2 cm)
Acquired from Jay Johnson, America's Folk Heritage Gallery, New York, 1978
M1989.227

Man is a relatively early example of Tolliver's painting at its most basic. His single standing nude is centered, frontal, and flatly composed against a plain white background. The enlarged *O*-shaped head and squat *X*-shaped body with arms raised and legs spread mark fundamental formal and emotional subdivisions at the expense of strict anatomical truth. Typical

as well are the creamy green-tan-pink color scheme, the painted border in lieu of frame (subtly varied to accommodate the figure's extremities), and the scrap plywood ground with an attached aluminum "pop top" hanger.

Although best known as a fantasy painter, *Man* shows the physical, often earthy side of Tolliver's work. Whether conceived as an individual portrait or as an archetypal "man," this outgoing figure literally defines the pictorial space while his most conspicuous features — dark full beard, bowed red lips, and heavily painted genitals — make an immediate, carnal impression. (JRH)

4
Lee Godie
Chicago, Illinois
Portrait of a Man 1983
Ink and watercolor on board
20 x 16 in.
(50.8 x 40.6 cm)
Acquired from the artist, 1983
M1989.245

Within Chicago Imagist tradition and especially among that city's respected line of idiosyncratic unschooled artists, Lee Godie is "as much a fixture as the two lions on the front steps of the Art Institute, where for years she would hawk her paintings and brag toothlessly . . . 'I'm much better than Cezanne'."[1] Most of her paintings are portraits that depict either herself; her favorite celebrities such as Princess Margaret or James Dean; ideal types including Prince Charming, Mona Lisa, and the Gibson Girl; or, most often, anonymous sitters selected on the street. Like her Eastern contemporary Inez Walker, Godie not only delineates her subjects very precisely — usually by means of a ballpoint pen — but also invests them with a gentility that contradicts and perhaps offsets her own harsh lifestyle. (JRH)

1. Michael Bonesteel, "Chicago Originals," *Art in America* 73 (February 1985), p. 131.

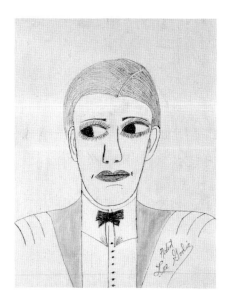

Lee Godie, *Portrait of a Man*, 1983 (cat. no. 4)

5*
Unidentified Artist
Still Life with Fruit ca. 1880
Oil on canvas
23 ¾ x 29 ¾ in.
(60.3 x 75.6 cm)
Acquired from Michael Pack, Flea Market, Ann Arbor, Michigan, 1984
M1989.205

The "still life of abundance" was a popular theme among both professional and amateur artists, and mirrored the dramatic rise in American material prosperity during the second half of the nineteenth century.[1] This "dessert picture" — a topical specialty ultimately derived from Dutch Baroque precedent — includes a standard profusion of fruits and nuts (some consumed), cheese, biscuits, utensils, glassware, ceramics, and a Victorian "turtle top" table, all arranged in a grand pyramid enlivened by the sharp, diagonal break from light to shade in the background.

Still Life with Fruit was found in Chicago,[2] home to a number of recognized still life specialists such as brothers Morston and Carducius Ream. Carducius's rich color, crisp modeling, and lush content made his work ideal for promoting Louis Prang & Company's popular series of "Dining-Room" chromolithographs in the 1870s,[3] a source that likely influenced this unknown but hardly uninformed local painter. (JRH)

1. See William Gerdts, *Painters of the Humble Truth* (Columbia: University of Missouri Press, 1981), pp. 81-97.

2. Michael and Julie Hall, interview by Julia Guernsey and Debra Brindis, 1 August 1991, transcript, Milwaukee Art Museum.

3. Peter C. Marzio, *The Democratic Art* (Boston: David R. Godine, Publisher, Inc., 1979), pp. 119, 318.

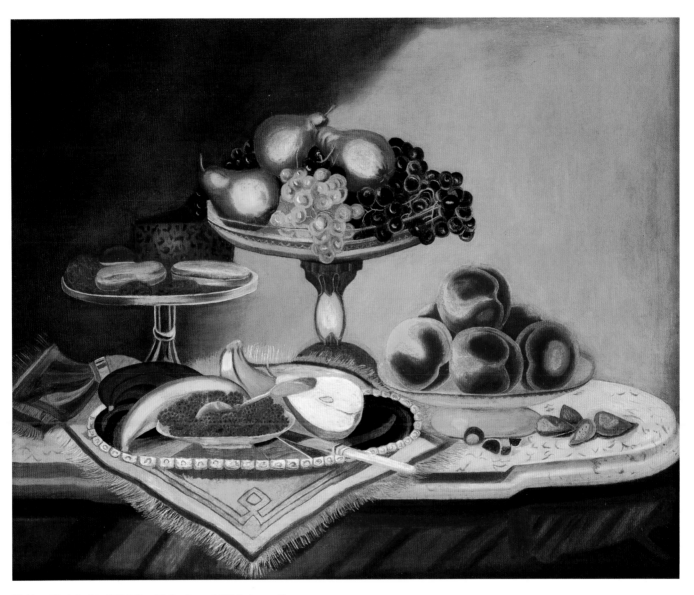

Unidentified Artist, *Still Life with Fruit*, ca. 1880 (cat. no. 5)

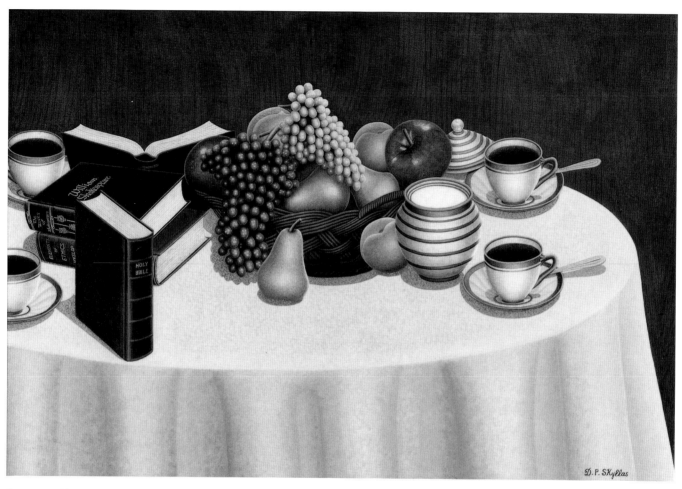

Drossos P. Skyllas, *Still Life*, ca. 1960 (cat. no. 6)

6*
Drossos P. Skyllas
Chicago, Illinois
Still Life ca. 1960
Oil on board
20 x 29 ½ in.
(50.8 x 74.9 cm)
Acquired from Phyllis Kind Gallery,
New York, 1980
M1989.212

"Some objects are rejected as folk art because they seem to be done too well."[1]

Although self-taught and unrecognized during his lifetime, Drossos Skyllas had good reason to consider himself a professional artist after leaving Greece and an accounting career to move to the U.S. in the late 1940s. Once settled in Chicago, he painted full-time, frequented museums, entered several major regional exhibitions, and actively sought commissions at prohibitively high prices.[2] More important, he developed a technically remarkable style characterized by precise draftsmanship, bold modeling, and dense, systematic paint application; indeed, when brushes of the highest quality could not be bought, he made his own. "Every painting of mine is beautifully detailed," Skyllas aptly declared, "No matter how large the canvas is, the same fine workmanship will be done . . . I love very much to do only pure, realistic paintings to such an extent that my works look 100% like photographs."[3] He also made an obvious effort to explore every historic category of Western painting — portraits, including three of Presidents Eisenhower, Kennedy and Johnson; religious and mythological subjects; nude figures; landscape; and still life, ranging from simple bouquets to more complex tabletop arrangements.

Still Life reflects on its own diverse art historical function by combining traditional illusionism (representation), formalist structure (abstraction), and personal, extrapictorial referents (sym-bolism). The books, for example, not only enrich the physical impression and compositional make-up of this painting, but their legible titles fuse ". . . intellectual (and) visual content."[4] Skyllas's strong religious convictions undoubtedly compelled him to place the Bible in a conspicuous, upright position well ahead of both Shakespeare's earthy "Works" and the speculative "Ethics" of modern meta-physician James Hervey Hyslop. (JRH)

1. Kenneth L. Ames, *Beyond Necessity* (Winterthur: Henry Francis du Pont Winterthur Museum, 1977), p. 94.

2. Telephone conversation with William Bengston, Phyllis Kind Gallery, Chicago, Illinois, 21 January 1992.

3. Drossos P. Skyllas, "Last Supper" (Typescript, Phyllis Kind Gallery, Chicago, Illinois).

4. Michael D. Hall, *Transmitters* (Philadelphia: Philadelphia College of Art, 1981), p. 52.

7*
Lawrence Lebduska
New York, New York
Four Horses Gamboling 1946
Oil on canvas
20 x 24 in.
(50.8 x 61.0 cm)
Acquired from George Schoellkopf,
New York, 1979
M1989.210

Although a part-time self-taught painter, Lawrence Lebduska was hardly an isolate. His formal training as a stained glass artisan in Leipzig prior to World War I afforded general exposure to European fine art and perhaps an awareness of emergent Expressionist groups such as the Fauves and Die Brucke. After settling in New York, where he worked as a professional decorator, Lebduska took up easel painting and occasionally exhibited his intensely colored, fanciful pictures at the pro-modern Stephan Bourgeois Galleries, Whitney Museum of American Art, and Valentine Gallery. He was also employed by the WPA Federal Art Project, headed by Holger Cahill, in the early 1940s.

Four Horses Gamboling is a representative canvas. Sidney Janis, the pioneering folk/modern art dealer and Lebduska's first biographer, properly noted: "Animals constitute [his principal] subject . . . They are usually brightly painted and vari-colored. Lebduska once lived with an uncle who breeds horses in Maryland where he had ample opportunity to observe these animals in all their tempers. He also researches at zoos and at the American Museum of Natural History, but . . . his observations lead not to reality, but to a world of folk-fantasy."[1] Indeed, Lebduska's horses are always set in imaginary landscapes where they seem moved by magical forces that recall the fairy tales and legends of his native Czechoslovakia.[2] They also echo equine imagery found in the carnival paraphernalia, paintings under glass, ceramic guild jugs, gingerbread molds, and "mayor's rods" of Czech folk art itself. (JRH)

1. Sidney Janis, *They Taught Themselves* (New York: Dial Press, 1942), p. 171.

2. See Josef Baudis, *Czech Folk Tales* (Millwood, New York: Kraus Reprint, 1971), pp. 16-38, 71-97, 103-108.

Animals

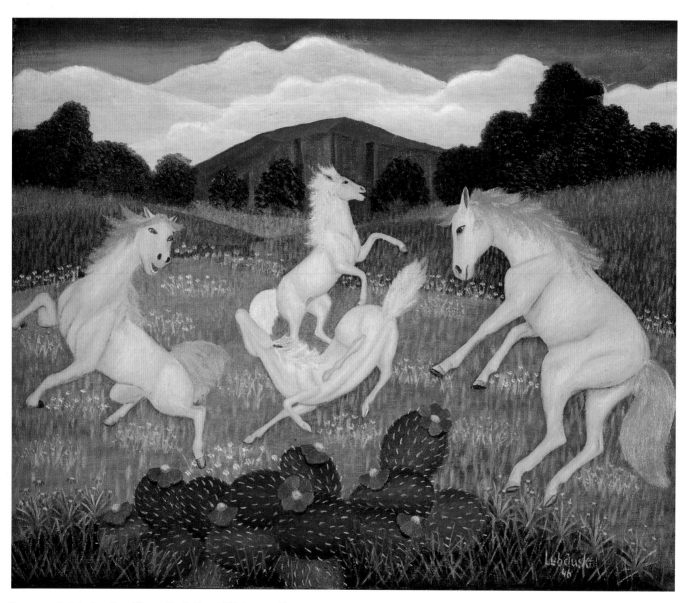

Lawrence Lebduska, *Four Horses Gamboling*, 1946 (cat. no. 7)

8
William Hawkins (attributed)
Kentucky
Rattlesnake early 1970s
Enamel housepaint on board
15 x 20 ⅞ in.
(38.1 x 53 cm)
Acquired from Kenneth Fadeley,
Ortonville, Michigan, 1974
M1989.223

"The snake, especially the 'rattler,' was a favorite of Hawkins . . . he painted many versions of this creature, in many color schemes, sizes, and media."[1] Nevertheless, *Rattlesnake* is an unusual work. While the materials, palette, and decorative border are typical of the artist, the painting lacks Hawkins's distinctive signature, solid brushwork and structure, and customary setting or accessory details. Because it appears quickly executed and was found near Hawkins' boyhood home in Kentucky, *Rattlesnake* is probably a "souvenir" image occasionally produced for friends or acquaintances, in this case during one of his regular visits to brother Vertia. (JRH)

1. Gary J. Schwindler, letter from Athens, Ohio, 29 August 1991.

William Hawkins (attributed), *Rattlesnake*, early 1970s (cat. no. 8)

Unidentified Artist, *Exotic Landscape*, ca. 1845 (cat. no. 9)

9*
Unidentified Artist
Exotic Landscape ca. 1845
Oil on canvas
19 ⅛ x 21 ¼ in.
(48.6 x 54 cm)
Acquired from David Pottinger,
Bloomfield Hills, Michigan, 1974
M1989.203

This painting, once part of the Abby Aldrich Rockefeller Folk Art Collection, features a waterfall that descends between rugged mountains and a lush tropical foreground plain. Dramatic "wilderness" vistas — often imaginary and based on popular prints or illustrations — suited the Romantic disposition of many early nineteenth-century American artists, and similar cascades appear in more elaborate scenes by Edward Hicks and Erastus Salisbury Field, as well as in the academic landscapes of Asher B. Durand, Frederic Church, and other members of the Hudson River School. Thomas Cole, whose *Landscape with Tree Trunks* (Rhode Island School of Design) and *A Wild Scene* (Baltimore Museum of Art) share this unknown painter's basic composition and repertoire of forms (including the evocative, tentacle-like branches), proposed that "the Waterfall . . . presents to the mind the beautiful, but apparently incongruous idea, of fixedness and motion — a single existence in which we perceive unceasing change and everlasting duration. The waterfall may be called the voice of the landscape."[1] (JRH)

1. Thomas Cole, "Essay on American Scenery" (1835), in John W. McCoubrey, *American Art 1700-1960* (Englewood Cliffs, New Jersey: Prentice Hall Press, 1965), p. 105.

10
C.D.G.
Untitled (Coast Scene) ca. 1850
Oil on board
8 x 12 ¹⁄₁₆ in.
(20.3 x 30.6 cm)
Acquired from Herbert W. Hemphill Jr.,
New York, 1969
M1989.215

In her influential study of nineteenth-century American visual culture, Barbara Novak could have been discussing an important link between *Exotic Landscape* (cat. no. 9) and this small coastal view when she wrote:

> Even in the large, dramatic compositions, which maintain contact with the older sublime, water often inserts a quota of stillness . . . The artist and spectator, after scaling the picture's height and descending to its valleys in an empathy that was encouraged, could here find rest. Thus when we see pockets of still water in nineteenth-century American landscape we may speak of a contemplative idea, a refuge bathing and restoring the spirit, and of a compositional device marrying sky and ground by bringing the balm of light down to the earth on which the traveler stands.[1]

Apart from technical limitations, *Untitled (Coast Scene)* resembles the "luminist" New England shorelines of John F. Kensett, Fitz Hugh Lane, and other professionals who brought a more intimate sense of present time and familiar locality to American landscape painting at mid-century. (JRH)

1. Barbara Novak, *Nature and Culture* (New York: Oxford University Press, 1980), pp. 40-41.

C.D.G., *Untitled (Coast Scene)*, ca. 1850 (cat. no. 10)

Church of the Parish of the Assumption of the Blessed Virgin Mary, Syracuse, New York, 1885. Photo courtesy of Parish of the Assumption of the Blessed Virgin Mary, Syracuse, New York

11*
Nazarenus Graziani
Syracuse, New York
Church of the Assumption
(The Pink Cathedral) 1885
Oil on canvas
41 ½ x 51 ½ in.
(105.4 x 130.8 cm)
Acquired from Herbert W. Hemphill Jr.,
New York, 1987
M1989.204

When little is known about an especially striking piece of folk art, it is often romanticized. Thus, this imposing portrait of an actual church — with its many quaint bystanders, knife-sharp linear perspective, and brilliant color scheme — has gradually assumed the exotic but purely superficial identity of a "Pink Cathedral."

Assumption Church of Syracuse, New York, was begun in early 1865, but the Civil War delayed its completion until 1867. Horatio Nelson White (1814-1892),

who would later plan Syracuse University's first building as well as the historic Onondaga Savings Bank, served as architect.[1] White's design was Romanesque Revival, a flexible mid-century style that permitted him to mix Italian and German elements in order to please both the Roman Catholic hierarchy and a largely German congregation that adopted "bricks at 10 cents apiece" to ensure completion. On the day of its consecration, the *Syracuse Courier and Union* proclaimed it "one of the finest [churches] in the state, and in fact, one will have to search the continent to find its equal in architectural beauty." Today, Assumption Church still operates and enjoys landmark status as the "Mother Church" of the Franciscan Order in the United States.[2]

Associate Pastor Nazarenus Graziani painted Assumption Church with its adjacent friary-courtyard and complementary Salina Street School building only five years after the latter had opened. The school's more richly textured,

Victorian Romanesque surfaces counterbalanced the larger church and offered the painter a spectacular yet unified vista. Father Graziani also painted at least one other version of this subject which, omitting details such as the two horse-drawn trolleys in the foreground, is virtually identical.[3] Indeed, it is very likely that the sale of such pictures was part of a larger campaign to satisfy construction debts and finance the then burgeoning school. (JRH)

1. Telephone conversation with William Hastings, Onondaga County Historical Association, Syracuse, New York, 7 November 1991.

2. *Fruit of the Vine and Work of Human Hands: A History of the Parish of the Assumption of the Blessed Virgin Mary* (Syracuse: 1981).

3. *Fruit of the Vine*, illustrated on p. 43, location unknown.

Nazarenus Graziani, *Church of the Assumption (The Pink Cathedral)*, 1885 (cat. no. 11)

Aerial Ferry, 1905. Photo courtesy of the Canal Park Marine Museum, Duluth, Minnesota.

Unidentified Artist, *Aerial Ferry Duluth to Minnesota Point*, 1905 (cat. no. 12)

12*
Unidentified Artist
Aerial Ferry Duluth to Minnesota Point
1905
Oil on canvas
19 ⅜ x 28 ⅛ in.
(49.2 x 71.4 cm)
Acquired from Herbert W. Hemphill Jr.,
New York, 1981
M1989.206

Space-defying steel bridges, like sky-scrapers, have long stood as emblems of American modernity. At the dedication of the seminal Brooklyn Bridge in 1833, the Rev. John Stoors was moved to announce a "new era" in which "the future of the country opens before us, as we see what skill and will can do to . . . make nature subservient to human design."[1] By 1905, the Great Lakes port city of Duluth had opened its own bridge which, despite more modest dimensions, was no less at-tuned to socioeconomic and technological advancement.

Instead of a customary fixed concrete or flexible suspension deck, the subject honored in this painting is the very first Aerial Transfer Bridge built in the United States. Modeled after a French car ferry over the Seine at Rouen, the bridge was designed to restore safe, year-round access to Minnesota Point after the Duluth Ship Canal had been cut through to Lake Superior in 1871. Transfer was achieved by two 40 horsepower motors that pulled a "gondola" back and forth along tracks mounted on an overhead truss. When completed, the bridge carried "up to 62-½ tons [of] traffic . . . took 5 cents and about 2-½ minutes to transit . . . and a round trip was made every 10 minutes when demand was heavy."[2] By 1930, that demand had grown to a point where the old "gondola" was replaced by a more efficient lift section that is still bound by the original towers and majestic head span.

A noted critic once called the Brooklyn Bridge "a work of art, a delight to the artist and poet, but equally well appre-ciated by the man in the street."[3] Judging from the three small figures posed here beneath its Midwestern counterpart, he might have just as well been speaking for this landmark and its unnamed painter. (JRH)

1. Quoted in Alan Trachtenberg, *Brooklyn Bridge: Fact and Symbol* (Chicago: University of Chicago Press, 1979), p. 125.

2. "Duluth's Aerial Bridges," US Army Corps of Engineers Fact Sheet, Detroit District, 1986.

3. Lewis Mumford, *The Brown Decades* (New York: Dover Publications, 1955), p. 105.

William A. Lo, *The Prusia*, 1908 (cat. no. 13)

13*
William A. Lo
New York, New York
The Prusia 1908
Oil on canvas
35 ¾ x 47 ⅞ in.
(90.8 x 121.6 cm)
Acquired from Herbert W. Hemphill Jr.,
New York, 1974
M1989.207

The *Prusia* undoubtedly represents the *Preussen*, one of only seven five-masted super ships built in Europe at the turn of the twentieth century. Measuring 490 feet from bow to stern and 54 feet on the beam with a displacement of over 11,000 tons, it was arguably the largest sailing vessel ever launched (1902). As flagship for the world famous Flying P-Line, so called because German owner Ferdinand Laeisz first-lettered the names of his entire fleet after beloved daughter-in-law "Pudel," the *Preussen* was specifically designed to carry valuable nitrates from Chile to Hamburg via the treacherous Straits of Magellan.[1]

The *Preussen* made only one trip to the United States. In April-May 1908 while under charter to Standard Oil Company, the ship docked in New York to accept cargo bound for Japan. That much publicized visit gave unschooled painter William Lo the opportunity to portray his nautical subject in classic folk fashion: centered on the horizon, viewed strictly from the side, and precisely rendered to illustrate its unique full-rigging and 60,000 square feet of sail. Moreover, by choosing to compress the ship's actual length a bit and wholly exposing its great masts within the close upper register of the picture, Lo devised an effective way to amplify the *Preussen*'s already colossal presence.

In retrospect, *The Prusia* remains an emblem of timely if transient power — the power of sail at its historical apex; the power of state on the brink of excess. Just two years after Lo completed his only known canvas, the *Preussen* embarked on its thirteenth voyage only to be struck by a steam-driven ferry and finally lost against the rocks beneath the Cliffs of Dover. (JRH)

1. See Kenneth Giggal, *Classic Sailing Ships* (W.W. Norton & Co., Inc., 1988), pp. 98-100.

14
H. A. Eller
War Memorial ca. 1945
Oil on canvas
27 ½ x 33 ½ in.
(69.9 x 85.1 cm)
Acquired from Roadside Antique Shop, Buffalo, New York area, 1979
M1989.208

In solemnly honoring the casualties of both World Wars, this local artist reconstituted folk tradition to create a modern "mourning picture." (JRH)

H. A. Eller, *War Memorial*, ca. 1945 (cat. no. 14)

Anna D. Celletti, *Fishing Scene*, ca. 1950 (cat. no. 15)

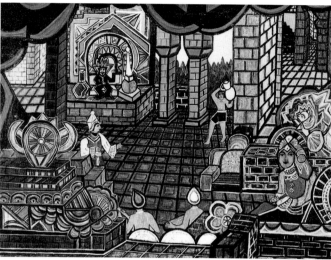

Anna D. Celletti, *Oriental Palace*, 1950 (cat. no. 16)

15
Anna D. Celletti
Brooklyn, New York
Fishing Scene ca. 1950
Oil on board
15 x 20 in.
(38.1 x 50.8 cm)
Acquired from Bruckner Antiques,
Queens, New York, 1979
M1989.219

16
Oriental Palace 1950
Oil on board
18 x 24 in.
(45.7 x 61 cm)
Acquired from Bruckner Antiques,
Queens, New York, 1979
M1989.221

Only seven paintings by Brooklyn barber Anna Celletti have been found,[1] but *Fishing Scene* and *Oriental Palace* show that her views of human leisure and recreation ranged from simple regional pastimes to ornate foreign spectacles. Perhaps these fancies afforded relief from her own demanding urban lifestyle. Such topical diversity notwithstanding, Celletti's imagery is linked by consistent use of bold contours, grid-like formal patterns, steeply planed space, and balanced design — qualities that scholar Henry Glassie deems basic to the folk artist's way of seeing:

> Natural and artificial symmetries fuse to produce the conventionalizing capacity of the artist, who reaches through the world to discover in its ornament (its birds and flowers) and in its deep order (its abstract geometries) the immanent power that is . . . represented in art. Cultures differ, topics vary, but folk art repeatedly

displays a style that favors the strong, clear colors of flowers and the strong, clear forms of geometry. It is not . . . vague. It is bright and firm.[2]

(JRH)

1. Michael and Julie Hall, interview by Julia Guernsey and Debra Brindis, 1 August 1991, transcript, Milwaukee Art Museum.

2. Henry Glassie, *The Spirit of Folk Art* (New York: Harry N. Abrams, Inc., 1989), p. 165.

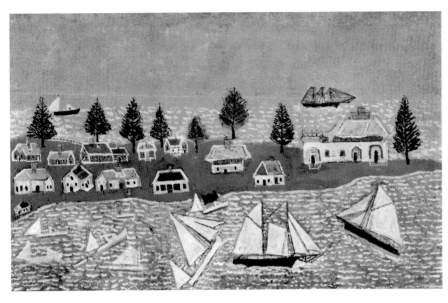

James Augustus Crane, *Dream Island*, mid-1960s (cat. no. 17)

17*
James Augustus Crane
Maine
Dream Island mid-1960s
Housepaint on cloth with paper collage
18 ⅝ x 30 ¼ in.
(47.3 x 76.8 cm)
Acquired from Bennett Bean,
Staten Island, New York, 1969
M1989.209

Mechanic-inventor James Crane began to paint late in life to help pay for the construction of a long-dreamed of "bird-motion" flying machine. He sold his pictures and a few handmade ship models from the front yard of his Ellsworth, Maine home where the fantastic but ultimately untried aircraft also took shape.[1]

Dream Island is characteristic of Crane's coastal landscapes. It is painted on bed-sheet — he otherwise used readily available scrap plywood or oil cloth — and includes a small section of paper collage. The composition divides neatly into horizontal bands of sea, land, and sky; colors are high key but local; brushwork is vigorous; and a few basic forms, many triangular, represent trees, buildings, and an assortment of sailing vessels. The steep, bird's-eye viewpoint recalls Crane's great fascination with flight.

As the title suggests, this picturesque scene is probably an imagined or composite view based on the artist's many fond memories of the area. There is, in fact, no Dream Island, Maine, much less a Sunset Hotel close by its shore; interestingly, though, there is a Dram Island not far from where Crane lived, and the village of Sunset stands on historic Deer Island just to the south. (JRH)

1. Lee Kogan, "New Museum Encyclopedia Shatters Myth," *The Clarion* 15 (Winter 1990-91), pp. 55-56.

18*
James Augustus Crane
Maine
The Titanic late 1960s
Housepaint on board
20 ½ x 37 ½ in.
(52.1 x 95.3 cm)
Acquired from Bennett Bean,
Staten Island, New York, 1970
M1989.222

Called the worst shipwreck in history, the British ocean liner *Titanic* struck an iceberg off the coast of Newfoundland on April 14, 1912, and sunk with a loss of over 1500 lives. The vessel was on its maiden voyage, and although it was the largest and most sumptuous boat ever built, the disaster was blamed on poor seamanship as the crew raced to reach New York ahead of schedule.

James Crane was in his mid-thirties when the *Titanic* went down, but public anguish must have recalled a far more personal tragedy, for at fourteen he had lost his own father in an accident at sea. Crane's portrait of the *Titanic* closely resembles another known version (Museum of American Folk Art) in composition and technique. In both, the ships move from left to right across the horizon line; four large smokestacks spew exhaust at top speed; and thick white wavy brush-strokes effectively mimic the frigid North Atlantic. However, the other version includes flags, a nameplate (collaged on the bow), and a fully visible upper deck using Crane's trademark multiple perspective, while the Hall painting leaves the same area blank, thereby indicating that this image was never quite completed. (JRH)

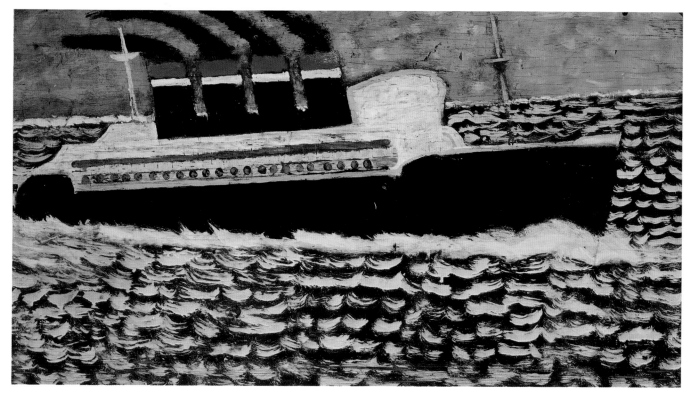

James Augustus Crane, *The Titanic*, late 1960s (cat. no. 18)

Views

Jack Savitsky, *Delaware Water Gap*, 1966 (cat. no. 19)

19*
Jack Savitsky
Pennsylvania
Delaware Water Gap 1966
Housepaint on board
8 ½ x 22 ⅞ in.
(21.6 x 58.1 cm)
Acquired from the artist, 1972
M1989.224

The Delaware Water Gap stands three miles east of East Stroudsburg, Pennsylvania, where Jack Savitsky emerged in the early 1960s as a member of Sterling Strauser's informal folk artists group which also included Victor Joseph Gatto and Justin McCarthy. The Gap itself is a dramatic 1200 foot gorge cut by the Delaware River between Mts. Minsi and Tammany along the Pennsylvania-New Jersey border. This picturesque site has long attracted self-taught as well as leading academic artists such as George Inness, who painted the subject several times between 1857 and 1891.

Delaware Water Gap is not a "textbook" Savitsky. It does not feature the coal mining towns, smoking locomotives, and dungareed characters of his own working past, nor does it include the bright commercial colors and decorative border panels that have become his trademark. Rather — and perhaps more interesting — this highly abstract, systematically rendered image reflects a folk artist's conscious distillation of a classic landscape subject and composition in the manner (if not the scale) of mainstream modernism. (JRH)

20
Mose Tolliver
Montgomery, Alabama
Bus ca. 1980
Housepaint on board
12 ⅜ x 22 in.
(31.4 x 55.9 cm)
Acquired from Estelle Friedman,
Washington, D.C., 1981
M1989.228

"Tolliver can make a painting of
a bus that seems to want to turn
into a doubleheaded snake . . ."[1]

The bus figures prominently among Mose Tolliver's subjects. Its appeal may be simply vicarious due to a foot injury that has severely reduced his mobility. For an African American who has spent most of his life in central Alabama, its emblematic significance may also derive from the historic Civil Rights struggle. Whatever the reason for this particular interest, Tolliver's buses are rendered in the same unitary fashion that characterizes his images of people and animals; indeed, what most distinguishes these vehicles is their transformation into wholly unmechanical beings, in this case replete with eyeball-like tires and a bosomy dash. Notable too are the variously repeated *T*-shapes that define the frame, seats, instruments, hood, and trunk of *Bus*. Besides the latter's apparent resemblance to popular wind-up toys, this formal device binds the composition and ultimately alludes to the first letter of the artist's last name — signed here a second time so as not to be missed. (JRH)

1. Andy Nasisse, "Aspects of Visionary Art," in *Baking in the Sun* (Lafayette: University of Southwestern Louisiana, 1987), p. 20.

Mose Tolliver, *Bus,* ca. 1980 (cat. no. 20)

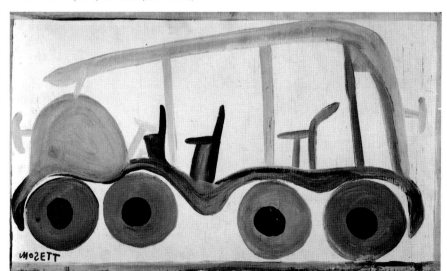

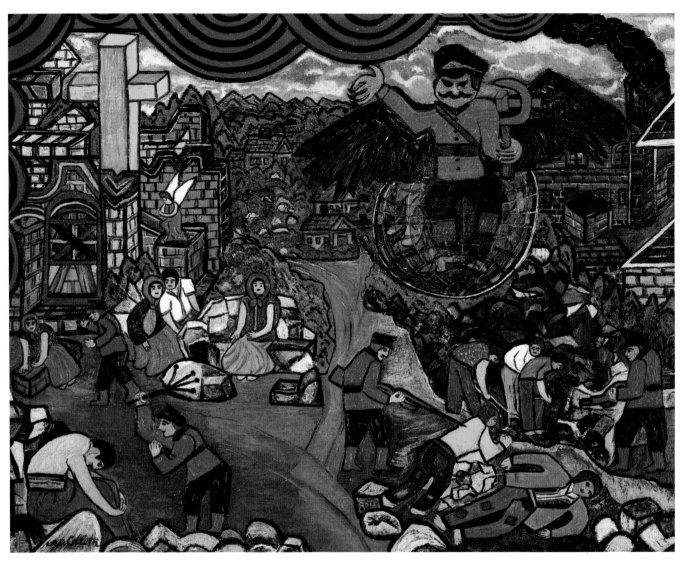

Anna D. Celletti, *Stalin as the Black Angel*, ca. 1950 (cat. no. 21)

21*
Anna D. Celletti
Brooklyn, New York
Stalin as the Black Angel ca. 1950
Oil on board
22 x 28 in.
(55.9 x 71.1 cm)
Acquired from Bruckner Antiques,
Queens, New York, 1979
M1989.220

In contrast to her scenes of human leisure (cat. nos. 15, 16), Celletti also painted more "strident" works that "question political authority . . . One depicts the evils of communism, another [portrays] the complacency of Western leaders."[1]

Stalin as the Black Angel is an unequivocal Cold War painting, completed after the Russian ruler's purge of all internal rivals and subsequent establishment of Soviet hegemony over most of Eastern Europe. That historical process is telescoped here as an oversized Stalin stands atop the globe with hammer and sickle in hand; provincial village and smoking factory lie beneath him, variously costumed citizens succumb to soldiers in the foreground, and a church on the left represents the sole but vacant alternative to his brutal power.

At a time when America's leading modernists were essentially mute on specific social and political issues, Celletti's unpretentious visual complaints were as pertinent to art as they were to life. (JRH)

1. Michael Hall, *The Ties that Bind* (Cincinnati: Contemporary Arts Center, 1986), p. 41.

Jesse Howard, *The Story of Haman and Mordecai*, ca. 1950s (cat. no. 22)

22*
Jesse Howard
Fulton, Missouri
The Story of Haman and Mordecai ca. 1950s
Housepaint and graphite on board
7 ⅞ x 62 ⅛ in.
(20 x 157.8 cm)
Acquired from Clay Morrison,
Chicago, Illinois, 1982
M1989.218

23*
Howard Finster
Pennville, Georgia
Sea Will Give Up Its Dead ca. 1977
Enamel on board
14 ⅝ x 28 ⅞ in.
(37.2 x 73.3 cm)
Acquired from Herbert W. Hemphill Jr.,
New York, 1980
M1989.229

Jesse Howard called his home in central Missouri "Sorehead Hill" and totally surrounded it with painted signs and other inscribed objects. His materials were scavenged, and his messages ranged from simple personal sentiments to stronger social commentary and morally charged biblical quotations. Although handmade, all of Howard's texts were carefully ruled, sized, and spaced, and red paint was often used alongside ordinary black and white to accent especially important passages, terms, or even punctuation marks. Arguably, his appreciation for words as both forms and ideas anticipated similar strategies advanced by a number of leading professional artists after 1960.

The Story of Haman and Mordecai is taken from the Old Testament book of Esther wherein the wicked courtier Haman tries to have innocent Mordecai and all other Jews killed. Ironically, Haman fails and is hung on the very same gallows meant for his adversary. Mordecai's ordeal and eventual vindication may have held particular appeal for Howard, who was legally threatened and repeatedly vandalized by neighbors because of his unconventional views and signage. (JRH)

Although Howard Finster possesses a distinctive pictorial style, it is the moral function of his "sermon art" that compels this former Baptist preacher and self-described "Cartoonist from God" to paint. Many of his verse-image paintings are evangelical and apocalyptic because, as he explains, "I know I was specially sent here . . . and I feel responsible for this world [which is] livin' out its Last Days . . . God sent me here to preach His Work in the Last Days."[1] In this case, favorite biblical passages from the prophetic books of Isaiah and Revelation surround the road to Final Judgement that draws even the dead from temporary graves. Moreover, elemental zones of air, earth, fire, and water intersect to effectively bind the form and text of Finster's urgent vision.

Sea Will Give Up Its Dead was probably completed shortly after Finster officially began to paint in 1976. Its purely religious theme, rough execution, unnumbered status, Hemphill provenance, and original burned-in and hand-colored "sunburst" frame indicate as much, as does its first-name signature with labor required (12 HOURS). An inscription penciled on the back of the frame also provides his

address and phone number — an early promotional device — and the weathered condition of the panel suggests that it first hung outside in Finster's eclectic *Paradise Garden*. (JRH)

1. Quoted in Tom Patterson, Howard Finster, *Stranger from Another World* (New York: Abbeville Press, 1989), p. 178.

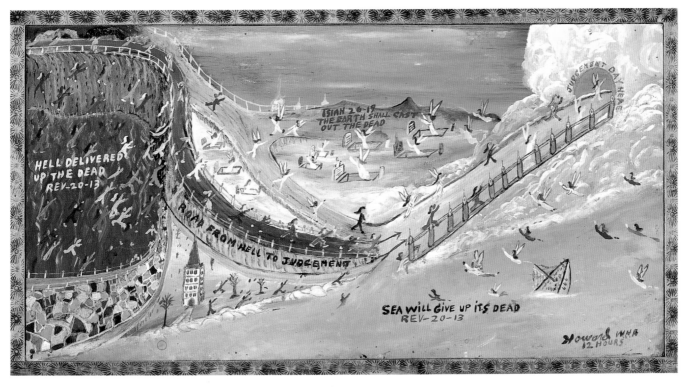

Howard Finster, *Sea Will Give Up Its Dead*, ca. 1977 (cat. no. 23)

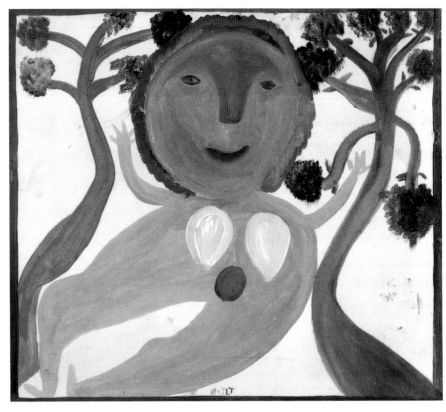

Mose Tolliver, *Eve*, ca. 1980 (cat. no. 24)

24
Mose Tolliver
Montgomery, Alabama
Eve ca. 1980
Housepaint on board
21 ⅜ x 23 ⅞ in.
(54.3 x 60.6 cm)
Acquired from Estelle Friedman,
Washington, D.C., 1981
M1989.226

25*
Figures and Birds mid-1970s
Housepaint on board
23 ¼ x 33 ⅞ in.
(59.1 x 86 cm)
Acquired from Jay Johnson, America's
Folk Heritage Gallery, New York, 1978
M1989.225

In keeping with his Southern fundamentalist upbringing, Tolliver's *Eve* is literally portrayed as the agent of original sin which is equated with sexual pleasure and symbolized by the apple that marks her genitals. *Figures and Birds* is less explicitly religious, but it too represents a primeval garden or jungle setting in which a line of small dark figures are surrounded by glossy tentacle-like tree limbs, giant blue parrots, and other supernatural forces. Despite their contrasting ethnohistorical sources, both paintings share an enchanted, diabolical quality which supports the view that "Tolliver's specters . . . inhabit a shimmering world of dark voids and luminous fields, where they dance strange ritual dances to a music that pulses with veiled eroticism."[1] (JRH)

1. Michael D. Hall, *Transmitters* (Philadelphia: Philadelphia College of Art, 1981), p. 34.

Mose Tolliver, *Figures and Birds*, mid-1970s (cat. no. 25)

26
Jim Lewis
Lansing, Michigan
Custer's Last Stand mid-1980s
Oil on canvas
30 ½ x 49 in.
(77.5 x 124.5 cm)
Acquired from Dorothy Rasche, Pontiac,
Michigan, 1984
M1989.213

27
Shoot-Out at the OK Corral mid-1980s
Oil on canvas
33 x 48 ⅛ in.
(83.8 x 122.2 cm)
Acquired from Dorothy Rasche,
Pontiac, Michigan, 1986
M1989.214

Because both of these subjects have developed into potent political and cultural icons, neither painting bears much resemblance to the actual situation that inspired it. General George Custer did not lead a single column of soldiers through a narrow valley with thousands of Sioux warriors visible above them — Custer did not even carry a sword that day; he did, however, grossly underestimate the resistance to a federal campaign to pacify the Plains Indians by confining them to reservations. (Perhaps this is why Lewis avoids the customary but truly disastrous battle scene?) Likewise, Marshall Wyatt Earp and his brothers did not save Tombstone from the Clantons in the middle of a crowded, commercial avenue with no less than seven American flags flailing behind them; rather, the fight began in an empty alley against an adobe wall with the Earps firing first, stemmed from competing economic interests, and was promptly condemned by many residents.[1] Nevertheless, both events soon assumed mythic proportions because prevailing notions of national character and progress depended on an orderly "winning" of the West. The era of Manifest Destiny is viewed far more critically today, but as these images show, the frontier "heroes" it invoked still persist in the popular imagination.[2] (JRH)

1. Bruce A. Rosenberg, *Code of the West* (Bloomington: Indiana University Press, 1982) and *Custer and the Epic of Defeat* (University Park: Pennsylvania State University Press, 1975).

2. See William H. Truettner, ed., *The West as America* (Washington, D.C.: Smithsonian Institution Press, 1991), p. 15.

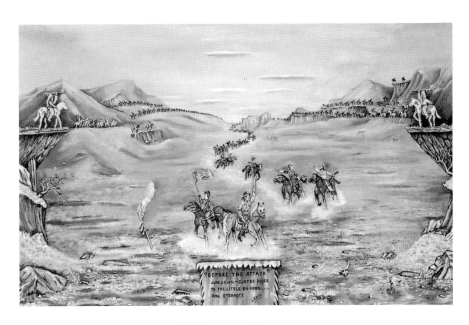

Jim Lewis, *Custer's Last Stand,* mid-1980s (cat. no. 26)

Jim Lewis, *Shoot-Out at the OK Corral,* mid-1980s (cat. no. 27)

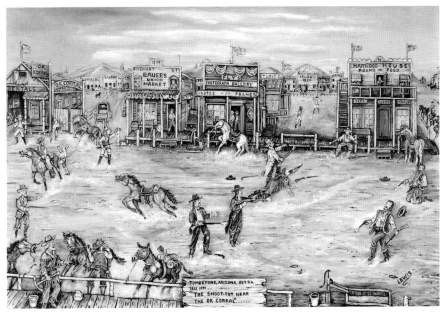

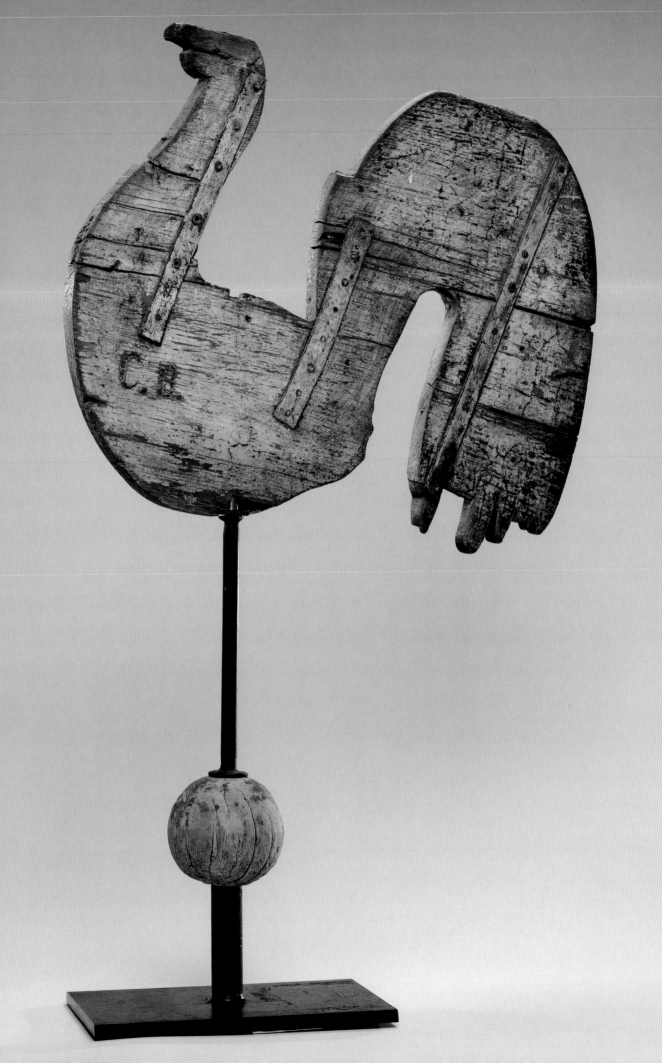

Sculpture

As Michael Hall has pointed out, "Three generations of collectors have discovered and preserved literally thousands of objects loosely labeled American folk sculpture."[1] In fact, the objects in the Hall Collection grouped under this subheading are indeed diverse and undoubtedly challenge individual definitions of what qualifies as "sculpture."

This chapter begins with objects that are utilitarian, and includes ceramics, decoys, walking sticks, objects and furnishings. Although the range of purposes they serve is great, they can be conceptually united through their basic, functional nature.

The next group of sculptural objects enters the realm of entertainment. Works like whirligigs, toys, models and gameboards were designed to amuse and provide escape from the rigors of daily existence. Others, like those found in the lodge hall section, performed a basic utilitarian role in various fraternal rituals, but were designed to capture the imaginations of participants. Perhaps most dramatically demonstrating the diversionary and recreational nature of objects in this category is Calvin and Ruby Black's *Possum Trot Midget Doll Theatre* (cat. no. 165). Created as part of an amusement park, this sculptural environment compels the definitions of folk sculpture to be further broadened.

Moving into a descriptive realm, the animals and genre figures in the collection evidence the need of individuals to recreate images from the world around them, and express universal thoughts and sentiments through their representation. Capturing images from everyday experience, as in Miles Carpenter's *Woman with Dog* (cat. no. 173), genre figures also broach more elemental concerns as in Bessie Harvey's *Pregnant Woman* (cat. no. 175).

Lastly, the sculpture section explores works that address religious and historical themes. These objects demonstrate the presence of more conceptual concerns in the creative impulse of their makers. They investigate political issues, as in Elijah Pierce's *Pearl Harbor and the African Queen* (cat. no. 199), or depict religious narratives that question the very nature of human existence, as in Edgar Tolson's *Fall of Man* (cat. no. 205) series.

Like the diversity of subject matter represented in the sculpture section, the materials and methods utilized by the artists are equally eccentric, and further defy the assignment of precise criteria for folk sculpture production. Ultimately, what one can glean from this range of material is the "common ground" of creativity that is eloquently expressed in all of the objects – and the realization, as Michael Hall has observed, that "the dialogue on folk sculpture is far from closed."[2] (JG)

1. Michael D. Hall, "Through a Collector's Eye," in *Stereoscopic Perspective* (Ann Arbor: UMI Research Press, 1988), p. 138.

2. Hall, "Through a Collector's Eye," p. 139.

Unidentified Artist, *Rooster Weathervane*, late 18th-early 19th century (cat. no. 34)

Trade Figures

The earliest American trade signs and figures derived from popular British examples which had long served as commercial beacons for consumers, many of whom were illiterate. Historian Philippe Schuwer cites one colorful instance when competing interests and similar symbols stirred great controversy in Stuart England, but "after endless wrangles, it was decided that surgeons should show copper bowls with three boxes (i.e., for ointment) and barbers should show tin bowls with the three red plaques (i.e., to indicate blood-letting).[1]

Even with increased literacy in the late nineteenth century, handmade trade emblems continued to flourish with "huge bombastic signs . . . watches three feet in diameter, and boots and hats of a giant race" obscuring much of Chicago's historic architecture.[2] Besides affording ready reference to necessary goods and services, these objects — though now largely displaced by modern electronic or mass-produced alternatives — still attract customers with striking designs and resourceful construction that transcends mere utility. (JRH)

1. Philippe Schuwer, *History of Advertising* (London: Leisure Arts Limited, 1966), p. 18.

2. Walter A. Wyckoff, "The Workers," in *The Land of Contrasts 1880-1901*, ed. Neil Harris (New York: George Braziller, 1970), p.105.

28*
Unidentified Artist
Maine
Deer ca. 1880
Carved and painted wood, nails and glue
37 x 9 x 35 in.
(94 x 22.9 x 88.9 cm)
Acquired from Robert Bishop, Inkster, Michigan, 1971
M1989.144

From a Maine hunting lodge,[1] this lithesome deer's worn coat of paint suggests years of exposure to the elements, probably as a commercial sign or ornament. The deer is constructed entirely of wood with mortise and tenon joints, while the carving conveys a fine sense of musculature and movement. Deeply incised sockets probably once held glass eyes which would have further enhanced its life-like quality. (JG)

1. Purchased along the East Coast, Robert Bishop asserted that this *Deer* came from a Maine hunting lodge.

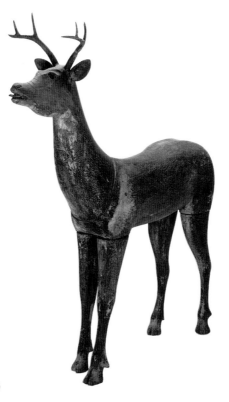

Unidentified Artist, *Deer*, ca. 1880 (cat. no. 28)

29*
Unidentified Artist
New England
Horse ca. 1880
Carved and assembled wood, painted canvas, glue, leather, glass eyes, horsehair tail, board, metal pole and studs
51 x 16 ¼ x 50 in.
(129.5 x 41.3 x 127 cm)
Acquired from Timothy and Pamela Hill, South Lyon, Michigan, 1978
M1989.146

A leather saddle, martingale and bridle are attached to this horse with a series of metal studs. Beneath, a finely applied layer of canvas stretches across its body which is carved and assembled with mortise and tenon joints. Painted in part to look like a saddle blanket, the canvas layer protected the joints while also cleverly concealing them. The horse's appearance and supporting pole at first suggest a carousel figure. However, the fine layer of canvas could not have withstood the constant mounting and dismounting of children. Furthermore, caster markings underneath its supporting baseboard suggest that the horse was probably a trade sign, pulled in and out of a saddle or livery shop each day. As nineteenth-century carousel figures were made by unemployed shipcarvers or specialty shops that manufactured trade figures, this horse may represent such a hybrid design. Its canvas-covered surface may also be related to the tradition of leather- or hide-covered hobby horses like the one pictured in Joseph Whiting Stock's *Boy with a Toy Horse* (1840s, New York Historical Society).[1] (JG)

1. Telephone conversation with Timothy Hill, Birmingham, Michigan, 17 December 1991.

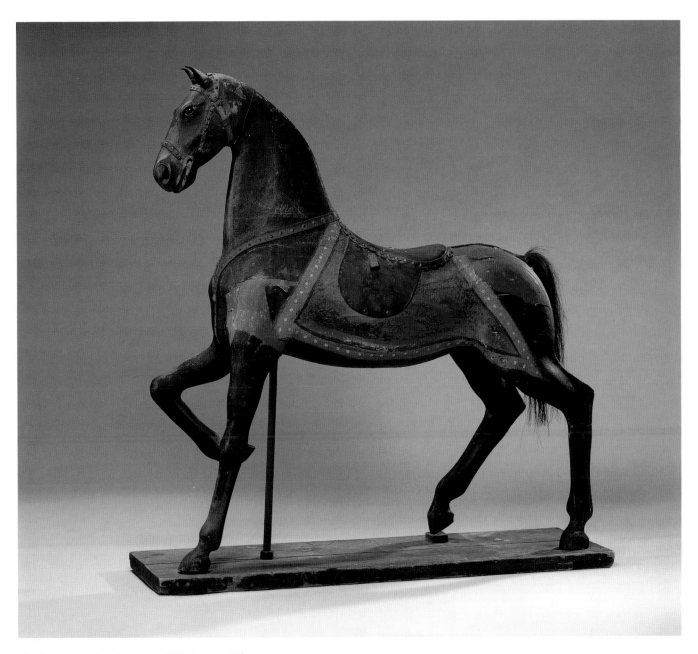

Unidentified Artist, *Horse*, ca. 1880 (cat. no. 29)

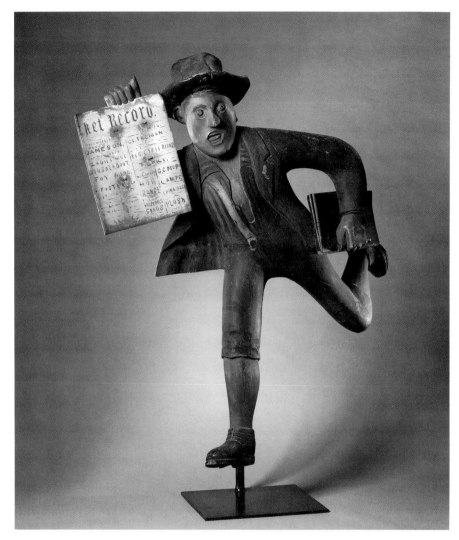

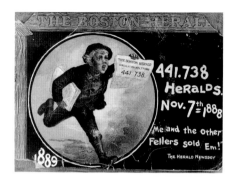

Invitation to news carriers banquet
sponsored by *The Boston Herald*, 1889.
Photo courtesy of Gary Stass, New York

Unidentified Artist, *The Newsboy*, 1888 (cat. no. 30)

30*
Unidentified Artist
Pawtucket, Rhode Island
The Newsboy 1888
Carved, assembled and painted wood
with folded tin
42 x 30 x 11 in.
(106.7 x 76.2 x 27.9 cm)
Acquired from David Pottinger,
Maze Pottinger Antiques,
Bloomfield Hills, Michigan, 1975
M1989.125

As sculpture, *The Newsboy* has been justly praised for its "intense portrayal of movement, itself rare in folk art" and for the "grace notes . . . added to his bold all-over structure, as in the staccato emphasis on the boy's fingers holding the paper up, the striped pattern of his shirt, the surprising dotted lining of his jacket, and the stylized newsprint."[1] Less often acknowledged, however, is the fact that this striding image of a boy with floppy hat and knickers, wide open mouth, and upraised arm hawking the latest edition was not unique, but graced the mastheads, publicity, correspondence, and in *The Newsboy*'s case, even the office façades of many nineteenth- and early twentieth-century newspapers.[2]

Following the recession of 1882-1885, newspapers along with the rest of the U.S. economy prospered due to ongoing urban population growth, increased wages and capital investment, and technological progress in crucial areas such as paper production and printing equipment. The newly founded *Pawtucket Record*, published between June 1886 and December 1890 by H.H. Sheldon for a circulation of 5,000 readers,[3] reflected that boom. Judging from replicas of its 13 November 1888 issue carried by *The Newsboy*, its four page format, single line headings, and sober display with some double columns but little illustration typified the practice of many mid-sized "town weeklies." Equally typical (if more surprising today) was the *Record*'s front page emphasis on commercial goods — Dongola boots, Hub ranges, Red Cross Brand butter, G. C. Peck's 5 & 10 — rather than "hard" news, a priority that simply echoed most publishers' relish for spiraling advertising revenues, which doubled during the 1870s and totaled more than $70 million by 1890.[4]

As a carved figure, *The Newsboy*'s physical detail and athleticism stands in marked contrast to the idealized, often sentimental representations of children by academic artists of the same period. Rather than connoting escape from the rigors of late nineteenth-century business and industry, he personifies an era in which child labor was commonplace and many juveniles worked for long hours and little pay as bootblacks, match sellers, or street vendors rather than go to school. He also recalls the rags-to-riches dream made plausible by Horatio Alger's popular stories of youthful enterprise. Newsboys were, in fact, lowly but vital cogs in the profitable operation of newspaper companies, which sponsored "little merchant" programs and organized clubs, bands, lodging halls, banquets, and recreational activities to maintain their allegiance. Nevertheless, by the turn of the century, labor reforms had been enacted which steadily reduced these practices and ensured the demise of the legendary "newsie."[5] (JRH)

1. Emily Genauer, "The Satisfaction of Folk Art," *New Haven Register*, 15 March 1976; see also Jean Lipman et al., *Five Star Folk Art* (New York: Museum of American Folk Art, 1990), pp. 114-5.

2. See brochure for "The American Journalist," A Library of Congress Exhibition (Washington, D.C.: April-August 1990) and Newsboy Banquet Invitation Card (*The Boston Herald*, 1889) in Milwaukee Art Museum files.

3. Christopher M. Campbell, Curator, Rhode Island Historical Society, letter to Michael and Julie Hall, 10 March 1977.

4. Frank L. Mott, *American Journalism 1690-1950* (New York: Macmillan Publishing Company, 1950), p. 503.

5. Alfred M. Lee, *The Daily Newspaper in America* (New York: Macmillan Publishing Company, 1937), pp. 287-300.

31*
Unidentified Artist
Michigan
Man Rushing ca. 1920s
Molded, welded, and painted sheet metal
33 ½ x 25 ¾ x 8 ⅝ in.
(85.1 x 65.4 x 22 cm)
Acquired from Tom Dalach, Ann Arbor,
Michigan, 1986
M1989.128

Despite the increasingly sophisticated sales technology of the twentieth century, trade figures endure as readily identifiable commercial logos and lures. Substantial rust and two small bracket holes through the coattails of *Man Rushing* indicate that this figure was once mounted outdoors, while its welded metal construction and sleek "deco" contours suggest an early modern origin, probably as a nightclub or restaurant sign. One historian makes apt reference to J. C. Leyendecker's elegant Arrow Shirt Man — whose tux, hairstyle, and upturned nose are all shared by *Man Rushing* — in describing the highbrow advertising spirit of that age:

> The tableaux of the 1920s and
> early 1930s associated all other
> pleasures with an explicit "class"
> setting. [These] ads portrayed
> people having fun at restaurants,
> ballrooms, nightclubs, and dinner
> parties . . . among the proper
> people, and appropriately defined
> as "belonging" by their attire . . .
> The "good life" in these tableaux
> was a life lived in evening clothes.[1]

(JRH)

1. Roland Marchand, *Advertising the American Dream* (Berkeley: University of California Press, 1985), pp. 200-1.

Unidentified Artist, *Man Rushing*, ca. 1920s (cat. no. 31)

32*
Unidentified Artist
Cincinnati, Ohio
Fred ca. 1974
Galvanized steel duct parts with fabric
details
55 x 67 x 34 in.
(139.7 x 170.2 x 86.4 cm)
Acquired from Laura Townsend, Antique
Market, Ann Arbor, Michigan, 1988
M1989.130

Unidentified Artist, *Fred*, ca. 1974 (cat. no. 32)

Bruno Podlinsek, *The Greeter*, ca. 1982 (cat. no. 33)

Bruno Poldinsek's *The Greeter* atop Duquet & Sons Heating Company, Highland, Michigan, 1987. Photo by Michael Hall

33*
Bruno Podlinsek
Highland, Michigan
The Greeter ca. 1982
Galvanized steel duct parts
67 x 33 x 18 in.
(170.2 x 83.8 x 45.7 cm)
Acquired from the artist, 1987
M1989.129

"Once I had brains, and a heart also; so, having tried them both, I should much rather have a heart." — Tin Woodsman, *The Wizard of Oz* (1900)

Tin men, today usually composed of galvanized (zinc-coated) steel, endure as one of the most conspicuous forms of modern trade signage. Their use as commercial emblems by tinsmiths, roofers, and other metal craftsmen dates from the early twentieth century, although now these figures are more often made and displayed by heating and air conditioning companies.

The two examples in the Hall Collection demonstrate the rich range of formal possibilities inherent in this kind of assemblage. *The Greeter* shows a matte finish, cylindrical body, upright stance, and is designed to pose against a wall. Conversely, *Fred* consists primarily of heavier 30 gauge sheet metal and has a shiny surface, rectangular torso, implied mobility, and is meant to be seen in the round. Despite these distinctions, a notable stylistic kinship is found in these and other post-Sputnik era tin men who reflect broad popular interest in science fiction, space suits, robotics, and high technology:

More recent tin men evoke the reality rather than the fantasy of outer space. The Mercury astronauts made their way into orbit and returned home quite human. Their travels [took] them far into a new world . . . where men and machines work as one. In the '70s the appearance of astronaut tin men signalled once again that tradesmen in metal shops draw heavily on their culture

for the imagery they incorporate into their artistic work.[1]

Beyond their stylistic relationship, this pair of trade figures also represents profoundly different modes of production that frame recent debate over the continued significance of individual authorship, handcraft, and originality in art. *The Greeter* was fashioned spontaneously by Duquet and Sons employee Bruno Podlinsek, who explained: "I was just fooling around in the shop one day and started putting various parts . . . together. I thought to myself, 'that kinda looks like a man,' so I finished it up and took it out and fastened it to the front of the building."[2] Moreover, by endowing *The Greeter* with traced and cut silhouettes of his own hands, Podlinsek "signed" his invention and reinforced its uniqueness. *Fred*, by contrast, was among the first of many "Mr. Seal-Tites" created by The Williamson Company, a major ductwork manufacturer for regular customers such as Harding Heating and Cooling of Troy, Ohio. An array of unnamed workers contributed to his assembly, and except for the bow tie and patch added later by Harding staff, he consists entirely of Titekote, Metalbestos, and other factory-made, prefinished parts such as the "latest flexible elbow unit" that serves as his arm.[3] Although conceived as a practical "inventory display" piece, *Fred* — as much as *The Greeter* or innumerable other metal figures made by plumbers, welders, and related tradesmen — attests to a purer creative impulse that still drives skilled workers at every level of American material culture. (JRH)

1. Michael D. Hall, "This Side of Oz: A Heart for the Tin Man," *Metalsmith* 8, no. 2 (Spring 1988), p. 25.

2. Quoted in Hall, "This Side of Oz," pp. 25-26.

3. Telephone conversation with Brian Cowdrey, Production Manager, Seal-Tite Corporation, Hillsboro, Ohio, 14 January 1992.

Weathervanes

Because they require strong design and meaningful imagery, weathervanes have been called "the first significant form of American sculpture."[1] Their capacity to indicate weather conditions, so crucial to early farming and seafaring industries, made weathervanes an essential part of national settlement. Examples in the Hall Collection reflect those beginnings on several levels: all are unique, handhewn objects rather than increasingly prevalent factory products of the later nineteenth century; basic wood or sheet iron construction represent readily available, commonly employed materials; and subjects such as the rooster, fish, Indian, and banner were clearly favored by the original makers of American weathervanes. (JRH)

1. Robert Bishop, *American Folk Sculpture* (New York: E. P. Dutton, 1974), p. 45.

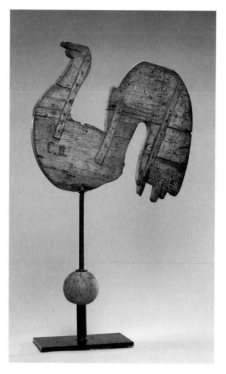

Unidentified Artist, *Rooster Weathervane*, late 18th-early 19th century (cat. no. 34)

34*
Unidentified Artist
New England
Rooster Weathervane
late 18th - early 19th century
Carved and painted wood (with metal strips added later)
34 ½ x 25 ½ x 1 in. (87.6 x 64.8 x 2.5 cm)
Acquired from Gerald Kornblau, American Folk Art, New York, 1970
M1989.172

The rooster is arguably the oldest and most popular motif found on American weathervanes. The first documented "weathercock" was brought from Holland for the Dutch Reformed Church of Albany, New York, in 1656, and Colonial artist Shem Drowne crafted another historical version in copper for Boston's New Brick Church in 1721.[1] Understandably, few eighteenth-century examples in wood survive, but in this case the legless silhouette form, carved board construction, multiple layers of paint, deeply weathered edges, and resemblance to other early specimens (Shelburne Museum) make such dating very probable.

Formal, functional, and conceptual interests coalesce in the *Rooster Weathervane*. Its recumbent S shape makes a spare but harmonious impression of solid and void, openness and closure, ascent and descent — qualities which recall Picasso's comment that "cocks have always been seen, but never as well as in American weathervanes."[2] Those features also serve the vane's practical purpose as a conspicuous directional and balanced windfoil. Moreover, the rooster's impact as a secular sign of diligence and productivity, as well as a spiritual call for steadfast faith in contrast to Peter's denial of Christ (Luke 22:34), made this symbol especially appealing to many hardworking, devout Americans.[3] (JRH)

1. Jean Lipman, *American Folk Art in Wood, Metal and Stone* (New York: Dover Publications, 1972), p. 49.

2. Alfred H. Barr, *Picasso: Fifty Years of His Art* (New York: The Museum of Modern Art, 1946), p. 214.

3. Charles Klamkin, *Weather Vanes: History, Design, and Manufacture* (New York: Hawthorn Books, 1973), pp. 72-3.

35*
Unidentified Artist
Sandwich, Massachusetts
Banner Weathervane
mid-19th century
Copper and lead with gold leaf
14 ¾ x 48 ½ x 1 ¾ in.
(37.5 x 123.2 x 4.5 cm)
Acquired from Hill Gallery,
Birmingham, Michigan, 1981
M1989.174

The Old English word *fane* referred to cloth banners which medieval nobles carried on horseback or mounted above their castles to signify their rank. Eventually those banners were produced in more durable wood or metal, and with the addition of swivels by the fourteenth century, they found further utility as wind signs.[1] Sir Christopher Wren's preference for banner-style vanes on many of the churches and public buildings he created after the Great Fire of London in 1666 ensured their transmission to America where Shem Drowne made two surviving examples for Boston's Old North and Christ Church, and later designers such as Asher Benjamin, Thomas Jefferson, and Charles Bulfinch made distinctive contributions to the genre.[2]

This *Banner Weathervane*, which once graced a church in the Cape Cod area, centers around a characteristic American arrow motif. The arrow is embellished by a pair of C-scrolls flanking its tip, several S-scrolls within its strapwork shaft, and part of a radiant sun at its tail, all common classical elements that marked the banner's nonheraldic, decorative evolution here. (JRH)

1. Robert Bishop and Patricia Coblentz, *A Gallery of American Weathervanes and Whirligigs* (New York: E. P. Dutton, 1981), p. 7.

2. Charles Klamkin, *Weather Vanes: History, Design, and Manufacture* (New York: Hawthorn Books, 1973), p. 53.

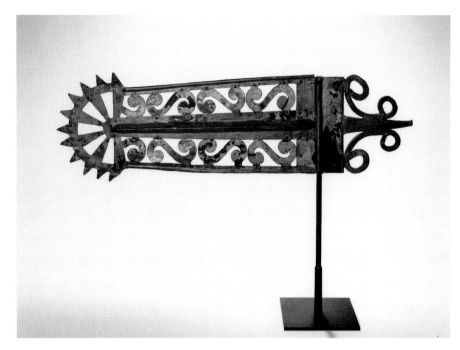

Unidentified Artist, *Banner Weathervane*, mid-19th century (cat. no. 35)

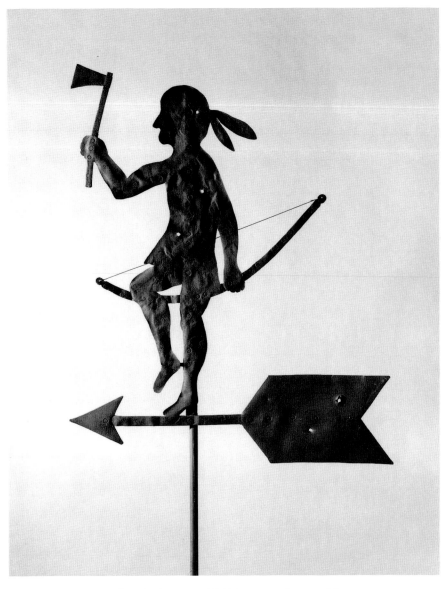

Unidentified Artist, *Indian Weathervane*, mid-19th century (cat. no. 36)

36*
Unidentified Artist
Pennsylvania
Indian Weathervane
mid-19th century
Sheet iron with forged supports
(metal bow wire added later)
40 ½ x 34 in. (102.9 x 86.4 cm)
Acquired from George Schoellkopf,
American Folk Art & Furniture,
New York, 1973
M1989.175

Tradition holds that the *versetzte* or displaced Indian motif originated in Eastern Pennsylvania where German settlers used it on weathervanes to show a desire for peaceful coexistence with their indigenous neighbors.[1] That dubious sign of respect persisted in Chief Tammany and TOTE (Totem Of The Eagle) vanes made for the Improved Order of Redmen and other nineteenth-century sociopolitical clubs whose all-white members appropriated native American imagery and ritual with little regard for its original meaning.

Like this *Indian Weathervane*, which once belonged to Pennsylvania folk art collector Charles Lamb, most early examples consist of a plain silhouette figure with short skirt and feathered headdress supported by an oversized directional arrow. Less typical, however, is the raised tomahawk and aggressive step of warrior rather than hunter – an impression ironically enhanced here with the "addition" of several bullet holes. By the late nineteenth century, interest in this subject diminished among vane makers as the frontier closed and the sportsman's gun, hound, or prey supplanted the Indian as vestigial symbol of American wilderness. (JRH)

1. Jean Lipman, *American Folk Art in Wood, Metal and Stone* (New York: Dover Publications, 1972), p. 53.

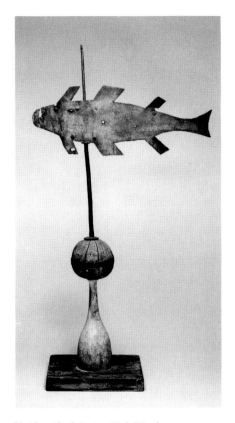

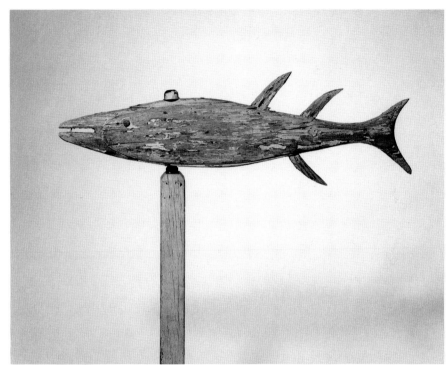

Unidentified Artist, *Fish Weathervane*, late 19th - early 20th century (cat. no. 38)

Unidentified Artist, *Fish Weathervane*, mid-19th century (cat. no. 37)

37*
Unidentified Artist
New England
Fish Weathervane mid-19th century
Sheet iron with paint traces and wood ball
with iron strap
9 ¼ x 24 ¼ in. (23.5 x 61.6 cm)
Acquired from George Schoellkopf,
Peaceable Kingdom, New York, 1970
M1989.173

38
Unidentified Artist
Fish Weathervane
late 19th - early 20th century
Carved, laminated and painted wood with
metal cap
9 ½ x 36 x 2 in. (24.1 x 91.4 x 5.1 cm)
Acquired from Frank Schmidt, Cornish,
Maine, 1978
M1989.176

Although many fish weathervanes are shaped after specific species, more generic versions such as these make excellent vanes because they too incorporate balance, wind resistance, and a strong sense of direction. For maximum performance, spindles are usually placed slightly to the front so that the heavier head area holds position while the broader body and tail section "catch" the wind.

The wood and copper-studded fish that once stood atop Paul Revere's Boston workshop is the most famous early vane of this type. Like the rooster, the fish motif enjoyed great popularity due to its symbolic versatility. On a church, its reference to Christ, St. Peter, or the ritual of baptism was widely recognized. On private or municipal buildings along the Atlantic coast, the "sacred cod" and related subjects also reflected the historic importance of fishing and other maritime industries. (JRH)

Unidentified Artist, *Bull Weathervane*, late 19th-early 20th century (cat. no. 39)

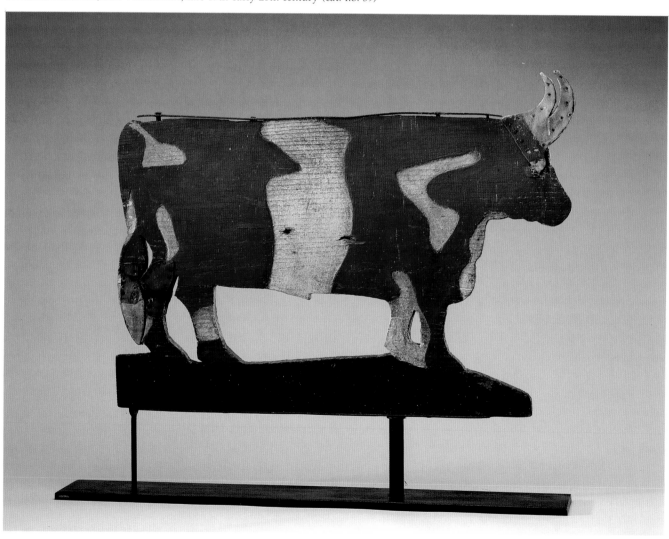

39*
Unidentified Artist
New York State
Bull Weathervane
late 19th - early 20th century
Carved and painted wood with iron strap
and zinc plates
20 ¾ x 31 ½ x 1 ¼ in.
(52.7 x 80 x 3.2 cm)
Acquired from Timothy and Pamela Hill,
South Lyon, Michigan, 1973
M1989.177

Although the vigilant rooster continued to rule many barnyards, the growing presence of cattle, sheep, and other livestock motifs on American weathervanes after 1865 reflected a shift from subsistence farming to larger and often highly specialized commercial operations. Vanes still reflected the weather, but also served as custom trade signs for a new generation of rural businessmen:

> A farm was no longer a place where the owner grew food only for his own family and raised animals to provide milk and meat for his own table. Around the middle of the century cattle were imported to America in order to develop large herds that would provide food for the urban areas of a country with a rapidly growing population Farms became factories for the production of milk and its by-products Ranching and breeding became big business, and huge barns were built to house the great herds necessary for the marketing of beef and milk products.[1]

The patterning, proportions, and distinctive backswept horns on this *Bull Weathervane* resemble the Ayrshire, a breed brought from Scotland at the turn-of-the-century and successfully used on dairies throughout the Northeast. The vane's silhouette and scale generally conform to factory-made versions of the same subject, but in this case the artist has created a unique and indelible "portrait" by carving diverse spots on both sides of the bull in shallow relief. (JRH)

1. Charles Klamkin, *Weather Vanes: History, Design, Manufacture* (New York: Hawthorn Books, 1973), p. 114.

Ducks

Decoys were developed by native Americans as early as 1000 A.D. in order to lure wildfowl, an important and abundant food source.[1] Eventually European settlers adopted this strategy, and decoys became an integral part of American hunting practices. As the use of decoys increased, their form evolved from simple stick-up varieties used along shorelines (based on Indian prototypes) to hand-carved and painted birds that floated alongside boats and rafts. Likewise, individual and factory carvers began to produce decoys of various species that met the regional needs of hunters. While ducks and geese were most popular, shorebirds were produced as well. Although most decoys attracted birds of the same species depicted, others — called "confidence" decoys — lured different birds by imparting a false sense of safety and security to them. Still others, such as the owl decoy, were used to attract their natural enemies. In both instances, confidence decoys were placed in close proximity to other decoys, creating a theater-like setting which lured flying birds within shooting range of hunters.

Fish decoys were also a native American invention. Fishing provided a reliable year-round food supply, particularly in the Upper Great Lakes region.[2] In summer fish were speared from the shore or canoes, while during winter months they were caught through holes cut in the lake ice. In both instances decoys were raised and lowered into the water in order to attract prey within spearing range. Most fish decoys found today were produced during the Depression of the 1930s when many people returned to living off the land.

Since decoys originated as utilitarian objects, originality and decoration were of importance only if they made the decoy a more effective lure. As the popularity of hunting and fishing grew in the late nineteenth and early twentieth centuries, and the nature of these activities changed from one of subsistence to that of recreational sport, carvers began to experiment with the style and decoration of their decoys. Although the potential for innovative decoration was great, function remained the principal arbiter of form, and ultimately the most prized decoys were those that synthesized aesthetic and practical interests. (DB, KM & JG)

1. See Adele Earnest, *The Art of the Decoy* (New York: Clarkson N. Potter, 1965).

2. Carol I. Mason, *Introduction to Wisconsin Indians: Prehistory to Statehood* (Salem, Wisconsin: Sheffield Publishing, 1988), p. 101.

40*
Nathan Cobb
Cobb Island, Virginia
Black Duck ca. 1870
Wood, paint, lead weight, brass screws, leather and glue
6 ½ x 5 ¼ x 15 ⅛ in.
(16.5 x 13.3 x 38.4 cm)
Acquired from Thomas Winstel, Cincinnati, Ohio, 1980
M1989.273

Although the hollow-body construction of this decoy differs from that of the Brant Goose (cat. no. 70) in this collection, both bear similar stylistic traits, such as wing and tail separation, and are attributed to Nathan Cobb. This finely crafted decoy also possesses the large incised *N* that identifies much of Cobb's work. (DB)

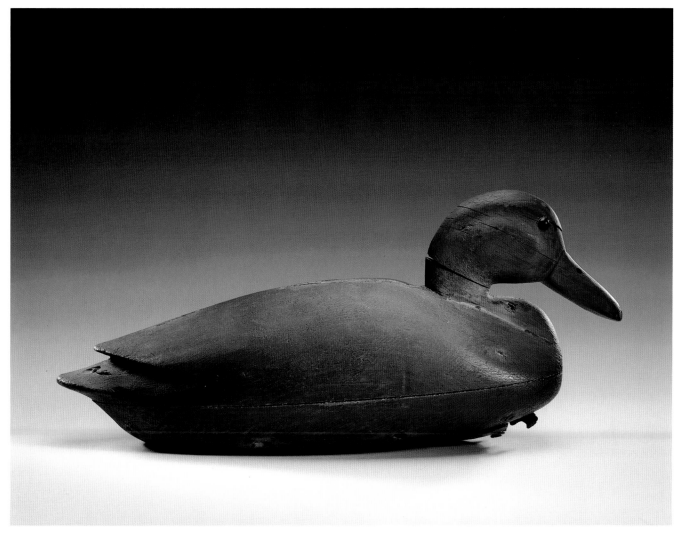

Nathan Cobb, *Black Duck*, ca. 1870 (cat. no. 40)

Ducks

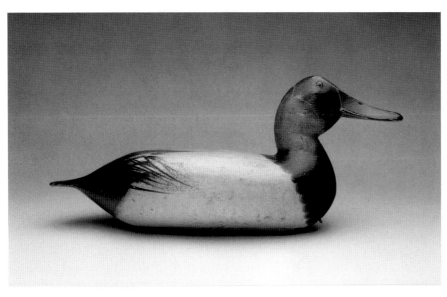

Robert A. and Catherine Elliston, *Canvasback*, ca. 1880 (cat. no. 41)

42*
Robert A. and Catherine Elliston
Bureau, Illinois
Blue Wing Teal ca. 1880
Wood, paint and glass
5 5/16 x 4 3/8 x 12 1/4 in.
(13.5 x 11.1 x 31.1 cm)
Acquired from Joe Tonelli, Spring
Valley, Illinois, 1977
M1989.271

Carved from pine, this rare *Blue Wing Teal* exhibits Robert Elliston's typical narrow-bodied, flat-back design. The paint, brushed with comblike tools to create a feathery appearance, is characteristic of Catherine Elliston's style. (GK)

41
Robert A. and Catherine Elliston
Bureau, Illinois
Canvasback ca. 1880
Wood, paint, metal, lead and glass
6 3/4 x 5 7/8 x 16 1/4 in.
(17.2 x 14.9 x 41.3 cm)
Acquired from Thomas Winstel,
Cincinnati, Ohio, 1981
M1989.270

The Illinois River, the most abundant waterfowl area in the Mississippi Flyway, has been an important food source for native Americans, European settlers, and later, Chicago's expanding population.[1] Effective decoys were eagerly sought by professional duck hunters who supplied urban markets, as well as by wealthy sportsmen who belonged to local duck hunting clubs. This demand ensured that a large number of high quality decoys would be produced in the area.

Robert Elliston has long been recognized as one of the first and finest commercial decoy carvers of the Midwest. His well crafted decoys, with their distinctively carved heads and bills, were fashioned from two pieces of hollowed white pine. Elliston's wife, Catherine, was responsible for painting and finishing the decoys. Her extraordinarily intricate feather patterns were rendered with graining combs as well as brushes. Together, Elliston and his wife established a tradition of quality emulated by many other Illinois River carvers. (DB)

1. Paul W. Parmalee and Forrest D. Loomis, *Decoys and Decoy Carvers of Illinois* (DeKalb: Northern Illinois University Press, 1969), p. 254.

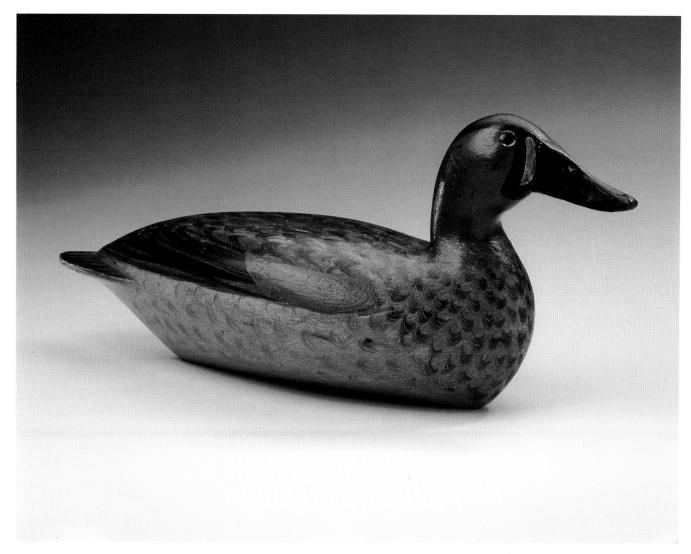

Robert A. and Catherine Elliston, *Blue Wing Teal*, ca. 1880 (cat. no. 42)

Ducks

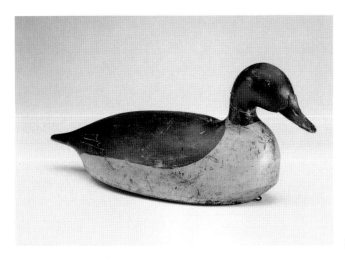

Nate Quillen, *Pintail Drake*, 1887 (cat. no. 43)

43
Nate Quillen
Rockwood, Michigan
Pintail Drake 1887
Wood, paint, lead weight, screws
and nails
6 ½ x 5 ½ x 16 ¼ in.
(16.5 x 14 x 41.3 cm)
Acquired from Richard Bourne Auction
House, Hyannis, Massachusetts, 1977
M1989.265

Nate Quillen, a professional boat
builder and cabinet maker, is well known
for his exquisitely carved decoys. His
technique of inletting — inserting the
neck into the body and securing it inter-
nally with a long screw — provided addi-
tional support for the neck. Inletting also
allowed Quillen to replace damaged
heads with a minimum of repair time.[1]
He employed this technique so skillfully
that the neck joints of his decoys are vir-
tually undetectable. Unfortunately, the
slim neck of this *Pintail Drake*, like so
many of Quillen's graceful, high-neck
style decoys, was unable to withstand
rugged use and exhibits some cracks. (DB)

1. Clune Walsh, Jr. and Lowell G. Jackson,
*Waterfowl Decoys of Michigan and the Lake St.
Clair Region* (Detroit: Gale Graphics, 1983),
p. 17.

44*
A. Elmer Crowell
East Harwich, Massachusetts
Preening Black Duck ca. 1890
Cedar, pine, metal loop, paint, nails, glass
eyes and glue
6 ⅝ x 7 x 16 in.
(16.8 x 17.8 x 40.6 cm)
Acquired from Timothy and Pamela Hill,
South Lyon, Michigan, 1981
M1989.259

This extraordinarily graceful *Preening
Black Duck* exemplifies the conflation of
utilitarian object and aesthetic excellence.
Elmer Crowell, a prolific carver with no
formal training, produced and sold his
decoys throughout the wildfowl areas of
North America.[1] He translated his inti-
mate knowledge of various eastern
Massachusetts species into strikingly effec-
tive likenesses. This decoy, shown clean-
ing its feathers, conveys a sense of leisure
and safety to ducks flying over head. Its
primary tail feathers and crossed wing
tips are characteristic of Crowell's earliest
and best work. The duck's soft, feathery
appearance was created by blending
layers of partially stiff house paint with a
dry brush. (DB)

1. Gene and Linda Kangas, *Decoys: A North
American Survey* (Spanish Fork, Utah:
Hillcrest Publications, 1983), p. 90.

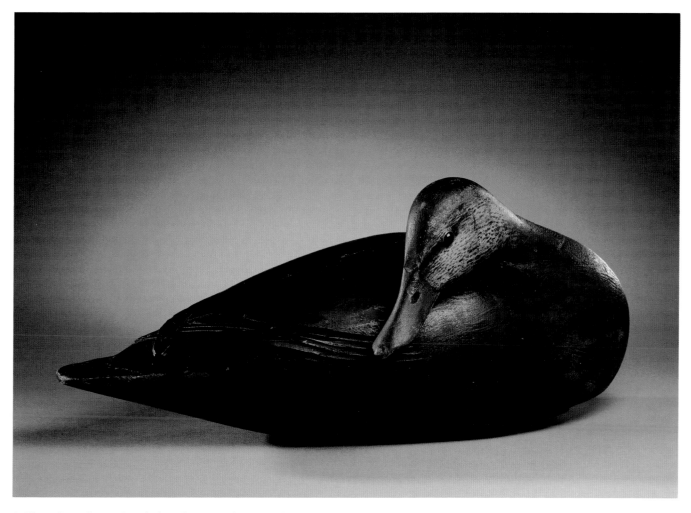

A. Elmer Crowell, *Preening Black Duck*, ca. 1890 (cat. no. 44)

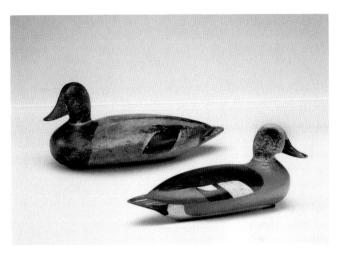

Sibley & Company, *Mallard*, ca. 1899 (cat. no. 45) and *Wigeon*, ca. 1899 (cat. no. 46)

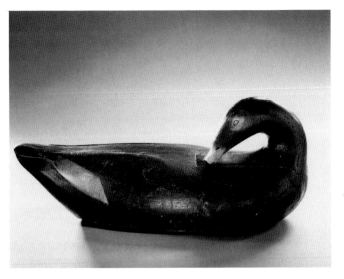

Aaron Augustus "Gus" Wilson, *Preening White Wing Scoter*, ca. 1900 (cat. no. 47).

45
Sibley & Company
Peoria, Illinois
Mallard ca. 1899
Wood and paint
6 ⅝ x 6 ½ x 13 ¾ in.
(16.8 x 16.5 x 34.9 cm)
Acquired from Joe Tonelli, Spring
Valley, Illinois, 1980
M1989.276

46
Wigeon ca. 1899
Wood, paint, metal, leather and glass
6 x 5 ½ x 12 ½ in.
(15.2 x 14 x 31.8 cm)
Acquired from Alan G. Haid,
Hamilton, Ohio, 1980
M1989.275

Attributed to "Mr. X" for years by decoy historian Joe French, the identity of the carver of these birds was recently discovered by collector Joe Tonelli.[1] Distinguished by their bills which are carved from a separate piece of hardwood, and the stamp "Patent applied for 1899" on their underside, numerous decoys by the same hand had been found along the Illinois and Mississippi Rivers. It was not until Tonelli noticed an old magazine advertisement that perfectly described these decoys that the mystery began to unravel:

> The Sibley Decoy . . . is the best hollow decoy ever put on the market . . . It is the only decoy made with a hardwood inserted bill (patent applied for) . . . All varieties cut in two above the water line, modeled and painted from specimens furnished us by the best taxidermist in Chicago, and will be found to be near the actual size, shape and coloring as can be.[2]

Further research revealed that Sibley & Company of Whitehall, Michigan, was owned by experienced waterfowlers J. A. and George M. Sibley, and operated between 1899 and 1902. The company produced most species of ducks found throughout the Illinois River Valley, including rare wigeons that few other decoy makers produced. The bodies of the decoys were machine turned on a lathe, then cut in half and hollowed. Later, the heads and hardwood bills were assembled, and the entirety hand finished.[3]
(JG & GK)

1. See Donna Tonelli, "The Sibley Decoy: The Identity Behind the Real Mr. X," *Decoys Magazine* (July/August 1991), pp. 8-13.

2. Tonelli, "The Sibley Decoy," p. 12.

3. Tonelli, "The Sibley Decoy," pp. 10-12.

47
Aaron Augustus "Gus" Wilson
Portland, Maine
Preening White Wing Scoter ca. 1900
Carved wood, paint and nails
7 x 8 ½ x 17 ½ in.
(17.8 x 21.6 x 44.5 cm)
Acquired from Frank Schmidt, Cornish,
Maine, ca. 1975
M1989.262

"Gus" Wilson was Maine's most
prolific carver between 1880 and 1940.
His decoys, found throughout the Maine-
Nova Scotia region, are distinguished by
unusually detailed bill and wing carving
and striking, life-like body positions.

This decoy's sleek body, extended tail,
and upturned chest are typical of Maine
decoys. The heavy tides and high waves
of the Atlantic Ocean, as well as the large
rivers and bays where Maine decoys were
used, necessitated heavy, flat-bottomed,
and often oversized lures. Simple,
abstracted paint patterns are also charac-
teristic of the region. Because of abrasive
salt water, most decoys were repainted an-
nually; thus few are found with their
original paint.[1]

The bird's inletted neck, another
common Maine construction technique,
increases durability and reduces neck
breakage. A precisely carved neck base is
fit into a hollowed-out area on its body
and then fastened by nails or screws. (DB)

1. Gene and Linda Kangas, *Decoys: A North
American Survey* (Spanish Fork, Utah:
Hillcrest Publications, 1983), pp. 100-101.

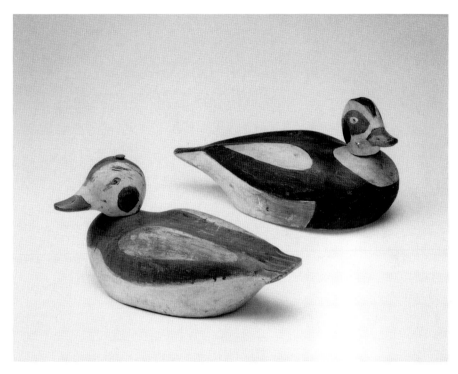

Aaron Augustus "Gus" Wilson, *Oldsquaw Drake and Hen*, ca. 1910-1915 (cat. no. 48a, b)

48a
Aaron Augustus "Gus" Wilson
Portland, Maine
Oldsquaw Drake ca. 1910-1915
Carved and painted wood and nails
6 x 5 ¾ x 13 ¼ in.
(15.2 x 14.6 x 33.7 cm)
Acquired from J. Miles, Chico,
California, 1974
M1989.261.1

48b
Oldsquaw Hen ca. 1910-1915
Carved and painted wood, nails
and lead
5 ½ x 5 ¼ x 12 in.
(14 x 13.3 x 30.5 cm)
Acquired from J. Miles, Chico,
California, 1974
M1989.261.2

The "rocking head" design of these
Oldsquaws, obtained by driving a nail
through an oversized hole in the decoy's
head, allowed the head to turn naturally
as the duck bobbed in the water. At the
outset of his career in the 1880s, Wilson's
ducks were clearly linked to a Monhegan
Island-Penobscot Bay school of decoy
carving, but by 1900 and through 1920,
his work grew more individualistic. It is
believed that his "rocking head" decoys
were carved during this second period,
although he may have been experimenting
with this novel technique for a number of
years.[1] (JG)

1. Benjamin H. Gaylord, "Gus Wilson:
Maine's Elmer Crowell," *North American
Decoys* (Winter 1975), p. 10.

Ducks

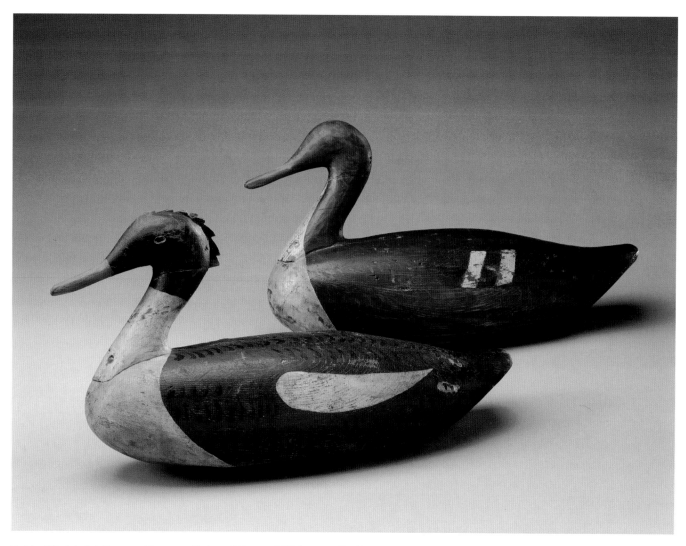

Unidentified Artist, *Common Merganser Drake and Hen*, ca. 1900 (cat. no. 49a, b)

49a*
Unidentified Artist
South Portland, Maine
Common Merganser Drake ca. 1900
Carved wood, paint, lead weight, nails
and metal loop
8 ½ x 5 ½ x 16 ¾ in.
(21.6 x 14 x 42.6 cm)
Acquired from J. Miles, Chico,
California, 1975
M1989.264.2

49b*
Common Merganser Hen ca. 1900
Carved wood, paint, lead weight, nails
and metal loop
8 ½ x 5 ½ x 17 ¼ in.
(21.6 x 14 x 43.8 cm)
Acquired from Thomas Winstel,
Cincinnati, Ohio, 1976
M1989.264.1

Contrary to popular perceptions, an
effective decoy need not exactly replicate
the species it represents. This abstract
pair of working decoys conveys the
essence of Common Mergansers through
alert, erect posture. Eyes are simple white
ovals and the detailed bills are reduced
and simplified into long, tubular projec-
tions. Paint patterns have also been
simplified. Only three Mergansers by
this unknown carver have been found;
the third is in a New England private
collection.

Quick divers and deep swimmers,
Common Mergansers are difficult targets
for hunters. Perhaps their elusive nature
contributes to the rarity of their represen-
tation by carvers. Their closest relative,
the Red-Breasted Merganser, is far more
frequently carved. (DB)

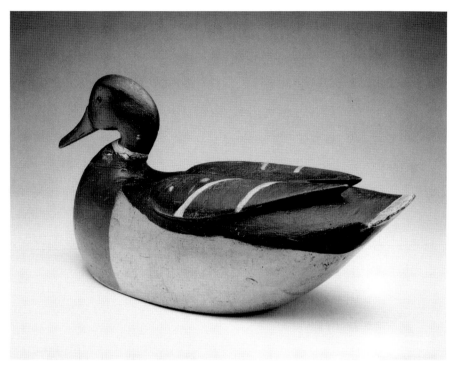

Huck Caines, *Mallard*, ca. 1900 (cat. no. 50)

50*
Huck Caines
North Island, South Carolina
Mallard ca. 1900
Wood, paint, metal and lead
9 ¼ x 6 ¾ x 18 ¼ in.
(23.5 x 17.2 x 46.4 cm)
Acquired from Dick McIntyre, Cambridge,
Maryland, 1981
M1989.266

Guide and market gunner Huck Caines
carved decoys for local use, as on the
Hobcaw Barony plantation where his
brother, Ball, was caretaker.[1] The Hobcaw
Barony plantation, which stretched from
North to South Island, was owned by
philanthropist Bernard M. Baruch and
attracted such guests as Winston Churchill
and Franklin D. Roosevelt.[2] This duck,
one of less than a dozen known Caine
Mallards, typifies his use of indigenous
gum or cypress to create an oversized
body designed to ride prominently on the
calm waters of rice fields or ponds. The
body is surmounted by a swan-like neck
and high-set, raised wings. (GK & JG)

1. Gene and Linda Kangas, *Decoys: A North
American Survey* (Spanish Fork, Utah:
Hillcrest Publications, 1983), p. 301.

2. Dan S. Young, "Those Great South
Carolina Decoys," *North American Decoys*
(Fall 1978), pp. 6-10.

Ducks

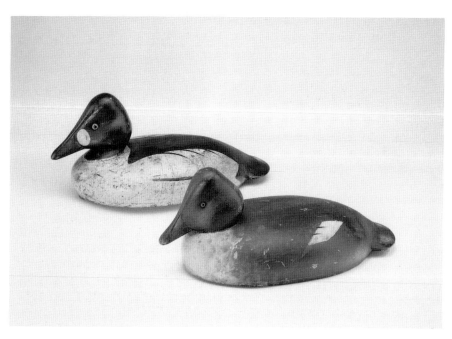

John Schweikart, *Whistler Drake and Hen*, ca. 1910 (cat. no. 51a, b)

51a*
John Schweikart
Mount Clemens, Michigan
Whistler Drake ca. 1910
Carved and painted wood, glass eyes,
nails, leather and screw
7 5/16 x 8 x 16 1/2 in.
(18.6 x 20.3 x 41.9 cm)
Acquired from Jerry Catana, Detroit,
Michigan, 1976
M1989.260.1

51b*
Whistler Hen ca. 1910
Carved and painted wood, glass eyes,
nails and leather
6 1/4 x 8 x 16 1/2 in.
(15.9 x 20.3 x 41.9 cm)
Acquired from Jerry Catana, Detroit,
Michigan, 1978
M1989.260.2

The origins of a school of decoy carving known for its large, bold designs have been traced to John Schweikart and the area around Strawberry Island in the St. Clair Flats between Michigan and Ontario.[1] These two Whistlers — with their massive, top-knotted heads; exaggerated cheeks; broad, flat bases; and hollow construction — typify Schweikart's style. Characteristically expressive, the hen exhibits a low "snuggled head" position that contrasts with the drake's quiet yet alert pose. (JG)

1. Julie Hall, "John Schweikart," *North American Decoys* Part I (1977), pp. 23-31.

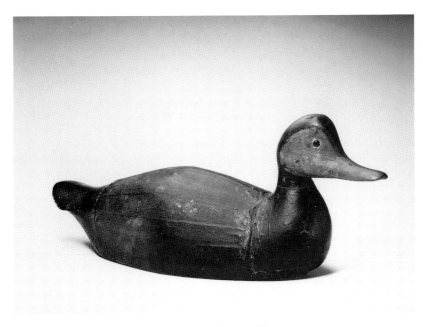

George Boyd, *Oversized Black Duck*, ca. 1910 (cat. no. 52)

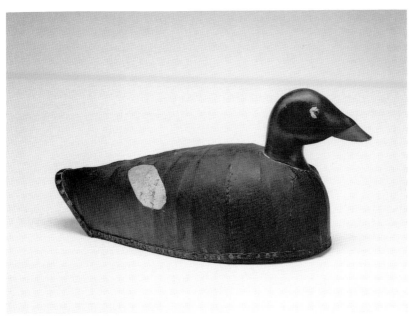

Captain Clarence Bailey, *Oversized White Wing Scoter*, ca. 1910 (cat. no. 53)

52*
George Boyd
Seabrook, New Hampshire
Oversized Black Duck ca. 1910
Wood, canvas, paint, metal, lead
and glass
8 ⅞ x 7 ½ x 23 in.
(22.5 x 19.1 x 58.4 cm)
Acquired from Winthrop L. Carter,
Portsmouth, New Hampshire, 1979
M1989.274

The dexterous and fastidious manipulation of both canvas and wood attests to Boyd's background as a shoemaker. After creating the head, chest and tail, canvas is stretched over the wooden slat body and then thickly painted. Like most Boyd decoys, the head is carved in a squared or "beetlehead" style; its slightly turned position is especially desirable among collectors. (GK)

53
Captain Clarence Bailey
Kingston, Massachusetts
Oversized White Wing Scoter ca. 1910
Carved and painted wood, wood frame,
canvas, brass tacks and nails
11 x 10 ¼ x 25 in.
(27.9 x 26 x 63.5 cm)
Acquired from William Butler,
Washington, D.C., 1982
M1989.263

Large, hardy Scoters, White wing Scoters and Surf Scoters were called "sea coots" by local hunters along the off-shore waters of Massachusetts.[1] In order to attract these birds in the rough sea, large or oversized flat-bottomed decoys with a distinct profile were needed. Accordingly, decoy carvers designed birds like this one by stretching canvas over a hollow, bent wood frame. (JG)

1. Gene and Linda Kangas, *Decoys: A North American Survey* (Spanish Fork, Utah: Hillcrest Publications, 1983), p. 88.

Ducks

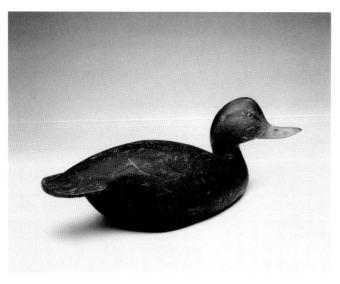

Lem and Steve Ward, *Black Duck,* ca. 1921 (cat. no. 54)

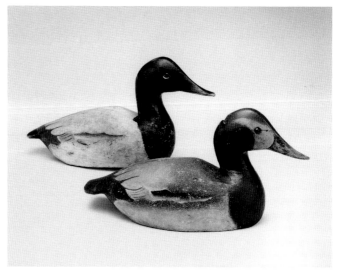

Lem and Steve Ward, *Canvasback Drake and Hen,* ca. 1932 (cat. no. 55a, b)

54
Lem and Steve Ward
Crisfield, Maryland
Black Duck ca. 1921
Wood, paint, metal and glass
6 x 6 ¼ x 16 ⅜ in.
(15.2 x 15.9 x 41.6 cm)
Acquired from George C. Channick,
Wilmington, Delaware, 1978
M1989.267

Originally carved for George Channick's gunning rig, the signature on the base of this decoy, "Lem Ward -1921-," was inscribed at Channick's request while he was visiting the Wards in Crisfield in the early 1970s.[1] Incorporated to give a more life-like appearance, the duck's glass eyes were expensive, and so the Wards chose to use them on only a few birds in each rig. (JG)

1. Hall Collection Provenance Records, Milwaukee Art Museum.

55a*
Lem and Steve Ward
Crisfield, Maryland
Canvasback Drake ca. 1932
Wood, paint, lead, metal, glass and leather
8 ¼ x 6 x 15 ⅜ in.
(21 x 15.2 x 39.1 cm)
Acquired from Pete Peterson,
Cape Charles, Virginia, 1982
M1989.268a

55b*
Canvasback Hen ca. 1932
Wood, paint, lead, metal and glass
7 ½ x 6 ⅛ x 15 ⅝ in.
(19.1 x 15.6 x 39.7 cm)
Acquired from Robert O. Coyle, Darien,
Connecticut, 1977
M1989.268b

These decoys illustrate the refined skill that brought the Ward brothers to prominence with hunters and collectors alike. Barbers who turned to full-time carving after the Depression, they created thousands of decoys of varying styles and materials. Both of these Canvasbacks exhibit a "slotback" style, or deep groove carved into the back directly behind the head, and are painted by Lem Ward in detailed and thickly textured paint.

The Wards produced most of their decoys in the 1930s before turning primarily to ornamental carving, but because they changed styles frequently and sometimes reverted to prior designs, precise dating is difficult.[1] Moreover, when hunters and collectors asked the Wards to inscribe decoys carved years earlier, the lapse in time often resulted in approximate or erroneous dates. Due to the drastic decline in Canvasbacks at mid-century which led to a 1959 hunting ban, the early 1930s date for these decoys is probable. (GK)

1. See Ronald J. Gard and Bryan J. McGrath, *The Ward Brothers' Decoys: A Collectors Guide* (Plano, Texas: Thomas B. Reel, 1989).

56
Benjamin J. Schmidt
Detroit, Michigan
Pintail ca. 1930
Carved and painted wood, plastic eyes
and lead
8 x 6 ½ x 15 ½ in.
(20.3 x 16.5 x 39.4 cm)
Acquired from Harry Seitz, Monroe,
Michigan, 1979
M1989.269

Ben Schmidt was esteemed by local
hunters for his skillful use of a hand axe.
His ability to rough out large numbers of
decoy bodies in a short period of time
allowed him to sell his lures at signifi-
cantly lower prices than other area
makers. Schmidt sold his work both
through his shop in Centerline as well as
through sporting goods stores in the
Detroit area. In addition to hunters,
carvers regularly purchased Schmidt
decoys to use as models for their own
work. (DB)

57
"Chief Cuffee"
Long Island, New York?
Wood Duck ca. 1930
Wood, paint and metal
7 x 5 ⅛ x 13 ½ in.
(17.8 x 13 x 34.5 cm)
Acquired from Steve Miller,
New York, 1981
M1989.277

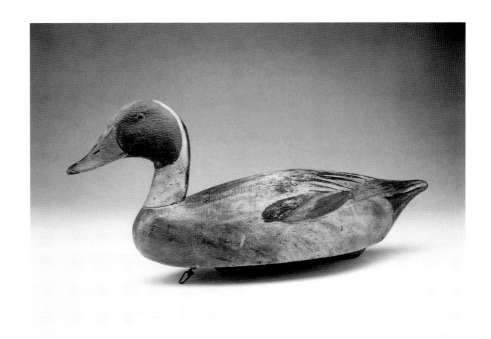

Benjamin J. Schmidt, *Pintail,* ca. 1930 (cat. no. 56)

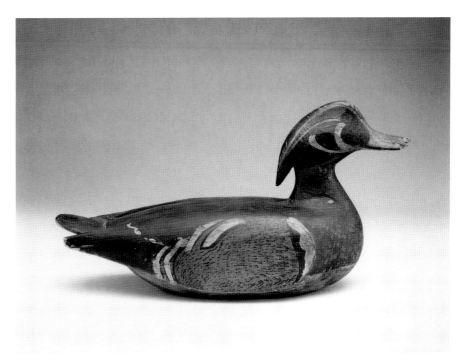

"Chief Cuffee," *Wood Duck,* ca. 1930 (cat. no. 57)

Ducks

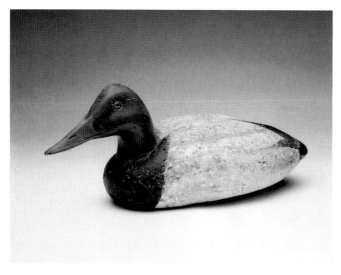

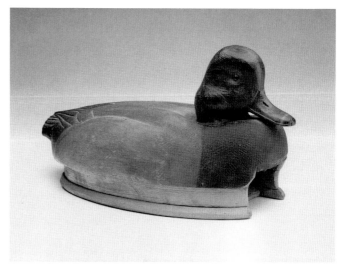

Charles "Shang" Wheeler, *Canvasback Drake*, ca. 1930 (cat. no. 58)　　　Tom Schroeder, *Redhead*, ca. 1949 (cat. no. 59)

58*
Charles "Shang" Wheeler
Stratford, Connecticut
Canvasback Drake ca. 1930
Carved and painted cork, lead and wood
6 ½ x 6 ¾ x 14 ½ in.
(16.5 x 17.2 x 36.8 cm)
Acquired from Robert O. Coyle,
Darien, Connecticut, 1978
M1989.278

From a genteel family, Wheeler was intimately connected with wildfowl environments through his interest in hunting, fishing and oystering. Later in his career, reacting to overdevelopment and uncontrolled hunting in his native Connecticut, Wheeler served terms as both a State Representative and State Senator. Following in the tradition of decoy carvers along the mouth of the Housatonic River, his most notable contribution was the introduction of a new style of naturalism that emphasized nuances of anatomy and feathering.[1] He also experimented with cork, which after the war had become cheaper and more readily available, using it for his birds' bodies

because of its natural ability to float. One of a pair, this *Canvasback Drake*'s "sleeper" hen counterpart is in the collection of Ron Swanson, Bloomfield Hills, Michigan.[2]
(JG)

1. Dixon Merkt, *Shang Wheeler and the Housatonic Decoy* (Hartford, Connecticut: Old State House, 1983), no pagination.

2. Hall Collection Provenance Records, Milwaukee Art Museum.

59
Tom Schroeder
Detroit, Michigan
Redhead ca. 1949
Wood, paint, metal and glass
6 ⅜ x 6 ¹³⁄₁₆ x 12 ¼ in.
(16.2 x 17.3 x 31.1 cm)
Acquired from Len Carnaghi,
Mount Clemens, Michigan, 1979
M1989.272

Tom Schroeder never made decoys for sale, but instead carved them for his own enjoyment and occasionally as gifts. In 1949 and 1950, he exhibited award winning examples of his work at New York's *National Decoy Contest*. After completing

his last hunting rig in 1960, he turned to creating only decorative ducks.[1] Carved in five pieces, this decoy's head and body are attached to a hollow wooden box that allows water to pass through, thereby enhancing its flotation. Known as "skirt bottom" style, this construction was developed by Schroeder as an experiment in hydro-dynamics. (GK)

1. Alan G. Haid, *Decoys of the Mississippi Flyway* (Exton, Pennsylvania: Schiffer Publishing, 1981), p. 59.

60a*
Lothrop T. Holmes
Kingston, Massachusetts
Lesser Yellowlegs ca. 1870
Carved and painted wood, tack eyes
6 x 3 ³⁄₁₆ x 12 in.
(15.2 x 8.1 x 30.5 cm)
Acquired from Timothy and Pamela Hill,
South Lyon, Michigan, 1978
M1989.286

60b*
Greater Yellowlegs ca. 1870
Carved and painted wood, tack eyes
6 ¼ x 3 ³⁄₁₆ x 12 ¼ in.
(15.9 x 8.1 x 31.1 cm)
Acquired from Timothy and Pamela Hill,
South Lyon, Michigan, 1978
M1989.285

These North American wading birds were a popular Atlantic coast game species during the late nineteenth century. As market gunning flourished during this period, the demand for decoys such as these by Lothrop Holmes increased.[1] Yellowlegs are distinguished by slight differences in height and color. Greater Yellowlegs range in height from 12-16 inches and are primarily grey, while Lesser Yellowlegs stand 10-12 inches tall and have redder tones.

Both Holmes' *Greater* and *Lesser Yellowlegs* exhibit graceful wings with calligraphic outlines, and while small bits of shot are evident in the wood along the sides of the Lesser Yellowlegs, its delicate beauty has not been diminished by the stray ammunition of avid hunters. (KM)

1. William J. Mackey Jr., *American Bird Decoys* (New York: E. P. Dutton, 1965), p. 11.

61*
Obediah Verity
Seaford, Long Island, New York
Hudsonian Curlew ca. 1875
Carved and painted wood
7 x 3 ¼ x 14 ½ in.
(17.8 x 8.3 x 36.8 cm)
Acquired from George W. Combs Jr.,
Amityville, Long Island, New York, 1981
M1989.281

This "Verity" curlew, with its plump shape and relief-carved eyes and wings, exemplifies the union of a regional style with the talents of a major Atlantic Coast carver. Because most of Obediah Verity's shorebird decoys were Plovers, this curlew is especially rare.[1]

Although the Long Island-born craftsman inscribed both his name and "Seaford" on the underside of this decoy, as many as six Obediah Veritys were listed in the Seaford village census during the late nineteenth and early twentieth centuries. While historians know very little about these Veritys, one Obediah has been identified as a lifelong bachelor and professional bayman during the late 1800s. This Obediah Verity was probably the famed carver.[2] (KM)

1. Henry A. Fleckenstein Jr., *Shorebird Decoys* (Exton, Pennsylvania: Schiffer Publishing, Ltd., 1980), p. 87.

2. Jane Townsend, *Gunner's Paradise: Wildfowling and Decoys on Long Island* (Stony Brook, New York: The Museums at Stony Brook, 1979), pp. 26, 137.

62a*
Unidentified Artist
Long Island, New York
Sentinel Long Billed Curlew ca. 1880
Carved and painted wood, bead eyes
9 ½ x 4 ⅛ x 18 ½ in.
(24.1 x 10.5 x 47 cm)
Acquired from Dr. John T. Dinan,
Portland, Maine, 1980
M1989.280b

62b*
Feeding Long Billed Curlew ca. 1880
Carved and painted wood, bead eyes
8 ½ x 4 x 19 ½ in.
(21.6 x 10.2 x 49.5 cm)
Acquired from Dr. John T. Dinan,
Portland, Maine, 1980
M1989.280a

These Long Billed Curlews are fine examples of one of the rarest species of shorebird decoys. The bodies of both the graceful Feeding Curlew and the upright Sentinel Curlew are crafted from single blocks of wood with long attached bills and black bead eyes. While the nut-brown coloring of the curlews is enhanced by a stippling of white and grey paint along the neck and back, it is the gently curving beaks and large, well-formed bodies that transform these Curlews into striking sculptural representations. (KM)

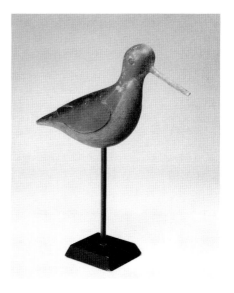

Obediah Verity, *Hudsonian Curlew*, ca. 1875
(cat. no. 61)

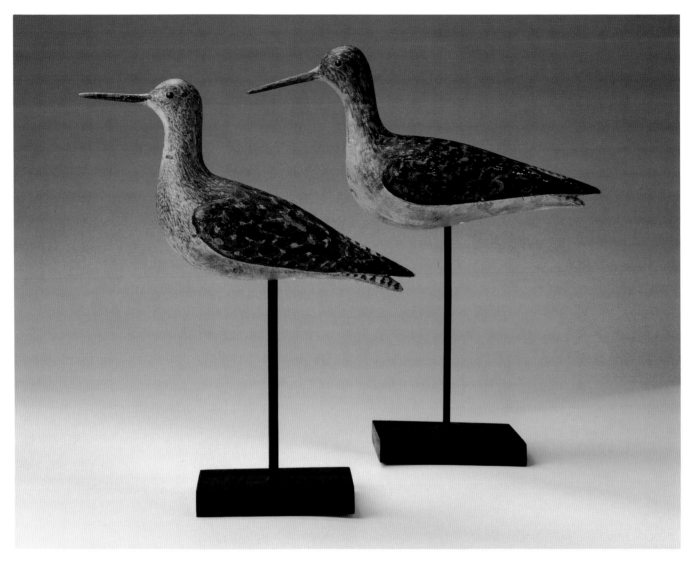

Lothrop T. Holmes, *Lesser and Greater Yellowlegs*, ca. 1870 (cat. no. 60a, b)

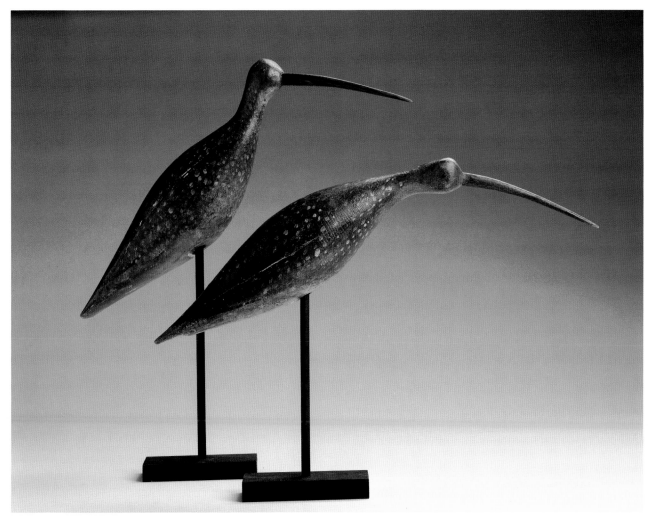

Unidentified Artist, *Sentinel and Feeding Long Billed Curlews*, ca. 1880 (cat. no. 62a, b)

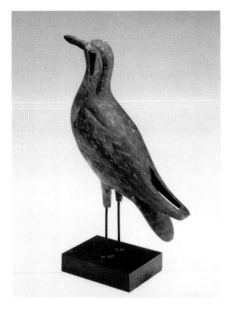

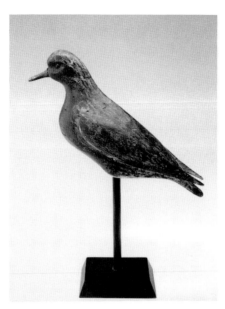

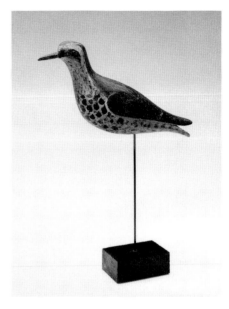

Unidentified Artist, *Golden Plover with Leg Carving,* ca. 1880 (cat. no. 63)

William Bowman, *Black-bellied Plover,* ca. 1880 (cat. no. 64)

Folger Family, *Golden Plover,* ca. 1890 (cat. no. 65)

63*
Unidentified Artist
Nantucket, Massachusetts
Golden Plover with Leg Carving ca. 1880
Carved and painted wood, wire and
bead eyes
7 x 2 ⅞ x 11 ½ in.
(17.8 x 7.3 x 29.2 cm)
Acquired from Ted Harmon,
West Barnstable, Massachusetts, 1980
M1989.283

Golden Plovers were a favorite among
decoy carvers because other varieties of
plovers also responded to them and could
be lured within shooting range. Similar in
appearance to Black-bellied Plovers, the
two can be distinguished by their seasonal
coloring: in spring, the darker Black-
bellied plover has more grey in its plum-
age, while the Golden Plover exhibits a
pale yellow-gold color.

While the curved, split tail of this
plover creates an elegant silhouette, the
copper wire woven tightly around its
short legs affords increased stability. Its
upright posture reflects the stance
frequently assumed by shorebirds in order
to brace themselves against strong winds.
According to Ted Harmon, from whom
the bird was acquired, an entire rig of this
unknown artist's birds turned up in a
basket at a girl scout rummage sale in
Massachusetts. (KM)

64*
William Bowman
Long Island, New York
Black-bellied Plover ca. 1880
Carved and painted wood, glass eyes
5 ¼ x 3 ⁹/₁₆ x 11 ½ in.
(13.3 x 9.1 x 29.2 cm)
Acquired from Charles T. Ward,
Oceanside, New York, 1982
M1989.288

Fine brushwork and meticulous carv-
ing distinguish this *Black-bellied Plover* and
demonstrate William Bowman's superior
artistic skill. Especially effective is his
combination of pale underpainting and
darker shades of black and brown to simu-
late real plumage. In addition to the
plover's uniquely carved thighs and
wings, other "signature" features include
realistic glass eyes, recessed eye sockets,
and the split tail design.[1] (KM)

1. Gene and Linda Kangas, *Decoys: A North
American Survey* (Spanish Fork, Utah:
Hillcrest Publications, 1983), p. 65.

65
Folger Family
Nantucket, Massachusetts
Golden Plover ca. 1890
Carved and painted wood, metal plug,
nails and plastic eyes
4 ½ x 2 ⅝ x 10 ¼ in.
(11.4 x 6.7 x 26 cm)
Acquired from Robyn Hardy, Slidell,
Louisiana, 1980
M1989.279

This *Golden Plover* decoy once
belonged to a rig of shorebirds that
included an Eskimo Curlew. Since the
Eskimo Curlew was extinct by the turn of
the century, an approximate date of 1890
can be confidently assigned to this decoy.
(DB)

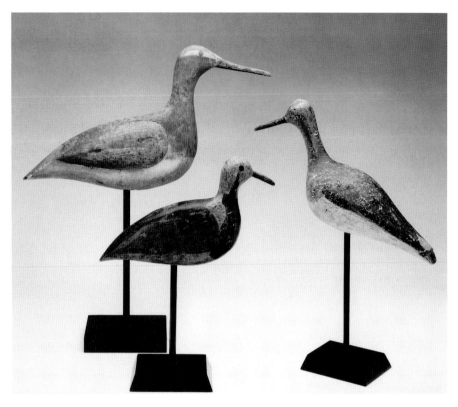

Unidentified Artists, *Marbled Godwitt*, late 19th century (cat. no. 66), *Ruddy Turnstone*, late 19th century (cat. no. 67), and *Yellowlegs*, late 19th century (cat. no. 68)

68
Unidentified Artist
Virginia
Yellowlegs late 19th century
Carved and painted wood
5 ⅜ x 3 ⁵⁄₁₆ x 11 in.
(13.7 x 8.4 x 27.9 cm)
Acquired from Adele Earnest,
Stony Point, New York, 1970
M1989.287

Like the *Great Blue Heron* (cat. no. 72), this *Yellowlegs'* beautiful, abstract silhouette exhibits modernist sensibilities. (DB)

69
Lloyd Sterling
Crisfield, Maryland
Ruddy Turnstone ca. 1930
Carved, painted and assembled wood
7 x 2 ½ x 8 ¼ in.
(17.8 x 6.4 x 21 cm)
Acquired from unknown antique dealer,
ca. 1982
M1989.289

66
Unidentified Artist
New Jersey
Marbled Godwitt late 19th century
Carved and painted wood
7 ½ x 2 ⅝ x 14 ½ in.
(19.1 x 6.7 x 36.8 cm)
Acquired from Richard A. Bourne,
Hyannis, Massachusetts, 1981
M1989.282

67
Unidentified Artist
New Jersey
Ruddy Turnstone ca. 1890
Carved and painted wood
5 ⅜ x 7 ½ x 8 ¾ in.
(13.7 x 19.1 x 22.2 cm)
Acquired from antique dealer, 1982
M1989.284

Lloyd Sterling, *Ruddy Turnstone*, ca. 1930
(cat. no. 69)

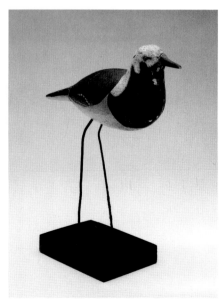

70*
Nathan Cobb
Cobb Island, Virginia
Brant Goose ca. 1870
Carved and painted wood, lead and glass
9 ¾ x 6 ¾ x 19 in.
(24.8 x 17.2 x 48.3 cm)
Acquired from Richard A. Bourne,
Hyannis, Massachusetts, 1976
M1989.290

"Doubtless many of your
readers are now casting about them
for a pleasant summer trip, and are
anxious to find a place where good
fishing and shooting can be had . . .
I have just returned from such a
place — Cobb's Island — and have
had most excellent sport. On
Friday last, with a friend, we shot
over stools eighty Grayback Snipe,
and would have killed more had
we been in practice. This bird is
now returning from the north, and
within a week or ten days myriads
of them will be found at the island
mentioned."
-Forest and Stream, 26 July 1883

This *Brant Goose* was probably made
for a private gunning club on Cobb
Island, Virginia. Many such clubs and
resorts developed in the late nineteenth
century as hunting became an increas-
ingly popular leisure sport. The Cobb
family, residents of the island and pur-
ported owners of the club and Cobb
Island Hotel, carved decoys for their
market gunning and guiding businesses.
The island resort prospered until 1896
when a violent hurricane destroyed most
of the buildings.[1]

This decoy, although lacking the
incised "*N*" found on many of his carv-
ings, is attributed to Nathan Cobb. Its
solid body construction suggests an early
period, perhaps predating his initialing
practice. It has the pronounced tail and
wing separation, inletted neck, and
splined oak bill characteristic of other
Cobb decoys.

Due to the strategic placement of its
lead weight, this decoy leans forward in
the water with its bill skimming the
surface in a feeding position. Because of
the heightened sense of reality such a
decoy lends to a grouping, some experts
categorize feeding, sleeping or preening
decoys as confidence decoys.[2] (DB)

1. Bernard Herman and David Orr, "Decoys
and Their Use; A Cultural Interpretation,"
Philadelphia Wildfowl Exposition (Philadelphia:
The Academy of Natural Sciences of Philadel-
phia, 1979), p. 24.

2. David S. Webster and William Kehoe,
Decoys at Shelburne Museum (Shelburne,
Vermont: Shelburne Museum, 1961), p. 101.

Nathan Cobb, *Brant Goose*, ca. 1870 (cat. no. 70)

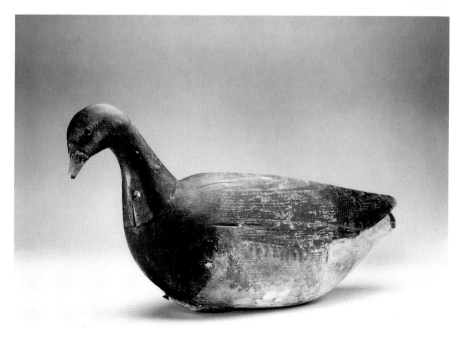

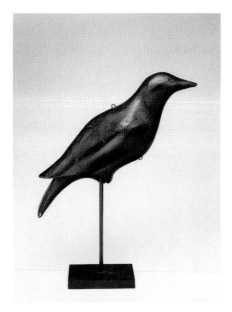

William Bowman, *Crow*, ca. 1875 (cat. no. 71)

71*
William Bowman
Long Island, New York
Crow ca. 1875
Carved and painted balsa wood, brass
5 ½ x 18 ½ x 5 in.
(14 x 47 x 12.7 cm)
Acquired from Charles T. Ward,
Oceanside, New York, 1980
M1989.299

Crow decoys are rare among Bill Bowman's carvings, even though they have long been a popular hunting target for farmers and sportsmen. Farmers, mistakenly believing that crows were crop destroyers, considered them pests. Sportsmen, however, valued them for their meat which is similar in taste to other wild fowl. This *Crow*, like Bowman's *Black-bellied Plover* (cat. no. 64), displays the carved thighs characteristic of Bowman's style. (DB)

72*
Unidentified Artist
New Jersey
Great Blue Heron ca. 1900
Carved and painted wood, metal
50 x 5 ½ x 36 ½ in.
(127 x 14 x 92.7 cm)
Acquired from John Hegarty,
Chincoteague, Virginia, 1977
M1989.297

In New Jersey and Long Island at the turn of the century, herons were hunted for their meat as well as for their plumage. In both instances, heron decoys were used in the same manner as duck decoys.[1] More frequently, however, carved herons functioned as confidence decoys.

This *Great Blue Heron* is one of a pair carved by an unknown New Jersey maker. Its normal body position has been inverted to mimic the natural movement of a heron reaching for its food. Its head and neck are formed from a tree root. Each of these rather simple forms combines to produce a thoroughly graceful aesthetic effect. (DB)

1. Paul A. Johnsgard, *The Bird Decoy: An American Art Form* (Lincoln: University of Nebraska, 1976), p. 175.

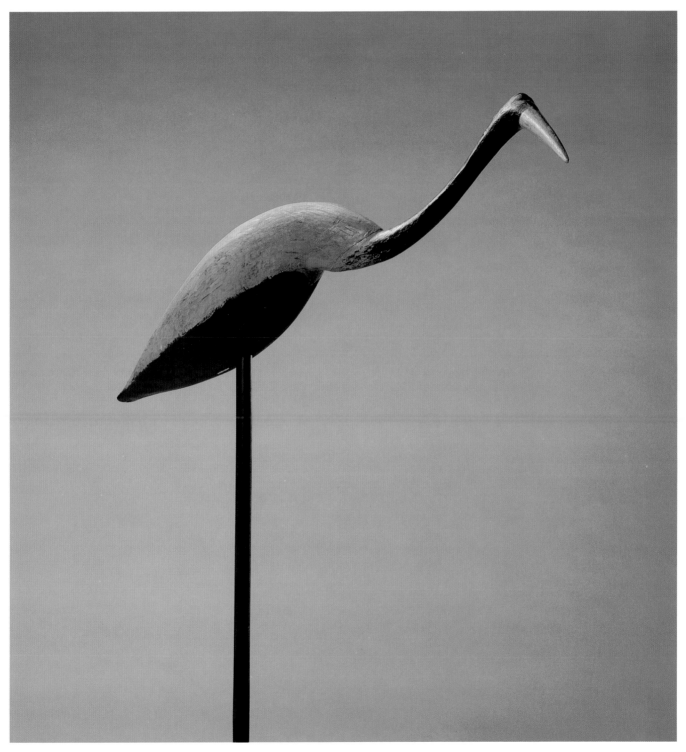

Unidentified Artist, *Great Blue Heron*, ca. 1900 (cat. no. 72)

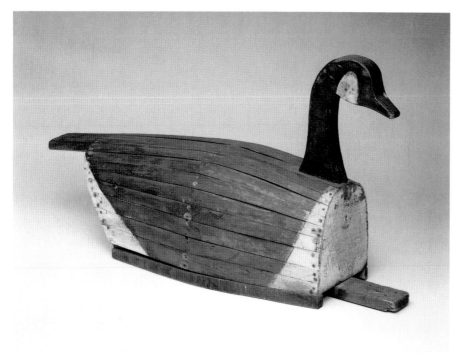

Unidentified Artist, *"Quarter-Miler" Slat Goose*, ca. 1900 (cat. no. 73)

Ira Hudson, *Canada Goose*, ca. 1920 (cat. no. 74)

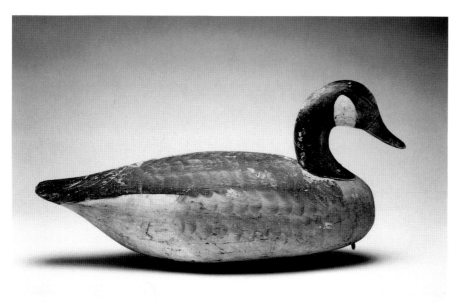

73
Unidentified Artist
Massachusetts
"Quarter-Miler" Slat Goose ca. 1900
Carved and painted wood
19 ¼ x 13 ¼ x 39 ½ in.
(48.9 x 33.7 x 100.3 cm)
Acquired from Ronald Swanson,
Bloomfield Hills, Michigan, 1987
M1989.295

74*
Ira Hudson
Chincoteague, Virginia
Canada Goose ca. 1920
Carved and painted wood, metal and lead
10 ½ x 8 ¼ x 22 ¼ in.
(26.7 x 21 x 56.5 cm)
Acquired from Winthrop Carter,
Portsmouth, New Hampshire, 1979
M1989.292

During his career as a professional carver, Hudson is believed to have carved more than 25,000 decoys. Averse to duplicating the same image, Hudson constantly altered the construction, design, posture, and paint pattern of his decoys. Consequently, they are often difficult to identify and nearly impossible to date.

This *Canada Goose* has an inletted neck, tack eyes, and a funnel-shaped groove on its back behind the neck joint. These characteristics are unique to decoys carved by Hudson after a brief stay in New Jersey and reflect the influence of Northeastern carvers.[1] The "feeder" mate to this decoy is in the Harmon Collection, West Barnstable, Massachusetts.[2] (DB)

1. Bernard Herman and David Orr, "Decoys and Their Use; A Cultural Interpretation," *Philadelphia Wildfowl Exposition* (Philadelphia: The Academy of Natural Sciences of Philadelphia, 1979), p. 14.

2. Michael and Julie Hall, interview by Julia Guernsey and Debra Brindis, 1 August 1991, transcript, Milwaukee Art Museum.

75
Unidentified Artist
Illinois?
Silhouette Stick-Up Goose ca. 1920
Sheet metal, paint, rivets, wire and clamps
32 ¾ x 9 ¾ x 20 ¾ in.
(83.2 x 24.8 x 52.7 cm)
Acquired from Patricia Hall, New York,
1982
M1989.294

Silhouette decoys, otherwise known as stick-up, profile, or shadow decoys, are widely used throughout the United States and are especially popular in southern Illinois.[1] These decoys are made of tin, iron, wood, or occasionally, thick cardboard. Although the manufacturer of this commercially produced *Silhouette Goose* is unknown, it bares a striking resemblance to others produced in Illinois. As with many decoys of this type, the wings fold down and the head rotates on a rivet making it highly portable. Although quite weathered now, the paint residue indicates that this sheet metal decoy was originally painted to resemble a Canada Goose. (DB)

1. Paul W. Parmalee and Forrest D. Loomis, *Decoys and Decoy Carvers of Illinois* (DeKalb: Northern Illinois University Press, 1969), p. 56.

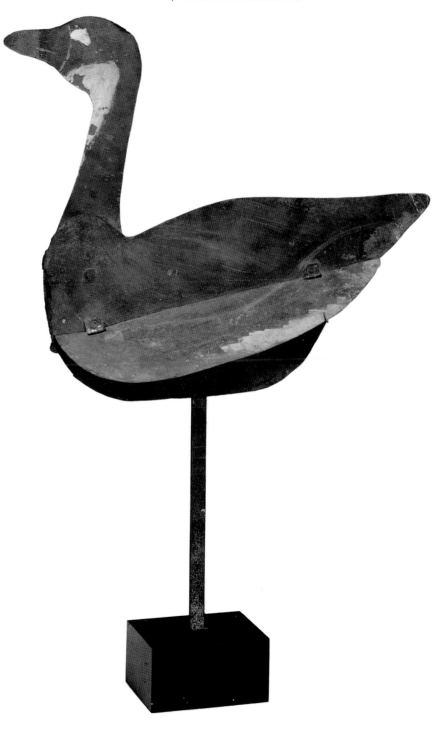

Unidentified Artist, *Silhouette Stick-Up Goose*, ca. 1920 (cat. no. 75)

Goose & Confidence

76*
Benjamin J. Schmidt
Detroit, Michigan
Blue Goose late 1930s
Carved and painted wood, glass
10 ¾ x 8 ¼ x 20 ¾ in.
(27.3 x 21 x 52.7 cm)
Acquired from Conrad Clippert,
Bloomfield Hills, Michigan, 1980
M1989.291

Blue Geese (Snow Geese) are rare in the Eastern Michigan-St. Clair region. Their appearance one winter in Port Austin, Michigan, in the late 1930s led local hunters to believe that migration patterns were shifting, when in reality, the flock had merely been blown off course by storms and strong winds. One hunter, mistakenly expecting to capitalize on this phenomenon, commissioned Ben Schmidt to carve several Blue Goose decoys.[1]

Although the *Blue Goose* is a rarity among Schmidt's work, it exhibits the same traits that distinguish his work from that of other local makers. Its large size is a functional adaptation to the rough waters of Lake Erie. His soft paint patterns and unusually textured surfaces, although atypical of the region, reduce the decoy's surface sheen, thereby producing a more naturalistic and effective lure. (DB)

1. Michael and Julie Hall, interview by Julia Guernsey and Debra Brindis, 1 August 1991, transcript, Milwaukee Art Museum.

Benjamin J. Schmidt, *Blue Goose*, late 1930s (cat. no. 76)

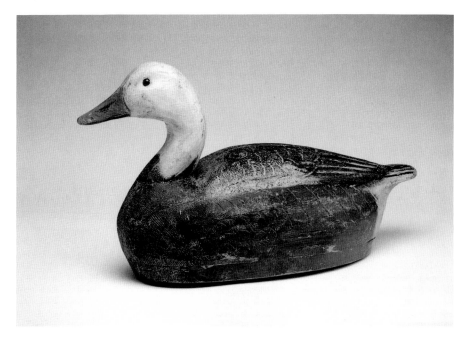

Goose & Confidence

77*
Unidentified Artist
Humboldt Bay, California
"Root Head" Black Brant Goose ca. 1930s
Carved and painted wood, lead
12 x 6 x 17 ¼ in.
(30.5 x 15.2 x 43.8 cm)
Acquired from Gene and Linda Kangas,
Painesville, Ohio, ca.1974
M1989.293

The head of this Black Brant decoy,
the Hall Collection's only West Coast
example, is fashioned from a tree root. Its
use reflects the functional application of a
natural form, a use which further illum-
inates the appeal of folk art to early
modern sculptors such as Robert Laurent,
William Zorach, and John Flannagan. (DB)

78*
Herter's Company
Waseca, Minnesota
Great Horned Owl ca. 1940
Balsa wood, paint, glass and claw beak
20 ¼ x 7 ¼ x 19 ¾ in.
(51.4 x 18.4 x 50.2 cm)
Acquired from Phyllis Tavares, Millis,
Massachusetts, 1978
M1989.300

Not all decoys were made by individ-
ual carvers. This *Great Horned Owl* decoy
was manufactured by the Herter's Com-
pany in Waseca, Minnesota. The Herter's
decoy factory opened in the 1890s during
the heyday of market gunning and sport
hunting. The great popularity of both of
these activities between 1890 and 1940
fostered widespread production of factory-
made decoys. During this period, adver-
tisements for every type and quality of
decoy filled the pages of sporting publica-
tions such as *Sports Afield Magazine* and
Hunting and Fishing Magazine.[1]

The term "factory-made" generally
refers to decoys that are fashioned mostly
by machine and mass marketed via adver-
tisements such as those mentioned above.
It should by noted, however, that many
factory-made decoys require some degree
of fine hand finishing.

While most decoys attract their own
species, the owl decoy functions differ-
ently. Because owls are a favorite prey of
crows, owl and crow decoys are some-
times used together by crow hunters to
ensure greater success. (DB)

1. Henry A. Fleckenstein, *American Factory Decoys* (Schiffer Publishing, Ltd., 1981), p. 7.

Unidentified Artist, *"Root Head" Black Brant Goose*, ca. 1930s (cat. no. 77)

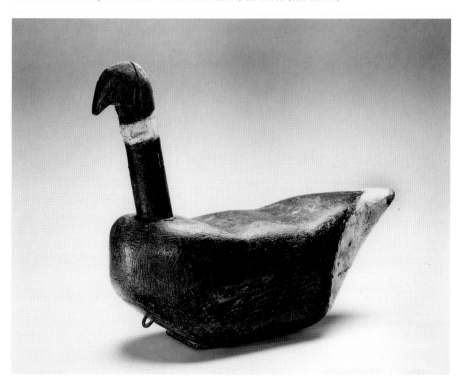

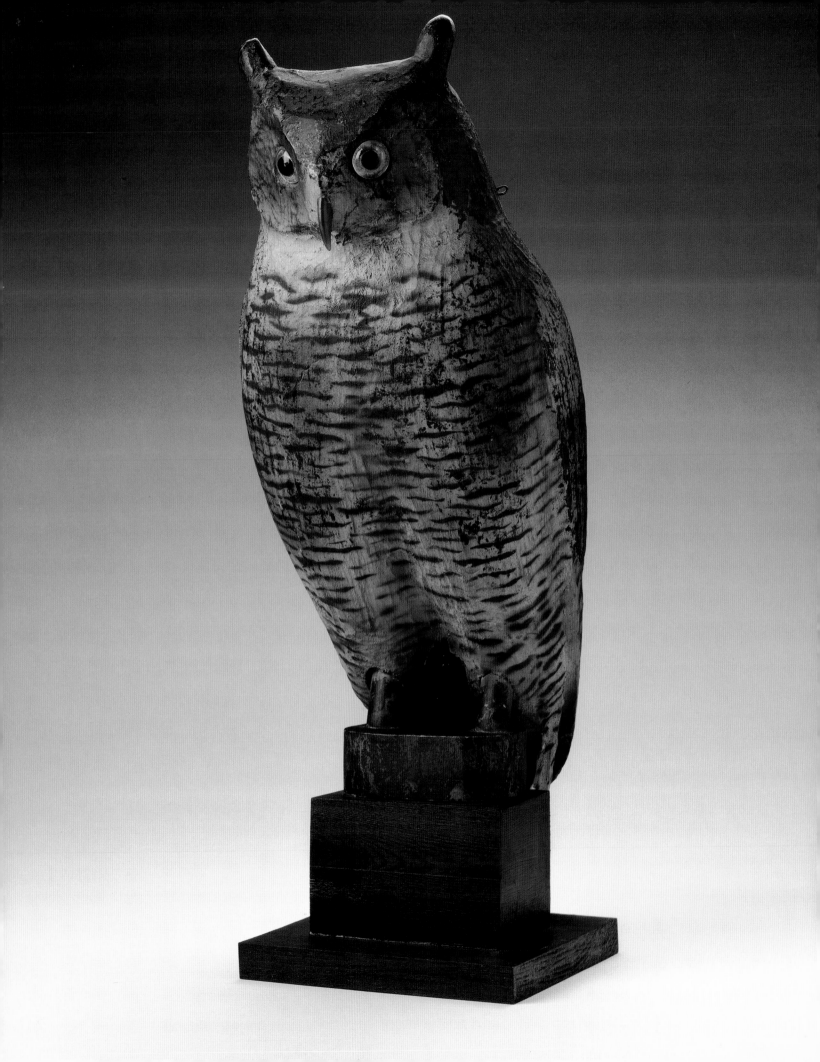

Amateur A. Savoie, *Black Backed Gull*, ca. 1940 (cat. no. 79); Unidentified Artist, *Loon*, ca. 1940 (cat. no. 80)

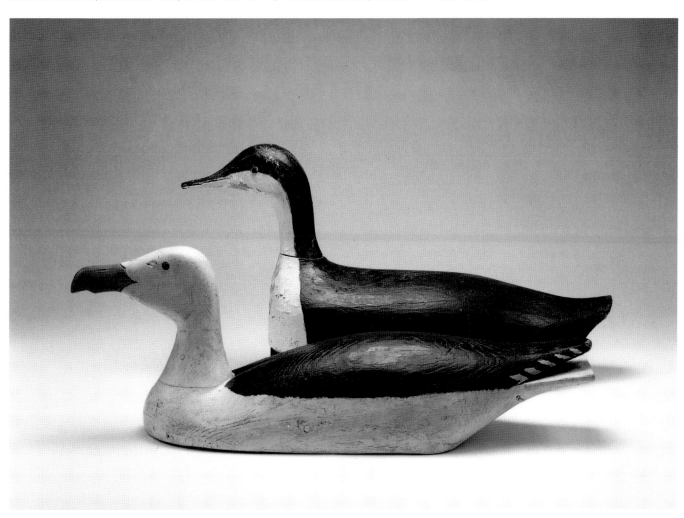

Herter's Company, *Great Horned Owl*, ca. 1940 (cat. no. 78)

79*
Amateur A. Savoie
Nequac, New Brunswick
Black Backed Gull ca. 1940
Carved and painted wood, glass
9 x 7 ⅜ x 26 ¼ in.
(22.9 x 18.7 x 66.7 cm)
Acquired from Don Snyder, Louisville,
Kentucky, 1970
M1989.296

Gulls are frequently regarded as the
only true "confidence" decoys. Hunters
feel that a gull or two placed near a rig of
duck decoys heightens realism and makes
a reassuring impression on wildfowl
flying overhead. (DB)

80
Unidentified Artist
Nova Scotia
Loon ca. 1940
Carved and painted wood, metal, iron,
cord and nails
12 ¾ x 7 ¾ x 25 ¼ in.
(32.4 x 19.7 x 64.1 cm)
Acquired from Chris Huntington, Halifax,
Canada, 1976
M1989.298

Although renowned decoy expert
William Mackey claims that hunters once
used the fatty skin of loons as a rust in-
hibitor on guns, there is no conclusive
evidence that these birds were ever
hunted as table fare or regarded as any-
thing other than a confidence species.[1]

The sleek, solid-body construction of
this decoy is characteristic of the Maine/
Nova Scotia style of carving where
abstract paint patterns of basic colors are
the norm. This *Loon*'s movable or
"swivel" head lends a sense of realism to
an otherwise highly stylized lure. (DB)

1. William F. Mackey Jr., *American Bird
Decoys* (New York: E. P. Dutton, 1965), p. 59.

81
Unidentified Artist
South Carolina
Swan ca. 1950
Canvas, wood, metal loops, paint and nails
15 ¼ x 10 ¾ x 40 in.
(38.7 x 27.3 x 101.6 cm)
Acquired from John C. Newcomer,
Charleston, West Virginia, 1974
M1989.301

In the mid to late 1800s, hunters used
swan decoys to attract swans which were
valued primarily for their plumage. Later,
when swan hunting was outlawed,
market gunners began using them as
confidence decoys, often to lure Wigeon
Ducks. Wigeons feed on the wild celery
and other underwater plants that swans
dislodge from the bottom of shallow bays;
hence, they are naturally attracted to a rig
with floating swans. Such canvas-covered
swans are also frequently found among
groupings of goose "stick-up" decoys
like the one in the Hall Collection
(cat. no. 75).[1] (DB)

1. David S. Webster and William Kehoe,
Decoys at Shelburne Museum (Shelburne,
Vermont: Shelburne Museum, 1961), p. 100.

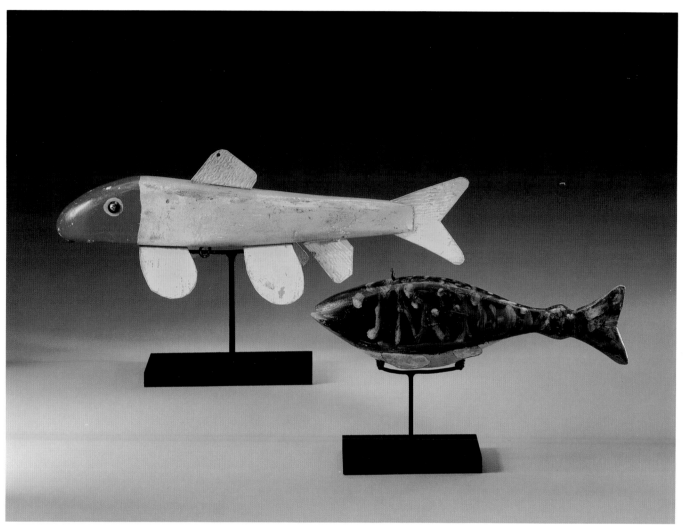

Unidentified Artists, *Sucker "Floater" Decoy*, ca. 1930 (cat. no. 87) and *Bass*, ca. 1930 (cat. no. 88)

Fish

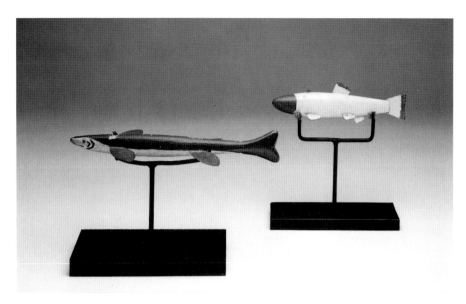

Gordon Sears, *"Shiner" Decoy*, ca. 1930 (cat. no. 89) and Marvin "Mase" Mason, *Sucker Decoy with Red Head*, 1950s-1960s (cat. no. 90)

89
Gordon Sears
Mount Clemens, Michigan
"Shiner" Decoy ca. 1930
Carved and painted wood, metal fins, hook and bead
1 x 2 ⅞ x 6 ¾ in. (2.5 x 7.3 x 17.2 cm)
Acquired from Jerry Catana, Detroit, Michigan, 1978
M1989.310

Gordon Sears worked as a hunting and fishing guide all of his life in the Michigan St. Clair Flats region. Always graceful, his fish were typically painted in a blue and white, red and white, or gold format, sometimes with the colors delicately blended.[1]

The large number of fish decoys from Michigan can be attributed to the regional penchant for ice fishing.[2] The best known Michigan makers include, among others, Sears, Hans Jenner Sr., Andy Trombley, Isaac and Abe Goulette, Abraham Dehate, Theodore Van den Bossche, Alton Buchman, Gordon Fox and Frank Schmidt. (JG)

1. Telephone conversations with Jerry Catana, collector, Mount Clemens, Michigan, 8 August 1992 and Howard Sears, Algonac, Michigan, 5 October 1992.

2. Marsha MacDowell and C. Kurt Dewhurst, "Expanding Frontiers: The Michigan Folk Art Project," in *Perspectives on American Folk Art*, eds. Ian M. G. Quimby and Scott T. Swank (New York: W. W. Norton & Co., 1980), p. 72.

90
Marvin "Mase" Mason
Tower, Michigan
Sucker Decoy with Red Head
1950s-1960s
Carved and painted wood with metal fins
1 ⅜ x 4 ¾ x 1 ¾ in. (3.5 x 12.1 x 4.5 cm)
Acquired from Ronald Swanson, Bloomfield Hills, Michigan, 1978
M1989.306

Marvin Mason is an avid spearfisherman who carved his first fish decoy from an orange crate at the age of five under the guidance of his father. Later, he continued to make fish decoys, carving them from pine with a jacknife and cutting fins from Crisco cans.[1] Mason probably created this *Sucker Decoy* as a teenager in Tower, Michigan. Although brightly painted, his decoys were created as functional rather than decorative objects. Mason now concentrates on carving other types of animals.[2] (KM & JG)

1. C. Kurt Dewhurst and Marsha MacDowell, *Rainbows in the Sky: The Folk Art of Michigan in the Twentieth Century* (East Lansing: Michigan State University, 1978), p. 36.

2. Telephone conversation with Ronald Swanson, collector, Bloomfield Hills, Michigan, 20 December 1991.

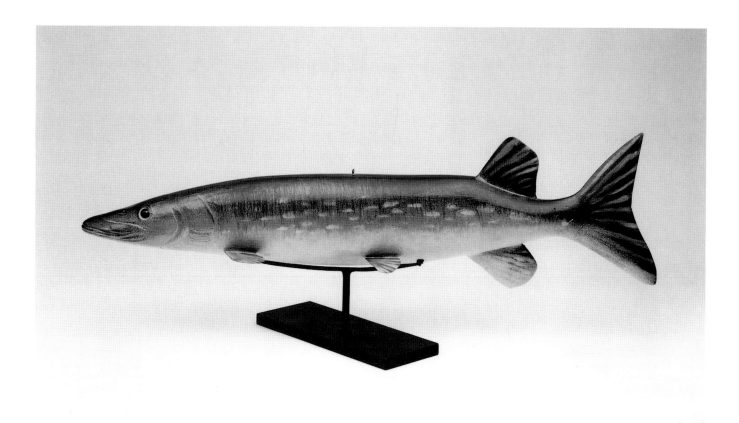

Alton "Chubby" Buchman, *Northern Pike*, ca. 1975 (cat. no. 91)

91
Alton "Chubby" Buchman
Mount Clemens, Michigan
Northern Pike ca. 1975
Carved and painted wood, glass eyes,
metal fins and hook
7 ⅜ x 6 ⅝ x 27 ½ in.
(18.7 x 16.8 x 69.9 cm)
Acquired from the artist, 1979
M1989.308

Alton Buchman, whose great uncle was famous decoy carver Ben Schmidt, began carving fish decoys in 1969. Designing his fish in the Michigan St. Clair Flats style with long, graceful lines, Buchman created over 600 decoys during his career including pike, trout, minnows, muskie, perch and bass. Although this *Pike* is quite naturalistic, Buchman also employed colorful, abstract schemes.[1] (JG)

1. Telephone conversation with Charlie and Julie Buchman Hart, Mount Clemens, Michigan, 26 October 1992.

Walking Sticks

Universally, canes have meaning ranging from status symbol to religious staff. Here, reflecting this diversity, meanings, are fraternal, commemorative, and religiously symbolic canes. Other examples, with elaborately carved narratives or personal insignia, functioned as physical supports or prestige items. The walking sticks in the Hall Collection also demonstrate the wide range of formal possibilities that can exist within a limited design. Without sacrificing functionality, the unique vision of each artist is conveyed through volume, line, and color, resulting in a cane that is also a fully three-dimensional sculpture.

Interestingly, the expressive role of canes often centers on themes of empowerment with masculine, authoritative connotations, and reflects a carving tradition dominated by men. Snakes, the most common motif on walking sticks, are both figuratively suited to canes and iconographically linked to themes of authority. Especially in the South where they are plentiful, snakes play an important role in folklore as a creature both feared and respected. For example, the Southern snake-handling cult turns to the dangerous and theatrical act of handling snakes to signify man's ability to overcome evil through faith in God. Like the snake's association with evil in the Genesis Temptation narrative, its reputed wisdom is also rooted in Judeo-Christian tradition (Matthew 10:16).

Belief in the power of serpents and other reptiles in African American folklore is manifested in the conjuring canes of the South. These sticks, carved with serpentine and reptilian imagery, are used to invoke supernatural powers. Conversely, serpents may also signify health and healing as in the caduceus, or symbolic staff of the medical profession that derives from Greco-Roman tradition. Taken from the snake's ability to shed and regenerate its own skin, rebirth is inherent. The serpent's phallic connotations impart a masculine context to such life-giving power.

A cane's function is as dependent upon personal specifications as is its meaning. For example, in order to be comfortably held, the type of handle is dictated by the size of a person's hand. Its height is equally specific to the individual, and is determined by measuring the distance from the ground to the wrist when the arm is held relaxed with hand bent slightly upwards. (JG)

92*
Unidentified Artist
Detroit River region
Dog Top Cane ca. 1830
Wood, metal, nails, felt, paint
and varnish
33 ½ x 1 ½ x 6 in.
(85.1 x 3.8 x 15.2 cm)
Acquired from Herbert W. Hemphill Jr.,
New York, 1980
M1989.347

This walking stick derives from the tradition of gadget canes equipped with clever contrivances that extend their function beyond walking aid.[1] A circular opening at the top of the shaft exposes a small cavity lined with green felt that may have held a watch or compass. A rectangular slot along the side, surmounted by a metal hinge, enhances that possibility by providing an opening for making adjustments. Although silver dollars were also frequently mounted on canes, the opening in this particular shaft (29 millimeters in diameter) is too small to have held one.

A fascinating although mysterious narrative is portrayed on this cane. A dog is alertly posed on the handle. Beneath, a serpent coils up the shaft, while a man's head is roughly carved along the side. Throughout the nineteenth and early twentieth centuries, dog head handles were a popular motif, although rarely was the entire figure included. In fact, the Remington Rifle Cane, a gadget cane with secret firearm capability that was advertised in the 1877 Remington catalogue, featured a dog head handle.[2] The vigilant dog and potential compass compartment suggest that this *Dog Top Cane* served as a decorative, yet functional, support while walking or hiking.

The name "Jousset" which appears on the reverse side of the shaft probably referred to the cane's original owner and can be genealogically traced to the eighteenth- and nineteenth-century Detroit River region. (JG)

1. See Catherine Dike, *Cane Curiosa* (Paris: Les Editions de L'Amateur, 1983).

2. Kurt Stein, *Canes and Walking Sticks* (New York: G. Shumway, 1974), p. 152.

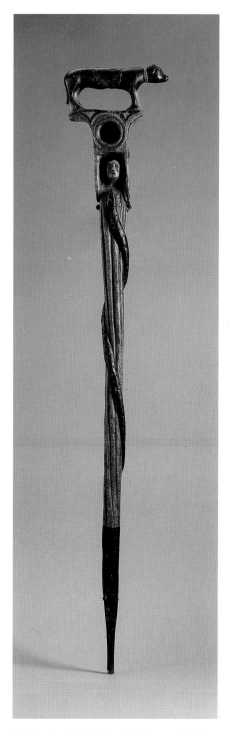

Unidentified Artist, *Dog Top Cane*, ca. 1830
(cat. no. 92)

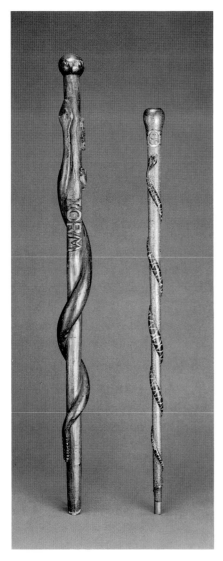

Unidentified Artist, *Improved Order of Red Men Cane*, detail, ca. 1860 (cat. no. 93)

93*
Unidentified Artist
Indiana
Improved Order of Red Men Cane ca. 1860
Wood, paint and varnish
H. 36 ½, Diam. 3 ½ in.
(92.7, 8.9 cm)
Acquired from William Sweeney, Detroit, Michigan, 1973
M1989.350

Unidentified Artists, *Improved Order of Red Men Cane*, ca. 1860 (cat. no. 93), and *Fraternal Order of the Eagles Cane*, ca. 1919 (cat. no. 94)

The Improved Order of Red Men Lodge, established in Baltimore, Maryland, in 1834, claimed admiration for the customs and history of native Americans, although it was not until 1974 that they allowed native Americans to join the organization. All of the ritual terminology of the fraternity derives from language stereotypically attributed to the American Indian: the lodge is referred to as "tribe"; a non-member is called a "paleface"; and a meeting site is a "wigwam."[1]

The handbook of the fraternity describes an initiation ritual in which an individual is presented with a "tomahawk" emblazoned with the letters "TOTE" which stand for "totem of the eagle." Although this cane's function was probably not ceremonial, the "TOTE" inscription announces the personal allegiance of the owner to the brotherhood.

The serpent which entwines the shaft recalls a legend. The Red Men Lodge originated from the Brothers of Tammany who took their name from Chief Tammany, a distinguished chief who fought the armies of DeSoto and LaSalle for land between the Alleghenies and the Rockies. The white men sent in plagues of rattlesnakes in an attempt to overcome Tammany, but he conquered them instead and ushered in a new era of peace in the region.[2] (JG)

1. Alvin J. Schmidt, ed., *The Greenwood Encyclopedia of American Institutions: Fraternal Organizations* (Westport: Greenwood Press, 1980), pp. 287-88.

2. Albert C. Stevens, ed., *The Cyclopedia of Fraternities* (New York: E. B. Treat and Co., 1907), pp. 239-40.

94
Unidentified Artist
Camden, New Jersey
Fraternal Order of the Eagles Cane ca. 1919
Wood, paint, varnish and metal tip
H. 32 ⅛, Diam. 2 in.
(81.6, 5.1 cm)
Acquired from Keene and Arndt,
Waterloo, New York, 1979
M1989.352

Canes encoded with the insignia of a fraternal organization were immediately identifiable to members of that society. They were also used in lodges for ceremonial purposes, such as presenting the staff to new initiates, or "dubbing" them in the manner of medieval chivalric rituals.

This cane is clearly inscribed with the insignia of the Fraternal Order of the Eagles, "FOE No. 65," which was founded in 1898 in Seattle, Washington. Radiating from this insignia in a ribbon design are the words "Camden" and "Aerie," identifying the owner of the cane as a member of Camden, New Jersey Lodge Number 65. A date inscribed on the cane, although not completely legible, appears to be 1919. Because a new lodge number, 065, was assigned in 1930 when Camden merged with the Pennsauken, New Jersey, lodge, the cane definitely predates this merger and a date of 1919 is probable. (JG)

Unidentified Artist, *Fraternal Order of the Eagles Cane*, detail, ca. 1919 (cat. no. 94)

Unidentified Artist, *Fraternal Order of the Eagles Cane*, detail, ca. 1919 (cat. no. 94)

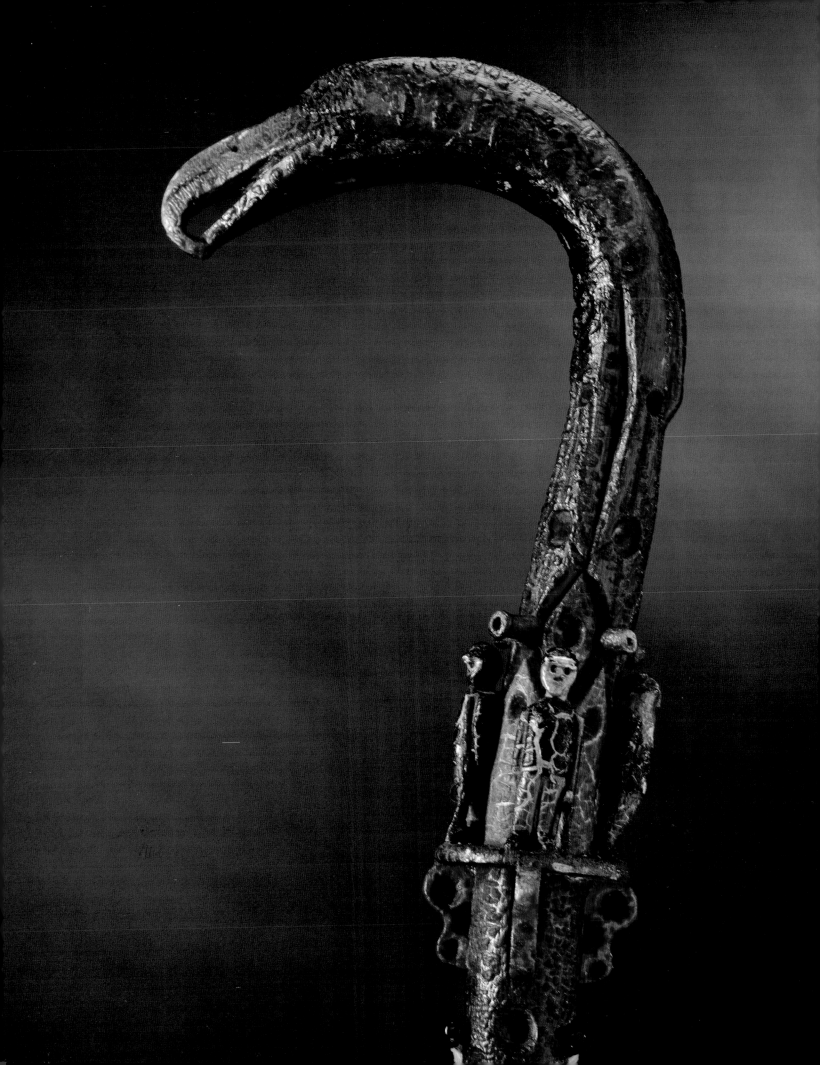

95*
Seth Thomas
Battle Mountain, South Dakota
Civil War Cane after 1865
Wood, paint, metal, varnish and
rubber tip
H. 35, Diam. 2 ¾ in.
(88.9, 7 cm)
Acquired from Larry Whiteley, Whiteley
Galleries, Los Angeles, California, 1979
M1989.346

According to an oral history supplied
by Larry Whiteley, who purchased this
cane from a chain of Thomas' family,
friends, and neighbors, Seth Thomas
carved this walking stick after serving in
the Civil War. He eventually retired to
Battle Mountain, South Dakota, and died
there at the age of 110 years.

The four figures in blue overcoats
encircling the cane represent Union sol-
diers posed with rifles and surmounted
by cannon-like projections. The handle is
formed by an eagle's head, a popular
nineteenth-century motif that symbolized
the Union. Traces of sparkling gold pig-
ment in the hollows along the shaft recall
the original, ornate character of the cane
and suggest a commemorative function.
Many canes with Civil War insignia were
carved during and after the war by
veterans or others to honor them at
reunions, parades, and similar events. (JG)

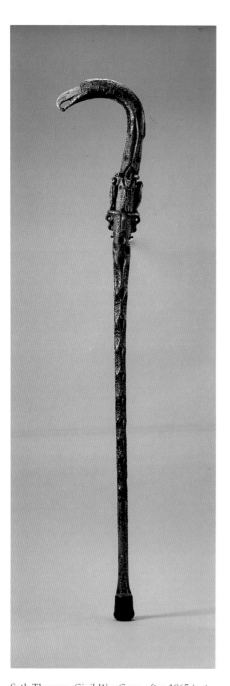

Seth Thomas, *Civil War Cane*, after 1865 (cat.
no. 95)

Seth Thomas, *Civil War Cane*, detail, after 1865 (cat. no. 95)

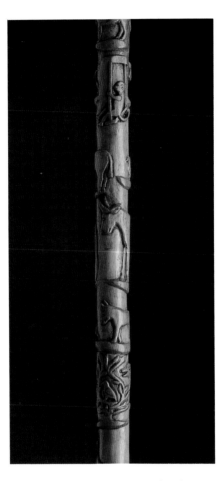

Unidentified Artist, *Animal Kingdom Cane*,
detail, ca. 1890 (cat. no. 96)

Unidentified Artist, *Animal Kingdom Cane*,
ca. 1890 (cat. no. 96)

96*
Unidentified Artist
Southeastern Pennsylvania
Animal Kingdom Cane ca. 1890
Dogwood, varnish and ink
H. 36 ⅛, Diam. 1 ½ in.
(91.8, 3.8 cm)
Acquired at Ohio State Fair Grounds
antique show, 1976
M1989.353

Diverse animals appear on this cane,
ranging from domestic and jungle to
aquatic creatures at the base. Of the
twenty-six animals portrayed, the twenty
that are arrayed horizontally stand on
small registers. Dogwood canes with
similar finely carved motifs are found
throughout Southeastern Pennsylvania,
although no other known examples
incorporate the unusual registers.[1] Such
regional stylistic affinities suggest that
this cane is an individual variant of a
local tradition.

Several of the animals appear to derive
from popular sources, especially the
swinging monkey, the cat with arched
back, and the bird in a tree. Similar bird
motifs, like the "partridge in a pear tree,"
are found in embroidery and quilts of this
period as well as in popular lithographs
such as N. Currier's *Adam Naming the
Creatures* of 1847. (JG)

1. Telephone conversation and letter from
Richard Machmer, Hamburg, Pennsylvania,
September 1991. See also Richard S. and
Rosemarie B. Machmer, *Just For Nice* (Read-
ing: The Historical Society of Berks County,
1991), pp. 30-31.

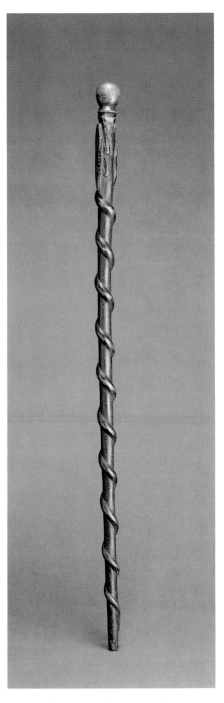

Unidentified Artist, *African American Cane*,
ca. 1900 (cat. no. 97)

97*
Unidentified Artist
Detroit, Michigan
African American Cane ca. 1900
Wood, varnish and paint
H. 35, Diam. 1 ¾ in.
(88.9, 4.5 cm)
Acquired from Jamie Kirchner, Detroit,
Michigan, 1979
M1989.344

The ordered spiraling of the serpent
and stylized rendering of the lizard
resemble motifs on a historic cane by
African American carver Henry Gudgell
(Yale University Art Gallery). Like
Gudgell, this artist carved the reptiles as
though seen from above, and covered the
entire cane in a layer of black paint.
Unlike other walking sticks that depict
aggressive chase scenes between two rep-
tiles, here the serpent and lizard function
as complements, achieving a perfectly
symmetrical balance. The combination of
such powerful, iconic motifs with the
strength and severity of the cane itself
suggests a ritualistic function, not unlike
that of Southern African American "con-
jure sticks" or African ceremonial staffs.
(JG)

98
Unidentified Artist
Texas
Cane with Metal Star ca. 1910
Wood, metal, nails, paint and varnish
H. 37 ¼, Diam. 2 ⅛ in.
(94.6, 5.4 cm)
Acquired at a Michigan antique show,
circa 1975
M1989.351

Found in Texas according to the dealer,
the single star on this cane may refer to
the "Lone Star" state. Its sleek propor-
tions are reminiscent of English walking
sticks, but the presence of a rattlesnake,
native only to North and South America,
indicates an American origin. (JG)

99
Edgar Tolson
Campton, Kentucky
Snake Cane ca. 1970
Carved, painted and varnished wood
H. 35, Diam. 1 ⅝ in.
(88.9, 4.1 cm)
Acquired from the artist, 1970
M1989.318

During his career, Tolson created canes
that typify traditional Appalachian wood-
carving. In this case, he achieved such a
precisely modeled surface by manually
twirling the shaft while pressing his knife
against it in the manner of a lathe.[1] (JG)

1. Michael and Julie Hall, interview by Julia
Guernsey and Debra Brindis, 1 August 1991,
transcript, Milwaukee Art Museum.

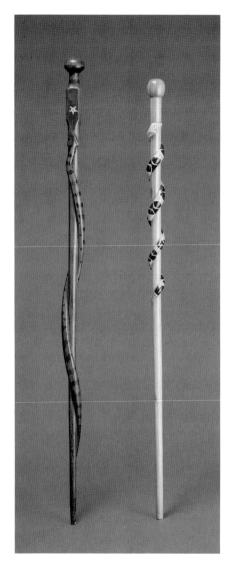

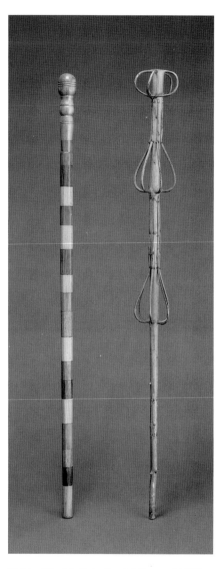

100
Unidentified Artist
Kentucky?
Banded Cane mid-20th century
Wood, varnish and glue
H. 36 ¼, Diam. 1 ¾ in.
(92.1, 4.5 cm)
Acquired in central Kentucky, 1968
M1989.356

A tradition of banded canes exists in which unusual materials, such as horn or vertebrae, are stacked to create interesting visual rhythms.[1] Similarly, this cane is constructed of sixteen units of various woods whose grains create a multi-patterned and multi-colored cadence. All units are laminated together with no internal support. According to the dealer from whom the cane was purchased, it came from central Kentucky. (JG)

1. Albert E. Boothroyd, *Fascinating Walking Sticks* (New York: White Lion Publishers, 1973), pp. 116, 119.

Unidentified Artist, *Cane with Metal Star*, ca. 1910 (cat. no. 98) and Edgar Tolson, *Snake Cane*, ca. 1970 (cat. no. 99)

Unidentified Artists, *Banded Cane*, mid-20th century (cat. no. 100) and *Adirondack Style Cane*, ca. 1920 (cat. no. 101)

101
Unidentified Artist
New York State
Adirondack Style Cane ca. 1920
Wood and metal staples
H. 36 ⅜, Diam. 4 in.
(92.4, 10.2 cm)
Acquired from Denny L. Tracey,
Ann Arbor, Michigan, 1988
M1989.354

This *Adirondack Style Cane* was a
popular tourist souvenir in the late
nineteenth and early twentieth centuries.
These intentionally rustic canes, produced
in the Eastern mountain regions, appealed
to wealthy vacationers wishing to escape
the burgeoning urban industrial revolu-
tion and "live in silence . . . away from all
the business and cares of civilized life."[1]

Delicate willow wood indicates a
primarily decorative function, while great
sensitivity to form is shown in the selec-
tion of a branch with symmetrically
balanced, gracefully tapering twigs. (JG)

1. Reverend William Murray, *Camp Life in
the Adirondacks* (1869), quoted in William
Chapman White, *Adirondack Country* (New
York: Alfred A. Knopf, Inc., 1967), p. 113.

102
Unidentified Artist
Southern United States?
Cane with Chase Scene
early to mid-20th century
Wood, rubber tip, carpet fragment,
paint and varnish
41 x 3 ¼ x 11 in.
(104.1 x 8.3 x 27.9 cm)
Acquired from Robert Bishop, Inkster,
Michigan, 1972
M1989.345

This cane demonstrates an artist's
ability to envision a complete narrative
within an unusually shaped branch. Only
minimal carving and incising created a
lively scene of pursuit. Although the
artist may simply have lacked enough
wood to carve the snake's head in raised
relief and been forced instead to depict it
swallowing the shaft, such a physically
impossible feat provides a humorous
variation on the traditional chase theme.
(JG)

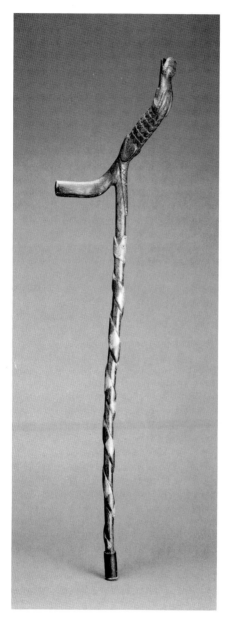

Unidentified Artist, *Cane with Chase Scene*,
early to mid-20th century (cat. no. 102)

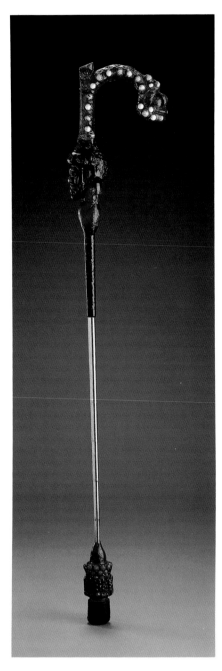

"Stick Dog" Bob, *Golf Club Cane*, ca. 1970s
(cat. no. 103)

"Stick Dog" Bob, *Golf Club Cane*, detail,
ca. 1970s (cat. no. 103)

103*
"Stick Dog" Bob
Chicago, Illinois
Golf Club Cane ca. 1970s
Golf club with metal shaft and rubber
grip, putty, plastic beads, rubber tip
and paint
36 ½ x 2 ¾ x 7 ¼ in.
(92.7 x 7 x 18.4 cm)
Acquired from Carl Hammer Gallery,
Chicago, Illinois, 1987
M1989.355

This cane is attributed to an African
American artist on the West Side of
Chicago called "Stick Dog" Bob.[1]
Acquired by Carl Hammer in the early to
mid-1980s, several other canes by the
same hand surfaced at the Maxwell Street
fleamarket in Chicago during the same
period. According to a vendor there, all
that was known about the artist was his
association with a storefront called
"House of the Strange."[2]

This cane, like others by "Stick Dog"
Bob, is formed from a golf club. Applied
to the shaft is a hard black putty, part of

which is modeled to form an African
American man's face. Numerous plastic
and glass jewels and beads are embedded
into its surface. Apparently the face and
fierce, serpentine creature that forms the
handle recur with slight variation on most
of the sticks. Another example shows
similar motifs and construction, although
"Stick Dog" Bob employed a lamp post
rather than a club to form a staff.[3]

The materials used in these canes
reflect their urban origin, and contrast
dramatically with others in the Hall
Collection. Rather than extracting images
from wood, they evidence a reverse, addi-
tive process in which original forms are
almost completely disguised. Such addi-
tive and textural sensibilities permeate
both African and African American art.
For example, Kongo charms, embellished
with beads, shells, and other objects in
order to convey a mystical presence, are
translated into ordinary household objects
by African Americans. These objects are
called "Mojos," a term that "refers to a
hex or spell, the medicine to cure some-
one, and the charm or amulet used to
cure a spell or protect one from evil
forces . . ."[4] The oral history surrounding
"Stick Dog" Bob and his use of repeated
motifs and anthropomorphic elements —
like the green-eyed creature on this hand-
le as well as the shape at the shaft's base
that resembles an inverted, headless doll
— do indeed suggest that the canes
served a mystical function. (JG)

1. Telephone conversation with Carl
Hammer, Carl Hammer Gallery, Chicago,
Illinois, 12 December 1991.

2. Telephone conversation with Mark
Jackson, Chicago, Illinois, 30 December 1991.
The storefront, purportedly located on the
West Side of Chicago, has never been found.

3. See George H. Meyer, *American Folk Art
Canes: Personal Sculpture* (Bloomfield Hills,
Michigan: Sandringham Press, 1992), cat.
no. 292.

4. Maude Southwell Wahlman, "Africanisms
in Afro-American Visionary Arts," *Baking in
the Sun* (Lafayette: University of South-
western Louisiana, 1987), p. 36.

104*
David Butler
Patterson, Louisiana
Figure on Umbrella Handle ca. 1980
Cut and painted tin with ribbon,
varnished umbrella handle, nails, cotton,
twist tie and plastic eye
34 x 11 ½ x 2 ¾ in.
(86.4 x 29.2 x 7 cm)
Acquired from Gasperi Folk Art Gallery,
New Orleans, Louisiana, 1982
M1989.185

Inspired by fanciful characters from his
dreams, Butler chisels figures from dis-
carded tin roof panels with a large knife
and hammer. In this case, the exotic
figure combines human, bird and reptilian
features and is probably a mermaid.[1]

This cane, one of several that Butler
fashioned from umbrella handles, exem-
plifies his sophisticated understanding of
positive and negative space. The addition
of a button eye and red bow contrasts
with the voids of the figure's contours,
yet balance is maintained through the
juxtaposition of fields of flat color and
polka dots.

Reference has been made to the
formal similarities between Haitian metal-
work and Butler's creations.[2] Here,
Butler's mermaid recalls powerful Haitian
sea goddesses or Sirenes, often depicted
with a combination of human and aquatic
features. Although there is no evidence of
direct contact between Butler and Haitian
art, such formal and topical affinities are
intriguing. (JG)

1. Telephone conversation with William A.
Fagaly, assistant director of art, New
Orleans Museum of Art, 9 September 1991.

2. Maude Southwell Wahlman, "Africanisms
in Afro-American Visionary Arts," *Baking in
the Sun* (Lafayette: University of South-
western Louisiana, 1987), p. 33.

David Butler, *Figure on Umbrella Handle*, ca. 1980 (cat. no. 104)

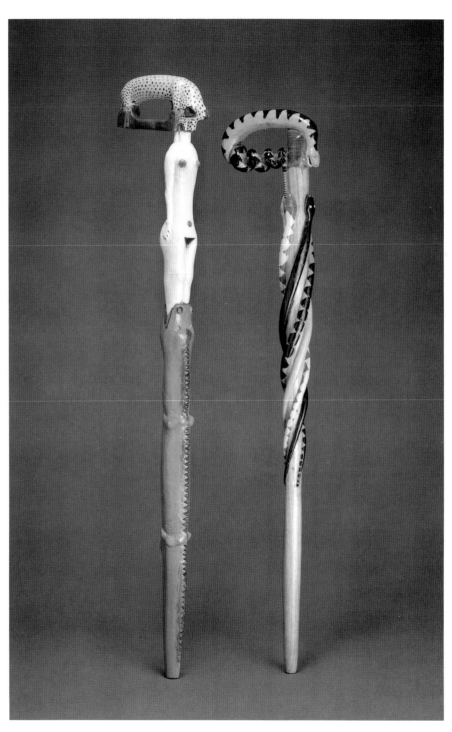

105
Denzil Goodpaster
Kentucky
Cane with Woman and Jaguar ca. 1983
Wood, costume jewelry, beads, glue, oil
paint and varnish
37 ½ x 8 x 2 ¾ in.
(95.3 x 20.3 x 7 cm)
Acquired from Kenneth Fadeley,
Ortonville, Michigan, 1980
M1989.357

The bizarre imagery on this cane
developed from an earlier, related image
of a frog being devoured by a cat and
an alligator. The shape of the frog's body,
pinned between the two opposing crea-
tures, reminded Goodpaster of the torso
of a woman, and inspired him to create
his first cane in which a woman was
being devoured by a jaguar and an
alligator.[1]

When asked why he creates such
images, Goodpaster responds that he just
"thinks them up" without any moral mes-
sage or hidden meaning. He finds the
images humorous, a quality he seeks to
invest in all of his work, although here
the humor involves explicit consumption
of the female form. (JG)

1. Conversation with Larry Hackley,
Milwaukee, Wisconsin, 26 November 1990.

Denzil Goodpaster, *Cane with Woman and Jaguar*, ca. 1983 (cat. no. 105) and *Cane with Five Snakes*, ca. 1985 (cat. no. 106)

106
Denzil Goodpaster
Kentucky
Cane with Five Snakes ca. 1985
Wood, costume jewelry, beads, plastic,
glue, oil paint and varnish
35 ½ x 2 ¾ x 7 ¾ in.
(90.2 x 7 x 19.7 cm)
Acquired from Kenneth Fadeley,
Ortonville, Michigan, 1981
M1989.349

Like many Kentucky farmers,
Goodpaster had always whittled, but did
not try any extensive carving until he
attended the Sorghum Festival in West
Liberty, Kentucky, where he saw a snake
cane carved by an acquaintance. When
the friend challenged him to do better,
Goodpaster accepted and produced the
first of his many canes.[1]

Goodpaster refers to himself as an art-
ist, viewing his present work as sculpture
and distinguishing it from his earlier
whittling. In this cane, that sculptural
sensibility is evidenced in the spiraling,
parallel bodies of the serpents which lead
the viewer's eye to the ferocious, snarling
snake on the handle. Goodpaster admits
that he obtains ideas for patterning and
color from reference books on snakes
given to him by his daughter; neverthe-
less, his final designs and effects always
seem more fanciful than real. (JG)

1. Telephone conversation with Denzil
Goodpaster, 4 November 1990.

107*
Ben Miller
Kentucky
Snake Cane ca. 1985
Wood, paint, ink, varnish, plastic beads,
glue and plastic tip
H. 38, Diam. 3 ½ in.
(96.5, 8.9 cm)
Acquired from Kenneth Fadeley,
Ortonville, Michigan, 1981
M1989.348

A miner for most of his life, Ben Miller
retired in 1965 due to black lung disease.
It was after accepting a job with the
University of Kentucky's reforestation
program that his life-long interest in cane
carving was rekindled.[1] His earlier walk-
ing sticks had been simple and designed
specifically for elderly friends in need.
However, as he uprooted small trees
while on the job, he became fascinated
with their eccentric root formations and
began to fashion canes from them. He
also employed thigmotropes, or sapling
branches deeply incised by twisting vines,
as in this cane. Miller chose to limit his
repertoire to animals from the same
environment: snakes, lizards, and squir-
rels. Here, he manipulated the inherently
serpentine quality of the wood to create a
tension between the undulating, muscular
bodies of the snakes and the shaft below.
Fluidity is enhanced through his distinc-
tive ink patterning that contrasts with the
natural grain of the wood. (JG)

1. Telephone conversation with Kenneth
Fadeley, 13 January 1992.

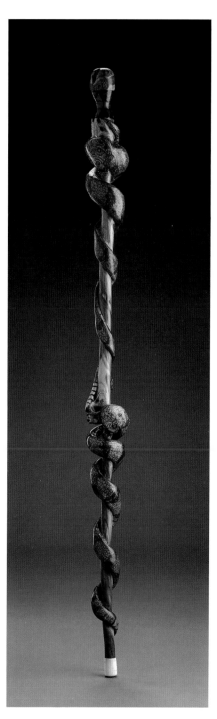

Ben Miller, *Snake Cane*, ca. 1985 (cat. no. 107)

Ceramics

Functional necessities, ceramic ware not only served as eating utensils in early American households, but also as the means to cook, preserve, and store liquid and solid food stuffs. Often too costly to ship from Europe, production in this country dates from the earliest settlements and rapidly developed from part-time family operations to full-scale industries. Potteries first dotted the eastern seaboard and later followed expansion westward.

From the seventeenth century, American folk pottery traditions reflected the British, German, and French lineage of early settlers. Earthenware, for example, was produced primarily in New England and eastern Pennsylvania where Germanic colonists continued to enhance their red earthenware with simple but traditional trailed slip designs.

Stoneware, because of its strength and the availability of clay deposits, was the material of choice for household and commercial storage vessels. The New York City area became an early center for stoneware production because of large deposits of high temperature clay. Clay transported by barge supplied early New England potteries, and in Pennsylvania, stoneware produced alongside earthenware sometimes caused the decline of that earlier tradition. As the population expanded west and south, potteries opened to meet new demand. Stoneware production was also established in the Ohio River Valley due to large and suitable clay deposits and the ease of river transportation.

Stoneware shapes, whether one-quart preserve jars or four-gallon butter churns, were simple in accordance with consumer demands and potters' time constraints. At the beginning of the nineteenth century, Albany slip, mined in New York, was often used to glaze the interior, and sometimes the exterior, of stoneware containers. Cobalt blue decoration, usually trailed or brushed in a floral motif, was popular. As competition among potteries increased due to mass-production techniques in the later nineteenth century, time-saving stencils and stamps were used. Unfortunately, these economies contributed to the decline of American folk pottery already threatened by industrialization and the mass marketing of canned goods which reduced the need to store food at home.[1] Molded glass and enameled tin containers, both practical and cheap, completed folk pottery's demise.

While the evolution of functional American pottery is well documented, the origins and meanings of face vessels are less clearly understood. Edwin Atlee Barber's account of a conversation with Colonel Thomas J. Davies, operator of a pottery at Bath, South Carolina, relates that some face vessels were made by "negro workmen."[2] Although this report formed a basis for the speculation that still persists regarding an African American attribution for face vessels, it cannot be overlooked that face vessels are part of the ceramic lexicon of many cultures. Accordingly, it is impossible to link American face vessels with only an African genesis.

Search for a unifying framework has led Michael Hall to align face vessel production with the spread of the temperance movement. He suggests that the vessels were emblematic warnings against overindulgence as the movement swept from 1800s New England to the mid-century South and ultimately to Ohio in the 1870s.[3] As face vessel production also roughly follows this geographic and chronological progression, his thesis contributes a possible social rationale for these curious vessels. Nevertheless, regional variants caution that other cultural and ethnic traditions should not be overlooked and that, although face vessels may have been adopted for specific social purposes, their inception, ongoing development, and popularity defies any single explanation. (SF)

1. Christopher Bensch, *The Blue and the Gray: Oneida County Stoneware* (Utica: Munson-Williams-Proctor Institute, 1987), p. 12.

2. Edwin Atlee Barber, *The Pottery and Porcelain of the United States* (New York: Feingold & Lewis, 1893), p. 466.

4. Michael D. Hall, "Brother's Keeper: Some Research on American Face Vessels and Some Conjecture on the Cultural Witness of Folk Potters in the New World," in *Stereoscopic Perspective* (Ann Arbor: UMI Research Press, 1988), pp. 195-226.

108*
Unidentified Artist
Pennsylvania?
Plate ca. 1790
Red earthenware, clear glaze and slip
decoration
H. 1 ¼, Diam. 9 ⅛ in.
(3.2, 23.2 cm)
Acquired from Herbert Schiffer Antiques,
Exton, Pennsylvania, 1972
M1989.337

A great deal of incised and slip-
decorated redware was made in
eighteenth-century Pennsylvania potteries
following the traditions of early German
settlers. Typically, plates were formed by
cutting a circle of clay from a slab and, at
the leather-hard stage, draping it over a
mold to form and trim it. Slip was trailed
over the surface when partially dry, some-
times in a free-form pattern as in this
case. A clear glaze was then applied over
the top before firing. (SF)

109
Unidentified Artist
New England
Water Pitcher ca. 1850
Stoneware, cobalt "sponge" decoration
and clear glaze
9 ½ x 8 ⅛ x 7 ½ in.
(24.1 x 20.6 x 19.1 cm)
Acquired from Steve White Antiques,
Syracuse, New York, 1971
M1989.342

110
Haxstun, Ottman & Company
Fort Edward, New York
Jug 1867-1872
Stoneware, salt glaze and cobalt
decoration
11 ½ x 6 ¼ x 6 ⅝ in.
(29.2 x 15.9 x 16.8 cm)
Acquired from Patriot Antiques, Novi,
Michigan, 1973
M1989.334

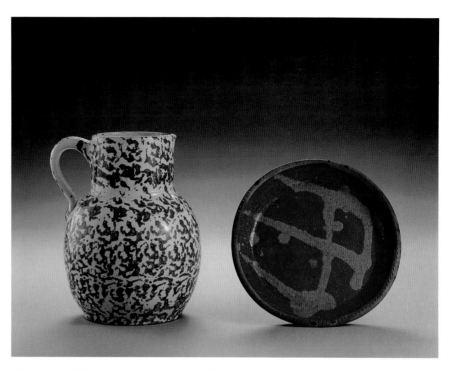

Unidentified Artists, *Water Pitcher*, ca. 1850 (cat. no. 109) and *Plate*, ca. 1790 (cat. no. 108)

111
Whittemore Pottery
Havana, New York
Two Gallon Crock 1868-1893
Stoneware, salt glaze and cobalt
decoration
8 ⅝ x 10 ¼ x 10 ⅛ in.
(22 x 26 x 25.7 cm)
Acquired from Patriot Antiques, Novi,
Michigan, 1973
M1989.332

Although stoneware, fired to about
2300 degrees Fahrenheit, is extremely
durable and will hold water without a
glaze, many such jugs and crocks pro-
duced in America were salt-glazed. In
this process, salt is thrown into the kiln
when it reaches its highest temperature,
causing the salt to vaporize and combine
with the free silica in the clay body to
produce a glaze with an "orange peel"
texture. (SF)

112
Hamilton & Jones
Greensboro, Pennsylvania
Storage Jar ca. 1880
Stoneware, salt glaze and cobalt
decoration
H. 10 ⅛, Diam. 6 ⅝ in.
(25.7, 16.8 cm)
Acquired from Maze Pottinger Antiques,
Bloomfield Hills, Michigan, 1973
M1989.333

In this example, the company's stamp
is integrated with a decorative motif to
form an interesting study in cobalt embel-
lishment. (JG)

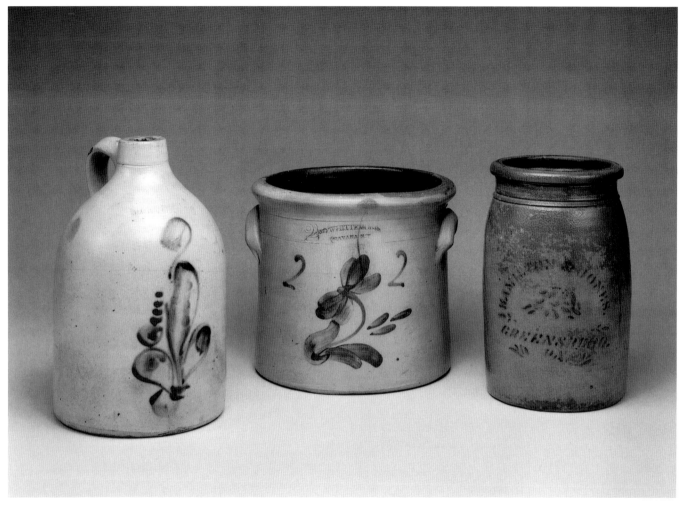

Haxstun, Ottman & Company, *Jug*, 1867-1872 (cat. no. 110), Whittemore Pottery, *Two Gallon Crock*, 1868-1893 (cat. no. 111), and Hamilton & Jones, *Storage Jar*, ca. 1880 (cat. no. 112)

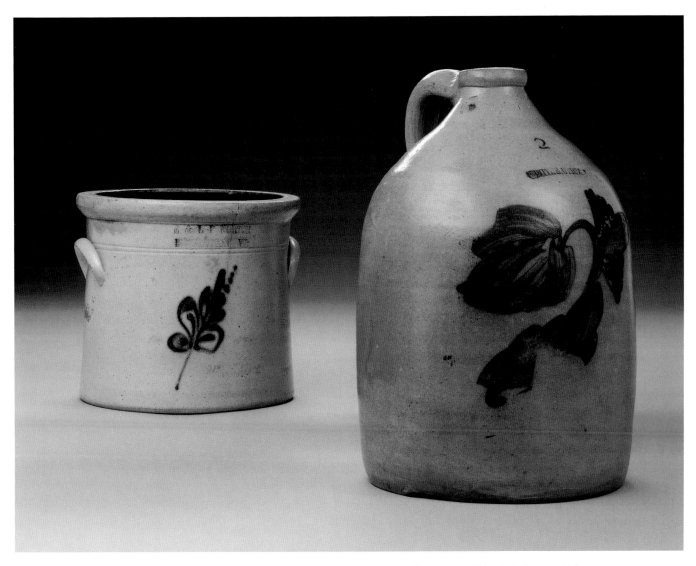

E. and L.P. Norton, *Storage Jar*, ca. 1865-1882 (cat. no. 113), and White's Pottery, *Two Gallon Jug*, ca. 1850s-1860s (cat. no. 114)

Ceramics

113
E. and L.P. Norton
Bennington, Vermont
Storage Jar ca. 1865-1882
Stoneware, salt glaze and cobalt
decoration
H. 7 ¼, Diam. 8 ⅜ in.
(18.4, 21.3 cm)
Acquired from Patriot Antiques,
Novi, Michigan, 1973
M1989.335

The Norton Pottery was established at
Bennington, Vermont, in 1793, two years
after Vermont became a state, by Captain
John Norton, a veteran of the Revolu-
tionary War. Variously called L. Norton &
Company, J. & E. Norton & Company, and
Norton & Fenton, it was the E. & L.P.
Norton pottery that produced this storage
vessel. Edward and Luman Preston
Norton, great-grandsons of Captain John,
operated the pottery between 1861 and
1881. An 1867 price list advertised
covered cream pots, covered preserve jars,
fruit or tomato jars, butter pots, pitchers,
flower pots, stove tubes, tea pots, spit-
toons, and Rockingham ware.[1] Due to a
drastic decline in demand for utilitarian
stoneware, the Edward Norton &
Company pottery began to wholesale
glassware, china and pottery in 1885.
Edward's abrupt death in 1894 ended the
Norton dynasty after 101 years.[2] (JG)

1. Richard Carter Barret, *Bennington Pottery
and Porcelain: A Guide to Identification* (New
York: Bonanza Books, 1958), p. 11.

2. John Spargo, *The Potters and Potteries of
Bennington* (Boston: Houghton Mifflin Com-
pany and Antiques Incorporated, 1926),
pp. 96-97.

114*
White's Pottery
Utica, New York
Two Gallon Jug ca. 1850s-1860s
Stoneware, salt glaze and cobalt
decoration
13 x 8 ⅞ x 9 in.
(33 x 22.5 x 22.9 cm)
Acquired from Strawberry Hill
Antiques, Lexington, Kentucky, 1968
M1989.331

Utica's optimum location along the
Chenango Canal and the Erie Canal
afforded transportation of clay and
finished objects from New Jersey.[1] Noah
White moved to Utica in 1828 and began
to manufacture stoneware at Addington
Pottery until he bought it out, along with
the Nash Pottery, in 1839. White's success
was undoubtedly fueled by the increased
demand for stoneware which paralleled
the population growth in Utica from ap-
proximately 3,000 in 1820 to over 8,000
ten years later.[2] By 1849, Noah White had
formed a partnership with his two sons
and changed his potters mark from "N.
White, Utica" to "Whites Utica," as on
this vessel. After Noah's death in 1865,
the business entered its most successful
years under the direction of Noah's son
Nicholas. During this period, the com-
pany replaced kick wheels and hand
throwing with steam powered wheels and
molds, although the increased mecha-
nization did not detract from the quality
of the wares. In response to competition
and the decline in demand for stoneware,
White's Pottery began to make fire brick
and sewerpipe by 1888. It eventually
ceased stoneware production in 1907, clos-
ing permanently in 1910. (JG)

1. Barbara Franco, *White's Utica Pottery*
(Utica: Munson-Williams-Proctor Institute,
1969), no pagination.

2. Christopher Bensch, *The Blue and the Gray:
Oneida County Stoneware* (Utica: Munson-
Williams-Proctor Institute, 1987), p. 7.

115*
H. Rhodenbaugh Pottery
East Akron, Ohio
Figurated Harvest Jug ca. 1880
Stoneware and Albany slip glaze
H. 9 ⅞, Diam. 7 in.
(25.1, 17.8 cm)
Acquired from Stephan Douglas,
Rutland, Vermont, 1982
M1989.340

The H. Rhodenbaugh Pottery was
located in Middlebury (now East Akron)
Ohio, during the late nineteenth century.
Middlebury was advantageously situated
along the Ohio-Erie canal which began
operation in 1827, and the opening of the
Atlantic and Great Western Railway in
1852 provided even greater distribution
and productivity potential for Middlebury
potters.[1]

Harvest jugs like this version were
often taken into the field to quench the
thirst of workers. Typically, they have
two spouts, the wider one serving to fill
the jug and the smaller one acting as a
drinking spout. As here, harvest jugs
were often decorated with botanical
motifs which were formed in molds and
applied to the jug's surface before firing.
When in use, jugs were best covered with
wet canvas to cool the contents. (SF & JG)

1. C. Dean Blair, *The Potters and Potteries of
Summit County 1828-1915* (Akron: Summit
County Historical Society, 1965), pp. 2, 29.

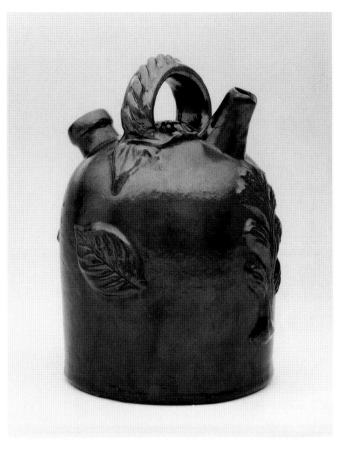

H. Rhodenbaugh Pottery, *Figurated Harvest Jug*, ca. 1880 (cat. no. 115) Unidentified Artist, *"Tobacco Spit" Glazed Jug*, ca. 1890 (cat. no. 116)

116*
Unidentified Artist
 Georgia?
"Tobacco Spit" Glazed Jug ca. 1890
Stoneware and alkaline glaze
H. 8 ½, Diam. 6 ⅛ in.
(21.6, 15.6 cm)
Acquired from Robert M. Doty,
New Canaan, Connecticut, 1969
M1989.339

The name of this jug derives from the appearance of its alkaline glaze formed from a combination of sand, clay and wood ash. Its use was limited mainly to the South where post-Civil War economic problems made salt scarce at times and Albany slip unavailable. This jug derives its beauty from the prominent wheel-throwing rings which caused the glaze to puddle and run during the firing, thus leaving subtle tonal variations. (SF)

Ceramics

Unidentified Artist, *Covered Storage Jar*, ca. 1890 (cat. no. 118), and Unidentified Artist, *Preserve Jar*, ca. 1910 (cat. no. 119)

V. Baumstard Pottery, *Four Gallon Butter Churn*, ca. 1890 (cat. no. 117)

117
V. Baumstard Pottery
Kentucky
Four Gallon Butter Churn ca. 1890
Stoneware and salt glaze
18 ⅛ x 10 ⅛ x 9 ¼ in.
(46 x 25.7 x 23.5 cm)
Acquired from Rebels Rest Antiques,
Lexington, Kentucky, 1969
M1989.336

The crackling and flashing which occurred during firing create subtle yet dramatic nuances across the surface of this vessel. (JG)

118
Unidentified Artist
Kentucky
Covered Storage Jar ca. 1890
Stoneware, salt glaze and cobalt
decoration
H. 8 ¹¹/₁₆, Diam. 4 ⅝ in.
(22.1, 11.8 cm)
Acquired from central Kentucky antique
shop, circa 1969
M1989.338a, b

119
Unidentified Artist
Western Kentucky
Preserve Jar ca. 1910
Stoneware and salt glaze with light rutile
slip decoration
H. 9 ⅜, Diam. 4 ¾ in.
(23.9, 12.1 cm)
Acquired from central Kentucky antique
shop, circa 1969
M1989.341

One of the hallmarks of folk pottery is
its adherence to a tradition in which the
forms, production methods, glaze and
decoration are handed from one genera-
tion to the next.[1] Although individual
variation is admired, gradual refinement
to meet changing functional and cultural
demands is emphasized over radical inno-
vation. The tendency for nineteenth- and
early twentieth- century pottery manufac-
turing to run in families, due in part to
the function of the family as the chief
economic unit, served to perpetuate this
continuity. (JG)

1. John Burrison, *Brothers in Clay* (Athens:
University of Georgia Press, 1983), p. 57.

120
E. Spalle
Midwest
Alligator ca. 1900
Stoneware with Albany slip glaze
1 ½ x 2 ¾ x 13 ½ in.
(3.8 x 7 x 34.3 cm)
Acquired from Robert Burger,
Columbus, Ohio, 1984
M1989.343

Whimsical objects were sometimes
made at the end of the day using
scrap material left over from regular
production. (SF)

E. Spalle, *Alligator*, ca. 1900 (cat. no. 120)

Ceramics

121*
Galloway (attributed)
Zanesville, Ohio region
Face Vessel late 19th-early 20 century
Stoneware, Albany slip glaze, metal, wood
and cork
9 x 7 ⅜ x 7 ½ in.
(22.9 x 18.7 x 19.1 cm)
Acquired from Kinzle Auction Center,
Duncansville, Pennsylvania, 1975
M1989.326

Fashioned from a basic jug shape,
small hand-formed pieces of clay are
added to the vessel to indicate ears, eyes,
nose and mouth. The nubby textured
hair, called "coleslaw," is characteristic of
face vessels from this central region of
Ohio, most of which were produced
between 1870 and 1890. Located along
the Muskingum River, Zanesville potters
had access to vast clay deposits, transpor-
tation routes and hydraulic water power
from the falls. Such resources contributed
to the region's reputation as a center for
stoneware and Rockingham ware produc-
tion in the nineteenth century.[1]

This jug is attributed to a potter
named Galloway whose face vessels are
known for their flat, plate lips. Galloway
worked at the Stein Pottery until a fire
devastated it, then relocated to nearby
Star Pottery which only operated between
1875 and 1888.[2] Such a transition from
one local kiln to another was typical of
folk potters who, having established a
regional reputation, often practiced their
skills at numerous potteries during their
careers. (JG & SF)

1. Joan Leibowitz, *Yellow Ware: The Transition-
al Ceramic* (Exton, Pennsylvania: Schiffer
Publishing, Ltd., 1985), p. 57.

2. Telephone conversation with David Good,
8 April 1992.

122*
Evan Javan Brown
Arden, North Carolina
Face Vessel ca. 1920s
Stoneware, alkaline glaze and kaolin teeth
7 ⅜ x 5 ½ x 5 ⅜ in.
(18.7 x 14 x 13.7 cm)
Acquired from Larry Hackley,
North Middleton, Kentucky, 1980
M1989.330

123
Face Vessel ca. 1920s
Stoneware, Albany slip glaze and kaolin
teeth
6 x 4 ½ x 4 ¾ in.
(15.2 x 11.4 x 12.1 cm)
Acquired from Tom Dalich, Kalamazoo,
Michigan, 1979
M1989.327

Descended from Bowling Brown, who
produced face vessels prior to the Civil
War, Evan Javan Brown learned the pot-
tery craft by age twelve. Although raised
in Atlanta, the Brown brothers worked for
potteries throughout Georgia, North
Carolina and Alabama. According to D.X.
Gordy, whose father owned the W. T. B.
Gordy Pottery in Aberdeen, Georgia, at
which Evan J. Brown was employed
during World War I, "Everybody that had
a pottery at one time or another had a
Brown working in it."[1] Later, E. J. Brown
worked for a Boggs in Alabama; John
Henry Stewart and Wiley and Rufus
Rogers at Jugtown, Georgia; George
Clayton at Inman, South Carolina; the
Cantrell Pottery in Paulding County,
Georgia; and at the Eason Pottery in
Phenix City, Alabama.[2] Finally, after his
brother Davis discovered quality clay at
Arden, North Carolina, in 1923, they estab-
lished the Brown Pottery there. These
jugs probably date from this early 1920s
period in Arden. (JG)

1. John Burrison, *Brothers in Clay* (Athens:
University of Georgia Press, 1983), p. 196.

2. Burrison, *Brothers in Clay*, pp. 196-198.

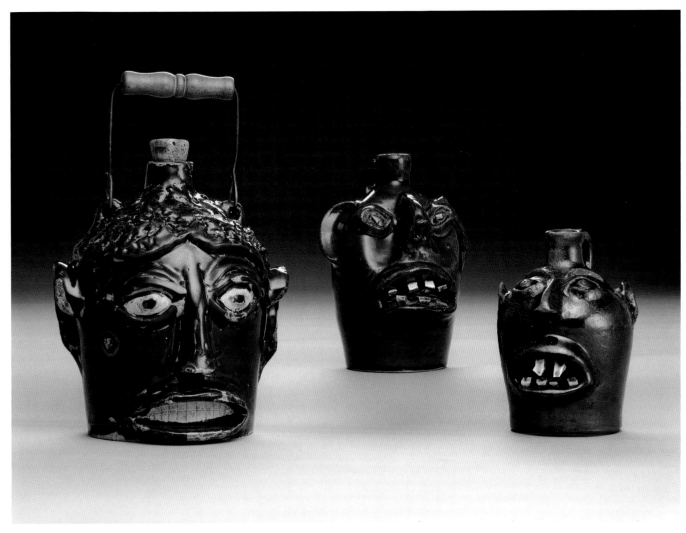

Galloway (attributed), *Face Vessel*, late 19th-early 20 century (cat. no. 121), and Evan Javan Brown, *Face Vessels*, ca. 1920s (cat. nos. 122 and 123)

Ceramics

124
Robert Brown (attributed)
Arden, North Carolina
Devil Face Jug ca. 1978
Stoneware and paint
13 x 8 ½ x 10 ½ in.
(33 x 21.6 x 26.7 cm)
Acquired from Larry Hackley,
North Middleton, Kentucky, 1980
M1989.328

During the Depression of the 1920s, demand for pottery from the Brown's Arden, North Carolina, shop declined, and forced Evan Javan Brown to relocate to Forest Park, Georgia, where he specialized in unglazed cylindrical collars used in chimney flues.[1] Meanwhile, his brother Davis began to market their pottery by traveling throughout North Carolina in his pick-up truck. Davis Brown remained at the Arden pottery until his death in 1967. His son, Louis, and grandsons, Charles and Robert who represent the eighth generation of Brown potters, still continue the pottery and face vessel tradition in Arden. According to Louis Brown,

face vessels were placed in storefront windows to catch the eye of passing shoppers: "Lots of places they would like to attract attention and draw crowds and so they'd order a bunch of them to be made 'cause everybody'll stop in front of a place to look at them."[2] This jug, produced circa 1978, is attributed to Robert Brown and incised with the stamp: "Brown's Pottery Arden N.C." (JG)

1. John Burrison, *Brothers in Clay* (Athens: University of Georgia, 1983), p. 197.

2. Charles G. Zug III, *Turners and Burners: The Folk Potters of North Carolina* (Chapel Hill: University of North Carolina Press, 1986), p. 384.

125
Burlon B. Craig
Vale, North Carolina
Face Vessel ca. 1980
Stoneware, alkaline glaze and kaolin teeth
7 ¼ x 6 ¼ x 5 ¼ in.
(18.4 x 15.9 x 13.3 cm)
Acquired from Larry Hackley,
North Middleton, Kentucky, 1980
M1989.329

Considered "the single remaining link between the potteries of today… and a heritage of folk pottery that extends back in time for over two centuries," Burl Craig has been making ceramics since the early 1930s, trained by family and neighbors whose pottery traditions date back to the nineteenth century.[1] He digs clay from the Catawba River, grounds it in his pug mill, and prefers to use the treadle wheel, a highly efficient mechanism pumped with the foot, instead of an electric wheel. Early in his career, Craig marketed his various jars, crocks and jugs to local customers and hardware stores, although now he primarily sells to collectors. As to when he began to create face vessels he states: "After I got to where I could turn a little jug, I put faces on a few."[2] He now produces whole "families" of face jugs in various sizes and admits, "making face vessels is getting old, but what I like is the money I get out of it."[3] (JG)

1. Charles G. Zug III, *Turners and Burners: The Folk Potters of North Carolina* (Chapel Hill: University of North Carolina Press, 1986), p. xiii.

2. Zug, *Turners and Burners*, pp. 383-4.

3. Zug, *Turners and Burners*, p. 386.

Robert Brown (attributed), *Devil Face Jug*, ca. 1978 (cat. no. 124)

Burton B. Craig, *Face Vessel*, ca. 1980 (cat. no. 125).

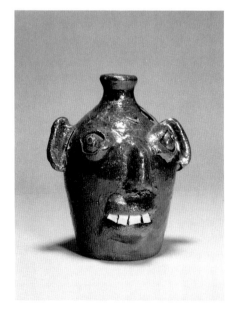

This eclectic group of objects demonstrates a range of creativity that embraces both utilitarian and decorative design. While retaining their basic form and function, ordinary household items like the *Box* (cat. no. 128), *Rocking Chair* (cat. no. 130), and *Sewing Stand* (cat. no. 131) have been transformed into sculptural entities. Others, such as the *Diorama* (cat. no. 126) and *Shrine* (cat. no. 129), are purely ornamental, yet expressive of individual beliefs or interests. Regardless, all were created in order to beautify and enhance a domestic environment. (JG)

Unidentified Artist, *Ship Vitrine and Diorama*, ca. 1890 (cat. no. 126)

126*
Unidentified Artist
New England
Ship Vitrine and Diorama ca. 1890
Painted cigar box, glass, carved and painted wood, string, beads, cloth, nails, cardboard and glue
6 ⅝ x 10 ¼ x 3 ½ in.
(16.8 x 26 x 8.9 cm)
Acquired from Frank Duffey, Staten Island, New York, 1969
M1989.179

Historically, dioramas — miniature wholly or partially three-dimensional scenes — are considered curiosities. Yet, many also contain a narrative that calls for the active participation and imagination of the viewer; indeed, the word diorama implies a "story in the round".[1] This scene, constructed from ordinary materials, is housed in a decorated cigar box and ingeniously combines painting, sculpture and drawing.

Members of many late nineteenth-century coastal communities produced shadow-box models like this one.[2] The two-masted schooner in this diorama was a very common Atlantic trade vessel from 1800 to the early 1900s. These small, highly purposeful craft were used in the New York brick trade, while others carried coal up the coast to Maine and returned with timber or granite. In Maryland, they worked for years freighting crabs and oysters around the Chesapeake Bay. In New England, these schooners sailed from small ports like Mystic, Connecticut; Penobscot Bay, Maine; and Rockport or Gloucester, Massachusetts. Any one of these ports could have inspired this charming harborside diorama. (BU)

1. Ray Anderson, *The Art of The Diorama* (Milwaukee: Kalmbach Books, 1988), p. 3.

2. William Ketchum, *The Catalogue of American Antiques* (Nashville: Rutledge Books, 1977), p. 91.

Unidentified Artist, *Figurated Stone Receptacle*, late 19th century (cat. no. 127)

Unidentified Artist, *Figurated Stone Receptacle*, late 19th century (cat. no. 127)

127*
Unidentified Artist
New England
Figurated Stone Receptacle
late nineteenth century
Carved stone
4 ½ x 2 ⅛ x 6 ½ in.
(11.4 x 5.4 x 16.5 cm)
Acquired from David Good Antiques,
Fairhaven, Ohio, 1984
M1989.178

After Napoleon's Egyptian campaign in the late eighteenth century, artists and designers became intrigued with ancient Egyptian ornamentation. In America, this interest was revived after 1881 when the obelisk known as Cleopatra's Needle arrived in New York. Shortly thereafter, Sarah Bernhardt portrayed Cleopatra on stage, and several new illustrated books of Egyptian art appeared. A similar fascination is evidenced by this object. The carved characters seated along one side closely resemble the monumental, enthroned figures of the Great Temple of Abu Simbel; likewise, the elongated fox head at the base recalls the Egyptian Sutekh, a hybrid animal believed to protect images of the pharaoh.

Clothing styles depicted on the other side of this object further indicate that is was carved in the late nineteenth century. The gentleman's cut-a-way coat, top hat and boots were in vogue from 1825-1900. Moreover, *Godey's Lady Book* depicts the fashionable woman of 1870-72 in garments consistent with those worn by the woman — her hair is gathered in a snood beneath a small hat, and she wears a tight-waisted dress with full skirt.

Perhaps the two cylindrical openings at the top, both of which extend approximately 3 inches down and are ½ inch in diameter, were designed to hold pipes or candles.[1] The detailed rendering of this receptacle suggests an artist familiar with stone cutting such as a quarrier or gravestone carver. (BU)

1. Michael and Julie Hall, interview by Julia Guernsey and Debra Brindis, 1 August, 1991, transcript, Milwaukee Art Museum.

128*
Unidentified Artist
Michigan
Trompe l'oeil Box ca. 1900
Carved and painted wood, metal hinges, lock, screws and nails
10 ⅞ x 8 x 4 ½ in.
(27.6 x 20.3 x 11.4 cm)
Acquired from Plain Dealer Antiques, Union City, Michigan, 1979
M1989.181

In the nineteenth century it was popular to use trompe l'oeil techniques to decorate furniture and boxes. The lock and removable, partitioned tray in this box indicate that it was used for storage and probably held jewelry or other valued trinkets. By resembling a book, it could be shelved in a library with its precious contents concealed.

Inscribed to "Hatty," this box was probably made as a gift. Its coloration and geometric pinstriping along the lid and spine are typically Victorian. Although handmade and handpainted, its machine-made screws and hinges indicate a late nineteenth- or early twentieth-century origin. (BU)

Unidentified Artist, *Trompe l'oeil Box*, ca. 1900 (cat. no. 128)

129
Unidentified Artist
Ohio
Shrine in the Form of a Church ca. 1920
Carved and painted wood, metal latch,
sockets and nails, pressed board, paper,
colored pencil, glass bulbs, and cloth-
covered electrical wire
41 x 23 ¼ x 9 ½ in.
(104.1 x 59.1 x 24.1 cm)
Acquired from John Williams,
Troy, Ohio, 1988
M1989.182

Found in the Midwest, this ornate
Shrine incorporates a wide mix of Euro-
pean and American architectural styles.
Its round arches resemble those used in
early Romanesque churches. The serrated
columns in the front echo the spiral forms
of the Spanish Baroque period; the veran-
da recalls Mediterranean loggias. The
tripartite façade — with its three steeples
each supporting globes, crosses, and
spires of varying heights — is a simplified
version of the Mormon Tabernacle built in
Salt Lake City, Utah between 1883 and
1893.

This architectural fantasy was probably
created by a woodworker familiar with
carpentry tools and basic electrical wiring.
All of the small bulbs decorating the
façade can be illuminated, as can those
supported by torcheres on the Doric
columns in front. The framed "windows,"
made to look like stained glass, are a com-
bination of prints — probably Christmas
cards — and free-hand colored pencil
decoration. The structure's cream-colored
surface is not original; an underlying
layer of sparkling gold paint suggests that
it once made a far more flamboyant
impression.

This unusual work may have once
belonged to Jerome E. Lang of Piqua,
Ohio, whose vast assortment of Christmas
ornaments and decorations was well
known. When he died without heirs in
the 1970s, his collection of approximately
30,000 objects was sold at public auction.
(BU)

Unidentified Artist, *Shrine in the Form of a
Church,* ca. 1920 (cat. no. 129)

Unidentified Artist, *Found Object Rocking Chair*, mid-20th century (cat. no. 130)

130*
Unidentified Artist
West Virginia
Found Object Rocking Chair
mid-twentieth century
Welded and painted steel farm
implements
32 ¾ x 21 x 36 ½ in.
(83.2 x 53.3 x 92.7 cm)
Acquired near Cooper Union,
New York, 1985
M1989.186

This *Rocking Chair* is composed entirely
of "found objects" endemic to mid-twen-
tieth-century farms. The metal seat comes
from a riding machine, mowing sickle
knives decorate the base, and a mule shoe
fastens to a hinge on the front. Welded to
the sides are shovels, a faucet handle, half
of a pair of tin snips, a fitting from a
single-tree harness, a small pitch fork, a
round cheek piece and half of a snaffle
horse bit, a pulley and hook, half a pair of
scissors, a pig ringer, railroad spikes, and
a handle for lifting wooden stove lids.
The chair's runners are lease springs, and
the front braces are railroad spikes. The
back of the chair consists of fancifully
bent wire rods, and an electrical conduit
forms the body. Completing the decora-
tion, chain link surrounds the back and
seat.

Two items which help to date this ver-
nacular equivalent to "high modern"
found art and assemblage are the
WALSCO long shank bicycle lock welded
to its side, and the slant front scale that
serves as the seat's balancing spring.
WALSCO made locks until the second
World War, and the slant front scale was
patented on October 29, 1912. (BU)

131
Unidentified Artist
Upper New York State
"Adirondack" Sewing Stand
mid-twentieth century
Painted and assembled twigs, leather
and nails
36 x 21 x 9 ½ in.
(91.4 x 53.3 x 24.1 cm)
Acquired from flea market,
Ann Arbor, Michigan, 1987
M1989.187

Like the *Adirondack Style Cane* (cat.
no. 101), this *Sewing Stand* exudes rustic
sensibilities. Using twig construction, wet
branches were either bent and tacked into
place or assembled like a log house. (BU)

Unidentified Artist, *"Adirondack" Sewing
Stand*, mid-20th century (cat. no. 131)

Lodge Hall Paraphernalia

Alexis de Tocqueville first noted in 1831 the growing tendency of Americans to form and join associations.[1] Motivated both by common objectives and mutual benefits, these alliances ranged from fire-fighting, temperance, and political groups to people assembling for barn raisings. One of the most important of these societies was the fraternal organization or lodge hall.

Members generally cited a number of practical reasons for joining: burial insurance, benefits for the families of a deceased member, moral self-development, and charitable concerns. But the burning question seems to be why, in a society which boasted not only a lack of restraint on the individual but one which was enjoying a sense of limitless personal freedom and economic prosperity, did countless Americans need these peculiar groups? Why were individuals drawn to organizations that endlessly preached the need to depend on others rather than on the self?

A consideration of several social forces at play in the United States during the nineteenth century provides insight into why individuals were drawn to fraternal organizations. The heterogeneity of nineteenth-century America, rapidly transformed by the winds of industrialization and urbanization, boasted a new order which, although exhilarating, generated an uneasy feeling of friendlessness and the desire to form social bonds. Concurrently, the ramifications of massive immigration induced many Americans and newcomers to pursue the sense of sheltered exclusivity that could be obtained through membership in a fraternity.[2]

Perhaps Charles W. Ferguson best summarized the eclectic nature of fraternal organizations in America:

[They] are but a perfectly natural expression of American life . . . Through their mysteries and ceremonies we progress literally by degrees to an understanding of the motives that lay hold upon men in group behavior. We cannot uproot these orders from the earth and inspect them as curiosities. We may observe the alignments of men one by one, but we must not lose sight of the fact that, taken together, they make the mass, the flesh and blood of a nation.[3]

Most of the lodge paraphernalia in the Hall Collection represents the Independent Order of Odd Fellows (I.O.O.F.). This fellowship, established in Baltimore by British immigrants in 1819, evolved from its members' prior association with the English Governing Lodge, more commonly called the Manchester Unity. By the late nineteenth century in America, Odd Fellows rolls rivaled the once preeminent society of Freemasons. Odd Fellows drew a great deal of symbolism for their ritual objects from Christian sources and Classical antiquity. (MP)

1. Alexis de Tocqueville, *Democracy in America* (New York: Vintage Books, 1945), pp. 114-115.

2. Ideas here will be elaborated on in an upcoming dissertation by Julie Hall, New York University.

3. Charles W. Ferguson, *Fifty Million Brothers* (New York: Farrar and Rinehart, 1937), p. 15.

132*
Unidentified Artist
Ohio
Odd Fellows Heart and Hand Staff ca. 1850
Carved, assembled and painted wood
74 ½ x 4 ⁷⁄₁₆ x 2 ¹⁄₁₆ in.
(189.2 x 11.3 x 5.2 cm)
Acquired from Robert Horn, Eaton, Ohio and John Auraden, Fairhaven, Ohio, 1983
M1989.189

Used in the Odd Fellows Initiation Ritual, the image of a heart in an open hand instructs that a greeting between members "should be [done] with a sincerity and affection which proceeds from the heart."[1] Ubiquitous among Odd Fellow paraphernalia, the heart and hand decorates a variety of objects and is often mounted on a long staff which may have hung on the wall during regular meetings. (MP)

1. J. Blanchard, *Revised Odd-Fellowship Illustrated: The Complete Revised Ritual of the Lodge, Encampment, Patriarch Militant and the Rebekah Degrees* (Chicago: Ezra A. Cook, 1889), p. 130.

133*
Unidentified Artist
Indiana
Odd Fellows Snake Staff ca. 1850
Carved, assembled and painted wood, nails and glue
72 x 6 ⁵⁄₈ x 6 ⁵⁄₈ in.
(182.9 x 16.8 x 16.8 cm)
Acquired from Robert Horn, Eaton, Ohio, 1983
M1989.188

In Odd Fellows iconography, the serpent is an emblem of wisdom. According to a nineteenth-century Odd Fellows manual, the serpent "is placed among our symbols to indicate the necessity of a wise caution, which will protect our mysteries from improper disclosure and guide us in the proper regulation of life and conduct."[1]

Here the serpent and staff, each carved from a single piece of wood, show expert craftsmanship. The serpent's undulating body remains flush with the rod from bottom to top, and is anchored only by a few tacks and thin wire that penetrates through to the shaft. (MP)

1. J. Blanchard, *Revised Odd-Fellowship Illustrated: The Complete Revised Ritual of the Lodge, Encampment, Patriarch Militant and the Rebekah Degrees* (Chicago: Ezra A. Cook, 1889), p. 133.

134*
Unidentified Artist
Greenville, Ohio
Odd Fellows Aaron's Budded Rod ca. 1860
Carved, assembled and painted wood
70 x 4 ½ x ⅞ in.
(177.8 x 11.4 x 2.3 cm)
Acquired from Robert Horn, Eaton, Ohio and John Auraden, Fairhaven, Ohio, 1983
M1989.197

This graceful staff is closely associated with the distinguished Patriarchal Degree of the Odd Fellows.[1] It refers to the Old Testament miracle through which Aaron was chosen by God: "and, behold, the rod of Aaron for the house of Levi was budded, and brought forth buds, and bloomed blossoms, and yielded almonds" (Numbers 17:1-8). It also reminds initiates that Divine Truth may sprout and grow from even the most barren objects. (MP & JG)

1. Reverend A.B. Grosh, *The Odd Fellows' Manual* (Philadelphia: Theodore Bliss, 1968), p. 167.

Unidentified Artists, *Odd Fellows Heart and Hand Staff*, ca. 1850 (cat. no. 132), *Odd Fellows Snake Staff*, ca. 1850 (cat. no. 133), and *Odd Fellows Aaron's Budded Rod*, ca. 1860 (cat. no. 134)

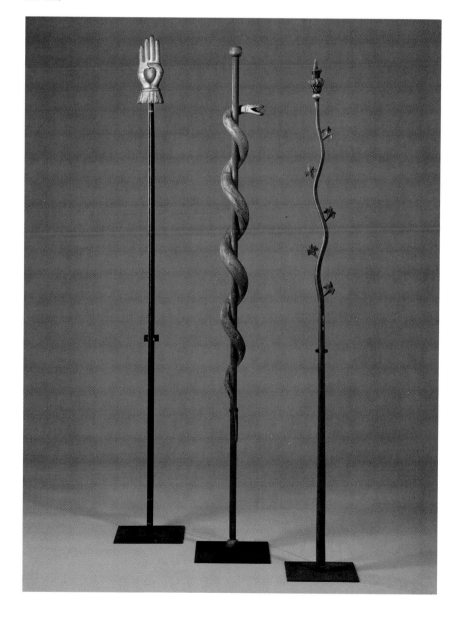

Lodge Hall Paraphernalia

Unidentified Artist, *Odd Fellows Linked Gold Rings*, ca. 1860 (cat. no. 135)

135
Unidentified Artist
Ohio
Odd Fellows Linked Gold Rings ca. 1860
Carved and painted wood
11 ½ x 3 ⅜ x 3 ½ in.
(29.2 x 8.6 x 8.9 cm)
Acquired from Pottinger/Walters
Antiques, Goshen, Indiana, 1980
M1989.195

Probably the most significant and widely reproduced symbol of the Odd Fellows is the three linked rings. Each link stands for a degree conferred by the lodge in addition to the Initiatory Degree. The three rings also reference the words Friendship, Love and Trust, or "FLT," the official emblem of the Odd Fellows fraternity. The rings, words or letters embellish a multitude of objects including canes, furniture, plaques and ceramic jugs. (MP)

136*
Unidentified Artist
Pennsylvania
Odd Fellows Axe ca. 1860
Carved and painted wood
44 x 10 x 1 ⅛ in.
(111.8 x 25.4 x 2.9 cm)
Acquired from Betty Darrow, flea market,
Ann Arbor, Michigan, 1979
M1989.196

137
Unidentified Artist
Indiana
Small Odd Fellows Axe ca. 1870
Carved and painted wood
20 ⅛ x 7 ⅝ x ⅞ in.
(51.1 x 19.4 x 2.3 cm)
Acquired from Betty Darrow, flea market,
Ann Arbor, Michigan, 1979
M1989.200

Although many lodges use a carved axe as part of their ritual paraphernalia, it was a central symbol for the Modern Woodmen of America.[1] Odd Fellows axes symbolize the progress that a "pioneer makes . . . through the forest for the spread of civilization."[2] Some axes are painted with slogans such as "Feed the Orphan and the Widow," and contributions placed on the blade to help distressed members and their families.

As the geographical spread of these two axes indicates, by mid-nineteenth century the Odd Fellows were represented in 28 states throughout the East, Midwest, and South. Membership figures totaled 30,000 in 1843; this grew to 200,000 in 1860, and by 1900 over one million Americans had joined.[3] (MP)

1. Alvin J. Schmidt, ed., *The Greenwood Encyclopedia of American Institutions: Fraternal Organizations* (Westport: Greenwood Press, 1980), p. 219. Schmidt states that the Modern Woodmen of America lodge was organized in Iowa in 1883. The founder of the Woodmen created a philosophy that was "a strange mixture of Roman dignity and forest freedom."

2. J. Blanchard, *Revised Odd-Fellowship Illustrated: The Complete Revised Ritual of The Lodge, Encampment, Patriarch Militant and the Rebekah Degrees* (Chicago: Ezra A. Cook, 1889).

3. Reverend A.B. Grosh, *The Odd Fellows' Manual* (Philadelphia: Theodore Bliss, 1968), p. 35.

138*
Unidentified Artist
Ohio
Odd Fellows Ark ca. 1880
Carved, assembled and painted wood
with decoupage
14 ½ x 49 x 10 ½ in.
(36.8 x 124.5 x 26.7 cm)
Acquired from Jeffrey's Antique Gallery,
Findlay, Ohio, 1991
M1991.626

A mid-nineteenth century *Odd Fellows'
Manual* equates a lodgehall ark to the Old
Testament Ark which contained the gold-
en pot of manna, Aaron's budded rod,
and the Ten Commandments. Like the
biblical Ark of the Covenant, this object
symbolizes the importance of following
the moral laws of the fraternal order.
Such a relationship exemplifies how
religious iconography and rhetoric is
absorbed into fraternal orders. (MP)

Unidentified Artists, *Odd Fellows Axe*, ca. 1860 (cat. no. 136), and *Small Odd Fellows Axe*, ca. 1870
(cat. no. 137)

Unidentified Artist, *Odd Fellows Ark*, ca. 1880 (cat. no. 138)

Unidentified Artist, *Odd Fellows Eye of God*, ca. 1870 (cat. no. 139)

Unidentified Artist, *Odd Fellows Sun*, ca. 1870 (cat. no. 140)

Unidentified Artist, *Odd Fellows Skull and Crossbones*, ca. 1870 (cat. no. 141)

139*
Unidentified Artist
Indiana
Odd Fellows Eye of God ca. 1870
Painted wood and plaster
Diam. 13 ⅜ in. (34 cm)
Acquired from Pottinger/Walters
Antiques, Goshen, Indiana, 1980
M1989.192

A common symbol in many fraternal organizations, the "all-seeing eye" symbolizes God's constant watchfulness over man, and is often combined with the motto "In God We Trust." The "eye" originated with the Masonic fraternity, progenitor of all American fraternal associations. The Masons, first established in the United States in Boston in 1773, had many wealthy and influential men as members, including George Washington and twelve other American presidents. Furthermore, many Revolutionary War soldiers were Freemasons, and the presence of the "all-seeing eye" motif on United States currency, as well as Federal period decorative arts, illustrates the hybrid of fraternal and nationalistic prototypes. (JG & MP)

140
Unidentified Artist
Indiana
Odd Fellows Sun ca. 1870
Painted wood and plaster
Diam. 13 in. (33 cm)
Acquired from Pottinger/Walters
Antiques, Goshen, Indiana, 1980
M1989.191

The shining sun is an important symbol of friendship in the Odd Fellows' First or White Degree ritual. This plaque suggests that the sun shines for all members with impartial benevolence. Here, the absence of clouds suggests to members that the occasional storms that can cloud one's peace of mind should be met with patience and fortitude.[1]

The molded plaster construction of these two objects indicates a commercial origin. In fact, by the mid-nineteenth century, numerous mail-order enterprises, such as the Fuller Regalia and Costume Company of Worcester, Massachusetts, were supplying standardized regalia to fraternal organizations.[2] (JG & MP)

1. Reverend A.B. Grosh, *The Odd Fellows' Manual* (Philadelphia: Theodore Bliss, 1969), p. 105.

2. Alvin J. Schmidt, ed., *The Greenwood Encyclopedia of American Institutions: Fraternal Organizations* (Westport: Greenwood Press, 1980), p. 244. The Odd Fellows are often referred to as "the poor man's Masonry." This may account for the plethora of cruder handmade and small factory Odd Fellows materials, and the less prevalent fine silver objects that are part of Masonic ritual.

141
Unidentified Artist
Indiana
Odd Fellows Skull and Crossbones ca. 1870
Painted wood and plaster
Diam. 15 in. (38.1 cm)
Acquired from Pottinger/Walters
Antiques, Goshen, Indiana, 1980
M1989.193

142
Unidentified Artist
Ohio
Odd Fellows Coffin with Skeleton ca. 1880
Assembled and painted wood, hardware,
papier-mâché, wire, string, metal strips
and spring
12 x 70 ½ x 17 ⅛ in.
(30.5 x 179.1 x 43.5 cm)
Acquired from Robert Horn,
Eaton, Ohio, 1982
M1989.198

How different would be the
condition of such a person, if in the
days of his health and strength he
had become a member of our Noble
Order! A competency would have
smiled round his hearth-stone;
sympathizing friends would have
watched round his sick-bed; and he
would close his eyes in death with
the sweet assurance that his family
was left in the care of brothers.
— *Odd Fellows Text Book and Manual*
1876[1]

The Odd Fellows use several forms of
"memento mori" in their ceremonies, in-
cluding carved or molded plaster plaques
bearing a skull and crossbones, skeleton
busts and miniature wooden coffins.
Even full-size coffins with skeletons, both
real and fabricated as in this example,
have been found. It appears that these
symbols of death serve both as grim
reminders of mortality, and as images of
the financial security families could expect
after a member's death. The Odd
Fellows, like other fraternal orders, prom-
ised economic security for the families of
deceased members. As a result, older
men were often barred from joining the
organizations in order to insure that their
interest in the fraternity was not solely
financial. The *Coffin with Skeleton* is the
first object to be encountered during an
Odd Fellows Initiation Ceremony. The

initiate is led blindfolded into a room, at
which point the blindfold is removed so
that the initiate confronts his own mor-
tality. Each "bone" of this *Skeleton* is a
separate piece of shaped papier-mâché,
joined by twisted lengths of wire and
strips of flat metal. There is a metal
spring connecting the skull and lower jaw,
which can be opened and closed with a
small piece of attached string. This
dramatic effect was used during the
ceremony when the skeleton "spoke" his
words of wisdom to the initiate.
(MP & JRH)

1. Quoted in Barbara Franco, *Fraternally
Yours* (Lexington: Museum of Our National
Heritage, 1986), p. 73.

143
Unidentified Artist
Ohio
Odd Fellows Scythe ca. 1870
Carved, assembled and painted wood
43 x 25 ⅝ x 5 ⅜ in.
(109.2 x 65.1 x 13.7 cm)
Acquired from Pottinger/Walters
Antiques, Goshen, Indiana, 1980
M1989.201

The scythe is mentioned in the Odd
Fellows handbook in conjunction with the
Royal Purple Degree. This object cautions
initiates that grass will fall before the
scythe just as Man will eventually fall
before God.[1] (MP)

1. Reverend A.B. Grosh, *The Odd Fellows'
Manual* (Philadelphia: Theodore Bliss, 1968),
p. 299.

Unidentified Artist, *Odd Fellows Coffin with
Skeleton*, ca. 1880 (cat. no. 142)

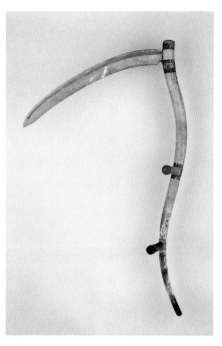

Unidentified Artist, *Odd Fellows Scythe*, ca. 1870 (cat. no. 143)

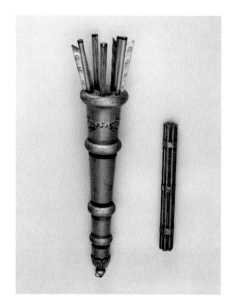

Unidentified Artists, *Odd Fellows Quiver of Arrows*, ca. 1875 (cat. no. 144), and *Odd Fellows Bundle of Sticks*, ca. 1850 (cat. no. 145)

144*
Unidentified Artist
Indiana
Odd Fellows Quiver of Arrows ca. 1875
Carved, assembled and painted wood
H. 29, Diam. 5 ½ in. (73.7 x 14 cm)
Acquired from Pottinger/Walters
Antiques, Goshen, Indiana, 1980
M1989.199

The quiver and arrows allude to the Old Testament covenant between Jonathan, Saul's oldest son, and David: "By them, we [the Odd Fellows] are taught to put forth every laudable effort to save a brother from the wrath of an enemy."[1] All American fraternal orders, for both men and women, stressed the group cohesiveness that was needed to survive the great social and economic changes of the period.

This object, along with the *Sun* (cat. no. 140), *Eye of God* (cat. no. 139), *Skull and Crossbones* (cat. no. 141), *Bundle of Sticks* (cat. no. 145), *Rings* (cat. no. 135), and *Scythe* (cat. no. 143) probably came from a Richmond, Indiana Odd Fellows lodge.[2] (MP & JG)

1. J. Blanchard, *Revised Odd-Fellowship Illustrated: The Complete Revised Ritual of the Lodge, Encampment, Patriarch Militant and the Rebekah Degrees* (Chicago: Ezra A. Cook, 1889), p. 130.

2. Hall Collection Provenance Records, Milwaukee Art Museum.

145*
Unidentified Artist
Ohio
Odd Fellows Bundle of Sticks ca. 1850
Carved and painted wood, string and glue
H. 14 ½, Diam. 1 ¾ in. (36.8, 4.5 cm)
Acquired from Pottinger/Walters
Antiques, Goshen, Indiana, 1980
M1989.194

As an integral part of the Odd Fellows' Second Degree ritual, the *Bundle of Sticks* symbolizes the need for mutual support between members. The work, constructed so that the center rod can be removed, demonstrates that "separated, we should be speedily broken and destroyed by the accumulating tide of worldly selfishness; but united as brothers, we bid defiance to all opposition and triumph over the greatest difficulties."[1] The image of the "bundle" is derived from the Roman fasces, a group of rods surrounding an axe with projecting blade, that served as a symbol of authority for Roman magistrates. (MP & JG)

1. J. Blanchard, *Revised Odd-Fellowship Illustrated: The Complete Revised Ritual of the Lodge, Encampment, Patriarch Militant and the Rebekah Degrees* (Chicago: Ezra A. Cook, 1889), p. 130.

Lodge Hall Paraphernalia

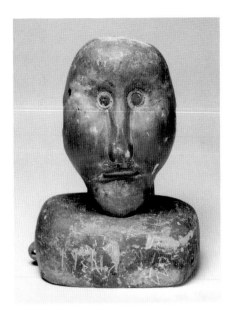

Unidentified Artist, *Stone Bust*, late 19th century (cat. no. 146)

146
Unidentified Artist
Missouri?
Stone Bust late 19th century
Carved and painted sandstone
9 x 6 ⅞ x 5 ⅝ in.
(22.9 x 17.5 x 14.3 cm)
Acquired from Timothy and Pamela Hill,
South Lyon, Michigan, 1975
M1989.132

This crudely carved bust and removable head, with stereotypical native American features, may have been part of a ballot box used by the Improved Order of Red Men.[1] This lodge based its philosophies and rituals on the romanticized lives of native Americans. The roughly incised images of Indians on either side of the base closely resemble other standardized profiles used on Red Men ritual objects. (MP)

1. Hall Collection Provenance Records, Milwaukee Art Museum.

147*
Unidentified Artist
Columbus, Ohio
Riding Goat on Wheels ca. 1923
Carved and assembled wood, steel, goat horns, cloth, leather, carpet, tacks, glue and newspaper
40 x 32 x 56 in.
(101.6 x 81.3 x 142.2 cm)
Acquired from Whitely Gallery,
Los Angeles, California, 1983
M1989.145

In the Modern Woodmen's initiation ceremony, an initiate symbolically experiences the perils of a non-member. "After being led through a ritual as a blind pauper, he [the initiate] was placed on a mechanical goat, which hung from the ceiling or moved on wheels. The goat and rider were lurched about, disoriented and completely out of control, an experience that was surely both frightening and humbling."[1] Such ceremonies stemmed from broader Masonic traditions, and goats used by Woodmen, Odd Fellows and other fraternities have been documented.

Occasionally, although not in this case, the goat was electrified so that a current could jolt the unsuspecting initiate through the saddle. This mild shock symbolically paralleled the goat's reputedly lascivious behavior. Such a painful lesson taught responsibility while simultaneously providing entertainment for seasoned members. (MP)

1. Lisa Stone, "The Painted Forest," *The Clarion* (Winter 1985), pp. 54-63.

Unidentified Artist, *Riding Goat on Wheels*, ca. 1923 (cat. no. 147)

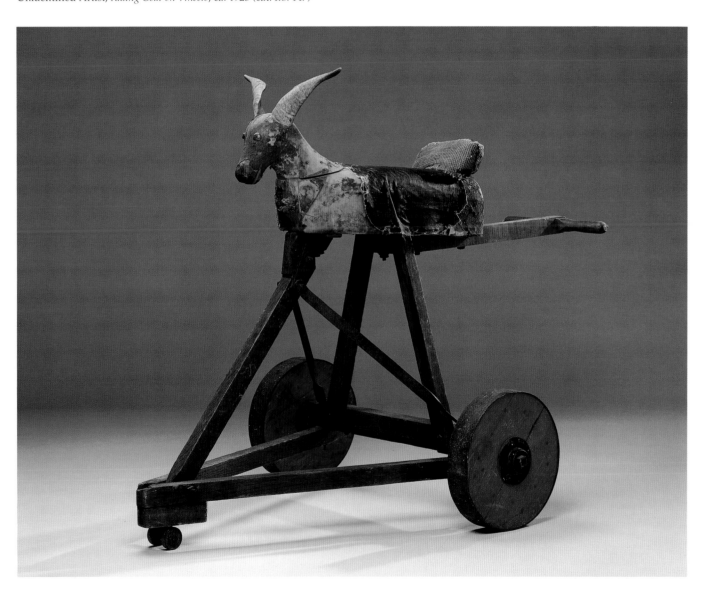

Toys & Models

Toys have always evoked a sense of innocence and child-like freedom. They provide passage into the world of imagination through their dismissal of adult, mature perspective. Although created as diversions from the rigors of daily life, toys are often accurate reflections of contemporary culture. For example *Smoking Man* (cat. no. 151) cleverly mimics the "habit" of a uniformed adult. Likewise, *The World of Work* crank toy (cat. no. 154) is an appraisal of American work standards in the early to mid-20th century.

As Donald Kuspit has written, "the folk object, then, is a species of toy . . . 'Reality' disappears at the same moment that it reappears in the sign-fragments of the folk art object, which is what it means to treat reality playfully and give it a soul unimaginable to the adult mind."[1] Kuspit recognized a paradigm in which folk art becomes the "toy" side of art: "This definition of folk art as toy-like is a response to its spiritual or psychosocial function in the contemporary art world. Contemporary affection, even admiration for folk art, presupposes the necessity for a new childhood for art, in the situation of its presumed decadence."[2] Such a view is certainly ingrained in traditional understandings of folk art that look at it as charming, naive or quaint.[3] Yet the toy remains central to folk art, perhaps by fulfilling longings for innocence and simplicity while simultaneously affording an alternative and insightful view into reality. (JG)

1. Donald Kuspit, "'Suffer The Little Children To Come Unto Me': Twentieth Century Folk Art," in *American Folk Art: The Herbert Waide Hemphill Jr. Collection* (Milwaukee: Milwaukee Art Museum, 1981), p. 39.

2. Kuspit, "'Suffer The Little Children To Come Unto Me,'" p. 40.

3. See, for example, Holger Cahill, *American Folk Sculpture* (Newark: The Newark Museum, 1931), pp. 13-18.

Unidentified Artist, *Checkers Game Board*, ca. 1875 (cat. no. 148)

Unidentified Artist, *Parcheesi Game Board*, ca. 1875 (cat. no. 149)

148
Unidentified Artist
Indiana
Checkers Game Board ca. 1875
Painted wooden panel
13 ³⁄₈ x 14 ½ x 1 ¼ in.
(34 x 36.8 x 3.2 cm)
Acquired from H. Alan Wainwright,
Medina, Ohio, 1972
M1989.217

This traditional checkerboard is framed
on two sides with breadboard ends. Origi-
nally used in furniture construction to
prevent warping and obscure rough
edges, these borders enhance an otherwise
plain design. (BU)

149
Unidentified Artist
Ohio
Parcheesi Game Board ca. 1875
Painted wooden panel
20 ¾ x 24 x 1 ¼ in.
(52.7 x 61 x 3.2 cm)
Acquired from Peaceable Kingdom Ltd.,
New York, 1971
M1989.216

Throughout the nineteenth century,
family evenings often centered around
playing popular games. Like many
objects found in American homes, game-
boards were handmade and handpainted.
Even after commercial versions became
available in the mid-nineteenth century,
gameboards continued to be handcrafted
either for family use or as gifts.[1] (BU)

1. Bruce J. and Doranna Wendel, "Winning
Moves: Painted Gameboards of North
America," *The Clarion* (Winter 1985),
pp. 48-53.

150
Unidentified Artist
Thoroughbred Horse
late 19th century
Carved wood with applied bronze paint
9 ¾ x 2 ½ x 11 in.
(24.8 x 6.4 x 27.9 cm)
Acquired from Country Schoolroom
Antiques, Paw Paw, Michigan, 1979
M1989.153

In folk art, the horse has long been
featured in weathervanes, hooked rugs,
shop signs, rocking and carousel horses.
This small carving from a single block of
wood may have once served as a child's
toy, although its delicate nature and hand-
some proportions raise the possibility of a
more precious or purely decorative func-
tion. (BU)

Unidentified Artist, *Thoroughbred Horse*, late 19th century (cat. no. 150)

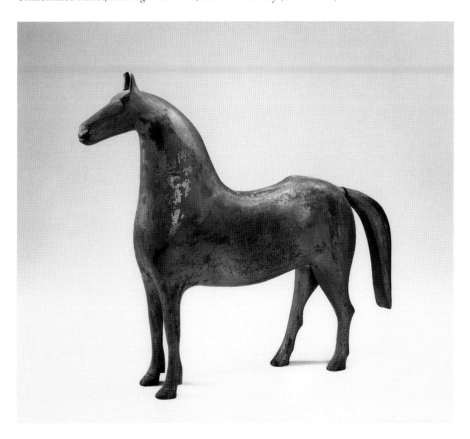

Toys & Models

151*
Unidentified Artist
Pennsylvania?
Smoking Man
late 19th-early 20th century
Carved, painted and varnished wood, nails
10 ¼ x 3 ¾ x 2 ¾ in.
(26 x 9.5 x 7 cm)
Acquired from Herbert W. Hemphill Jr.,
New York, 1978
M1989.131

This is an American version of the
"smoker" — a popular German toy carved
like a nutcracker in which the flat head,
rectangular torso with square shoulders,
rigid arms, and clothespin-like legs attach
to a square base. Smokers were enter-
taining gadgets with detachable torsos
that allowed incense to be placed in a pan
clipped inside the lower section. Once the
top was replaced, smoke from the burning
incense escaped through the mouth in
rings. Most of these toys were made
during quiet winter months in the moun-
tainous Thuringer Wald and Erzebirge
regions of southeastern Germany when
the logging industry slowed. Usually
they were carved to resemble mountain
men or foresters.

Probably from Pennsylvania, this toy
was undoubtedly made by someone
familiar with Germanic tradition despite
the figure being dressed in the uniform of
a soldier, bell-hop or train conductor.
Although he comes apart like a German
smoker, he lacks the tiny incense holder;
the same effect, however, could probably
be achieved by placing a cigarette inside
the hollowed body. (BU)

Unidentified Artist, *Smoking Man*, late
19th-early 20th century (cat. no. 151)

152*
John Scholl
Germania, Pennsylvania
Acrobats ca. 1910
Carved and painted wood, metal and
leather parts
33 x 20 x 13 in.
(83.8 x 50.8 x 33 cm)
Acquired from Stony Point Folk Art
Gallery, Stony Point, New York, 1970
M1989.180

John Scholl, who whittled throughout
his life, began to carve intricate wooden
sculpture in his eighties. This mechanized
wooden "toy" is one of forty-two surviv-
ing examples.[1] Its simple wooden gears
and string recall the toys of his German
childhood, while the cross and dove
motifs reflect the iconographic legacy of
southeastern Pennsylvania's early German-
speaking settlers ("Pennsylvania Dutch").
The balustrade rails and wooden balls —
decorative Victorian architectural forms —
stem from his long career as a carpenter.
(BU)

1. See Katherine C. Grier, *Celebrations in
Wood: The Sculpture of John Scholl (1827-1916)*
(Harrisburg, Pennsylvania: William Penn
Memorial Museum, 1979). According to
Grier, Scholl's "toys" were not meant to be
played with, although Scholl loved to
demonstrate them. A photo of the parlor of
Scholl's house that shows his pieces in situ
can also be seen in Charlotte Emans, "In
Celebration of a Sunburst: The Sculpture of
John Scholl," *The Clarion* (Fall 1983),
pp. 56-59.

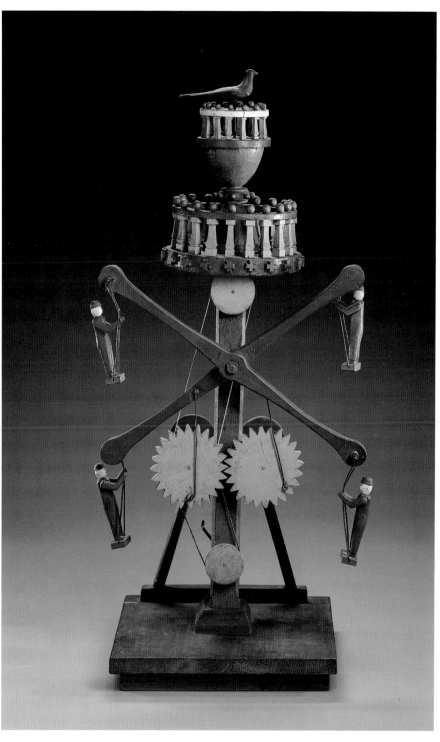

John Scholl, *Acrobats*, ca. 1910 (cat. no. 152)

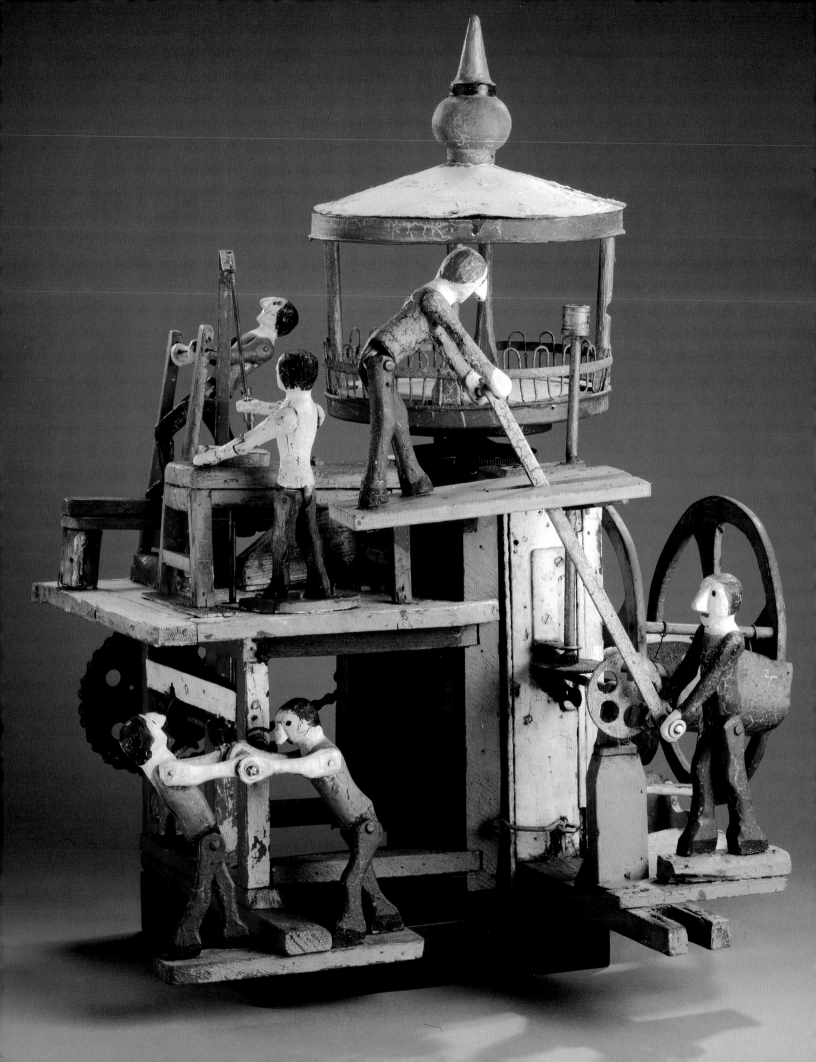

153*
Unidentified Artist
Midwest
Dancing Doll ca. 1920
Doweled and assembled wood, wire pins
and bead eyes
9 x 2 ¼ x 1 in.
(22.9 x 5.7 x 2.5 cm)
Acquired from The Keeping Room,
Ferndale, Michigan, 1979
M1989.133

This jointed *Doll* is carved in the tradi-
tion of eighteenth- and nineteenth-century
milliner's dolls. However, its mortise and
tenon joints, assembled with finishing
nails rather than pegs, suggest a later
date. Used by milliners to advertise the
latest fashions, such dolls also made
popular toys. A stick, inserted into a slit
in the doll's back, enabled a child to shake
its loosely jointed legs or make it "dance."
(BU)

Unidentified Artist, *Dancing Doll*, ca. 1920
(cat. no. 153)

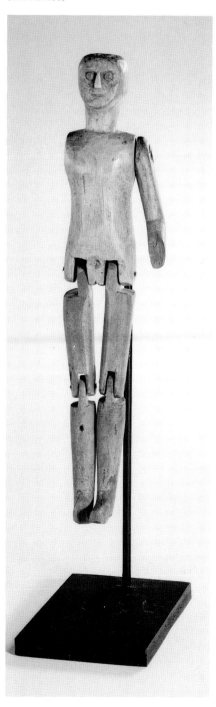

154*
Unidentified Artist
Missouri
The World of Work ca. 1940
Carved and painted wood with metal
gears and crank
27 x 30 x 34 in.
(68.6 x 76.2 x 86.4 cm)
Acquired from Dale Eldred, Kansas City,
Missouri, 1978
M1989.183

In this mechanical "crank toy", pulleys
made from found objects such as a bicycle
chain, gears, belts, and bolts are activated
by turning a handle. Once in motion, one
figure operates a foot pump while the
man next to him manages a grinding
wheel. Two other men saw in a backward-
forward motion and the remaining two
workers, joined by hand, move back and
forth, up and down. Slightly above the
workroom is a revolving gazebo, perhaps
a watchtower for management.

Like *Fighting Cats* (cat. no. 160), this all-
male kinesis appears to parody the
American "work ethic" by humorously
suggesting the endless grind of repetitive
toil. (BU)

Unidentified Artist, *The World of Work*, ca.
1940 (cat. no. 154)

Sculpture

155*
Luther Jones
Livingston, Kentucky
L & N Engine and Tender ca. 1960
Painted wood, tin, jar lids, nails, radio
wire, spools, springs, popsicle sticks,
staples, glue and coal
14 x 12 x 78 in.
(35.6 x 30.5 x 198.1 cm)
Acquired from Stagecoach Antiques,
Georgetown, Kentucky, 1969
M1989.184

This replica of a Louisville & Nashville engine and tender was made by a railroad employee who lived in Livingston, Kentucky, between Berea and Corbin, in the mountainous Daniel Boone National Forest. At one time, this was a shipping center for coal mined in the region, and due in part to the natural barriers, routes developed in a north-south direction with an L & N short line running from Richmond, Kentucky, through Berea, to Jellico, Tennessee.

Throughout the piece, Jones exhibits modernist sensibilities by conflating real and inventive elements. For example, although actual metal nails are used in some places, he cleverly paints trompe l'oeil replicas in others. Similarly, he incorporates diverse found objects: the engine and tender are made of logs; the wheels are lids from Crisco cans and baby food jars; the smoke stacks are spools, while another spool suffices for a headlight; and the rods are radio wire. Nevertheless, in a final clever twist, the tender carries real coal. (BU)

Luther Jones, *L & N Engine and Tender*, ca. 1960 (cat. no. 155)

Whirligigs, from the Middle English word *whirlegigge* meaning "toy that spins," date from the Late Middle Ages when Europeans began to use wind-driven devices to entertain children (pinwheels), as well as to pump water, grind grain, and perform other practical tasks (windmills). Brought to America by early settlers, they afforded simple pleasure amid hardship, sometimes doubled as scarecrows or weathervanes, and served in Pennsylvania as "Sabbath Day toys" when other playthings were prohibited. Throughout the nineteenth century, whirligigs grew increasingly complex and sculptural, and along with articulated dolls, limberjacks, and other related figures, attained their fullest development.[1]

The nine examples in the Hall Collection, all unique and handcarved during the whirligig's mid-nineteenth- to early twentieth-century heyday, illustrate primary structural and topical preferences. Three basic designs for the classic, single figure whirligigs include 1) straight arm + paddles that are mounted close to the shoulders on a rod running through the body (*Teddy Roosevelt*, cat. no. 162); 2) arm-paddles that are bent at the elbows or wrists (*Soldier*, cat. no. 157); and 3) arms that project straight from the shoulders with paddles turning in a perpendicular direction (*Man with Top Hat*, cat. no. 158). These are followed by more elaborate, multifigural works with integrated rod, gear, and propeller assemblies (*Fighting Cats*, cat. no. 160). Although most whirligigs were intended merely to amuse (*Pumping Man*, cat. no. 161) or to poke fun at figures of authority (*Abraham Lincoln*, cat. no. 159), others appear to honor their subject (*George Washington on Horseback*, cat. no. 156), and a few represent more ambitious narrative or social themes (*The Sport World*, cat. no. 163). By

the 1930s, mass produced commercial replicas and popular "plank-type" versions cut by hobbyists from magazine patterns all but eclipsed what has been deemed "the true folk art of the immigrant woodcarver and Yankee whittler to whom idle hands were sinful."[2] (JRH)

1. See Ken Fitzgerald, *Weathervanes and Whirligigs* (New York: Brahmhill House, 1967) and Robert Bishop and Patricia Coblentz, *A Gallery of American Weathervanes and Whirligigs* (New York: E.P. Dutton, 1981).

2. Charles Klamkin, "Wind Toys," *Weather Vanes* (New York: Hawthorne Books, 1973), p. 194.

156*
Unidentified Artist
Indiana
George Washington on Horseback ca. 1850
Carved wood with nails, glue and varnish
13 x 10 ¼ x 2 ¾ in.
(33 x 26 x 7 cm)
Acquired from Robert Horn,
Eaton, Ohio, 1974
M1989.163

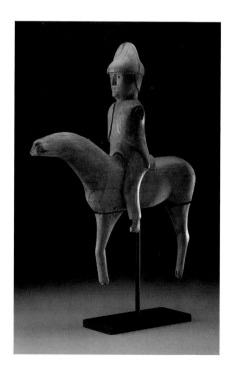

Unidentified Artist, *George Washington on Horseback*, ca. 1850 (cat. no. 156)

This whirligig was found in Henry County, Indiana, and once had arms "with sword paddles" which are now lost.[1] Also missing are the figure's feet and the horse's tail, hoofs, and part of its head, including the lower jaw, most facial detail, and a bridal which probably attached to three small remaining nails. Despite this damage, the piece still shows masterful carving, well balanced design, and an economy of form epitomized by the horse's inventively consolidated front and hind legs.

Prominent or powerful people were popular (and sometimes unpopular) sources of inspiration for whirligigs, as evidenced by the three Presidential subjects in the Hall Collection. This example was almost certainly positive since "throughout the 1840s and 1850s interest in George Washington, America's supreme *exemplum virtutis*, ran extraordinarily high. Coming at a time of flourishing prosperity and increasing estimation of the country's own history and destiny, the veneration of Washington helped link Americans and foster national identity."[2] Although "cult of Washington" nationalism was openly demonstrated by professional sculptors Henry Kirke Brown and Thomas Crawford in mid-century equestrian monuments for New York City and Richmond, Virginia, similar sentiments must have also influenced the makers of *George Washington on Horseback* and other local icons. (JRH)

1. Hall Collection Provenance Records, Milwaukee Art Museum.

2. Mark Thistlethwaite, *Grand Illusions* (Fort Worth: Amon Carter Museum, 1988), p. 39.

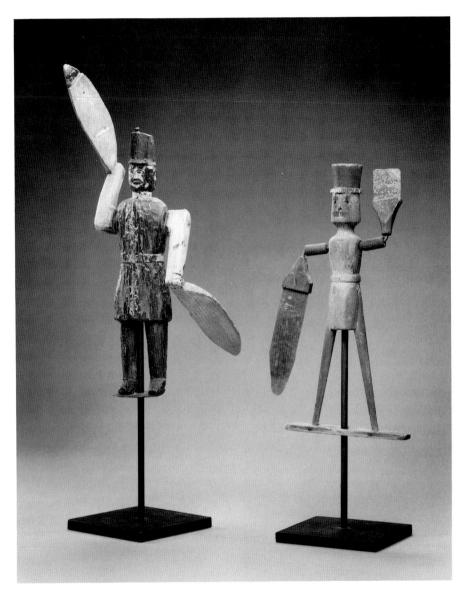

Unidentified Artists, *Soldier*, mid-19th century (cat. no. 157), and *Man with Top Hat*, mid- to late 19th century (cat. no. 158)

157*
Unidentified Artist
Pennsylvania?
Soldier mid-19th century
Carved and painted wood, nails and metal rod
14 ¾ x 5 ½ x 6 ¼ in.
(37.5 x 14 x 15.9 cm)
Acquired from Maze Pottinger Antiques, Bloomfield Hills, Michigan, 1970
M1989.166

In contrast to *George Washington on Horseback* (cat. no. 156), the actions of this authority figure evoke more ridicule than respect. Soldier whirligigs probably originated in Pennsylvania, where eighteenth-century carvers scornfully portrayed the Hessian mercenaries who had fought for the British and were even rumored to "eat little children."[1] This *Soldier*'s uniform does not appear to be Hessian, but he does recall another image of futility from Washington Irving's *The Legend of Sleepy Hollow*, wherein "honest Balt would sit smoking his evening pipe [while] watching the achievements of a little wooden warrior who, armed with a sword in each hand, was most valiantly fighting the wind."

Except for his feet and arms, the *Soldier* is carved from a single piece of wood. His typically oversized blades, though secured to the arm in an unusual manner, are set at opposite angles so that when one cuts the wind the other always faces it. (JRH & JH)

1. Rodney Atwood, *The Hessians* (New York: Cambridge University Press, 1980), p. 60.

158*
Unidentified Artist
Pennsylvania
Man with Top Hat
mid- to late 19th century
Carved wood and tin with paint, nails
and metal hardware
9 ⅞ x 6 ¼ x 1 ¼ in.
(25.1 x 15.9 x 3.2 cm)
Acquired from Maze Pottinger Antiques,
Bloomfield Hills, Michigan, 1970
M1989.164

A resourceful artist used a chair turn-
ing to form the head and torso of *Man
with Top Hat*, while his hat and extremities
were made from separate pieces of wood.
The same maker produced at least one
other whirligig (Harvey and Isobel Kahn
Collection), judging from the distinctive
tapered legs which are inset slightly and
nailed to the body.[1] The top hat, elevated
brows, and full moustache suggest that
this may have been meant as a comedic
"portrait" of high society, although the
traces of white, red, and yellow paint add
the possibility of an always energetic
Uncle Sam figure. (JRH & JH)

1. Hall Collection Provenance Records,
Milwaukee Art Museum, and Robert Bishop
and Patricia Coblentz, *A Gallery of American
Weathervanes and Whirligigs* (New York: E. P.
Dutton, 1981), p. 122.

Unidentified Artist, *Abraham Lincoln*, ca.
1870 (cat. no. 159)

159
Unidentified Artist
Maryland
Abraham Lincoln ca. 1870
Carved and painted wood, metal rod
and hardware
20 x 6 ½ x 2 ½ in.
(50.8 x 16.5 x 6.4 cm)
Acquired from Stephen Score, Maine, 1978
M1989.165

According to dealer Stephen Score, this
piece was found in a shed on the eastern
shore of Maryland.[1] Because it originally
faced another figure on a common base, it
is believed to represent Abraham Lincoln
during his famous debates with U.S.
Senate seat opponent Stephen Douglas in
1858. Lincoln was indeed beardless at
that time, and both men are shown with-
out hats but formally attired. Moreover,
the caricatural figure of Douglas (George
Meyer Collection) is noticeably shorter
with slicked back hair and a portly
physique.

The Lincoln-Douglas debates centered
around the issue of slavery, with Lincoln
contending that free and slave states
could no longer coexist and his adversary
maintaining that they could. Although
personal friends, their public arguments
were often fierce, and on at least one oc-
casion, their excited audience encouraged
them to come to physical blows.[2] This
whirligig, when complete and activated,
would have effectively conveyed that
extreme sentiment in keeping with the
medium's traditional penchant for satire
and absurdity.

Besides missing its right arm and
probably a necktie, *Abraham Lincoln* is the
only whirligig in the collection whose arm
and arm blades are carved from different
blocks of wood. (JH & JRH)

1. Hall Collection Provenance Records,
Milwaukee Art Museum.

2. Don E. Fehrenbacher, *Abraham Lincoln
Speeches and Writings 1832-1858* (New York:
Library of America, 1975), pp. 485-86.

Whirligigs

160*
Unidentified Artist
Northeast
Fighting Cats late 19th century
Carved and painted wood, metal, leather,
fabric, wire, hardware and glue
29 x 23 ¾ x 19 ½ in.
(73.7 x 60.3 x 49.5 cm)
Acquired from Kennedy Galleries,
New York, 1974
M1989.171

Unidentified Artist, *Fighting Cats*, late 19th century (detail, cat. no. 160)

Only the most sophisticated whirligigs
contain a gearbox that protects key parts
and preserves lubrication. In this case,
that housing also includes a crank which
permits the whirligig to be hand-wound
and driven by springs as well as by the
wind. This mechanical finesse extends to
an overall system of precisely carved and
coordinated outer gears, leather pulleys,
wire push rods, and jointed figures with
detailed features, costumes, and acces-
sories.

Fighting Cats is the colloquial name
given by the Halls to this whirligig, which
is thought to be by the same hand that
made the equally elaborate *Early Bird Gets
The Worm* (Museum of American Folk
Art).[1] Besides their physical kinship, both
works also carry strong socioeconomic
overtones. While the latter shows obvious
racial bias, *Fighting Cats* appears to empha-
size class differences during a period of
intense but largely unregulated indus-
trialization. The factory setting, tophatted
owner perched on his stool, and trio of
workers sawing, running, and literally
doing back-flips behind him support this
view, as does a larger (emblematic?) fig-
ure who gestures frantically from above in
a shirt marked STOP and HELP. The
meaning of the four cats, who were often
kept in factories as mousers, is less clear.
Their blackness usually connotes evil, and
their face-to-face pairings may very well
reinforce political conflict or "fighting" as
the theme. Interestingly, a bicycle bell set
to ring constantly on the back of this
piece no doubt heightens the sense of
workplace pressure, but given the prover-
bial tenor of *Early Bird Gets The Worm*, it
also brings to mind Aesop's fable of the
mice who conspire to "bell-the-cat" in
order to protect themselves. (JRH)

1. Robert Bishop and Patricia Coblentz, *A
Gallery of American Weathervanes and Whir-
ligigs* (New York: E. P. Dutton, 1981), p. 107.

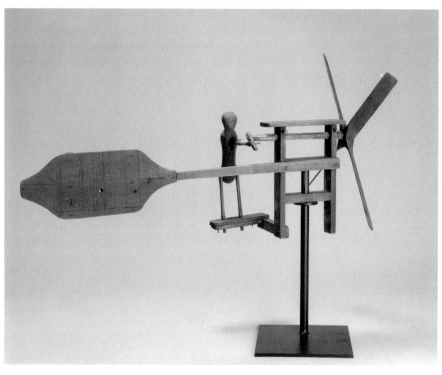

Unidentified Artist, *Pumping Man*, ca. 1900 (cat. no. 161)

Unidentified Artist, *Fighting Cats*, late 19th century (cat. no. 160)

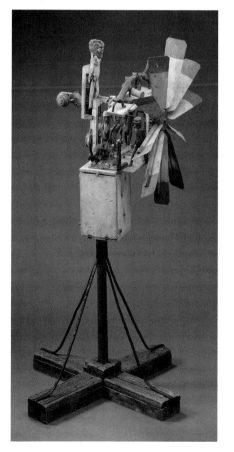

161*
Unidentified Artist
Ohio
Pumping Man ca. 1900
Carved and assembled wood, traces of paint and metal hardware
24 x 38 ½ x 24 in.
(61 x 97.8 x 61 cm)
Acquired from James Kronen, Berman Kronen Gallery, New York, 1973
M1989.170

In contrast to *The Sport World*'s (cat. no. 163) unusual complexity, this combination whirligig-weathervane consists of an upright front propeller that drives a single figure, and a plain horizontal shaft that leads to a broader tail section. The simply rendered subject is also a standard — pumping figures and other "perpetual" laborers (e.g., sawing, milking, washing) are customary emblems of hard work found in this predominantly rural form of folk sculpture. (JRH)

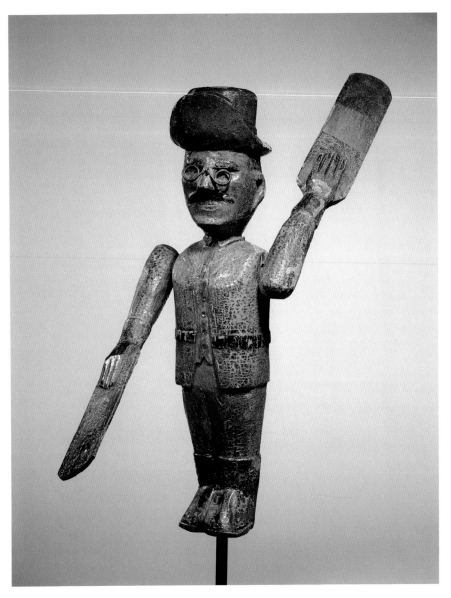

Unidentified Artist, *Teddy Roosevelt the Rough Rider*, ca. 1910 (cat. no. 162)

162*
Unidentified Artist
New York State
Teddy Roosevelt the Rough Rider ca. 1910
Carved and painted wood with wire
11 ¼ x 4 ½ x 2 in.
(28.6 x 11.4 x 5.1 cm)
Acquired from David Pottinger,
Bloomfield Hills, Michigan, 1974
M1989.168

Everyone saw Roosevelt . . . In his soiled brown trousers and white suspenders crossed over his blue shirt, he was the most conspicuous man on the field. With a typical Roosevelt flair . . . he had tied a blue bandanna to his hat which streamed behind him like a banner. He did not have his saber — he never carried it in battle again after it had tripped him at Guasimas — but he punctuated his shouts of encouragement by waving his revolver over his head. The Arizona men never forgot his performance.[1]

On May 6, 1898, Assistant Secretary of the Navy Theodore Roosevelt resigned to become second-in-command of the First U.S. Volunteer Cavalry, soon to be known as the Rough Riders. Assembled shortly after President McKinley declared war on Spain over Cuba — a confrontation which Roosevelt actively promoted as the "opportunity to drive the Spanish from the Western World" — the Rough Riders were an odd mix of Western cowboys and lawmen, Eastern police, prominent athletes, and Ivy League alumnae that mirrored Teddy's own past as rancher, police commissioner, avid sportsman, and Harvard graduate. This colorful unit, also dubbed Colonel "Wood's Weary Walkers" because only the officers were ultimately allowed horses, fought bravely at Las Guasimas and Kettle (not San Juan) Hill, where Roosevelt took command and became a hero.[2] His war record led quickly to the New York governorship in 1898, the U.S. vice-presidency in 1900, and after McKinley's assassination in 1901,

Roosevelt became the nation's youngest president at forty-two.

Voted "greatest American" in a 1913 poll, Teddy the Rough Rider remained Roosevelt's official persona throughout his career.[3] That resolute image — in khaki uniform and high boots with hat blown back, steel spectacles, teeth bared, and arms waving — still endures in this rare and skillfully crafted whirligig. (JRH & JH)

1. Charles Weaver, *Arizona Rough Riders* (Tucson: University of Arizona Press, 1970), p. 146.

2. Edmund Morris, *The Rise of Theodore Roosevelt* (New York: Coward, McCann, & Geoghegan, 1979), pp. 593-661.

3. See Albert Shaw, *A Cartoon History of Roosevelt's Career* (New York: Reviews Company, 1910), p. 39.

163*
Unidentified Artist
Pennsylvania
The Sport World ca. 1920s
Carved and painted wood, metal, plaster and hardware
58 x 92 ½ x 14 ½ in.
(147.3 x 234.9 x 36.8 cm)
Acquired from Harry and Maudie Zane, Red Barn Antiques, Intercourse, Pennsylvania, 1969
M1989.169

The Sport World is a monumental whirligig-weathervane that originally stood on a "derrick-like structure" in the front yard of a Lancaster County, Pennsylvania farm.[1] Nearly eight feet long, its principal features include a U.S. flag and flagpole, four propellers, eleven figures, two seesaws, a merry-go-round, central gazebo, and tail section in the form of a bull's-eye. Between the gazebo and tail, there is also an enclosed platform where footings indicate two boxers once stood, each larger than the other figures and animated by overhead propellers. Made primarily of wood with metal push rods and fittings, each figure is modeled with plaster details, miniature composition shingles cover the gazebo, and the whole is painted in mostly red, white, and blue. Michael Hall, who carefully constructed a new drop-shaft for the lower seesaw shortly after obtaining the piece, describes it as a "fascinating device . . . an interesting survival of earlier Pennsylvania toy, whimsy, wind-driven things. It's direct — it's not refined craftsmanship, but it's good craftsmanship . . . very coherent, very straight through, no unattended details."[2]

The multilayered, ostensibly patriotic color scheme, the knickers and short hair worn by all seven female figures, and specific materials such as the modern shingles and brass bushing beneath the main horizontal bar support a 1920s dating of this work. The theme itself further suggests that *The Sport World* was created during what one contemporary historian called the "Age of Play" when

many Americans first gained the knowledge that "unremitting toil is not necessarily a law of human destiny . . . (and) millions learned to play where only thousands played before."[3] Indeed, shorter work hours and increased income during the 1920s gave rise to a Recreation Movement that doubled the nation's playground facilities, spurred unprecedented growth in public as well as commercial amusement parks, and made professional spectator sports a major industry.[4] Because boxing was especially successful during this decade when ten top bouts earned over eleven million dollars, it is tempting to surmise that *The Sport World*'s two missing figures were carved in honor of heavyweight champions Jack Dempsey and Gene Tunney whose 1926 fight in nearby Philadelphia drew an astounding 120,000 fans. (JRH & JH)

1. Maudie Zane, per Michael and Julie Hall, interview by Julia Guernsey and Debra Brindis, 1 August 1991, transcript, Milwaukee Art Museum, and Hall Collection Provenance Records, Milwaukee Art Museum.

2. Michael and Julie Hall, interview by Julia Guernsey and Debra Brindis, 1 August 1991, transcript, Milwaukee Art Museum.

3. Robert Duffus, "The Age of Play" (1924), *Annals of America* 14 (Chicago: Encyclopedia Britannica Incorporated, 1968), p. 468.

4. See Jesse F. Steiner, *Americans at Play: Recent Trends in Recreation* (New York: McGraw-Hill Incorporated, 1933), pp. 1-121.

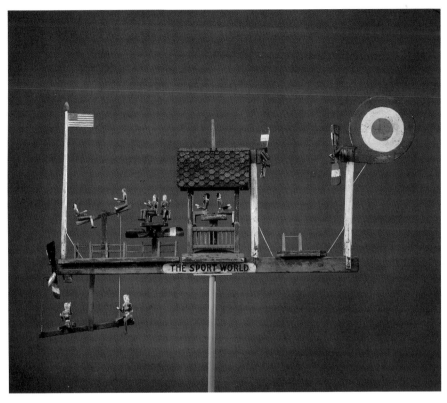

Unidentified Artist, *The Sport World*, ca. 1920s (cat. no. 163)

164
Unidentified Artist
Ohio?
Man with a Tin Cap ca. 1930s
Carved and painted wood, tin, glue and
metal hardware
23 ¼ x 8 x 5 in.
(59.1 x 20.3 x 12.7 cm)
Acquired from Elliot and Elliot
Antiques, Harbor Springs, Michigan, 1986
M1989.167

The scale, densely layered surface
color, and heavy base of this figure
suggest that it once stood on a pedestal as
a conspicuous yard ornament. Its formal
and structural severity, which consists of a
single piece of wood, irregularly cut sheet
metal blades and cap, and assorted
hardware, exemplifies the homemade,
seemingly "primitive" side of American
folk art. (JRH)

Unidentified Artist, *Man with a Tin Cap*,
ca. 1930s (cat. no. 164)

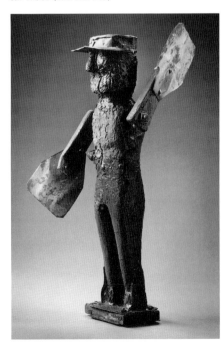

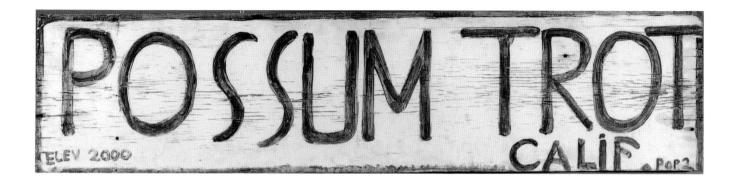

Calvin Black married Ruby Ross, twelve years his junior, in 1933. Ruby, who had never been outside of Tennessee, then followed her husband to California to pan for gold. Eventually, they bought land, site unseen, in the Mojave Desert outside Yermo. Taking advantage of the occasional tourists who passed their land en route to *Knott's Berry Farm Ghost Town*, Ruby opened a rock and souvenir shop. While she supported them with this meager income, Calvin began to build his own attraction, *Possum Trot*, which took its name from a Southern term for the shortest distance between two points.

Although it started with a wooden train and several wind propelled merry-go-rounds, *Possum Trot* eventually became a hundred yard stretch of carousels, stagecoaches, and Ferris wheels. Calvin also carved dozens of wind-powered dolls from wood that he scavenged from fence posts and telephone poles hit in car accidents on the road which passed their home. By 1969 Calvin had built the "Birdcage Theatre," a roughly enclosed building with a low stage on which visitors, for fifty cents, could see the "Beautiful Dolls of the Desert Wasteland" perform. Although the great majority of dolls that Calvin carved were female, he did create several male dolls, including "Big Chief" and "Jim and His Limb," that remained outdoors.

Although similar in their long, smooth faces and stylized features, each of Calvin's female dolls was an individual, modeled after a friend or famous woman. The "adult" dolls each had carved cork breasts which were attached by nails to their chests. Many also wore bras, slips and undergarments, as well as frocks and dresses that Ruby designed. Ironically, although she was in charge of clothing the dolls, Ruby did not take part in their performances, but instead remained in the shop to wait on customers. As if to compensate for her absence, Calvin created a "Ruby" doll who participated in the shows.[1]

Eventually dissatisfied with dolls that only moved, Calvin endowed them with the ability to speak and sing through a system of speakers and recorded tapes. On these tapes, Calvin supplied the narrative, talking and singing in a different falsetto voice for each doll. Between numbers, he took the part of Helen Marvel, mistress of ceremonies, and responded to her invitations to sing in the voices of other dolls. He often came out from behind the curtains during performances to watch, mesmerized by his creations and their talents. After especially successful performances, he would talk to the dolls and apply perfume to their bodies.

After Calvin's death, Ruby explained that "we didn't never have any children . . . He called [the dolls] our children."[2] She added that the dolls often accompanied them on visits with friends and relatives in the South. The dolls undoubtedly served to fulfill unsatisfied needs and fantasies; indeed, Calvin's resolve to create this very personal community and environment recalls Oskar Kokoschka's obsessive attachment to a life-size doll, as well as other surrogate companions devised by Armando Reverón.

Calvin described his creation as "a bunch of girls in a gilded bird cage."[3] Put another way, Calvin established a patriarchy; though he invested each doll with the personality and attributes of a living woman, he alone could dictate and implement such qualities. In a final mandate to Ruby, Calvin told her to burn the dolls after his death so that they would not be separated. Ruby, however, refused, "I wouldn't do no such thing, 'cuz when I made a promise to a person I carried it out, and I wasn't gonna a burn the dolls."[4] (KB & JG)

1. As seen in the film by Allie Light and Irving Saraf, producers, *Possum Trot — The Life and Work of Calvin Black* (San Francisco: Light-Saraf Films, 1976).

2. Light and Saraf, *Possum Trot.*

3. Light and Saraf, *Possum Trot.*

4. Ann Japenga, "From Out of the Desert, Wooden Dolls Carved a Niche in Folk Art World," *Los Angeles Times*, 7 December 1986, part VI.

Calvin and Ruby Black, *Possum Trot Midget Doll Theatre*, ca. 1950-1972 (cat. no. 165)

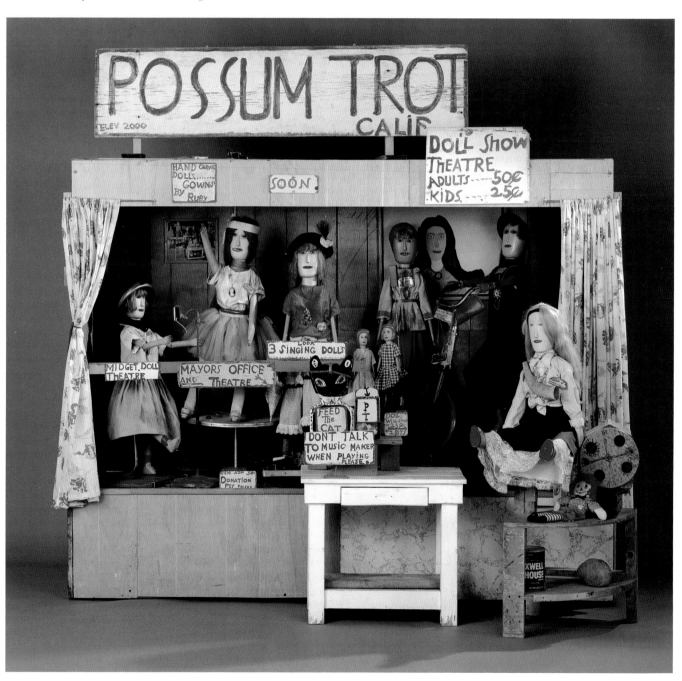

Calvin and Ruby Black
Yermo, California
Possum Trot Midget Doll Theatre *
ca. 1950-1972
Wood, wood paneling, laminated
masonite, nails, bolts, paint, electrical
components and carved and assembled
dolls
81 ⅞ x 98 ¼ x 28 ¾ in.
(208 x 249.6 x 73 cm)
M1989.325.1-21

The *Possum Trot* stage was constructed
by Michael Hall and Ken Steinbach to
replicate the original stage created by
Calvin Black for his *Fantasy Doll Show*.
The frame consists of lumber, overlaid
with scraps of plywood and laminated
masonite. Conceived as a flexible struc-
ture, the stage serves not only as a perfor-
mance arena with walls and stage floor,
but it also houses sound and light equip-
ment and mechanical activators which
move some of the dolls. This equipment
is installed under the stage floor and
accessed behind the stage. In Black's
original version, several of the dolls
moved by pulley systems attached to
wind driven devices on the theatre roof.
Here, however, Hall utilizes a motor and
pulleys to replicate the original wind-
propelled mobility that allowed Maple
Harris to bicycle, and Helen Marvel to
rotate on her stand.

The wiring attached to several of the
dolls' heads runs under the stage to a
cassette recorder below. The six-minute
composite tape is derived from forty
hours of Black's original recording, and
includes an introduction to the *Fantasy
Doll Show*, a conversation between Helen
and Charlene, and a short song sung by
Calvin in one of the several falsetto voices
he developed for various doll performers.
Originally, Black sat behind the stage to
play the tapes and accompanied the
dolls on his guitar. A light box, which
contained a light bulb covered with red
and blue plastic, casts a dim warm or cool
glow on the performers depending on the
position of the dial. (SF)

Feed the Cat donation box ca. 1950-1972
Wood, nails, plastic, leather dog collar,
paint and coins
19 ¾ x 17 ½ x 10 ⅛ in.
(50.2 x 44.5 x 25.7 cm)
Acquired from Larry Whiteley Gallery,
Los Angeles, California, 1984
M1989.325.9

The *Feed the Cat* donation box takes the
shape of a cat's head and shoulders, and
is brightly painted in red, white, and
black. The cat's eyes are enlivened by red
plastic reflectors. To the left of the cat, a
money box with plexiglass front reveals
the pennies, nickels, and dimes donated
by members of the audience who were
encouraged by the sign "Doll will sing for
25 cents or 2 bits."

In the original "Birdcage Theatre"
there were several "kitty boxes" placed in
proximity to groupings of dolls. Patrons
were encouraged to place donations in the
box nearest to their favorite doll. Calvin
then used the money to buy treats for that
particular doll, often jewelry or perfume.
(SF)

Sheila ca. 1950-1972
Carved and assembled wood, paint,
synthetic wig, various fabric apparel,
metal, stone and electrical components
39 x 16 x 17 in.
(99.1 x 40.6 x 43.2 cm) including base
Acquired from Larry Whiteley Gallery,
Los Angeles, California, 1984
M1989.325.7

As the "glamour girl" of the *Fantasy
Doll Show*, *Sheila* is poised to kick her leg
high as she holds the edge of her dress in
her left hand. A metal rod, connected to
her right leg, runs through the stage floor
to a mechanism which raises and lowers
her leg. Her knees, elbows, hips and
shoulders are articulated, and she too has
a speaker attached to her head beneath
her long, dark blond wig. Her black
feathered hat with gold trim and black
velvet collar lend an alluring accent to the
demure blue and white crepe dress with
bow. (SF)

Miss Helen Marvel ca. 1950-1972
Carved and assembled wood with paint,
fabric, net tutu, synthetic wig, metal
and plastic
37 ½ x 19 x 15 in.
(95.3 x 48.3 x 38.1 cm)
Acquired from Larry Whiteley Gallery,
Los Angeles, California, 1984
M1989.325.1

As the *Fantasy Doll Show*'s mistress of
ceremonies, *Helen Marvel* was the star, and
Calvin Black often would address other
dolls and the audience through her
persona. Throughout the years, Helen
played a number of different roles and
wore a variety of costumes.[1] Here, how-
ever, she is a beautiful ballerina with dark
wig and chic pink headband who attaches
to a pole at the center of stage that allows
her to spin freely. (JG)

1. See, for instance, Herbert W. Hemphill Jr.
and Julia Weissman, *Twentieth-Century Folk
Art and Artists* (New York: E. P. Dutton,
1974), p. 131. *Helen Marvel* appears in this
scene, third from the left, dressed in a plaid
dress.

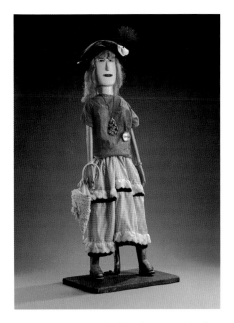

Calvin and Ruby Black, *Miss Mary Ripple*, ca. 1950-1972 (cat. no. 165a)

165a
Miss Mary Ripple ca. 1950-1972
Carved and assembled wood, paint, cloth apparel, metal jewelry and electrical components
42 x 17 ¼ x 14 in.
(106.7 x 43.8 x 35.6 cm)
Acquired from Larry Whiteley Gallery, Los Angeles, California, 1984
M1989.325.3

As one of the lead singers in the *Fantasy Doll Show*, *Miss Mary Ripple* stands at center stage and is wired to a speaker connected to the sound system. She is one of only three dolls to have a tongue, which protrudes prominently from her mouth. *Miss Ripple*'s construction is similar to the other dolls, and her breasts are formed from halved balls of cork. Her outfit, made by Ruby from a child's gingham and corduroy suit, includes a short nylon slip, red denim pantaloons, and shoes with carved wooden soles and leather straps. The pink and turquoise polished stones on her pendant are probably similar to those Ruby sold to "rockhounds" at her shop. (SF)

165b
Little Red Riding Hood ca. 1950-1972
Carved and assembled wood, plywood, paint, cloth apparel, metal and plastic jewelry and electrical components
37 x 18 ⅜ x 12 ¼ in.
(94 x 46.7 x 31.1 cm)
Acquired from Larry Whiteley Gallery, Los Angeles, California, 1984
M1989.325.1

Calvin took the character for this *Fantasy Doll Show* singer from a familiar children's story. A speaker, hidden under her wig and nylon scarf, is wired to the back of her head. Like the other large dolls, her head and neck were carved from a single piece of redwood with oval holes made to indicate eyes and mouth. Drilled openings form the iris of each eye and also mark the teeth, a feature unique to this doll. The arms and legs are carved from soft sugarpine and bolted to the torso so that they move back and forth. The face, neck, arms, and legs are painted rosy pink, but the torso is left unpainted. Because *Little Red Riding Hood* is meant to be a child, Black did not attach breasts to her torso as he did for the other "mature" dolls. (SF)

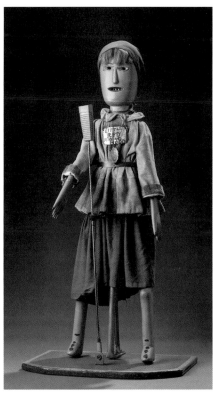

Calvin and Ruby Black, *Little Red Riding Hood*, ca. 1950-1972 (cat. no. 165b)

165c
Jane ca. 1950-1972
Carved and assembled wood, paint, metal stand, handsewn clothing, stone and metal jewelry
14 ¾ x 7 x 5 ¾ in.
(37.5 x 17.8 x 14.6 cm)
Acquired from Larry Whiteley Gallery, Los Angeles, California, 1984
M1989.325.4

165d
Dottie ca. 1950-1972
Carved and assembled wood, paint, metal stand, handsewn clothing, stone and metal jewelry
13 ¾ x 5 ½ x 4 ½ in.
(34.9 x 14 x 11.4 cm)
Acquired from Roberta Stewart, Bloomfield Hills, Michigan, 1989
M1989.325.5

These rare, small dolls were also part of the *Midget Doll Theatre*. Each doll's head, neck, and body is carved from a single piece of wood, while their arms and legs are attached with bolts to permit movement back and forth. Unlike most of the larger dolls who wore wigs, their hair is carved from the original block of wood and painted a bright orange. (SF)

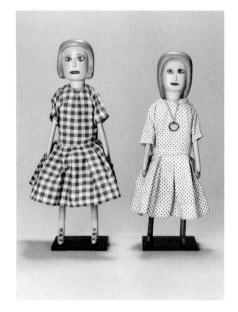

Calvin and Ruby Black, *Jane* and *Dottie*, ca. 1950-1972 (cat. no. 165c, d)

Maple Harris ca. 1950-1972
Carved and assembled wood, paint, various fabrics, toy cap gun, rhinestone, metal and plastic jewelry, leather purse, synthetic wig and bicycle
45 ½ x 48 x 16 in.
(115.6 x 121.9 x 40.6 cm) including bicycle
Acquired from Larry Whiteley Gallery, Los Angeles, California, 1984
M1989.325.6

Astride her bicycle, *Maple Harris*'s distinctive role is described on her name tag: "Maple Harris Bycyclest [sic] Possum Trot." Her construction resembles the other dolls, except that her legs are articulated at both the knee and hip so that she may peddle the bike. This effect is achieved by a pulley connected to her foot and attached to a motor under the stage. (SF)

165e
Miss Johnna Dawson ca. 1950-1972
Carved and assembled wood, paint, various fabrics, synthetic wig, metal, leather and plastic
36 ⅜ x 13 x 9 in.
(92.4 x 33 x 22.9 cm)
Acquired from Pat Hall and Peter Newman, Cheshire, England, 1989
M1989.325.23

Most of the clothing, accessories, and all of the wigs with which Ruby dressed the dolls were salvaged from a city dump near *Possum Trot*. For *Miss Johnna Dawson*, Ruby used a child's oxford shirt with a skirt and slip fashioned from remnants. Her shoes were created from gold leather nailed to carved wooden soles. (SF)

Calvin and Ruby Black, *Miss Johnna Dawson*, ca. 1950-1972 (cat. no. 165e)

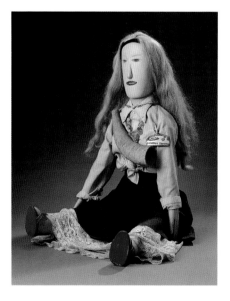

View of Calvin and Ruby Black's living room with *Possum Trot* dolls, December 1975.
Photo by Seymour Rosen, courtesy of SPACES, Los Angeles, California.

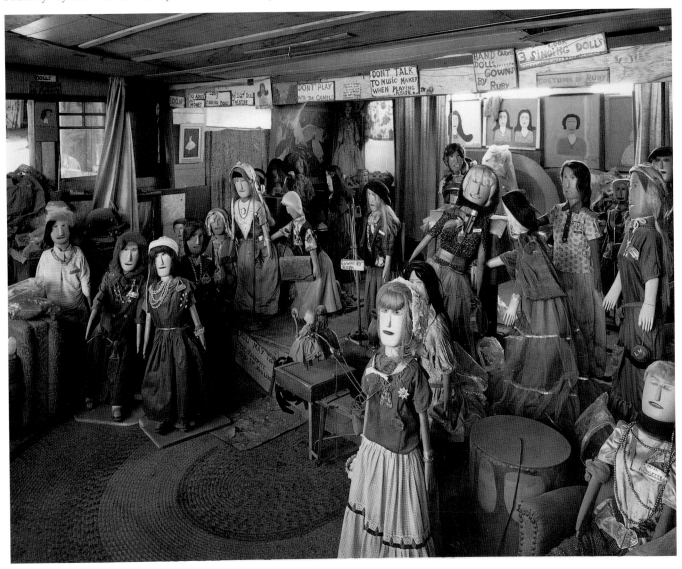

Whittlers abounded, but few of them saw a face in the wood they were holding. Those who did had a different eye and a desire to create. . .[1]

Genre, meaning type, refers to "everyday" subjects or themes that transcend the specificity of portraiture but lack the intellectual priority of historical, religious, and philosophical works of art. Although seemingly matter-of-fact, traditional genre imagery is "often subtly patronizing" due to social or class disparities between the types depicted, the types for whom the depictions are made, and even the artists doing the depicting.[2] While the ten works in this section — all vernacular Southern wood carvings — admit various degrees of humor, judgement, and personal affection, none show condescension because in each case the subject, intended audience, and maker have much in common. (JRH)

1. Vaughan Webb, "Sculpture," in *Southern Folk Art*, ed. Cynthia Elyce Rubin (Birmingham: Oxmoor House, 1985), p. 98.

2. See Elizabeth Johns, *American Genre Painting: The Politics of Everyday Life* (New Haven: Yale University Press, 1991), pp. xi-xiv.

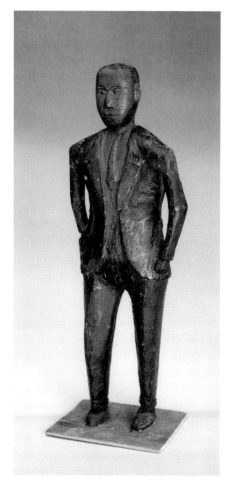

Unidentified Artist, *Black Man*, 1940 (cat. no. 166)

166
Unidentified Artist
Texas
Black Man 1940
Wood and paint
13 ¼ x 4 ⅜ x 3 ½ in.
(33.7 x 11.1 x 8.9 cm)
Acquired from Main Street Antiques, West Branch, Iowa, 1982
M1989.134

167*
Edgar Tolson
Campton, Kentucky
Man with Pony 1958
Carved, assembled and painted wood
23 x 11 ¼ x 32 in.
(58.4 x 28.6 x 81.3 cm)
Acquired from Mrs. Forest Cable, Campton, Kentucky, 1969
M1989.314

And God said, Let us make man in our image, after our likeness; and let them have dominion over the fish of the sea, and over the fowl of the air, and over the cattle, and over all the earth, and over every creeping thing that creepeth upon the earth. (Genesis 1:26-27)

Michael Hall maintains that Tolson's art is highly symbolic, and that eternal truths are allegorically depicted in seemingly innocuous figures. He contends more specifically that *Man and Pony*, Tolson's first major work, represents Tolson's view of the order of things in a Christian world. Man's superiority over the creatures of nature is exhibited in the relationship between the two figures. The verticality of the man asserts his dominance in the world, as does his hand placed over the saddle and restraining gesture with the reign. Likewise, the crisply painted features articulate the divinity in man as ordered and rational. In contrast, the horizontal form of the horse is aligned with the plane of the earth. The spots of the horse are blurred and blend together, representing the chaos and unpredictability of nature.[1] (LVS)

1. Michael D. Hall, *Stereoscopic Perspective* (Ann Arbor: UMI Research Press, 1988), p. 169.

Genre Figures

168
Edgar Tolson
Campton, Kentucky
Blue-Eyed Man with Black Moustache 1970
Carved and painted wood, pencil, glue
and nails
26 x 5 ½ x 6 ¼ in.
(66 x 14 x 15.9 cm)
Acquired from the artist, 1970
M1989.319

169
Standing Figure 1977
Carved and painted wood, pencil and glue
13 ½ x 3 ⅜ x 3 ¹⁵⁄₁₆ in.
(34.3 x 8.6 x 10 cm)
Acquired from the artist, 1980
M1989.324

These single figures by Tolson
evidence a popular perspective in his art
that contrasts with the profound religious
concerns of his *Fall of Man* tableaux (cat.
no. 205). Interestingly, the *Blue-Eyed Man*
was intended to represent Adam and
accompany a completed Eve. However,
as Tolson sold Eve before Adam was
finished, he was forced to reinterpret the
single figure. As a result, Tolson
presented the figure to Michael Hall, who
at that time had a moustache, and said,
"Well, this is you anyways."[1] (JG)

1. Conversation with Michael and Julie Hall,
Milwaukee, Wisconsin, 14 March 1991.

Edgar Tolson, *Man with Pony*, 1958 (cat. no. 167)

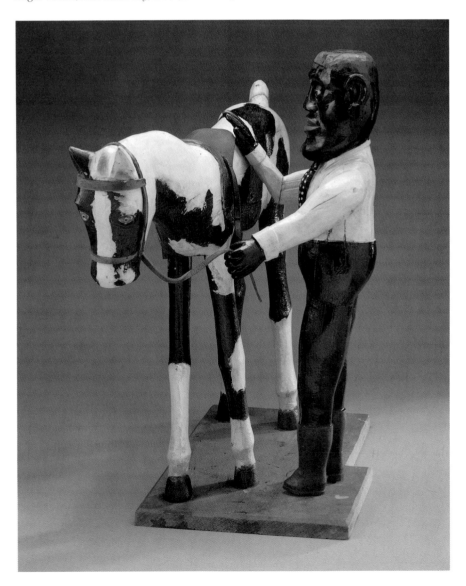

170*
Edgar Tolson
Campton, Kentucky
Snake Handler in Bikini 1977
Carved and painted wood, pencil and glue
11 x 3 ¼ x 3 ½ in.
(27.9 x 8.3 x 8.9 cm)
Acquired from the artist, 1977
M1989.322

An occasional preacher, Tolson delivered sermons to various audiences: "There were Free Will Baptists and Hard-Shelled Baptists and then there were Holy Rollers with their snakes."[1] The Holy Rollers referred to are members of independent Pentecostal Holiness churches who, based upon a literal interpretation of the passage "they shall take up serpents" (Mark 16:18), perform this extraordinary act to demonstrate their faith in the power of God.[2] Here, Tolson seems to have fused a snake-handling cultist with a popularized side-show caricature. By clothing the figure in a bikini, a prurient undertone has been introduced. (JG)

1. Tolson quote in Priscilla Colt, *Edgar Tolson: Kentucky Gothic* (Lexington: University of Kentucky Art Museum, 1981), p. 14.

2. Steven Kane, "Snake Handlers," *Encyclopedia of Southern Culture*, eds. Charles Reagan Wilson and William Ferris (Chapel Hill: University of North Carolina Press, 1989), p. 1330.

Edgar Tolson, *Blue-Eyed Man with Black Moustache*, 1970 (cat. no. 168)

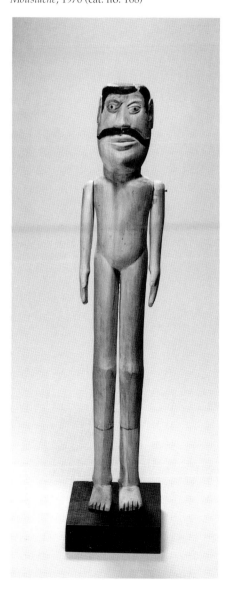

Edgar Tolson, *Standing Figure*, 1977 (cat. no. 169)

Edgar Tolson, *Snake Handler in Bikini*, 1977 (cat. no. 170)

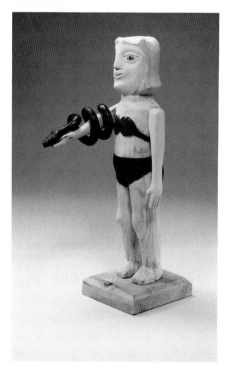

171
W. S. Rosenbaum
West Virginia
Man with Horse and Cart 20th century
Painted wood, fabric, thread, rope, metal, wire, bolts and shoe laces
30 ½ x 23 x 12 ½ in.
(77.5 x 58.4 x 31.8 cm)
Acquired from Herbert W. Hemphill Jr., New York, 1979
M1989.136

Horse-drawn carts were common subjects for both individual and commercial toymakers during the early twentieth century.[1] The Southern toy-craft tradition is characterized by simplicity of form and nostalgic reference to a pre-industrialized era. The individual toys developed from this tradition offer a poignant contrast to their mass-produced counterparts.

Rosenbaum has meticulously attended to the hand-carved and painted details. The wooden cart, inscribed "RFD Mail," includes spoked wheels articulated with metal strips, and halts before a hand-painted but unmistakably modern railroad signal. The driver is a black man whose head and torso are carved from a single piece of wood, and his wooden arms and legs are movable. The rest of his body is composed of hand-sewn and stuffed clothing. (LVS)

1. See Joseph Doucette and C.L. Collins, *Collecting Antique Toys* (New York: Macmillan Publishing Company, 1981).

W.S. Rosenbaum, *Man with Horse and Cart*, 20th century (cat. no. 171)

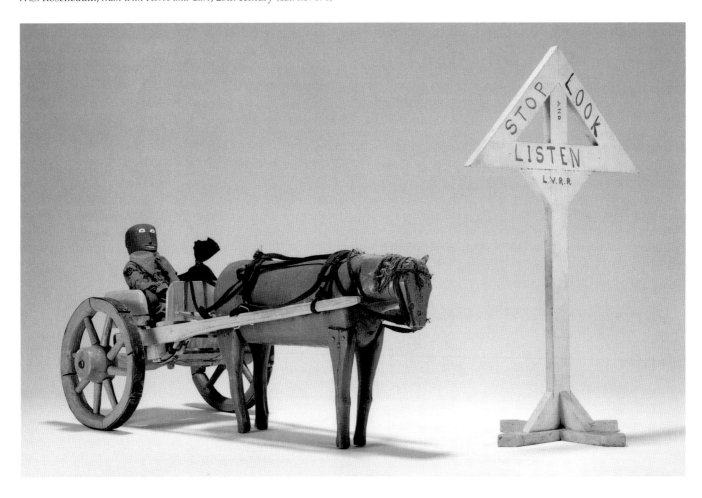

172
Steve Ashby
Delaplane, Virginia
Woman with Umbrella 1970
Wooden crate, panel and block base,
paint, plastic, fabric, wire and solder
9 ½ x 3 ⅝ x 2 ¹⁄₁₆ in.
(24.1 x 9.2 x 5.2 cm)
Acquired from Ken Fadeley, Ortonville,
Michigan, 1977
M1989.141

 Like Miles Carpenter and S. L. Jones,
Ashby's artistic activity intensified after
the death of his wife. His work falls into
two categories, with *Woman with Umbrella*
representing the first: small figures cut
from plywood either by hand or with an
electric saw. Ashby would then paint
these or attach photographs, hair, clothes
and various other found objects. The
second category constitutes larger, near
life-sized figures fashioned from tree
trunks and branches and often dressed in
his wife's old clothes. (LVS)

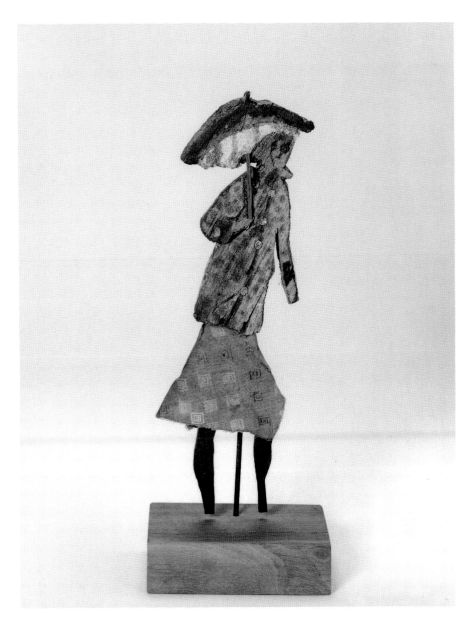

Steve Ashby, *Woman with Umbrella*, 1970 (cat. no. 172)

Genre Figures

Miles B. Carpenter, *Woman with Dog*, 1971 (cat. no. 173)

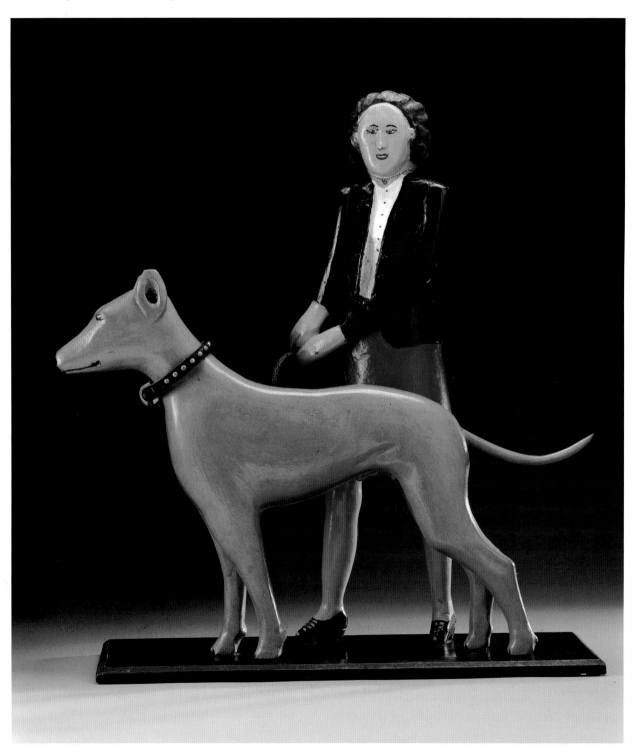

173*
Miles B. Carpenter
Waverly, Virginia
Woman with Dog 1971
Painted wood, leather and fiber cord
19 x 18 ½ x 6 ¼ in.
(48.3 x 47 x 15.9 cm)
Acquired from the artist, 1972
M1989.138

A Greyhound Bus advertisement triggered the imagination of Carpenter, who re-interpreted the image three-dimensionally. The work replicates an earlier version carved in 1941. The smooth but anxious pose of both figures suggests a precarious, slightly absurd relationship between dog and master. The bright shades of the woman's clothing are typical of the artist's palette, and may derive from his Pennsylvania Dutch background. The greyhound's comical facial expression belies the sleek intensity of its pose, perhaps reflecting Carpenter's renowned, wry sense of humor. (LVS)

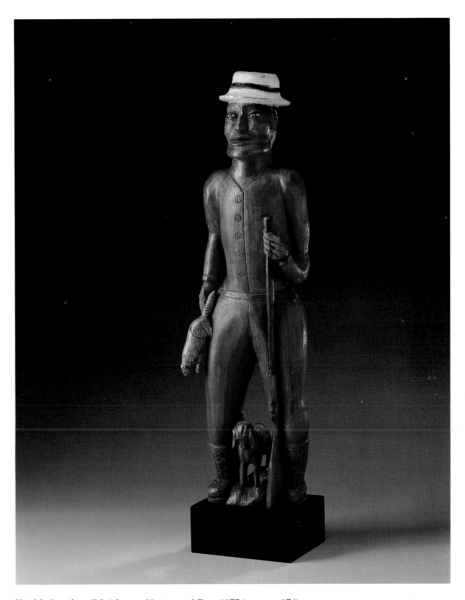

Shields Landon (S.L.) Jones, *Hunter and Dog*, 1975 (cat. no. 174)

Genre Figures

174*
Shields Landon (S. L.) Jones
Hinton, West Virginia
Hunter and Dog 1975
Carved, stained and painted wood
21 ¼ x 5 x 4 in.
(54 x 12.7 x 10.2 cm)
Acquired from Jay Johnson, America's
Folk Heritage Gallery, New York, 1977
M1989.139

Hunter and Dog once belonged to
Herbert Hemphill Jr. who noticed Jones'
carvings in a small display at the Charles-
ton, West Virginia Historical Society in
1972.[1] Begun in retirement following the
death of his first wife, Jones' early work
is modestly scaled, produced strictly
with a pocket knife, and stained with
only limited use of paint; nevertheless, its
broadly modeled forms and stoic fron-
tality clearly anticipate his later sculpture.

Because they all derive from local or
personal experience, it has been said that
"every carving Jones does is somebody,
but at the same time they are all Jones."[2]
In this case, the piece effectively combines
his fond recollection of whittling and
hunting as quintessential Appalachian
activities: "Whittling was something I was
pretty good at, something I did to pass
the time. Waiting for my dog, Dan, to
sniff out game, I'd find me a piece of buck-
eye, and carve a squirrel or a bird."[3] (JRH)

1. Lynda Roscoe Hartigan, *Made with Passion*
(Washington, D.C.: National Museum of
American Art, 1990), p. 56.

2. Michael D. Hall, *Transmitters* (Philadel-
phia: Philadelphia College of Art, 1981),
p. 37.

3. Ramona and Millard Lampell, *O, Appa-
lachia* (New York: Stewart, Tabori & Chang,
1989), p. 21.

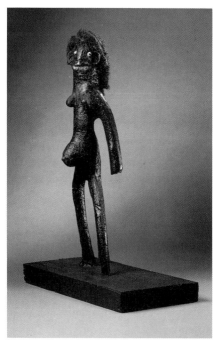

Bessie Harvey, *Pregnant Woman*, ca. 1985
(cat. no. 175)

175*
Bessie Harvey
Tennessee
Pregnant Woman ca. 1985
Wood, wood putty, paint, beads, glue
and hair
15 x 10 x 5 ½ in.
(38.1 x 25.4 x 14 cm)
Acquired from Cavin/Morris Gallery,
New York, 1988
M1989.142

The ability to perceive and concep-
tualize unique figures in root and branch
forms constitutes an important genre in
Bessie Harvey's art. An intensely
spiritual woman, Harvey considers her
animistic perceptions a "collaboration
with God and Nature." She regards her
"dolls" as "soul people" who belong to a
"family" or "tribe."[1]

Harvey's stick sculptures are related
to the earliest Congo twisted root charms.
The transformation of charms is an impor-
tant religious concept in African cultural
tradition, and the addition of other
materials to sculptural forms is common-
place in the Nigerian Congo. Harvey has
used beads to represent the pupil of an
already carved eye, and the subtle addi-
tion of human hair and paint further
develops the individual nature of the char-
acter. Compelling in its directness, the
stark black figure asserts a life and energy
inherent in ancestral charm traditions.
(LVS)

1. Lucy R. Lippard, *Mixed Blessings* (New
York: Pantheon Books, 1990), p. 66.

And God said, Let the earth bring forth the living creature after its kind, cattle, and creeping thing, and beast of the earth after its kind: and it was so.

And God made the beast of the earth after its kind, and cattle after their kind, and every thing that creepeth upon the earth after its kind: and God saw that it was good.
(Genesis 1:24-25)

Since the days of prehistoric cave paintings, animals have played a prominent role in artistic expression. The histories of religion, science and politics are also permeated with references to the animal kingdom. Especially fascinating is the universal tendency to project human characteristics upon animals, as in folklore and fables. Throughout the nineteenth and twentieth centuries in America, artists incorporated animals into a diversity of works: the deeply religious Peaceable Kingdoms of Edward Hicks, the technical studies by John James Audubon, the boldly ornamental figures of Wilhelm Schimmel, the romantically majestic visions of Albert Bierstadt, the expressive portrayals by Anna Hyatt Huntington, and the reductive and direct sculpture of John Flannagan or William Edmondson.

The animals in the Hall Collection range from wild to domestic, prehistoric to contemporary, whimsical to sober, and miniature to life-size. The root snakes (cat. nos. 176-178), the result of spontaneous inspiration from nature, contrast with the eerily anthropomorphic *Monkey* (cat. no. 179), or Tolson's abstract *Lion* (cat. no. 189). Perhaps most easily compared are Miles Carpenter's and Felipe Archuleta's pigs. Whereas Carpenter's finely finished *Pig* (cat. no. 190) forms a compact and delightful caricature, Archuleta's *Spotted Pig* (cat. no. 192) is life-sized and fiercely aggressive. In any case, whether through scrutiny or admiration, each sculpture effectively captures the essence of animal. (JG)

176
Spala
St. Clair County, Michigan
Large Root Snake ca. 1920
Carved and painted wood
55 ½ x 5 ½ x 3 ⅜ in.
(141 x 14 x 8.6 cm)
Acquired from Robert Bishop, Inkster, Michigan, 1971
M1989.148

Spala, *Large Root Snake,* ca. 1920 (cat. no. 176)

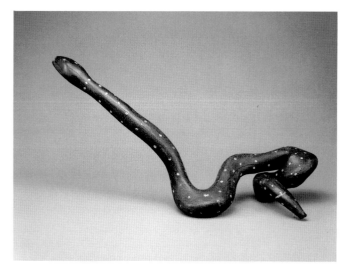

Unidentified Artist, *Coiled Root Snake*, ca. 1930 (cat. no. 177) Unidentified Artist, *Dotted Root Snake*, late 19th century (cat. no. 178)

177
Unidentified Artist
Michigan
Coiled Root Snake ca. 1930
Carved and painted wood with applied tongue
3 ¾ x 1 ½ x 27 in.
(9.5 x 3.8 x 68.6 cm)
Acquired from Jerry Catana, East Detroit, Michigan, 1983
M1989.158

178*
Unidentified Artist
Dotted Root Snake late 19th century
Carved and painted root
21 ¾ x 3 x 50 in. (55.3 x 7.6 x 127 cm)
Acquired from Jay Johnson, America's Folk Heritage Gallery, New York, 1979
M1989.154

Root carving relies on an artist's ability to envision a form within nature; only minimal sculpting transforms a found object into an undulating serpent. The prevalence of snake imagery within folk art and its universality within all cultures undoubtedly stems from a fascination with a creature who "lives below the ground, can swim in the water, move rapidly on the earth, and climb trees . . ."[1]

The *Dotted Root Snake* is attributed to the maker of a turtle in the collection of the Museum of American Folk Art.[2] Both animals are painted with the same carefully applied rows of dots and have similarly animated, open jaws. The *Large Root Snake*'s attribution to an artist named Spala is based on an oral history supplied by Robert Bishop. However, no other works by this artist have been found.[3]
(JG)

1. E. McClung Fleming, "Seeing Snakes in the American Arts," The Delaware Antiques Show (1969), as quoted in Kenneth Ames, *Beyond Necessity* (Winterthur: The Henry Francis du Pont Winterthur Museum, 1977), p. 57.

2. See Robert Bishop, *American Folk Sculpture* (New York: E. P. Dutton, 1974), figure 518.

3. Telephone conversation with C. Kurt Dewhurst, director, Michigan State University Museum, East Lansing, Michigan, 18 December 1991.

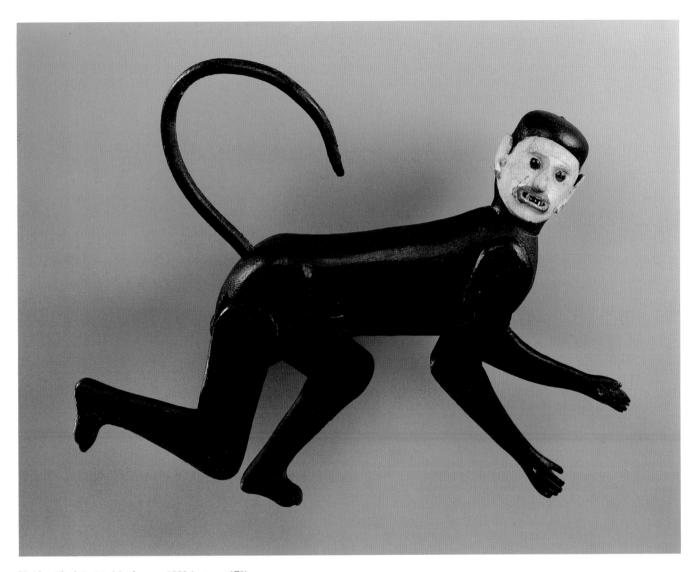

Unidentified Artist, *Monkey,* ca. 1900 (cat. no. 179)

Animals

179*
Unidentified Artist
New York?
Monkey ca. 1900
Carved and painted wood, glass eyes,
rope and nails
31 x 5 x 5 ½ in.
(78.7 x 12.7 x 14 cm)
Acquired from Herbert W. Hemphill Jr.,
New York, 1974
M1989.147

This *Monkey*, assembled with simple
halved-*L* joints that facilitate movement of
its articulated arms and legs, was prob-
ably designed to hang by its hands from a
pole or rope. Although the maker is
unknown, several works that appear to be
by the same hand exist in other collec-
tions. Four standing male figures, another
monkey, and a horse and bareback rider
are in the Museum of American Folk Art;[1]
a farmer is owned by the New York State
Historical Association; and a standing
male figure by the same hand is pictured
in Robert Bishop's *American Folk Sculpture.*[2]

All of the pieces are oriented to a
single direction, share the same jointed
construction, and possess inset glass eyes
and a fixed, penetrating gaze. The
Monkey in the Hall Collection is distin-
guished by its wooden ears, which are
formed from tin in the other figures. The
animated, swinging postures of both
monkeys, as well as the bareback rider's
exotic costume all suggest a kinetic circus
environment. The various standing
figures may represent performers or
audience members, although there is little
consistency of scale among them. Certain-
ly during the height of popularity of
circuses at the turn of the century, inspira-
tion for any of these works could have
come from circus posters or firsthand
experience with a traveling show or
parade. (JG)

1. See Gerard C. Wertkin, "The Museum at
20: Challenges and Perspectives," *The Clarion*
(Fall 1981), p. 27.

2. See Robert Bishop, *American Folk Sculpture*
(New York: E. P. Dutton, 1979), figure 534,
present location unknown.

180
Aaron Augustus "Gus" Wilson
Portland, Maine
Spring Robin ca. 1910
Carved and painted wood with metal legs
6 ½ x 2 ½ x 10 ½ in.
(16.5 x 6.4 x 26.7 cm)
Acquired from Frank Schmidt, Cornish,
Maine, ca. 1978
M1989.157

This songbird exemplifies the diversity
of expression achieved by Wilson, a
renowned decoy carver. A fisherman and
lighthouse keeper on the Maine coast,
Wilson carved various birds and other
exotic animals throughout his career.
"Sometimes he carved on impulse," noted
one observer, "To see a bluejay from a
window in the winter meant that work on
duck decoys would stop until a dozen or
more of these birds were made . . . Later
in the spring and summer, he carved a
few robins, orioles, crows, herons, etc. for
a change of pace."[1] This Robin's bill is in-
cised and slightly parted at the end. Such
realistic detailing, as well as its perch on
bent metal legs, are characteristic of
Wilson's songbirds. (JG)

1. Benjamin H. Gaylord, "Gus Wilson:
Maine's Elmer Crowell," *North American
Decoys* (Winter 1975), pp. 9-10.

Aaron Augustus "Gus" Wilson, *Spring
Robin,* ca. 1910 (cat. no. 180)

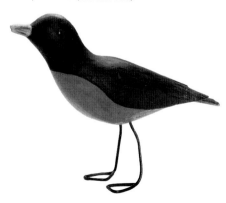

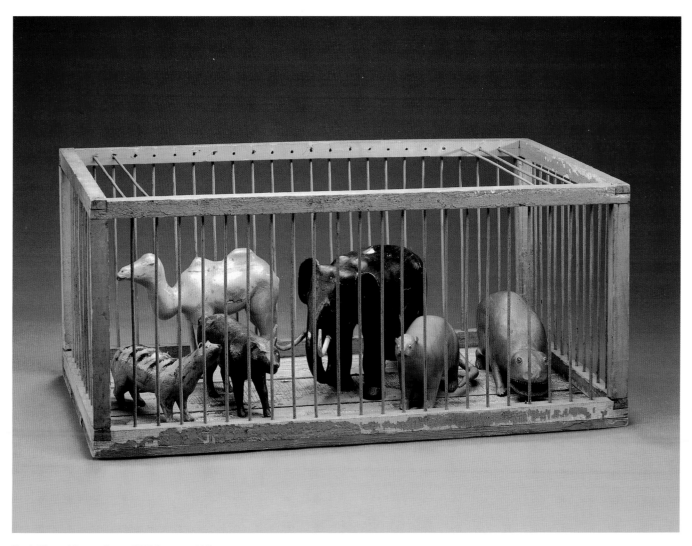

Fred Alten, *Menagerie*, ca. 1910 (cat. no. 181)

Animals

181*
Fred Alten
Wyandotte, Michigan
Menagerie (Elephant, Wolf, Camel, Otter, Dinosaur, Jungle Cat) ca. 1910
Carved and painted wood
13 ⅛ x 17 ⅛ x 29 ⅞ in.
(33.3 x 43.5 x 75.9 cm)
Acquired from Joe and Lee Dumas, Southgate, Michigan, 1980
M1989.156.1-6

The primary source of inspiration for Alten's animals was *Johnson's Household Book of Nature*, a popular encyclopedia of natural history based on the writings of Audubon, Wallace, Brehm, Wood and other nineteenth-century naturalists. Alten's preoccupation with creating his own philogenetic system featuring representative examples from various family "trees" probably stemmed from the gradual popularization of Darwin's evolutionary theories. A statement from *Johnson's Household Book of Nature* exemplifies a consequent, early twentieth-century attitude toward the relationship of man to animal: "No less instructive is it to note how the lower animals differ from or resemble Man, the crown of Nature's work . . ."[1] Although great care was taken in the creation of each animal, Alten seems ultimately to have viewed them as specimens, caged for the convenience and education of humanity.

Alten carved over 156 animals that he grouped according to genus or species and placed in cages of his own design. The animals in this *Menagerie* are not an original Alten grouping. Rather, they represent a cross-section of his philogenetic tree, and bear witness to the diversity of his creation.

The care with which Alten assigned each animal to their correct species is demonstrated by the inscription on the underside of the *Jungle Cat* in which the genus *Pale Genet* is recorded. Actually, the cat carved by Alten is genus *Hemigale*, which is pictured above genus *Pale Genet*

in plate XII (carnivora) of Johnson's book. Alten must have inadvertently confused the two and assigned the incorrect genus. (JG)

1. Henry J. Johnson, *Johnson's Household Book of Nature*, ed. Hugh Craig (New York: Henry J. Johnson, 1880).

182
Fred Alten
Wyandotte, Michigan
Fighting Dinosaurs ca. 1910
Carved, assembled and painted wood
15 x 10 x 24 in.
(38.1 x 25.4 x 61 cm)
Acquired from Jay Johnson, America's Folk Heritage Gallery, New York, 1979
M1989.155

Alten's *Fighting Dinosaurs* reflects his interest in Darwin's theory of "survival of the fittest." He probably saw similarly imaginative scenes of prehistoric creatures engaged in battle in nineteenth-century paleontology books such as Hutchinson's *Extinct Monsters* (1893) or Adams' *Life in the Primeval World* (1872).

The construction of *Fighting Dinosaurs* evidences Alten's technical skills in pattern and mold-making gained through employment at his father's iron foundry in Lancaster, Ohio and later as a self-employed carpenter.[1] (JG)

1. Julie Hall, *The Sculpture of Fred Alten* (Michigan Artrain, 1978), p. 11.

Fred Alten, *Fighting Dinosaurs*, ca. 1910 (cat. no. 182)

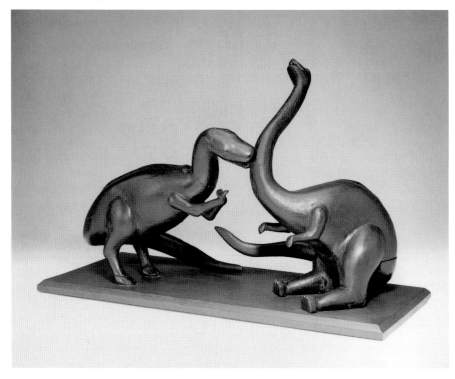

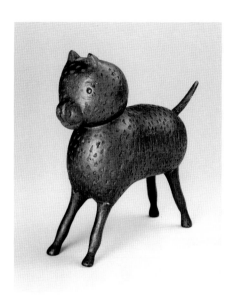

Unidentified Artist, *Cat,* 1930s-1940s (cat. no. 184)

183
Unidentified Artist
Indiana
Squirrel ca. 1930
Carved and varnished wood, beads
6 ½ x 2 x 6 ¾ in.
(16.5 x 5.1 x 17.2 cm)
Acquired from Stagecoach Antiques, Akron, Ohio, 1972
M1989.159

This *Squirrel*'s brass bead eyes and rich dark stain suggest that it served an ornamental function. Carved from two vertically joined pieces of wood, it probably attached to an object with its outstretched arms and rectangularly indented stomach. Similar squirrels, sometimes grasping a nut, decorated lamps or gateposts.[1] A name, Tom Wills, and initials, R. P., are crudely inscribed onto either side of the *Squirrel*, although both may be graffiti. (JG)

1. See Robert Bishop, *American Folk Sculpture* (New York: E. P. Dutton, 1974), p. 279 and Wendy Lavitt, *Animals in American Folk Art* (New York: Alfred A. Knopf, Inc., 1990), p. 98.

184
Unidentified Artist
Pennsylvania?
Cat 1930s-1940s
Carved and painted wood
4 ¹⁵⁄₁₆ x 2 x 5 ⅛ in.
(12.5 x 5.1 x 13 cm)
Acquired from Eugene Rappaport, Flea Market, Ann Arbor, Michigan, 1979
M1989.437

The attention to detail and decorative gold pigment suggest that this tiny *Cat* was created as a precious token of affection for someone. As Kenneth Ames points out, such miniaturized animals often serve as an outlet for tender feelings amidst the tensions of daily existence.[1] Its surface of saw-tooth-edge indentations suggests tramp art, and also recalls similarly textured works by Wilhelm Schimmel, Aaron Mountz and other Pennsylvania chip-carvers.[2] (JG)

1. Kenneth Ames, *Beyond Necessity* (Winterthur: The Henry Francis du Pont Winterthur Museum, 1977), p. 50.

2. Richard S. and Rosemarie B. Machmer, *Just for Nice* (Reading, Pennsylvania: The Historical Society of Berks County, 1991), figures 37, 41, 45-46, 113-20.

Unidentified Artist, *Squirrel,* ca. 1930 (cat. no. 183)

Animals

Albert Zahn, *Bluejay*, ca. 1950 (cat. no. 185)

185
Albert Zahn
Door County, Wisconsin
Bluejay ca. 1950
Carved, assembled and painted wood
5 ¾ x 3 ¾ x 11 in.
(14.6 x 9.5 x 27.9 cm)
Acquired from Hammer and Hammer
Gallery, Chicago, Illinois, 1981
M1989.160

Zahn placed hundreds of carved birds
around the yard of his home which he
referred to as "Birds' Park."[1] Augmenting
his first-hand observation with nature
books, he captured the form and move-
ment of these creatures which were then
painted by his wife. That Zahn's work
captured the interest of regional fine
artists is demonstrated in a painting by
Aaron Bohrod which depicts Zahn's home
and an assortment of his sculptures.[2] (JG)

1. Chuck and Jan Rosenak, *Encyclopedia of
20th Century American Folk Art and Artists*
(New York: Abbeville Press, 1990), p. 337.

2. Aaron Bohrod, *A Decade of Still Life*
(Madison: The University of Wisconsin
Press, 1966), p. 38. See *The Bird House*,
ca. 1952, oil on gesso panel.

186*
Edgar Tolson
Campton, Kentucky
Rock Dog ca. 1945
Carved and painted limestone
30 x 15 ½ x 24 in.
(76.2 x 39.4 x 61 cm)
Acquired from Mrs. Nobel Jones,
Morefield, Kentucky, 1969
M1989.312

Tolson's *Rock Dog*, carved from lime-
stone quarried on his farm, is one of
seven such sculptures created early in his
career to embellish the yard of the family
home. The other six include two smaller
dogs and a cat (in private collections), a
turtle (destroyed), and a squirrel tethered
by chain to the figure of a man (now
lost).[1] (JG)

1. Michael and Julie Hall, interview by Julia
Guernsey and Debra Brindis, 1 August 1991,
transcript, Milwaukee Art Museum.

Edgar Tolson, *Rock Dog*, ca. 1945 (cat. no. 186)

Edgar Tolson, *Ox Plaque,* ca. 1957 (cat. no. 187)

187
Edgar Tolson
Campton, Kentucky
Ox Plaque ca. 1957
Carved and varnished wood, pencil
and glue
5 ½ x 8 x 2 ½ in.
(14 x 20.3 x 6.4 cm)
Acquired from the Taulbee Family,
Campton, Kentucky, 1969
M1989.313

This early work, given as a gift to
neighbors who provided Tolson's family
with food after his stroke,[1] evokes
Appalachian handicraft traditions. The
chain, carved from a single block of wood,
is a skillfully crafted riddle that plays
with the interrelationship of parts to a
whole, reality to illusion. A craft that
demonstrated skill while fascinating its
audience, chain carving has been a tradi-
tion in America since Colonial times, a
product of both African and European
traditions.[2]

This plaque also clearly demonstrates
the manual skill that forms the foundation
for Tolson's later work like the *Fall of Man*
(cat. no. 205) series. Tolson perceived a
clear distinction between whittling, as in
this piece, and carving: "Well there are
differences in it. When you're carving
something you've got your mind with it.
You have your whole being in it. You
have to. But just sitting there whittling
on a stick, you ain't got nothin' in it but
just a little time."[3] (JG)

1. Michael and Julie Hall, interview by Julia
Guernsey and Debra Brindis, 1 August 1991,
transcript, Milwaukee Art Museum.

2. Simon J. Bronner, *Chain Carvers* (Lexing-
ton: University Press of Kentucky, 1985),
p. 11.

3. Michael D. Hall, "You Make It with Your
Mind: Edgar Tolson," in *Stereoscopic Perspec-
tive: Reflections on American Fine and Folk Art*
(Ann Arbor: UMI Research Press, 1988),
p. 163.

188
Edgar Tolson
Campton, Kentucky
Winston the Dog 1969
Carved and painted wood
8 ⅜ x 3 ½ x 11 ½ in.
(21.3 x 8.9 x 29.2 cm)
Acquired from the artist, 1970
M1989.320

In order to complete this portrait of Julie Hall's dog, Tolson required photographs of Winston's left side, right side and back.[1] He first created a general form for Winston's body, then after receiving the photos painted the spots exactly as they appeared. Rather than viewing paint as mere decorative finish, Tolson used it to impart essential information to his sculpture. Calling Winston a "pieded" dog, and referring to his piebald coat, Tolson believed that the black and white spots truly identified Winston. (JG)

1. Michael and Julie Hall, interview by Julia Guernsey and Debra Brindis, 1 August 1991, transcript, Milwaukee Art Museum.

Michael and Julie Hall, their son Collin, and dog Winston at home, Cranbrook Academy, Bloomfield Hills, Michigan, fall 1970. Photo by Lewis Alquist.

Edgar Tolson, *Winston the Dog*, 1969 (cat. no. 188)

Animals

189
Edgar Tolson
Campton, Kentucky
Lion ca. 1972
Carved wood, glue, pencil, nail and
wood filler
7 ¼ x 3 ½ x 13 ½ in.
(18.4 x 8.9 x 34.3 cm)
Acquired from the artist, 1973
M1989.317

190
Miles Carpenter
Waverly, Virginia
Pig 1972
Carved and painted wood
4 ½ x 2 ½ x 7 ½ in.
(11.4 x 6.4 x 19.1 cm)
Acquired from the artist, 1973
M1989.161

Encouraged by his wife, Carpenter
carved various small animals throughout
the 1940s. After her death in 1966, he
turned to carving with renewed vigor.
Setting up a display beside his roadside
icehouse, he sold small birds, rhinos and
other animals. In his own words: "I was
almost giving them away at a moderate
price just to keep me busy. I hadn't made
a pig. I made it and a good specimen too.
So everytime I finished a pig somebody
would get it and from then on I made
many pigs."[1] (JG)

1. Miles Carpenter, *Cutting the Mustard*
(Tappahannock, Virginia: American Folk Art
Company, 1982), p. 47.

Edgar Tolson, *Lion*, ca. 1972 (cat. no. 189)

Miles Carpenter, *Pig*, 1972 (cat. no. 190)

Felipe Archuleta, *Rooster*, 1978 (cat. no. 191), and *Spotted Pig*, ca. 1975 (cat. no. 192)

Animals

191
Felipe Archuleta
Tesuque, New Mexico
Rooster 1978
Carved and painted cottonwood
23 ½ x 10 x 29 ½ in.
(59.7 x 25.4 x 74.9 cm)
Acquired from Davis Mather, Tesuque,
New Mexico, 1978
M1989.151

All of Archuleta's creatures reveal an underlying aggression. Although the product of a more secular world than the nineteenth-century *santos* of the same Southwestern environment, an iconic intensity is present in both. Notwithstanding formal and functional distinctions, it is this expressive kinship that qualifies Archuleta as heir to a rich New Mexican carving tradition.

The rooster does appear in *santos* iconography. For example, a basalt cross (*La Cruz Mayor*) from Sonora, Mexico, depicts a rooster beneath the face of Christ.[1] Such an image references the Passion and Peter's denial of Christ: "I tell you, Peter, the cock will not crow this day, until you three times deny that you know me" (Luke 22:34). The rooster's alert, profile pose also recalls the popular weathervane motif which blends religious symbolism with a secular sign of vigilance. Interestingly, tradition states that the Christian adaptation of the weathercock originated with a ninth-century pope's decree that every church should be capped with a rooster weathervane as a call for steadfast faith.[2] Its presence on a seventeenth-century Mexican cross probably reflects the assimilation of Franciscan missionaries' devotional and didactic imagery into an evolving *santero* tradition, much as Archuleta's *Rooster* may reflect the continuity of such syncretism into the twentieth century. Nonetheless, his depiction of animals indigenous to the southwest also speaks to the vernacular grounding of his art and his ability to draw from an immediate, everyday reality. (JG)

1. Collection of Dr. Carl S. Dentzel, Los Angeles, California. Pictured in Jean Stern, ed., *The Cross and the Sword* (San Diego: Fine Arts Society of San Diego, 1976), figure 123.

2. Robert Bishop, *American Folk Sculpture* (New York: E. P. Dutton, 1974), p. 44.

192
Felipe Archuleta
Tesuque, New Mexico
Spotted Pig ca. 1975
Carved and painted cottonwood with applied hemp tail
24 x 17 ½ x 46 in.
(61 x 44.5 x 116.8 cm)
Acquired from Davis Mather, Tesuque,
New Mexico, 1978
M1989.150

This anatomically detailed *Pig* was burned in a workshop fire, but restored and repainted by Archuleta in 1977.[1] As many of Archuleta's early sows were accompanied by piglets, this *Pig* may have lost her litter in the fire. Although a domestic animal, he invested it with characteristic ferocity. (JG)

1. Michael and Julie Hall, interview by Julia Guernsey and Debra Brindis, 1 August 1991, transcript, Milwaukee Art Museum.

193*
Felipe Archuleta
Tesuque, New Mexico
Lynx 1976
Carved and painted cottonwood with straw and plastic details
35 x 16 x 28 ¾ in.
(88.9 x 40.6 x 73 cm)
Acquired from the artist and Davis Mather, Tesuque, New Mexico, 1976
M1989.152

Although Archuleta only inscribed "CAT" on its underside, he clearly portrayed a lynx. Known for its tufted ears, muttonchop whiskers, black-tipped tail and exceptionally aggressive behavior, Archuleta captured its very essence in his first attempt at this subject.

Photographs taken by Michael Hall record Archuleta's unique construction and painting methods.[1] After carving the *Lynx*'s basic form from cottonwood, he modeled features and attached appendages with a filler paste. Details such as hair, tail, and whiskers were created from hemp or other found materials. In one photo, Archuleta consults a large magazine print of a wild lynx, indicating that he did refer to sources like *National Geographic* in order to accurately capture the animal's posture, coloration, and expression. Such documentation attests to Archuleta's incorporation of all three historic sculpting techniques — constructing, carving and modeling. (JG)

1. Documentary photos by Michael Hall, Milwaukee Art Museum files.

Felipe Archuleta, *Lynx*, 1976 (cat. no. 193)

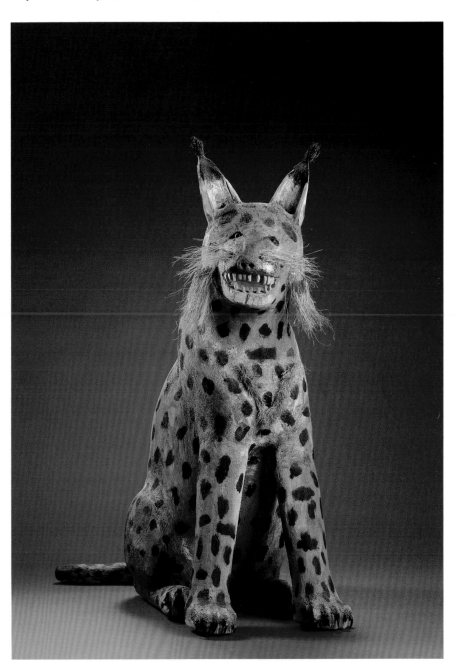

Religion & History

Religious and historical subjects, long revered within academic art circles for their moral and intellectual gravity, also figure prominently in folk art. Indeed, many folk artists, despite seldom receiving the public and institutional commissions available to their professional counterparts, purposely adopt such subjects because they reinforce "core" values and provide continuity against the constant prospect of cultural change or degeneration. Hence, duty to country and community, respect for leaders, devotion to God, and affirmation of racial or ethnic identity are all themes which distinguish this aspect of the Hall Collection.

Syncretism — the blending of different formal and communicative traditions, often when preservation of time-honored standards is at stake — likewise abounds in folk art. Examples such as the two watchful *Black Figures*, John Perates' iconic carvings, and Luis Tapia's modern *santos*, each show sacred African, Greek, or Mexican conventions substantially infused with American features. Fusion of another sort is also evident in *Miss Liberty*'s familiar iconography which is actually the popular translation of various earlier models derived from "high" culture. Moreover, in much of the work in this section, religious and historical consciousness all but merge, as in the bas-reliefs of Elijah Pierce and Josephus Farmer which associate particular Old Testament narratives with more recent African American experiences. Similarly, the full meaning of Edgar Tolson's characteristic *Paradise* tableau is gained only through a parallel understanding of the artist's deep feelings for his native Appalachia: "At the time (of redemption) we come to be accountable to know good from evil . . . we don't gain a thing back — only what we lost. We get our Eden home back. And the Eden home is this world."[1] (JRH)

1. Quoted in Michael D. Hall, "You Make It With Your Mind: Edgar Tolson," *The Clarion* 12 (Spring-Summer 1987), p. 39.

Unidentified Artist
Hamilton, Ohio
Pair of Black Figures
194a*
Black Figure with Raised Hands ca. 1880
Painted wood, hemp, plastic buttons, glass eyes, jewels, plaster and metal
56 ½ x 18 ½ x 19 in.
(143.5 x 47 x 48.3 cm)
Acquired from Clark Garrett, Fairhaven, Ohio, 1971
M1989.126a

194b
Black Figure Standard Bearer ca. 1880
Painted wood, hemp, plastic buttons, glass eyes, jewels, plaster and metal
53 ½ x 18 x 19 in.
(135.9 x 45.7 x 48.3 cm)
Acquired from Clark Garrett, Fairhaven, Ohio, 1971
M1989.126b

Unidentified Artist, *Pair of Black Figures*, ca. 1880 (cat. no. 194a, b)

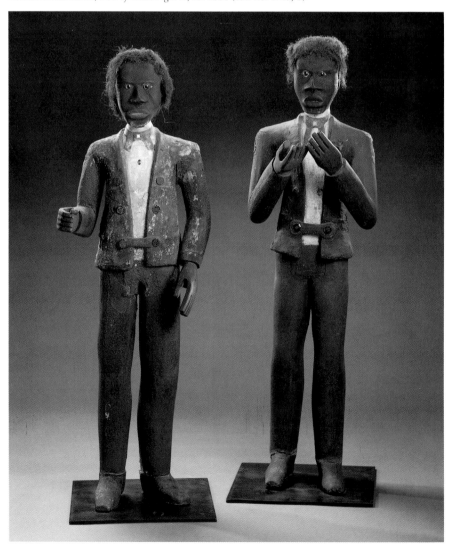

In spite of their unknown origin, this dignified pair of figures is attributed to a black artist. Rather than the stereotypical caricature that typified the portrayal of blacks in nineteenth-century America, this pair exhibits characteristics present in both African and American cultures. This hybrid effect is produced when the compositional devices linked to one culture blend with the content specific to another. Here the western-style clothing combines with an economy of form consistent with an African aesthetic. The symmetrical, frontal, and rigid position of the figures is derived from an African past. The faces, mask-like in their simplicity, exhibit a quiet dignity; in African sculpture, a passive face is the seal of noble character.[1]

It has been suggested that the pair functioned in a funerary context, perhaps as trade figures in a mortuary, or as ceremonial figures in a lodge setting. The two figures are related in costume and accessories. The jewel on their shirts and maltese cross securing their ties indicate a possible Masonic connection. Black lodge activity abounded in southern Ohio during the late nineteenth and early twentieth centuries. An association between fraternal organizations and insurance companies existed to provide burial coverage for lodge members which leads to speculation about the figures' use in funeral rites. The clenched fist of the one figure may have supported a staff or standard specific to the lodge or ritual, and the figure with raised hands seems poised to hold a book, perhaps a lodge manual, hymnal or the Bible. A loop in the lapels of each figure may have held a cut flower appropriate to formal ceremonies.[2] (LVS)

1. John Michael Vlach, *Afro-American Traditions in the Decorative Arts* (Cleveland: Cleveland Museum of Art, 1978), p. 31.

2. Michael and Julie Hall, interview by Julia Guernsey and Debra Brindis, 1 August 1991, transcript, Milwaukee Art Museum.

Unidentified Artist, *Miss Liberty*, early 20th century (cat. no. 195)

195*
Unidentified Artist
New England
Miss Liberty early 20th century
Carved, assembled, and painted wood, sheet metal, coach bolt, struts and iron ring
82 x 27 x 47 in.
(208.3 x 68.6 x 119.4 cm)
Acquired from Herbert W. Hemphill Jr., New York, 1970
M1989.127

Miss Liberty epitomizes the combination of individual expression and cultural connectedness that produces momentous folk art. Appreciated strictly from an aesthetic standpoint, her rough but resourceful construction and "harsh linear quality" make a powerful impression that is "free from the dogma and restrictions that . . . dominant culture (and its academic art world) imposes."[1] Seen in terms of her original context, however, *Miss Liberty*'s construction from ordinary cord wood, physical resemblance to traditional whirligigs and scarecrows, and evident use as a prominent yard ornament add significant human and social value to her unique formal properties.

As both private sculpture and public icon, *Miss Liberty*'s gender, pose, and various attributes reflect other historic or popular symbols of America such as the Indian Queen, Liberty goddess, Columbia, Statue of Liberty, and "liberty princesses" featured in many Fourth of July parades.[2] Her cannon lends an unusual and particularly militant note consistent with escalating U.S. nationalism between the Spanish-American War (1898) and the 1920s; interestingly, the long "special-headed" coach bolt that secures her arms also dates from this period. (JRH)

1. Herbert W. Hemphill Jr., *Folk Sculpture USA* (Brooklyn: Brooklyn Museum, 1976), p. 8.

2. Nancy Jo Fox, *Liberties with Liberty* (New York: E.P. Dutton, 1985), pp. 2-8.

Religion & History

196*
William Edmondson
Nashville, Tennessee
Lion late 1930s
Carved limestone; later repairs to legs and
tail made by Michael Hall with epoxy,
pins, and cement finish
22 x 6 ¾ x 35 ½ in.
(55.9 x 17.2 x 90.2 cm)
Acquired from Mrs. Alfred (Elizabeth)
Starr, Nashville, Tennessee, 1970
M1989.149

Because William Edmondson was both
self-taught and a black artist, his solo
exhibition in 1937 at The Museum of
Modern Art, New York, was unprece-
dented. Discovered by Nashville
neighbor and poet Sidney Hirsch,
Edmondson's work was subsequently
endorsed by other early modern artists
and intellectuals who were impressed by
its elemental form and technical direct-
ness, qualities that no doubt stemmed as
much from his limited tools, salvaged
limestone, and practical aims as a tomb-
stone and outdoor ornament carver as
from any preconceived aesthetic agenda.

A powerful religious vision compelled
Edmondson to begin carving three-dimen-
sional figurative subjects around the age
of sixty. "This here stone and all them
out there in the yard come from God," he
explained, "It's the work in Jesus speak-
ing His mind in my mind. ...These here is
miracles I can do."[1] Originally made as
grave markers and sold to fellow mem-
bers of the local United Primitive Baptist
Church, many featured doves, lambs, and
other spiritually significant animal motifs.
Of these, Edmondson's lions are the most
majestic,[2] and may allude to St. Mark's
noble conception of Christ as the Lion of
Judah or to Daniel's storied salvation
from the den through faith in God. (JRH)

1. Quoted in Edmund L. Fuller, *Visions in
Stone* (Pittsburgh: University of Pittsburgh
Press, 1973), p. 3.

2. See Edmondson's *Lion*, Tennessee State
Museum, Nashville, Tennessee.

William Edmondson, *Lion,* late 1930s (cat. no. 196)

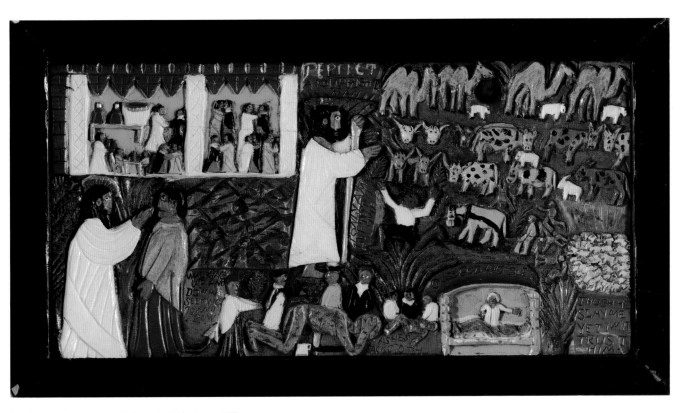

Elijah Pierce, *The Story of Job*, ca. 1936 (cat. no. 197)

197*
Elijah Pierce
Columbus, Ohio
The Story of Job ca. 1936
Carved and painted wood
16 x 29 x 2 in.
(40.6 x 73.7 x 5.1 cm)
Acquired from the artist, 1970
M1989.254

The story of Job's extraordinary suffering and triumph over evil forms the eighteenth book of the Old Testament. Its dramatic style and didactic content made it a popular ingredient in Baptist sermons, a fact echoed by Elijah Pierce's claim that "a preacher don't hardly get up in the pulpit without preaching some picture I got carved."[1] Pierce's depiction is based on the key first and second verses of the text.

At center, a "perfect and upright" Job learns from a lone survivor that his property, servants, and even his children who are shown above have been inexplicably destroyed. Along the lower register, from left to right, God is seen giving Satan permission to further test Job's faith, first with physical torture and then with taxing spiritual inquests conducted by three close friends. Another small section labeled "cuss God and die" quotes Job's wife at the height of their desperation. Finally, an inscription on the far right which is clearly set off from the rest of the design attests to Job's "trust" in God, even if God should take his life.

Job's ordeal and redemption are generally regarded as an Old Testament prefiguration of the Passion of Christ.

His story has also been treated by theologians as a lengthy parable on undeserved suffering in which worldly or rational notions of justice are subordinated to the ultimate prerogative of divine grace. In that sense, Pierce may well have offered Job's experience as a timely model of human fortitude amidst the Depression's inordinate hardships. (JRH & DS)

1. Elijah Pierce, quoted in *Elijah Pierce, Woodcarver* (Columbus: Columbus Gallery of Fine Arts, 1973), unpaginated.

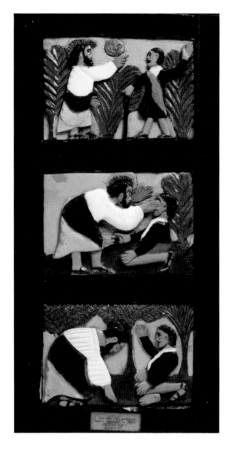

Elijah Pierce, *The Man That Was Born Blind Restored To Sight*, 1938 (cat. no. 198)

198*
Elijah Pierce
Columbus, Ohio
The Man That Was Born Blind Restored to Sight 1938
Carved and painted wood
23 ¼ x 11 ¹⁵⁄₁₆ x 1 ⅛ in.
(59.1 x 30.3 x 2.9 cm)
Acquired from the artist, 1972
M1989.252

Son of a church deacon and an ordained Baptist preacher himself, Pierce's "sermons" in wood often exalt the ministry of Christ. *The Man That Was Born Blind Restored To Sight* (John 9:1-7) depicts one of the miracles which Christ performed before his disciples to demonstrate God's omnipotence. As Pierce himself told it, "He saw that man. He was born blind from his mother's womb. And he was crying by the wayside and Jesus stopped and went out and takin' time out to heal him and give him sight."[1] With similarly impressive formal and narrative economy, Pierce's three panels show Christ, from top to bottom: 1) greeting the blind man who carries a cane, 2) placing a balm of spittle and clay on the man's eyes, and 3) bowing in honor of God's power while the cured man gives thanks *without a cane*. At the apex of the composition, a bright and smiling sun amplifies the artist's conviction that worldly wrong can only be righted with help from above for "it ain't no secret what God can do." (JRH & DS)

1. Pierce quotes from taped interview with Elijah Pierce by Michael Hall, accompanied by McArthur Binyon and Nancy Brett, fall 1971, Columbus, Ohio.

199
Elijah Pierce
Columbus, Ohio
Pearl Harbor and the African Queen 1941-?
Carved and painted wood with glitter
23 ¼ x 27 x 1½ in.
(59.1 x 68.6 x 3.8 cm)
Acquired from Boris Gruenwald, Tempe, Arizona, 1975
M1989.253

Even Elijah Pierce's nonreligious subjects reflect his view of the world as a place of essential moral choice and responsibility. *Pearl Harbor and the African Queen*, which exemplifies Pierce's occasional use of multiple carvings to form a single unified relief, is a richly symbolic work begun shortly after the United States entered World War II. The upper left panel portrays President Franklin D. Roosevelt standing before the flag, flanked by male and female sergeants who represent steadfast American youth. A wider panel to the right shows Uncle Sam being reassured by a duplicitous Japanese diplomat just as bombers launch their surprise attack on the Pacific fleet.[1]

The shared meaning and ideology of the two lower panels, though less explicit, also addresses the grave historical situation through parables that warn against avarice, arrogance and dishonesty. The African queen on the right sees her own face for the first time and rather than concede that other women are more beautiful, she bans mirrors within her kingdom. To the left, the greedy dog from Aesop's fable is about to lose the bone he holds for a larger but illusory one reflected in the water. While Pierce equated both of these storied images with Japanese conceit, he also carved the word DUTY in bold relief and included a row of commemorative flowers to signify an alternative American standard of willing national service and profound self-sacrifice.[2] (JRH)

1. Michael and Julie Hall, interview by Julia Guernsey and Debra Brindis, 1 August 1991, transcript, Milwaukee Art Museum.

2. For further discussion of this iconography, see E. Jane Connell, Annotated Checklist, *Elijah Pierce, Woodcarver* (Columbus Museum of Art, 1992), cat. no. 155; also listed is a related work, *African Queen and the Mirror*, cat. no. 156.

200
Elijah Pierce
Columbus, Ohio
Winged Lion ca. 1979
Carved and painted wood with glitter
4 7⁄8 x 7 x 1 3⁄4 in.
(12.4 x 17.8 x 4.5 cm)
Acquired from the artist, 1978
M1989.162

Pierce recalled that his first significant carving was an elephant made in the 1920s as a birthday present for his second wife.[1] Although his subsequent work turned increasingly religious, animals — whether depictive, fantastic, or emblematic — remained conspicuous among his subjects. This *Winged Lion* is the symbol of St. Mark the Evangelist. According to legend, lions are born dead but come to life three days later when breathed upon by their sire. Because the Gospel of St. Mark places great emphasis on the Resurrection of Christ, the winged lion became his principal attribute.[2]
(DS & JRH)

1. Elinor L. Horwitz, *Contemporary American Folk Artists* (Philadelphia: J.B. Lippincott, 1975), p. 86.

2. George Ferguson, *Signs and Symbols in Christian Art* (New York: Oxford University Press, 1959), p. 8.

Elijah Pierce, *Pearl Harbor and the African Queen*, 1941-? (cat. no. 199)

Elijah Pierce, *Winged Lion*, ca. 1979
(cat. no. 200)

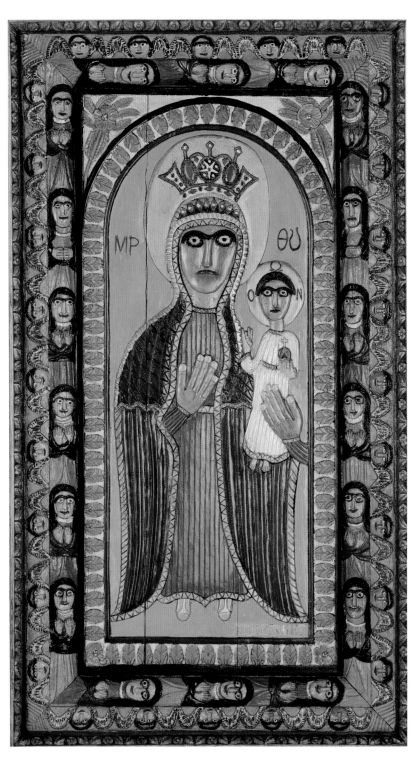

John W. Perates, *Madonna and Child*, ca. 1940
(cat. no. 201)

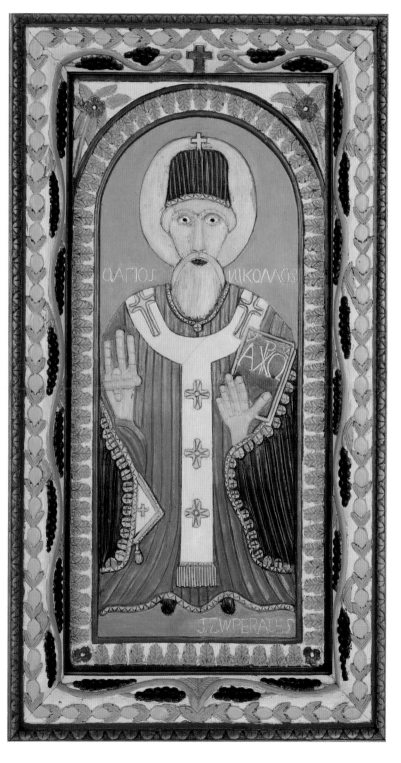

John W. Perates, *Saint Nikolos*, ca. 1950
(cat. no. 202)

201*
John W. Perates
Portland, Maine
Madonna and Child ca. 1940
Carved, painted, and varnished wood
53 ¾ x 30 ⅞ x 5 ⅝ in.
(136.5 x 78.4 x 14.3 cm)
Acquired from the artist's estate, 1973
M1989.256

Here, John Perates employs a common Byzantine iconographic type, the Virgin Hodegetria or "Pointer of the Way." In this role, the Madonna looks toward the observer while gesturing to the Christ Child. As Queen of Heaven, she wears a jeweled crown over her maphorion, while the Greek letters *MPOV* identify her as the Mother of God. Similarly, the Greek inscription on Christ's halo signifies "the Eternal," the divine name of Jehovah revealed to Moses and belonging to Christ's divine nature (Exodus 3:14).[1] Like *St. Nikolos* (cat. no. 202), the Christ child performs a traditional blessing.

Perates' innovative syncretism is present in this work. Although angels frequently appear as attendants in Eastern iconography, Perates' border of non-corporeal, winged, and consecutive angels probably derives from New England gravestone carving where such simplified motifs are common. Emphasized in Byzantine art to demonstrate receptivity to the vision of God,[2] the accentuated and thickly ringed eyes of these figures can also be found on early American tombstones. (JG & DS)

1. A. Dean McKenzie, *Greek and Russian Icons* (Milwaukee: University of Wisconsin-Milwaukee, 1965), p. 23.

2. Nora Lucas, "The Icons of John Perates," *The Clarion* (Winter 1981), p. 38.

202*
John W. Perates
Portland, Maine
Saint Nikolos ca. 1950
Carved, painted, and varnished wood
52 ¾ x 28 ¾ x 5 ⅞ in.
(134 x 73 x 14.9 cm)
Acquired from the artist's estate, 1973
M1989.255

Cabinet maker John Perates began carving icons in the late 1930s. He considered these works "furniture for the house of the Lord," and donated them to his local Greek Orthodox church. Although "icon," from the Greek word *eikon*, refers to a sacred image of members of the Christian hierarchy which is usually painted on a wooden panel and rendered in a conventional manner, Perates conflates several different artistic traditions. For example, the influence of Classical motifs from his youth in Amphikleia, Greece, can be seen in *St. Nikolos'* border of tightly knit acanthus leaves. Juxtaposed to this, however, are grapes and vines that symbolize the relationship between God and humans through Christ: "I am the vine, you are the branch" (John 15:5).

Bishop of Myra in Asia Minor in the fourth century and known for his extraordinary piety, zeal, and numerous miracles, St. Nikolos is invoked as a "great hierarch and ecumenical teacher" in the Greek Orthodox liturgy.[1] Perates, in accordance with Byzantine conventions, depicts St. Nikolos wearing a bishop's robes and mitre, holding the gospels in his left hand, and performing a blessing with his right in which his fingers form the first and last letters of the Greek words for Jesus Christ (*IC* and *XC* from *Ihcuc Xpictoc*). Also according to custom, Perates names St. Nikolos in Greek script on either side of his head. Interestingly, however, Perates departs from formal strictures by bestowing the saint with a gaze that directly meets the observer's eyes — unlike most Byzantine icons in which the saint glances to the side. Furthermore, and perhaps most dramatically, it is Perates' unique blend of bold relief carving with painting that distinguishes his sculpture from the strictly two-dimensional iconic tradition. (JG & DS)

1. Alban Butler, *Lives of the Saints*, volume IV, eds. Herbert Thurston and Donald Attwater (New York: P.J. Kennedy and Sons, 1956), pp. 503-6.

203*
Albert Zahn
Baileys Harbor, Wisconsin
Seated Figure 1950
Carved, painted and assembled wood
13 x 5 ⅝ x 8 ⅞ in.
(33 x 14.3 x 22.5 cm)
Acquired from Hammer and Hammer
Gallery, Chicago, Illinois, 1981
M1989.135

204*
Standing Figure 1950
Carved, painted and assembled wood
14 ⅛ x 3 ¾ x 2 ⅜ in.
(35.9 x 9.5 x 6 cm)
Acquired from Hammer and Hammer
Gallery, Chicago, Illinois, 1981
M1989.143

Zahn created pyramidal configurations that he referred to as "family trees" which incorporated figures like these two.[1] Typically, the bearded patriarch sat at the base of the construction with the younger male or an angel above him, while female figures projected from the sides. His son, Elmer, suggests that Zahn, an intensely religious man, may have been inspired by David's Psalms in the Old Testament.[2] Perhaps the bearded patriarch and other figures represent the family tree of David, who became King of Israel:

> May our sons be like plants
> Growing strong from their earliest
> days, Our daughters like corner
> statues, Carvings fit for a
> palace . . . (Psalm 144: 12-13)

(JG)

1. See Chuck and Jan Rosenak, *Encyclopedia of 20th Century American Folk Art and Artists* (New York: Abbeville Press, 1990), p. 337 and Robert Bishop, *American Folk Sculpture* (New York: E.P. Dutton, 1974), p. 190.

2. Telephone conversation with Elmer Zahn, Sturgeon Bay, Wisconsin, 8 October 1991.

Albert Zahn, *Seated Figure*, 1950 (cat. no. 203), and *Standing Figure*, 1950 (cat. no. 204)

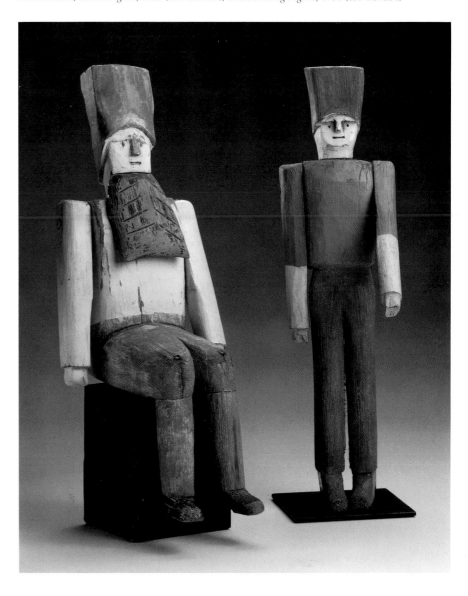

Fall of Man Series

Edgar Tolson is Kentucky's best-known woodcarver. Tolson often whittled as a young man, but did not begin to carve in earnest until 1957, after suffering a stroke. His early work consisted primarily of traditional Appalachian subjects: birds, snakes, farm animals, single figures and walking sticks. Occasionally he produced more complex scenes, such as *Man with Pony* (cat. no. 167) and *Crucifixion* (cat. no. 206), reportedly Tolson's first religious carving.[1]

In 1967, Tolson's work underwent a dramatic change when he was commissioned by John Tuska, Associate Professor of Sculpture at the University of Kentucky, to carve " . . . an Adam and Eve with no clothes on and a tree with a snake in it."[2] That scene, which Tolson called *Temptation* (cat. no. 205b), was frequently reproduced along with several other related biblical subjects and ultimately led to the artist's culminant *Fall of Man* series (cat. no. 105a-h). The eight tableaux which make up this series recount the events of Genesis chapters 2-4, beginning with Adam and Eve in Paradise and ending with Cain's banishment for the murder of Abel.

For Tolson, *Fall of Man* and its constituent episodes represent "all the stories possible in the Bible . . . from Genesis to Revelations."[3] In addition to the series' obvious biblical script, *Fall of Man* also reflects Tolson's personal religious convictions as well as a number of issues and values fundamental to Appalachian culture. In Appalachia, the Bible provides a strict moral code for living. It is widely regarded as the source of absolute truth and is believed to contain explicit solutions to all of life's difficulties. Such fundamentalism further holds that humans are, by nature, sinful. Paradoxically, acceptance of this belief along with decades of economic depression and social isolation have resulted in a society tolerant of human weakness. Such seem-ingly minor offenses as swearing, Sabbath breaking, drinking, gambling, card playing, dancing and sexual license all receive stern religious rebukes. On the other hand, a "practical permissiveness" is allowed to co-exist and "acts of violence, often within a family context, are accepted realities."[4] These conflicting cultural attitudes are reflected both in the subjects of Tolson's series and in the manner in which they are portrayed. Themes of innocence, corruption, childbirth, murder, grief, alienation and redemption are conveyed in a seemingly objective, matter-of-fact manner. Yet, at the same time, Tolson also seems to emotionally identify with his characters. Restricted gestures simultaneously express feelings of shame, paternal love, shock, and grief.

In this series, as in all of his work, Tolson used local and readily available materials. Throughout the eight tableaux, his carving style is simple and reductive. His figures, true to the craft tradition of the region, retain a log-shaped appear-ance. Their movements are restricted, and their faces, all similarly carved, are expres-sionless with eyes that stare straight ahead.

Although the individual episodes of the *Fall of Man* were not produced sequen-tially, an evolution of style is discernible within the series. Between 1969 and 1971, figures change in size and scale. Initially, figures are short and somewhat flat (*Paradise* cat. no. 205a). Within a brief period of time, they become taller and fuller (*Original Sin* cat. no. 205c), then change again to an increasingly thin and elongated form (*Temptation* cat. no. 205b). During this period, compositions also change. Beginning with the *Birth of Cain* (cat. no. 205f), they become drastically simplified — all elements that previously implied a setting are eliminated. Further-more, the compositions are no longer sym-metrically arranged along a central axis. These changes reveal an increasingly self-aware artist who constantly sought to refine his expression even if that meant breaking with some of the craft traditions of his formative years.

Although Tolson continued to carve non-religious subjects such as animals and figures throughout his life, it was works related to and derived from the eight *Fall of Man* scenes that were his major preoccu-pation and brought him international recognition. (DB)

1. Priscilla Colt, *Edgar Tolson: Kentucky Gothic* (Lexington: University of Kentucky, 1981), p. 15.

2. Telephone conversation with Miriam Tuska, collector, 19 November 1990.

3. Edgar Tolson quoted in Michael D. Hall, "You Make It With Your Mind: Edgar Tolson," in *Stereoscopic Perspective* (Ann Arbor: UMI Research Press, 1990), p. 171.

4. Catherine L. Albanese, "Appalachian Religion," in *Encyclopedia of Southern Culture*, eds. Charles Reagan Wilson and William Ferris (Chapel Hill: University of North Carolina Press, 1989), p. 1276.

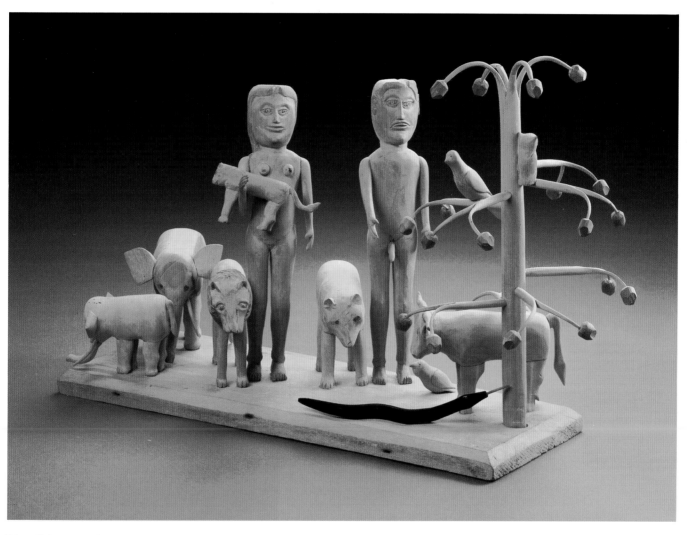

Edgar Tolson, *Paradise*, 1969 (cat. no. 205a)

205
Edgar Tolson
Campton, Kentucky
Fall of Man Series
205a
Paradise 1969
Poplar, paint, pencil, glue and pen
12 ⅛ x 6 ⅛ x 17 ⅜ in.
(30.8 x 15.6 x 44.1 cm)
Acquired from the artist, 1969
M1989.314.1

This tableau is one of Tolson's earliest in the *Fall of Man* series. The tree and snake motifs, which probably originated in a garden scene that Tolson carved in 1962, are present in each of the first five scenes, but conspicuously absent in the last three.

Tolson's inclusion of a black snake as a symbol of evil in his vision of *Paradise* seems to underscore his belief in the inherent sinfulness of human beings. The snake's presence also foreshadows the approaching biblical events as they unfold in this series.

This scene is the most elaborate of the six known *Paradise* scenes carved by Tolson. It contains more animals, wild as well as domestic, than any others. (DB)

205b
Temptation 1971
Poplar, cedar, paint, glue, pencil and pen
15 ½ x 9 ¼ x 11 ½ in.
(39.4 x 23.5 x 29.2 cm)
Acquired from the artist, via Ken Fadeley, Ortonville, Michigan, 1973
M1989.315.2

Tolson carved three *Temptation* scenes before expanding his repertoire to include other events from Genesis. Over the years he produced more than one hundred carvings depicting Adam and Eve, but *Temptation* was his most frequently reproduced scene.[1]

Tolson's motivation for repeatedly carving *Temptation* is based both on economics and personal belief. Multiple requests for this tableau provided much needed additional income for his large family. Moreover, Tolson's own moral code stressed the significance of personal choice and its effect on one's lot in life, a concept central to the *Temptation* theme.

Here Eve is portrayed in her traditional role as temptress. In other versions in which Adam tempts Eve or Adam and Eve eat of the tree simultaneously (National Museum of American Art), a greater sense of shared responsibility is implied. The variations among the many *Temptation* scenes appear deliberate on the part of Tolson, who played with the position of the figures and their gestures in order to change the psychology of the scene. (DB)

1. Michael D. Hall, "You Make It With Your Mind: Edgar Tolson," in *Stereoscopic Perspective* (Ann Arbor: UMI Research Press, 1990), p. 167.

205c
Original Sin 1970
Poplar, water birch, cedar, paint, glue, pencil and pen
14 ½ x 10 ⅛ x 13 ½ in.
(36.8 x 25.7 x 34.5 cm)
Acquired from the artist, 1970
M1989.315.3

Original Sin is a graphic depiction of the biblical passage, "And Adam knew his wife . . ." (Genesis 4:1). Such explicitness is virtually unprecedented in the history of art. Sex, for Tolson, is a more familiar and tangible symbol of humanity's loss of innocence than the apple.

The significance of Eve's raised arms and turned head is unclear. Are these gestures meant at once to imply shame, acceptance, or indifference? If so, these contradictory attitudes reflect a paradox that exists in Appalachian society. A fundamentalist approach to religion provides a strict moral code for living that prohibits sexual license; yet, the acceptance of a sinful nature undermines this standard and results in more tolerant social practices.[1] Tolson's own actions further illustrate this paradox, for upon completion of this scene, he hid it from public view for several days.

This *Original Sin* tableau is unique and was conceived by Tolson expressly for the *Fall of Man* series. His only other tableau featuring a sex act is *Adam and Eve* (National Museum of American Art), a scene carved much later and never intended to be part of a series. (DB)

1. Fred J. Hood, "Kentucky," in *Encyclopedia of Religion in the South*, ed. Samuel S. Hill (Macon: Mercer University Press, 1984), p. 388.

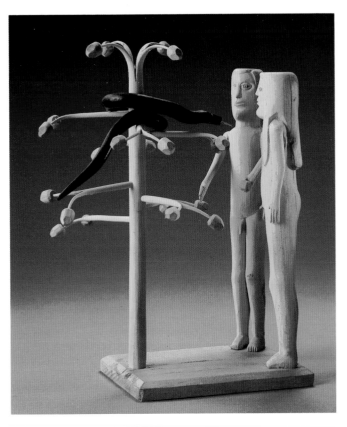

Edgar Tolson, *Temptation*, 1971 (cat. no. 205b)

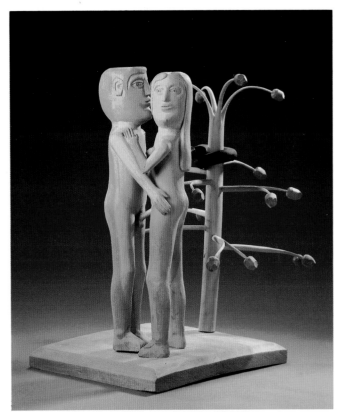

Edgar Tolson, *Original Sin*, 1970 (cat. no. 205c)

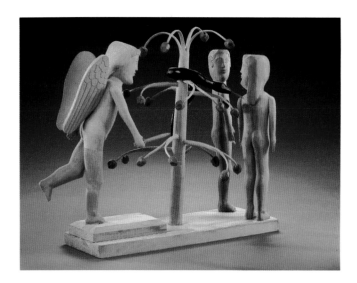

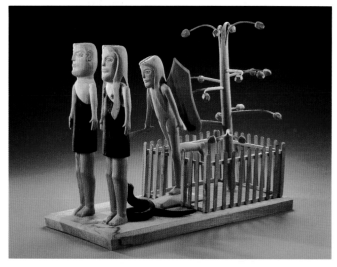

Edgar Tolson, *Expulsion*, 1969 (cat. no. 205d)

Edgar Tolson, *Barring of the Gates of Paradise*, 1970 (cat. no. 205e)

205d
Expulsion 1969
Poplar, water birch, cedar, paint,
varnish, glue, pencil and marker
12 ½ x 7 ½ x 15 in.
(31.8 x 19.1 x 38.1 cm)
Acquired from the artist, 1969
M1989.315.4

The *Expulsion* and *Paradise* (cat. no. 205a) scenes in this collection were carved in the same year; hence, the similarity in size and figurative proportions. These tableaux and several *Temptations* were carved before Tolson began to experiment with larger forms.

The raised platform on which the flying angel alights signifies the angel's superiority over earthbound Adam and Eve. By centering the tree and snake between Adam and Eve and the angel, Tolson suggests that the latter is also being expelled. This arrangement is a revision of his two earlier *Expulsion* scenes in which the tree and snake are placed behind the angel.

In this scene, Adam and Eve are not clothed, nor do they exhibit any sign of recognizing their nakedness. This depiction is contrary to the biblical account in which God clothes Adam and Eve before they are expelled from the garden. Tolson's various deviations from the biblical text illustrate his penchant for drama and highly individual character. (DB)

205e
Barring of the Gates of Paradise 1970
Poplar, water birch, cedar, glue, paint,
pencil and marker
15 ½ x 9 ⅜ x 18 ¾ in.
(39.4 x 23.9 x 47.6 cm)
Acquired from the artist, 1970
M1989.315.5

This tableau from Genesis 3:24 depicts the angel driving Adam and Eve out of the Garden which is then guarded by a cherubim with flaming sword. Adam and Eve's black garments, along with the snake trailing behind them, serve as a visual metaphor for man's new sinful condition and its cause. Note that the snake is also forced from the garden.

Interestingly, Tolson portrays Adam and Eve as expressionless. Their stoic, militaristic stances evoke a sense of resignation and fatefulness, attitudes shared by the Appalachian people themselves who have long endured the hardships of mountain life. (DB)

205f
Birth of Cain 1970
Poplar, paint, nails, glue, pencil and marker
8 x 9 ¼ x 9 ⁵⁄₁₆ in.
(20.3 x 23.5 x 23.7 cm)
Acquired from the artist via Ken Fadeley, Ortonville, Michigan, 1970
M1989.315.6

The rendering of the *Birth of Cain* is unprecedented in the history of art. Tolson's scene combines a literal and personal interpretation of the biblical text. It depicts both the literal pain of childbirth, and more generally, the resultant suffering caused by Adam and Eve's sin.

Tolson's decision to show Adam assisting with Cain's birth may stem from a life spent in the hills of eastern Kentucky where the nearest neighbor is often miles away and a shortage of medical professionals often forces family members to fill this role. Adam's participation may also reflect the special relationship that exists between males and newborn babies in Appalachian society. Males cherish their new sons and daughters and are frequently involved in the care of the newborn. As the child grows older, however, this initial involvement wanes, and the child becomes the primary responsibility of female relatives.[1]

The sparseness of this scene marks a dramatic change in Tolson's style. The figures are presented without setting or extraneous detail. Such stark simplicity effectively evokes Adam and Eve's solitude after being expelled from the Garden. On a more personal level, it may also reflect the social and economic isolation felt by members of Appalachian society. (DB)

1. Jack E. Weller, *Yesterday's People* (Lexington: University of Kentucky Press, 1975), p. 62.

205g
Cain Slaying Abel 1970
Poplar, paint, nails, glue, pencil and marker
12 ¾ x 9 ¾ x 9 ⅜ in.
(32.4 x 24.8 x 23.9 cm)
Acquired from the artist, 1971
M1989.315.7

In this scene, Tolson depicts the moment just before Cain slays Abel. Abel stares at the stick that his brother wields, and both are cognizant of what is about to transpire. As in *Temptation* (cat. no. 205b), where Eve makes a decision that will determine her lot in life as well as that of all humankind, Tolson shows Cain at a similar crossroad. More generally, Tolson uses both scenes to portray a profound moment of choice when human fate hangs in the balance.

Tolson carefully distinguishes Cain from Abel for the viewer by differing their costume. Cain's toga-like robe drapes over his right shoulder, Abel's over his left. (DB)

205h
Cain Going Into The World 1970
Poplar, paint, glue, nails, pencil and marker
14 ½ x 13 ⅜ x 9 ¼ in.
(36.8 x 34 x 23.5 cm)
Acquired from the artist, 1971
M1989.315.8

Cain Going Into The World is arguably the most powerful scene in the entire series. It simultaneously depicts Eve's discovery of the slain Abel, and Cain's banishment from his home and family. Eve's restricted gestures convey at once the shock, horror and grief of her discovery, and by extension Tolson's own more personal grasp of her tragedy.

Cain's new boots provide a humorous but poignant anecdote to this scene. They are a practical, yet insightful response to Cain's punishment. Cain stands frozen at the edge of the tableau as he faces the unknown. Constrained by his past actions and by what he knows he is leaving behind, he can neither go forward nor move backward. Michael Hall suggests that *Cain Going Into The World* is Tolson's most sophisticated piece and that it autobiographically portrays the artist's psychological struggle. According to Hall, Tolson was not only conscious of man's inherent fallibility, but also of a personal inability to control his own destiny.[1] (DB)

1. Telephone conversation with Michael D. Hall, 18 January 1992.

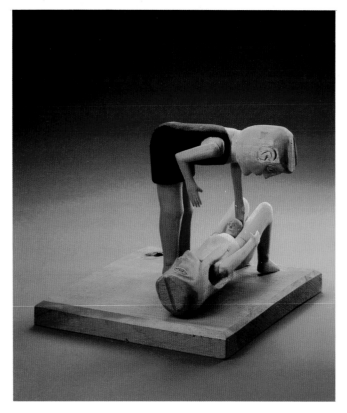

Edgar Tolson, *Birth of Cain*, 1970 (cat. no. 205f)

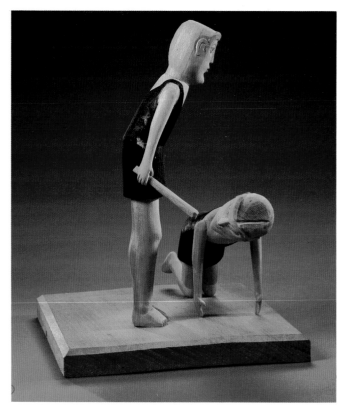

Edgar Tolson, *Cain Slaying Abel*, 1970 (cat. no. 205g)

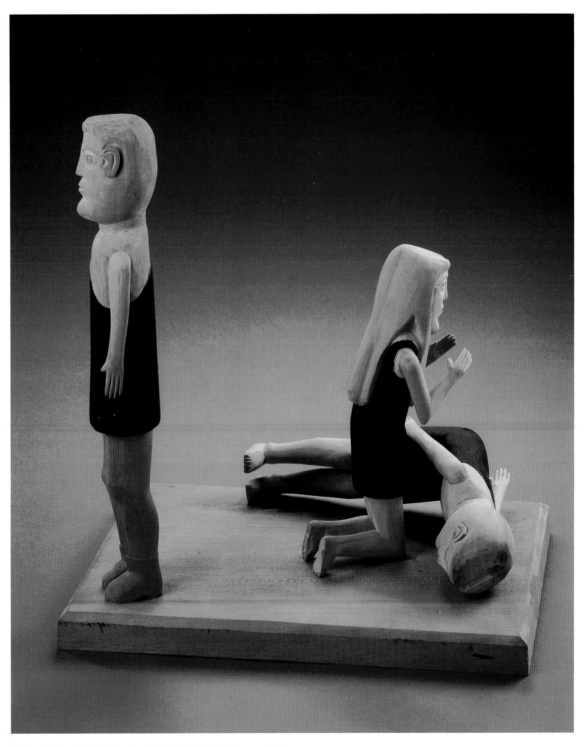

Edgar Tolson, *Cain Going Into The World*, 1970 (cat. no. 205h)

206
Edgar Tolson
Campton, Kentucky
Crucifixion 1969
Poplar, glue, nails and pencil
9 ¾ x 16 ½ x 3 ¼ in.
(24.8 x 41.9 x 8.3 cm)
Acquired from the artist, 1970
M1989.321

There are only two extant crucifixion scenes in Tolson's *oeuvre*. Reportedly, Tolson was ambivalent toward the crucifixion theme and other New Testament subjects. He felt that the New Testament's promise of salvation diluted the basic laws and lessons of the Old Testament. In addition, he preferred the clarity of the Old Testament, which he believed contained more truth because it was not mediated by the potential for redemption.[1] (DB)

1. Michael and Julie Hall, interview by Julia Guernsey and Debra Brindis, 1 August 1991, transcript, Milwaukee Art Museum.

207*
Edgar Tolson
Campton, Kentucky
Preacher 1972
Poplar, pine, glue, nails, pencil and marker
22 ½ x 12 ½ x 6 ⅛ in.
(57.2 x 31.8 x 15.6 cm)
Acquired from the artist, 1973
M1989.316

The subject of a preacher at his lectern was especially relevant to Tolson, who himself was once an unordained "lay" preacher. This piece, however, was not intended to be autobiographical, but was first conceived as an Uncle Sam figure and varies only slightly from two other subjects, *Standing Man with a Cap* (1968) and *Self Portrait* (1971).[1] This "recycled" Uncle Sam and other similar conversions demonstrate both the primacy and range of the single figure in Tolson's work. (DB)

1. Telephone conversation with Michael Hall, 8 April 1991. The two pieces are pictured in Priscilla Colt, *Edgar Tolson: Kentucky Gothic* (Lexington: University of Kentucky, 1981), figures 32 and 57.

Edgar Tolson, *Preacher*, 1972 (cat. no. 207)

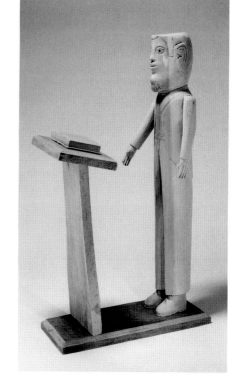

Edgar Tolson, *Crucifixion*, 1969 (cat. no. 206)

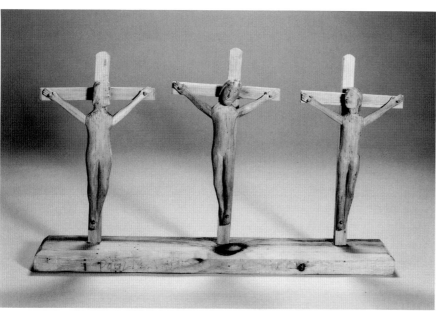

208
Edgar Tolson
Campton, Kentucky
Unicorn in a Garden 1972
Poplar, popsicle sticks, cedar, glue, pencil,
leather and nails
15 x 11 ½ x 11 ½ in.
(38.1 x 29.2 x 29.2 cm)
Acquired from the artist, 1973
M1989.323

This tableau confirms the influence of
popular media on Tolson's work. Its
design derives from a postcard sent to the
artist depicting a tapestry with a unicorn
from the Cloisters Museum, New York.[1]
In other instances, Tolson was likewise
inspired by images on a matchbook cover,
orange juice can, and an army recruiting
poster.

This unicorn is one of eight carved by
Tolson. All of the unicorns wear "pet"
collars and are chained to a tree. The
chain, carved from a single piece of wood
and also seen on Tolson's *Ox Plaque* (cat.
no. 187), is a *tour de force* whittling techni-
que that derives from traditional Appala-
chian folk craft. (DB)

1. Telephone conversation with Miriam
Tuska, collector, 19 November 1990.

209
Luis Tapia
New Mexico
Nativity ca. 1970
Carved and painted wood, straw
17 ⅛ x 12 x 11 in.
(43.5 x 30.5 x 27.9 cm)
Acquired from Estelle Friedman,
Washington, D.C., 1980
M1989.137

Tapia is a well known contemporary
santero (carver or painter of saints) who
combines traditional and updated ele-
ments in his work. His early *Nativity*, for
example, is a conventional subject that
honors and protects the Christian family,
yet Tapia employs quasi-geometric forms
and bright, synthetic colors that link it to
modernism. (DS)

Edgar Tolson, *Unicorn in a Garden*, 1972 (cat. no. 208)

Luis Tapia, *Nativity*, ca. 1970 (cat. no. 209)

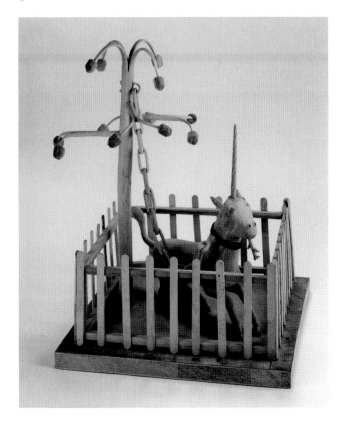

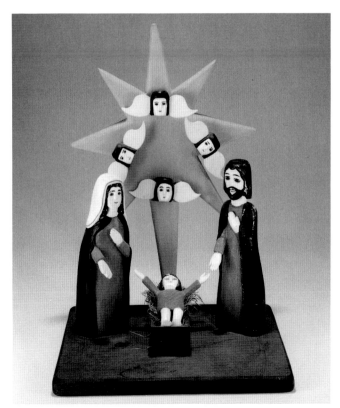

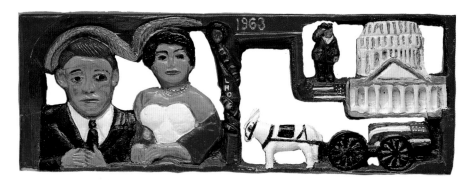

Josephus Farmer, *Tribute to the Kennedys*, 1970s (cat. no. 210)

210
Josephus Farmer
Milwaukee, Wisconsin
Tribute to the Kennedys 1970s
Carved and painted wood
11 x 31 ¼ x 1 ½ in.
(27.9 x 79.4 x 3.8 cm)
Co-acquired with Estelle E. Friedman
from Richard Flagg, Milwaukee,
Wisconsin, 1983; wholly acquired in 1989
M1989.258

Although Josephus Farmer carved historical as well as religious subjects, he depicted both as literal truths which were meant "not only to inform but also to inspire."[1] Among his several portraits of Abraham Lincoln, Franklin D. Roosevelt, and other exemplary national leaders, John F. Kennedy figures most prominently as "the greatest President and . . ." — recalling the African American liberation subtext of *The Passover* (cat. no. 211) — "the man responsible for Civil Rights."[2]

Tribute to the Kennedys consists of three sections. On the left, the former President and First Lady are rendered in formal, bust-length fashion, their physical and emotional presence enhanced by Farmer's novel use of a drill to penetrate the panel and surround the couple with actual "open" space. In the center, a tree trunk rises from the lower to the upper border of the relief where "1963" is inscribed; around the trunk, a coiled serpent with a

demonic face is marked with the initials of Lee Harvey Oswald. On the right, Kennedy's great funeral procession down Constitution Avenue is represented by the U.S. Capitol, a flag-draped coffin and hearse drawn by a team of white horses, and a small saluting figure reminiscent of "John John" Kennedy's poignant farewell to his father — all impressions that could well have accrued from four consecutive days of network television coverage. Consistent with Farmer's deeply patriotic sentiments, the entire composition is bathed in glossy red, white and blue enamel.
(JRH)

1. Joanne Cubbs, *The Gift of Josephus Farmer* (Milwaukee: University of Wisconsin-Milwaukee Art History Gallery, 1982), p. 7.

2. Quoted in Cubbs, *The Gift of Josephus Farmer*, p. 26.

211*
Josephus Farmer
Milwaukee, Wisconsin
The Passover 1970s
Carved and painted wood, rhinestone
13 ⅞ x 47 ¼ x 1 1/16 in.
(35.2 x 120 x 2.7 cm)
Acquired from Estelle E. Friedman,
Washington, D.C., 1983
M1989.257

Like Howard Finster, Sister Gertrude Morgan, and other artist-evangelists, the Reverend Josephus Farmer's creative work served as a teaching tool and source of revenue for his primary religious activities. As Joanne Cubbs has observed, most of his deeply carved and enameled wood reliefs depict Old Testament subjects in a highly dramatic, improvisational narrative style that approximates traditional African American folk "sermonizing."[1] In *Passover*, the well known Exodus story is condensed into three unequal but vivid frames that move from 1) the first Passover ceremony to 2) the death of the Pharaoh's first-born to 3) the Egyptians' final, disastrous pursuit of the Jews. Oratorical intensity is reinforced by brightly inscribed scriptural citations, rich color and a red rhinestone for the Pharaoh's eye, and bold amplification of the closing word HALT, while the emancipation theme itself finds potent equivalence in black American history. Although Farmer used Bible illustrations as the model for some of his religious images, in this instance a book of still photos from Cecil B. de Mille's extravagant 1956 movie *The Ten Commandments* influenced his design, which probably explains the unorthodox prominence of a climactic chariot scene. (JRH)

1. Joanne Cubbs, *The Gift of Josephus Farmer* (Milwaukee: University of Wisconsin-Milwaukee Art History Gallery, 1982), pp. 17-19.

Josephus Farmer, *The Passover*, 1970s (cat. no. 211)

212*
Shields Landon (S.L.) Jones
Hinton, West Virginia
Head of Christ late 1970s
Carved, painted and stained wood with
filler in seams at base of neck
12 x 12 ½ x 8 ¼ in.
(30.5 x 31.8 x 21 cm)
Acquired from Herbert W. Hemphill Jr.,
New York, 1979
M1989.140

Unlike his earlier work, Jones' full-
sized heads are first roughed out with a
chain saw and further shaped with chisels
and rasp before being finished with a
knife and various shades of opaque
housepaint. Whether sacred or more typi-
cally secular, all of these subjects seem re-
lated by their projecting foreheads and
chins, broad lips, pencil-thin brows, thick
noses, and invariably uneven but sensitive
eyes. A devoutly religious man, Jones'
bust of Christ includes the scarlet robe
worn during his mockery (Matthew 27:28-
29) and symbolic of the Passion. (JRH)

Shields Landon (S. L.) Jones, *Head of Christ*, late 1970s (cat. no. 212)

Works on Paper

This section reflects the problematic and often arbitrary nature of categorizing art. Drawings, watercolors, and other paper-based imagery constitute a highly traditional class of art, yet most of the artists included here are classified as "outsiders" because their lives seem strange or unusual by mainstream standards — Bill Traylor, for example, was born a slave but became a curbside artist in his eighties; Charley Kinney had little schooling and seldom left his Appalachian farm; Inez Nathaniel-Walker began drawing in prison; Martin Ramirez spent half his life in a mental hospital; Sister Gertrude Morgan portrayed herself as the bride of Christ; and career civil servant Ted Gordon took up "doodling" as an "exercise in self-observation and self-transformation".[1] Nevertheless, while the subjects, styles, and materials of these artists are distinctive and at times even original, these qualities are no more unique to their production than to the work of many academically trained innovators. Arguably, if anything isolates their creative endeavor, it is not biographical detail in itself but the *exclusory* emphasis placed on certain social, economic, and cultural factors by the collectors, dealers, and other art-world "insiders" who form their audience and judge their output. Michael Hall finds a profound if ambivalent mythology behind that judgment, for while the "outsider" is kept safely in exile, he or she serves to satisfy a vital contemporary human need:

> The veneration of the "other" should not be seen as a simple quirk of the art world. In a broader sense it expresses a general distrust of modernism and the specific belief . . . that the price paid for progress has been the loss of a certain spirituality in modern life — both the spirituality within the individual and that presumed to have belonged to whole communities in pre-modern times.[2]

(JRH)

1. Letter, Theodore H. Gordon to Russell Bowman, 5 February 1992, Milwaukee Art Museum files.

2. Michael D. Hall, "The Mythic Outsider," *New Art Examiner* 19, 1 (September 1991), p. 17.

J. C. Huntington, *Figures in a Garden*, detail, ca. 1944 (cat. no. 224)

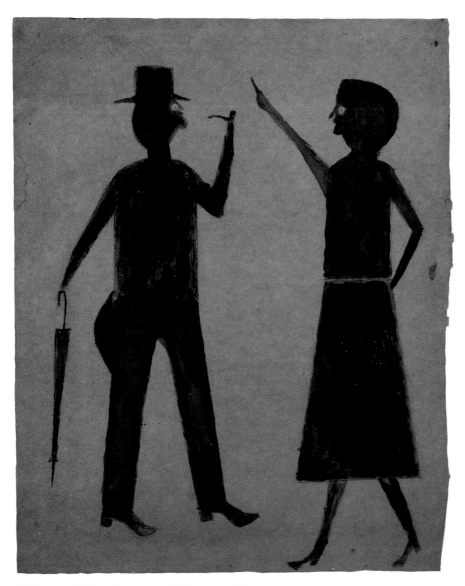

Bill Traylor, *Talking Couple*, ca. 1940 (cat. no. 213)

213*
Bill Traylor
Montgomery, Alabama
Talking Couple ca. 1940
Brown and blue tempera paint over
pencil on cardboard
14 ⅞ x 12 ¹⁄₁₆ in.
(37.8 x 30.6 cm)
Acquired from Luise Ross, New York, 1982
M1989.236

The two figures in *Talking Couple* seem
to be arguing rather than talking, a scene
Traylor may have witnessed on Monroe
Street or recalled from his own past. Inter-
action between the figures is suggested by
their extended arms. The economy with
which his images convey a narrative is
masterful.

The blue color of the woman evinces
Traylor's disregard for naturalism. He
often used brown and black, as well as
primary and binary colors, but he never
mixed pigments.[1] Blending colors might
have diminished the immediacy of
Traylor's work and impeded his delib-
erate drawing technique. (MA)

1. Diane Finore, "Art by Bill Traylor," *The
Clarion* (Spring/Summer 1983), pp. 44-45.

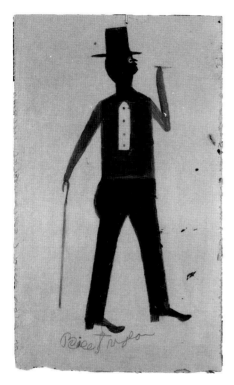

Bill Traylor, *Gentleman with Top Hat and Cane*, ca. 1940 (cat. no. 214)

Verso

214
Bill Traylor
Montgomery, Alabama
Gentleman with Top Hat and Cane ca. 1940
Brown and black tempera paint over pencil on cardboard
16 ⅛ x 9 ⅝ in.
(41 x 24.5 cm)
Acquired from Luise Ross, New York, 1982
M1989.238

Traylor had a very deliberate drawing technique. He would begin a figure by fashioning a rectangle, square, or occasionally a triangle with a block of wood. Using these simple shapes as a foundation, he would complete his figures freehand.[1] It is this geometric basis that lends a distinctly modern quality to Traylor's work.

Gentleman with Top Hat and Cane was begun by drawing the rectangular torso first, after which the head, arms, legs, and buttocks were completed. This work retains the string Traylor used to hang his works while selling them.[2] On the verso of the irregularly shaped cardboard, the trademark *5 Diamonds Dress Shirt* is still legible. (MA)

1. Michael Bonesteel, "Bill Traylor, Creativity and the Natural Artist," in *Bill Traylor Drawings* (Chicago: Chicago Office of Fine Arts, 1988), p. 23.

2. Jane Livingston and John Beardsley, *Black Folk Art in America 1930-1980* (Jackson: University of Mississippi Press, 1982), p. 140.

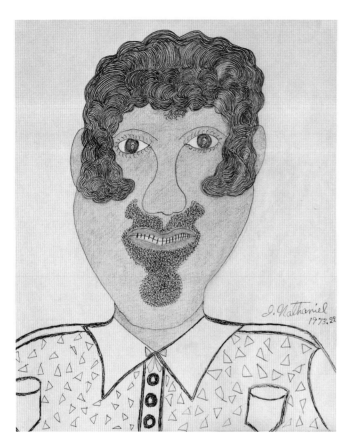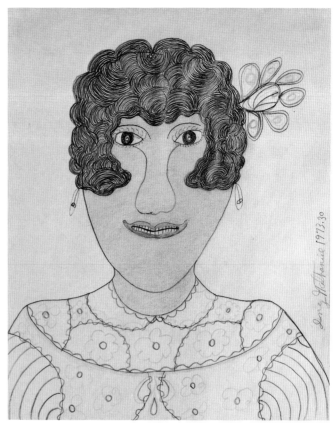

Inez Nathaniel-Walker, *Pair of Portraits (Man and Woman)*, 1973 (cat. no. 215a, b)

215*
Inez Nathaniel-Walker
Port Byron, New York
Pair of Portraits (Man and Woman) 1973
Wax crayon, ball point pen and pencil on
wove paper
17 ⅛ x 13 ¾ in.
(43.5 x 34.9 cm)
Acquired from Webb Parsons Gallery,
New Canaan, Connecticut, 1973
M1989.243a,b

These rather plainly delineated and
moderately colored portraits exemplify
the early phase of Nathaniel-Walker's
artistic development, before she began
drawing full figures. The man and
woman share many of the same features,
including frontal poses, hairstyles which
frame the face, large unblinking eyes, and
truncated figures. The rigid directness of
the subjects recalls early folk portraits, as
does the artist's interest in costume.

This set of portraits is unique accord-
ing to Michael Hall, who knows of no
other true "pair" done by Nathaniel-
Walker.[1] Most of the artist's figures are
either single or groups of females — often
identified as the "bad girls" she met while
in prison[2] — and although males do
appear with females in her drawings, a
lone male is rare. (MA)

1. Hall Collection Provenance Records,
Milwaukee Art Museum.

2. Elinor Horwitz, *Contemporary American
Folk Artists* (Philadelphia: J.B. Lippincott,
1975), p. 58.

216*
Inez Nathaniel-Walker
Port Byron, New York
Stylish Couple 1977
Colored pencil on paperboard
28 ⅛ x 22 in.
(71.4 x 55.9 cm)
Acquired from the artist, 1975
M1989.244

The full-length figures and expansive surface decoration of *Stylish Couple* characterize Nathaniel-Walker's later work. Although always interested in costume, here the lively design of her subjects' clothing is enriched by competing patterns in the surrounding space.

Like Bill Traylor, Nathaniel-Walker's technique was deliberate and sure. Her reluctance to erase anything once she began to draw gives her work a directness that is matched by the unblinking eyes of her subjects.[1] In this portrait, the woman is depicted strictly from the front, while the man is seen from a dual side/front perspective that recalls Egyptian practices. (MA)

1. Michael D. Hall, *Transmitters* (Philadelphia: Philadelphia College of Art, 1981), p. 33.

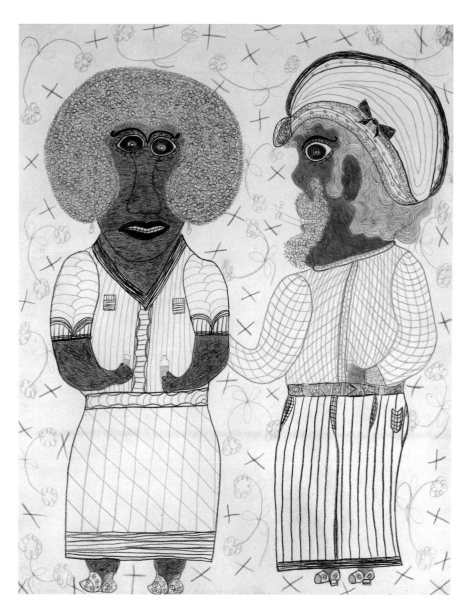

Inez Nathaniel-Walker, *Stylish Couple*, 1977 (cat. no. 216)

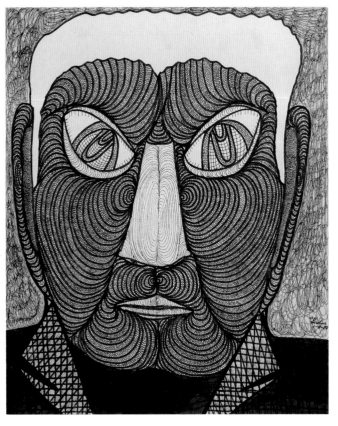

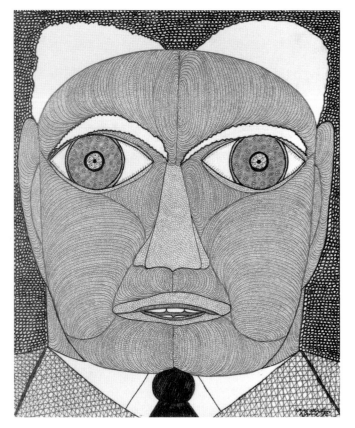

Theodore Gordon, *Demonic Visage*, ca. 1980 (cat. no. 217)

Theodore Gordon, *Visage of a Man with Blue Eyes*, ca. 1980 (cat. no. 218)

217*
Theodore Gordon
Laguna Hills, California
Demonic Visage ca. 1980
Ball point pen and magic marker over
pencil on paperboard
17 x 14 in.
(43.2 x 35.6 cm)
Acquired from Braunstein Gallery,
San Francisco, California, 1982
M1989.246

218
Visage of a Man with Blue Eyes ca. 1980
Ball point pen and felt tip marker on
paperboard
17 x 14 in.
(43.2 x 35.6 cm)
Acquired from Braunstein Gallery,
San Francisco, California, 1982
M1989.247

Ted Gordon primarily draws visages
because he is fascinated by the various
expressions and appearances of the
human face. By his own admission, he is
"totally self-absorbed," and his doodles
are exercises in self-exploration. All of his
faces are self-portraits that comprise
various aspects of his whole personality;
through his drawings he has created an
alphabet by which to express his
emotions.[1]

These two visages — with their
exaggerated facial features, emphatic
shapes, and dense patterning — typify
Gordon's style. The obsessive need to
pack space with detail is considered a
prime trait of visionary artists or so-called
"outsider" artists,[2] a recent subcategory of
folk art that Gordon recognizes and readi-
ly accepts for himself. Interestingly, his
very awareness of this controversial and
largely academic distinction raises ques-
tions about both the classification and
Gordon's proper assignment to it. (MA)

1. Telephone conversation with Ted Gordon,
Laguna Hills, California, 20 January 1992.

2. Andy Nasisse, "Aspects of Visionary
Art," in *Baking in the Sun* (Lafayette: Univer-
sity of Southwestern Louisiana, 1987), p. 16.

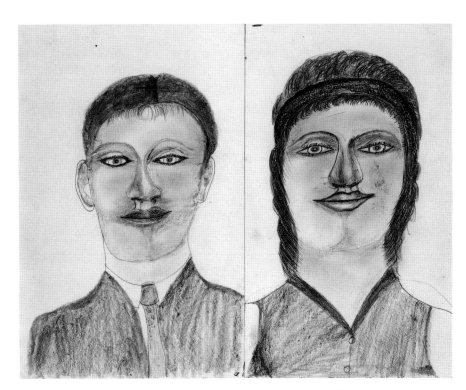

Shields Landon (S. L.) Jones, *Man and Woman*, ca. 1982 (cat. no. 219)

219
Shields Landon (S. L.) Jones
Hinton, West Virginia
Man and Woman ca. 1982
Pencil, ink and wax crayon on wove paper
9 15/16 x 12 5/8 in.
(25.2 x 32.1 cm)
Acquired from Ken Fadely, Ortonville,
Michigan, 1984
M1989.248

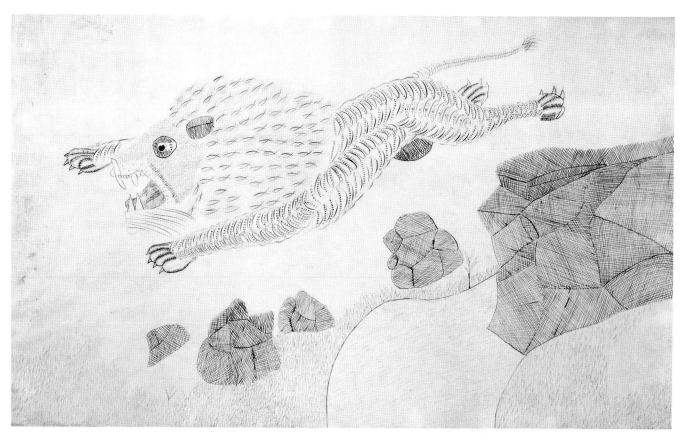

Unidentified Artist, *Spencerian Penmanship Drawing of a Lion*, mid- to late 19th century (cat. no. 220)

220*
Unidentified Artist
Eastern United States
Spencerian Penmanship Drawing of a Lion
mid- to late 19th century
Iron gall ink over graphite on wove paper
17 x 28 in.
(43.2 x 71.1 cm)
Acquired from Clarice Bailey, flea market,
Ann Arbor, Michigan, 1988
M1989.231

The art of penmanship flourished in the last half of the nineteenth century. Steel-tipped pens were used to create elaborate drawings based on a system of script developed by writing master P. R. Spencer. This drawing, thought to be by an artist named Billman,[1] demonstrates various calligraphic strokes which enhance the form and enliven the movement of this subject. (MA)

1. Michael and Julie Hall, interview by Julia Guernsey and Debra Brindis, 1 August 1991, transcript, Milwaukee Art Museum.

221*
Bill Traylor
Montgomery, Alabama
Bird ca. 1940
Black paper with brown tempera paint
over pencil on cardboard
13 $\frac{7}{8}$ x 9 $\frac{3}{8}$ in.
(35.2 x 23.9 cm)
Acquired from Luise Ross, New York, 1982
M1989.237

Traylor's earliest images were simple
shapes such as shoes and cups. His
images grew larger and more complex as
he continued to draw. Animals were his
favorite subject, and probably derive from
his many years of work on the Traylor
farm.

The majority of Traylor's drawings
were done on irregularly shaped card-
board which he found on the street. His
mastery of irregular space can be seen in
the simply titled *Bird*. The cardboard
which serves as "canvas" in his work
retains the black tape border of a box.
The lower left corner has been broken off,
and Traylor uses its edge as the delicate
resting place for the bird's feet. Using
this imperfect edge as a balancing device,
the rest of the body expands into space
without hesitation. The imperfections of
the cardboard became for Traylor the
stimulus for his images.[1] (MA)

1. Frank Maresca and Roger Ricco, *Bill
Traylor: His Art — His Life* (New York: Alfred
A. Knopf, Inc., 1991), p. 11.

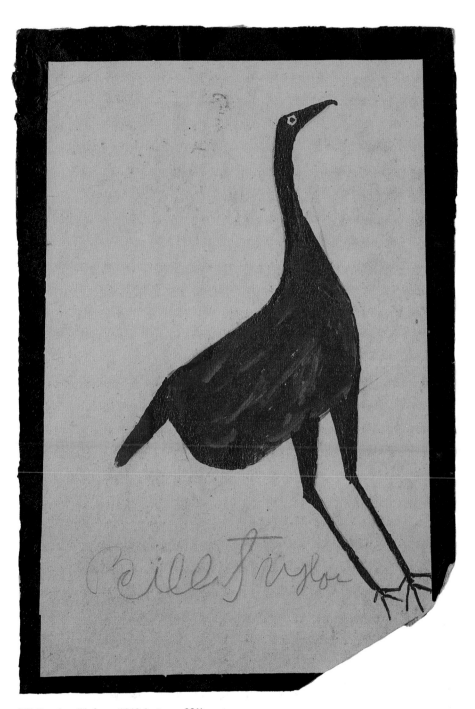

Bill Traylor, *Bird*, ca. 1940 (cat. no. 221)

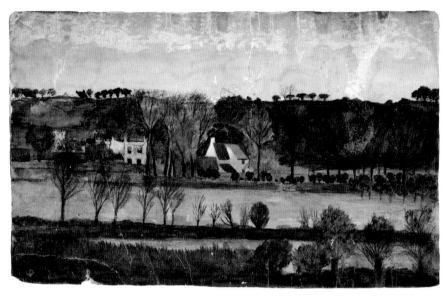

Unidentified Artist, *Landscape*, ca. 1890 (cat. no. 222)

222
Unidentified Artist
Kentucky?
Landscape ca. 1890
Watercolor over graphite on wove paper
6 ⅝ x 10 ¾ in.
(16.8 x 27.3 cm)
Acquired from Strawberry Hill
Antiques, Lexington, Kentucky, 1969
M1989.232

223
Alax Butz
New York City
Art Deco Apartment ca. 1930
Watercolor over pencil on wove paper
14 ⅝ x 21 in.
(37.2 x 53.3 cm)
Acquired from Joel Weber, Flea Market,
Ann Arbor, Michigan, 1988
M1989.233

Alax Butz, *Art Deco Apartment*, ca. 1930 (cat. no. 223)

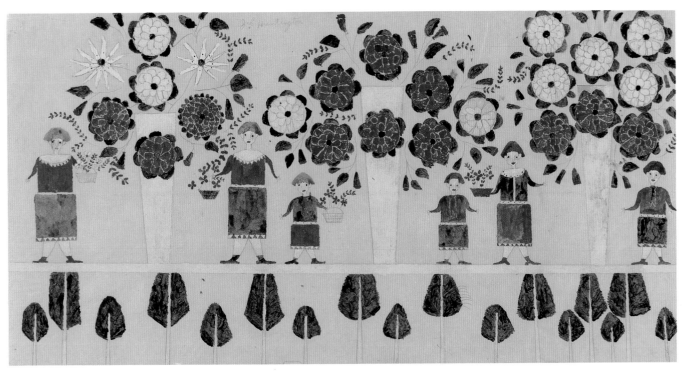

J.C. Huntington, *Figures in a Garden*, ca. 1944 (cat. no. 224)

224*
J. C. **Huntington**
Sunbury, Pennsylvania
Figures in a Garden ca. 1944
Pencil and watercolor on wove paper
20 ⅛ x 39 ⅜ in.
(51.1 x 100 cm)
Acquired from Sterling Strauser,
East Stroudsburg, Pennsylvania, 1970
M1989.234

Huntington was a retired railroad
worker who lived in southeastern Pennsyl-
vania where the art of Fraktur developed
in the eighteenth century. Vestiges of that
tradition are seen here in the large, flat,
brightly colored flowers that recall similar
decorations used on birth certificates and
other important documents by the area's
early German settlers. (MA)

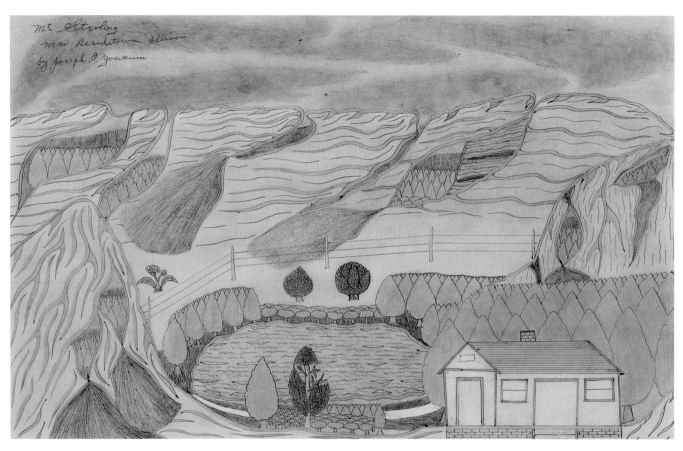

Joseph E. Yoakum, *Mt. Sterling Near Beardstown Illinois*, 1972 (cat. no. 225)

225*
Joseph E. Yoakum
Chicago, Illinois
Mt. Sterling Near Beardstown Illinois 1972
Pastel, ink and wax crayon on wove paper
11 7/8 x 19 in.
(30.2 x 48.3 cm)
Acquired from Phyllis Kind Gallery,
Chicago, Illinois, 1972
M1989.240

226*
*Mt. Black Mountain in Lunar Range near
Perry South Dakota* 1969
Pastel and ink on wove paper
12 1/16 x 19 1/8 in.
(30.6 x 48.6 cm)
Acquired from Phyllis Kind Gallery,
Chicago, Illinois, 1972
M1989.239

227
*Mt. Whitney in Sierra Nevada Mtn. Range
Near Lone Pine California* 1970
Pastel, ink and felt tip pen on wove paper
12 3/16 x 19 in.
(31 x 48.3 cm)
Acquired from Phyllis Kind Gallery,
Chicago, Illinois, 1972
M1989.241

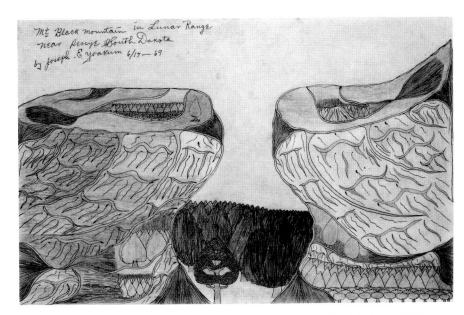

Joseph E. Yoakum, *Mt. Black Mountain in Lunar Range near Perry South Dakota*, 1969 (cat. no. 226)

Joseph E. Yoakum, *Mt. Whitney in Sierra Nevada Mtn. Range Near Lone Pine California*, 1970 (cat. no. 227)

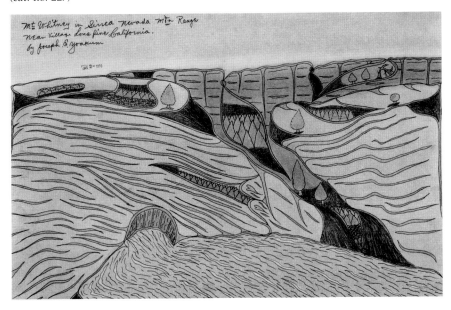

In telling his life story, Joseph Yoakum claimed to have been born on a Navajo reservation, to have traveled with a circus (eventually becoming a personal valet to John Ringling), and to have visited every continent but Antarctica. Precisely how much of this is true has yet to be confirmed, but it is known that Yoakum served in France during World War I, moved his family to Missouri, Florida, California, and Indiana, and finally settled in Chicago about 1950. At the age of 76 Yoakum had a dream in which, as he recounted, God appeared to him and commanded him to draw. Calling his work a "spiritual unfoldment," he worked at a feverish, even obsessive pace, producing an estimated 1500 to 2000 drawings before his death in 1972.[1] Despite an apparently restless life, it is clear that Yoakum was not an "outsider." In the storefront to which he moved in 1966 he displayed his drawings, marking many with the date of completion, his signature, and a copyright mark. Through an article in the *Chicago Daily News* that reported Yoakum's exhibition at a church coffeehouse, the artist came to the attention of art historian Whitney Halstead and a number of Chicago artists such as Jim Nutt, Gladys Nilsson, Ray Yoshida and Roger Brown. Yoshida recalls Yoakum refusing to part with a work because it was unfinished — a clear indication of artistic self-awareness.[2]

"Spiritual unfoldment" seems a particularly accurate description of both Yoakum's inspiration and his formal vocabulary. Although he occasionally produced portraits of famous figures from African American history, sports or the entertainment world, landscape was his primary subject. Almost always inscribed with specific titles (probably drawn from the *National Geographic* and the *Encyclopedia Britannica* known to be in his possession), the scenes were probably imaginary. Yoakum's landscapes look little like the actual places which inspired their titles; they are most likely drawn from his memory of sights seen while traveling and his own fully formed and active vision.

The three landscapes in the Hall Collection are comprised of elements common in Yoakum's work: high horizon lines, volcano-like peaks or stratified layers of rock, winding rivers or roads, pockets of trees usually receding in precisely overlapping rows, and fluidly outlined clouds or a sun bursting with clearly delineated rays. What is remarkable about these works is that the relatively limited vocabulary is capable of almost infinite variation, and that each drawing seems freshly invented. The flexibility, vitality and defining power of the motifs undoubtedly derive from the organic line which forms them. Yoakum's forms do indeed seem to unfold in a rich panoply of organic shapes and densely patterned but always fluid compositions. It is this seemingly infinite variety of formal solutions and their evocation of the creative power of nature that have inspired so many trained artists to seek Yoakum's example.

In the three works here, developed in his usual medium of ballpoint pen, pencil, colored pencil, and pastel, Yoakum explores his most common format — the horizontally extended landscape with high horizon. Yoakum is also known to have used vertical landscape formats, usually with stratified rock formations (sometimes suggesting strange profiles) arrayed along either side of a deep canyon-like vista. In *Mt. Sterling near Beardstown Illinois* he adds a house, and in *Mt. Black Mountain in Lunar Range near Perry South Dakota*, he gives the mountains an arid brown tone, thereby imparting greater specificity to his fully imagined world. (RB)

1. *Outsiders: An Art Without Precedent or Tradition*, exhibition catalogue (London: Arts Council of Great Britain, 1979), p. 384.

2. Russell Bowman, "Looking to the Outside: Art in Chicago, 1945-75," in *Parallel Visions: Modern Artists and Outsider Art* (Los Angeles: Los Angeles County Museum of Art and Princeton University Press, 1992), p. 159. Bowman recounts the story as told by Yoshida.

228
Unidentified Artist
New England
Mourning Picture early 19th century
Watercolor and graphite on paperboard
13 ⅝ x 17 ⅜ in.
(34.6 x 44.1 cm)
Acquired from Herbert W. Hemphill Jr.,
New York, 1970
M1989.230

Modeled after the classical motif of figures weeping over a tombstone, mourning pictures usually depict one or more mourners, a weeping willow tree, and a lake or village in the background.[1] This mourning picture may have been made in a female seminary as an exercise in watercolor technique. Produced in large numbers in the early nineteenth century, they were given or sold to someone in need of a memorial. The lack of an inscription on the tomb indicates that this work was never used. (MA)

1. William P. Campbell, "American Primitive Water Colors and Pastels," in *101 American Primitive Water Colors and Pastels from the Collection of Edgar William and Bernice Chrysler Garbisch* (Washington, D.C.: National Gallery of Art, 1966), p. 14.

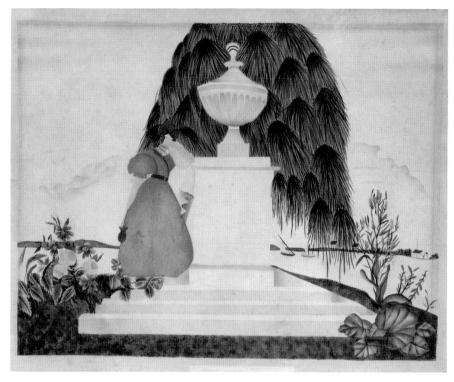

Unidentified Artist, *Mourning Picture*, early 19th century (cat. no. 228)

229*
Martin Ramirez
Auburn, California
El Soldado 1954
Watercolor and wax crayon over pencil on
wove paper
29 x 36 ⅛ in.
(73.7 x 91.8 cm)
Acquired from Phyllis Kind Gallery,
New York, 1976
M1989.235

Born in the Jalisco province of Mexico in 1885, Martin Ramirez entered the United States to work as a railroad laborer. In 1930 he was institutionalized at the DeWitt State Hospital in Auburn, California, and diagnosed as a "paranoid schizophrenic, deteriorated." He did not speak and apparently remained mute throughout his life. In 1948 he began to draw using available bits of paper, gluing pieces together with a paste of mashed potatoes, bread and saliva. His work came to the attention of Dr. Tarmo Pasto, who had an awareness of Hans Prinzhorn's pioneering work with the art of the mentally ill, and who provided encouragement, materials, and preserved Ramirez's work. Dr. Pasto was primarily interested in the work as illustrations for his abnormal psychology classes at Sacramento State College. It was there, in 1968, that the work came to the attention of Chicago artist Jim Nutt, then a member of the faculty, who was responsible for bringing the work to the attention of a larger art world. Ramirez died in 1963, but took evident pride in the communication his drawings afforded.[1]

The some three hundred drawings, ranging from a few inches to twelve feet, which Ramirez produced during his lifetime reflect a narrow range of subject matter: religious figures such as the Virgin, numerous images of a mounted cowboy/soldier, animals, trains, churches and other colonial Mexican architecture, and a variety of landscapes combining these motifs with undulating hills, rivers and tunnels. All of these subjects are rendered in his signature method of repeated striated forms. The highly patterned surrounds for his figures alternately reiterate the flatness of the paper, suggest a perspectival movement into illusionistic space, or more frequently move freely from one to the other creating a highly ambiguous spatial tension. Ramirez's patterning can be seen as reflective of the "will to order" seen in the obsessive, decorative elaboration of some outsiders and institutionalized artists.[2] However, his use of pattern not simply to fill space but to build it in his compositions sets him apart as one of the most compellingly inventive of twentieth-century self-taught artists.

It must be remembered that institutionalized artists like Ramirez are not outside of culture. Convincing arguments suggest that Ramirez's Virgins reflect standard representations of Our Lady of Guadalupe or the Virgin of the Immaculate Conception; the cowboy/soldier recalls the Zapatistas, or guerilla fighters who supported Emilio Zapata in the Mexican Revolution of 1910; and various architectural, animal, and decorative motifs evoke the artisan production of Tonala, Jalisco, near his birthplace.[3] The railroads may well reflect his experience as a laborer, and the women and cars that occasionally appear may represent his familiarity with American popular culture through magazines (illustrations from magazines do find their way into his collages). Ramirez fully reinvented these elements to create his own highly individualized iconography and formal vocabulary, one that seems to express anxiety between the need for self-realization and fear of the world.

Although *El Soldado* (our title, not the artist's) represents Ramirez's most common motif of a mounted figure in peasant costume with bandoliers and sombrero set in a proscenium architectural setting composed of repeated linear forms, this rendition is unique in his work. First, the horse is seen from the rear and the peculiar horned snout and teeth, odd slotted rump, and low tail appear in no other representation of the subject. Second, the figure holds what appears to be a rabbit, suggesting the return from a hunting trip. The tank-like horse and victorious hunter are more fearsome than in typical representations of this motif. The architectural setting, too — which some commentators have likened to altars or *capillas* — is more enclosing, like a stronghold.[4] Its combination of one-point perspective in the lower image, the receding striations of the lateral wall, and the low, dark lintel which skews the perspective yet again, produce the ambiguity of space that lends Ramirez's iconic forms their disquieting resonance. *El Soldado* remains one of the most disturbing representations of one of Ramirez's most common motifs. (RB)

1. Elsa Weiner Longhauser, "Foreword," in *The Heart of Creation: The Art of Martin Ramirez* (Philadelphia: Goldie Paley Gallery, Moore College of Art, 1985), p. 3. Longhauser quotes Dr. Tarmo Pasto: "[Ramirez] has recently shown considerable pleasure with groups of student visitors, to whom he displays his work with obvious pride."

2. Sander L. Gilman, "Madness and Representation: Hans Prinzhorn's Study of Madness and Art, in its Historical Context," in *The Prinzhorn Collection* (Champaign-Urbana: Krannert Art Museum, University of Illinois, 1984), p. 10.

3. Bowman, in "Martin Ramirez: A Visionary's Journey," in *The Heart of Creation: The Art of Martin Ramirez*, suggests the historical significance of the armed soldier, and notes the correlation between Ramirez's Virgins and the Virgin of Guadalupe. Randall Morris suggests that representations of both the Virgin of Guadalupe and the Virgin of the Immaculate Conception are synthesized in Ramirez's representations. Morris also explores the influence of artisan production from Jalisco in Ramirez's art. See Morris, "Mapas de Visiones: Los Dibujos de Martin Ramirez desde una Nueva Perspectiva" in *Martin Ramirez, Pintor Mexicano*, exhibition catalogue (Mexico City: Centro Cultural/Arte Contemporaneo, 1989), pp. 61-70.

4. Nelson Oxman, "Martin Ramirez: Las Imágenes Primordiales de la Conciencia," in *Martin Ramirez, Pintor Mexicano*, p. 83.

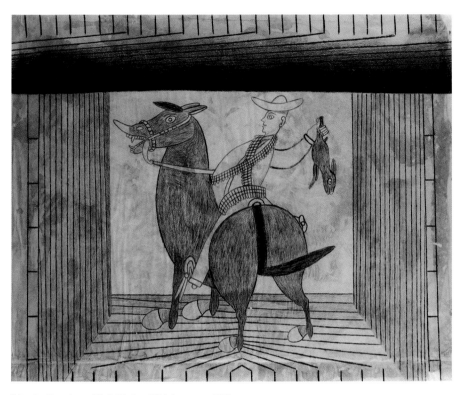

Martin Ramirez, *El Soldado*, 1954 (cat. no. 229)

230*
Sister Gertrude Morgan
New Orleans, Louisiana
Heaven ca. 1965
Tempera paint and ink on cardboard
12 ³/₁₆ x 19 ⅛ in.
(31 x 48.6 cm)
Acquired from Regenia Perry,
Richmond, Virginia, 1982
M1989.242

The crowded composition and bright colors of *Heaven* typify the religious work of Sister Gertrude Morgan, who became a devout evangelist after a voice told her to "Go and preach, tell it to the world."[1] Here, in keeping with the "divine word" she received in 1957, Morgan portrays herself as the bride of Christ standing at the top of the stairway to heaven.

Morgan's paintings were strictly an extension of her ministry and of preaching the word of God. The message was most important, and usually transmitted in well structured compositions. Indeed, many of her images are accompanied by biblical text or her own writings to further explain the iconography. *Heaven*, although lacking text, is organized horizontally and vertically by the green and yellow rectangles, while on the far right and left sides, angels with bright red hair serve to clearly frame Morgan's vision. (MA)

1. Jane Livingston and John Beardsley, *Black Folk Art in America 1930-1980* (Jackson: University Press of Mississippi, 1982), p. 97.

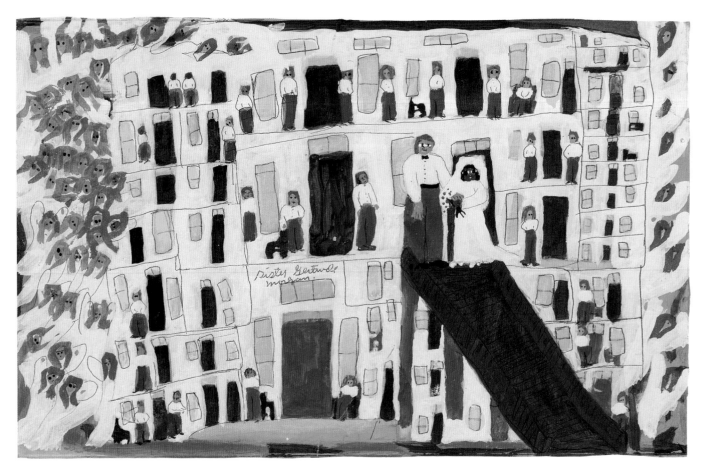

Sister Gertrude Morgan, *Heaven*, ca. 1965 (cat. no. 230)

Peter Minchell, *He Turned Water Into Blood*, ca. 1975 (cat. no. 231)

231*
Peter Minchell
Florida?
He Turned Water Into Blood ca. 1975
Watercolor over pencil on wove paper
13 ¾ x 17 ¾ in.
(34.9 x 45.1 cm)
Acquired from Lewis Alquist, Tempe,
Arizona, 1973
M1989.249

He Turned Water Into Blood depicts
Moses and his brother Aaron, who were
sent by God to convince the Pharaoh to
let the Jews leave Egypt. As a means of
persuasion, Moses performed several
miracles, including turning the water of
the Nile into blood with his staff
(Exodus 7:20). Minchell depicts Moses
with his signatory horns and the staff that
became a serpent. The space in which the
two figures stand is an ambiguous
combination of interior with a richly
decorated Egyptian column, and exterior
with the boat in the river. This nontradi-
tional *mise-en-scene* may derive from a
popular source such as the 1956 film
The Ten Commandments; indeed, even
Minchell's fanciful architecture resembles
the ornate set designs of Cecil B.
DeMille's Hollywood classic. (MA)

Anthony Joseph Salvatore, *Story from Habakkuk*, ca. 1983 (cat. no. 232)

232*
Anthony Joseph Salvatore
Akron, Ohio
Story from Habakkuk ca. 1983
Oil crayon over enamel paint on wove
paper
25 ⅛ x 38 ⅛ in.
(63.8 x 96.8 cm)
Acquired from Ethnographic Arts,
New York, 1984
M1989.250

Because the "glory" cloud is a well
known symbol for God who is heard but
must not be seen (Exodus 33:20), this
drawing may illustrate Habakkuk's
dialogue with God while in the desert
with the long-suffering Israelites. When
the prophet asks why a merciful God
would allow evil to persist in the world,
God answers that justice based on faith
will invariably triumph over wrong. The
scene may also refer more specifically to
the closing psalm in the Book of Habak-
kuk where "The clouds poured down
water/The abyss uttered its voice" (3:10),
and the prophet envisions God's justice
sweeping the earth. Whatever the exact
subject, Salvatore's intense color and
undulating composition effectively convey
his own belief that biblical events still
have vital relevance in today's world.
(MA & JRH)

Charley Kinney, *The Devil Calls*, 1987 (cat. no. 233)

233*
Charley Kinney
Kentucky
The Devil Calls 1987
Pencil and poster paint on wove paper
22 ½ x 28 ½ in.
(57.2 x 72.4 cm)
Acquired from Larry Hackley,
North Middleton, Kentucky, 1987
M1989.251

Many of Charley Kinney's drawings
feature skeletons, "hants" (spirits returned
from the dead),[1] and the devil. For this
rural Southern fundamentalist, the devil is
a finite figure who carries a pitchfork to
control and punish the eternally damned.
Like the Reverend Howard Finster, Sister
Gertrude Morgan, and other visionary
folk artists, Kinney often uses text to
clarify his imagery, as in a closely related
drawing that shows a vengeful Satan
exclaiming, "If I turn him loose out of the
skillet, he'll take over all Hell."[2] Kinney's
fierce and very tangible vision of hell is
heightened by quick brushstrokes, fren-
zied forms, and luminous colors. (MA)

1. Ramona and Millard Lampell, *O,
Appalachia: Artists of the Southern Mountains*
(New York: Stewart, Tabori and Chang,
1989), p. 248.

2. Ramona and Millard Lampell, *O,
Appalachia*, p. 248.

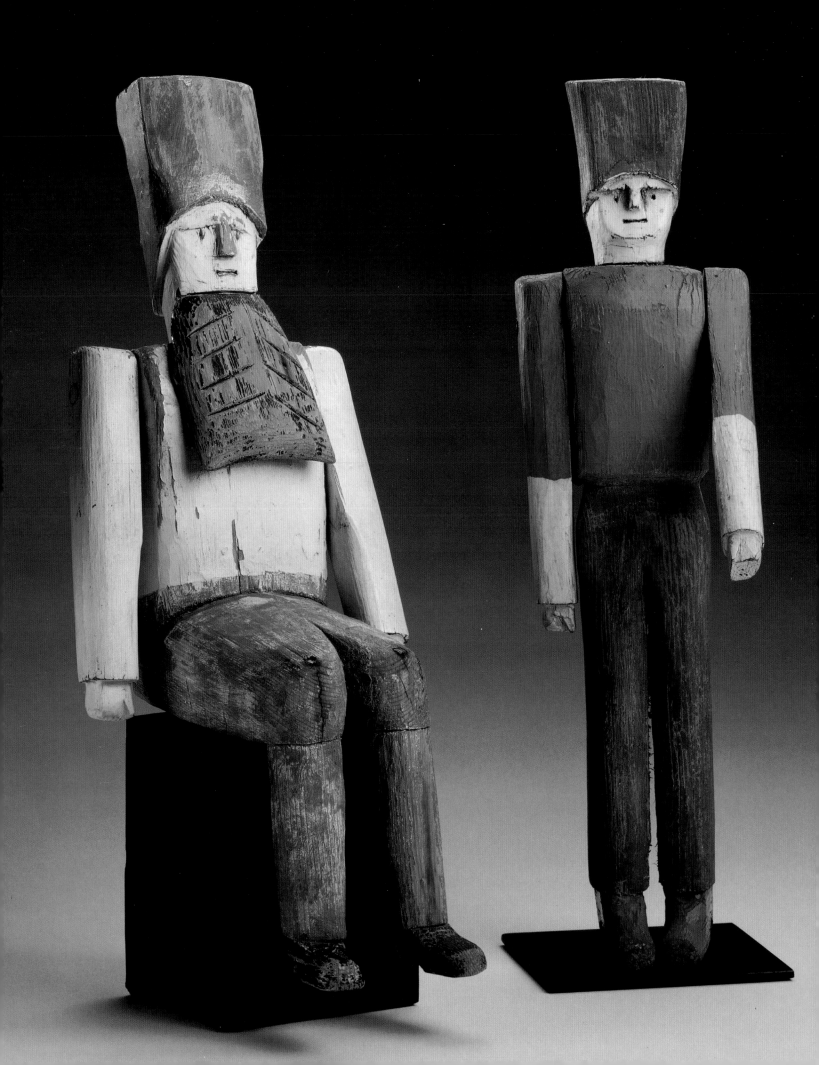

Artists' Biographies

Fred Alten

Born in Lancaster, Ohio, in 1871, Alten was the son of German immigrants. Employed for years in his brother's machine shop, he moved with his wife and five children to Wyandotte, Michigan, in 1912. There he performed various jobs including furniture moving, carpentry, janitorial services, and foreman at Ford Motor Company. During this period Alten mysteriously began to carve in the garage behind his home, allowing very few people to view the work inside. After his wife's death in 1944 and ill himself, Alten returned to Lancaster, abandoning the sculptures in his garage. He died in Ohio in 1945, and it was not until an estate sale in 1975 that the carvings were rediscovered.

Selected Group Exhibitions: *Michigan Folk Art: Its Beginnings to 1941*, Kresge Art Gallery, Michigan State University, East Lansing, Michigan, 1976; *American Folk Art from the Traditional to the Naive*, Cleveland Museum of Art, Ohio, 1978; *American Folk Art: Expressions of a New Spirit*, Museum of American Folk Art, New York, New York, 1982.

Felipe Benito Archuleta

Archuleta was born in 1910 in Santa Cruz, New Mexico, where he left school at an early age to pick potatoes and chilies, herd sheep and cook for Civilian Conservation Corps camps during the Depression. After marrying in 1937, he moved to Santa Fe to raise his seven children, joining the United Brotherhood of Carpenters and Joiners of America with whom he remained until a union dispute in 1964. It was during this period of conflict that he received a vision from the Lord which told him to "carve wood." He replied, "I am not worthy to be a *santero*. So I will carve animals." Archuleta and his family eventually moved to Tesuque, and one of his menageries was exhibited at the Museum of International Folk Art, Santa Fe, in the 1970s. He received the New Mexico Governor's Award for Excellence and Achievement in the Arts in 1979. By 1987, Archuleta suffered from severe arthritis which prohibited him from carving major works. He died in January 1991.

Selected Group Exhibitions: *Folk Sculpture USA*, The Brooklyn Museum, New York, 1976; *Contemporary American Folk and Naive Art: The Personal Visions of Self-Taught Artists*, School of The Art Institute of Chicago, Illinois, 1978; *Transmitters*, Philadelphia College of Art, Pennsylvania, 1981; *American Folk Art: The Herbert Waide Hemphill, Jr. Collection*, Milwaukee Art Museum, Wisconsin, 1981; *The Ties that Bind*, Contemporary Arts Center, Cincinnati, Ohio, 1986; *Hispanic Art in the United States*, Museum of Fine Arts, Houston, Texas, 1987; *The Cutting Edge*, Museum of American Folk Art, New York, New York, 1990; *Made with Passion*, National Museum of American Art, Smithsonian Institution, Washington, D.C., 1990.

Steve Ashby

Born in Delaplane, Virginia, in 1904, Ashby worked on the same farm that his father had worked as a freed slave. According to family, he carved throughout his life but began making what he called "fixing-ups" after the death of his wife in 1962. As he said, "I wake up with an idea that won't let me back to sleep. So I get up and make that idea." His work was first introduced to collectors after meeting dealer Kenneth A. Fadeley in 1972. Ashby died in Delaplane in 1980.

Selected Group Exhibitions: *Six Naives*, Akron Art Institute, Ohio, 1973; *American Folk Art from the Traditional to the Naive*, Cleveland Museum of Art, Ohio, 1978; *Black Folk Art in America 1930-1980*, Corcoran Gallery of Art, Washington, D.C., 1982; *A Time to Reap*, Seton Hall University, South Orange, New Jersey, 1985; *Made with Passion*, National Museum of American Art, Smithsonian Institution, Washington, D.C., 1990.

Captain Clarence Bailey

Captain Clarence Bailey lived in Kingston, Massachusetts, and worked as a Boston Harbor pilot. In his leisure time Bailey built decoys. In 1902, he built a rig of four-foot long Canadian geese formed from canvas stretched over ash frames. Bailey's limited output includes oversized hollow-carved Oldsquaws, Mergansers and at least one Whitewing Scoter. It is thought that he produced most of his decoys in the early 1900s.

Calvin and Ruby Black

Calvin Black, born in 1903 in Tennessee, worked for various circus and carnival shows, eventually learning ventriloquism in order to operate a puppet show. After marrying Ruby Ross (born 1913 in Georgia) in 1933, the couple moved to Northern California to prospect for gold. In 1953, the Blacks purchased land in Yermo on which they planned to operate a mineral and rock shop. Soon realizing that their isolated location was drawing little business, Calvin began to carve dolls which he placed in front of the store to attract customers. Gradually adding more dolls, he created a "Fantasy Doll Show" with moving figures. After Calvin's death in 1972 and Ruby's in 1980, *Possum Trot* was dismantled, and most pieces sold into various museum and private collections.

Selected Group Exhibitions: *Pioneers in Paradise: Folk and Outsider Artists of the West Coast*, Long Beach Museum of Art, California, 1984; *The Ties that Bind*, Contemporary Arts Center, Cincinnati, Ohio, 1986; *Made With Passion*, National

Albert Zahn, *Seated Figure*, 1950 (cat. no. 203), and *Standing Figure*, 1950, (cat. no. 204)

Biographies

Museum of American Art, Smithsonian Institution, Washington, D.C., 1990.

William Bowman

Born circa 1824, specific information about this Long Island decoy carver is lacking. Bowman is generally thought to have been either a cabinetmaker or saw-mill worker who resided near Bangor, Maine. Bowman traveled to the South Shore of Long Island annually for the hunting season where he undoubtedly became familiar with the Long Island style of carving. Bowman is best known for his shorebird carvings in that style, but he also produced duck and goose decoys. He died in 1906.

Selected Group Exhibitions: *The Decoy Maker's Craft*, IBM Gallery of Arts and Sciences, New York, New York, 1966; *American Wildfowl Decoys*, U.S. Pavilion, World's Fair, Osaka, Japan, 1970; *Gunners Paradise*, The Museums at Stony Brook, Long Island, New York, 1979; *The Decoy as Folk Sculpture*, Cranbrook Academy of Art Museum, Bloomfield Hills, Michigan, 1987; *An American Sampler*, Shelburne Museum, Vermont, 1987.

George Boyd

Decoy maker George Boyd was born in 1873 and lived his entire life in Seabrook, New Hampshire. After completing grammar school he became a market gunner and farmer, later working at a local shoe factory where he was promoted to fore-man. Boyd applied his shoemaking skills to producing canvas-covered decoys. He retired from shoemaking in the early 1930s and spent the remaining years of his life producing miniature wildfowl in a wide range of species. He died in 1941.

Selected Group Exhibitions: *The Decoy Maker's Craft*, IBM Gallery of Arts and Sciences, New York, New York, 1966; *American Wildfowl Decoys*, U.S. Pavilion, World's Fair, Osaka, Japan, 1970; *Annual Mid-Atlantic Waterfowl Festival of Virginia Beach*, Virginia, 1978; *By Good Hands: New*

Hampshire Folk Art, Currier Gallery of Art, Manchester and University Art Galleries, Durham, New Hampshire, 1989; *Treasures of American Folk Art*, The Abby Aldrich Rockefeller Folk Art Center, Williamsburg, Virginia, 1989.

Evan Javan Brown Sr.

Born in 1897, Evan Javan Brown was the great-grandson of Bowling Brown, a potter who had been active in Jugtown and Howell's Mills, North Carolina, before and after the Civil War. The Brown family claims eight generations of potters who worked at various mills throughout North Carolina, Georgia and Alabama. Evan Javan Brown died in 1980.

Robert Brown

Robert Brown, born in 1953, belongs to the eighth generation of Brown family potters. His father, Louis, was the son of Davis Brown, who was the brother of Evan Javan Brown Sr. Robert, along with his brother Charles, still operates the Brown pottery in Arden, North Carolina.

Alton "Chubby" Buchman

Born in 1916, Alton Buchman did not begin carving fish decoys until approximately 1969. He began to make them for his own use, eventually trading and selling them upon request. His total output is estimated between 600 and 700 fish, including pike, trout, chubs, minnows, muskie, perch and bass. Throughout his life, Buchman was employed as a pile driver, sea wall maker and building inspector. He died in May of 1989.

David Butler

Born in Good Hope, Louisiana, in 1898, Butler performed a variety of jobs ranging from building roads to shipping lumber. Forced to retire in the early 1960s after a sawmill accident, Butler began to decorate the yard of his home in Patterson, Louisiana, with a variety of intricately cut tin constructions. His work

was discovered by William Fagaly, Director of the New Orleans Museum of Art, in the 1970s.

Solo Exhibitions: New Orleans Museum of Art, Louisiana, 1976.

Selected Group Exhibitions: *Black Folk Art in America 1930-1980*, Corcoran Gallery of Art, Washington, D.C., 1982; *Baking in the Sun*, University Art Museum, Lafayette, Louisiana, 1987; *It'll Come True*, Artists' Alliance, Lafayette, Louisiana, 1992.

Caines Brothers

Hucks, Sawny, Pluty, Ball and Bob Caines were commercial fishermen and market gunners in the area of George-town, South Carolina, from the mid-1800s to the early 1900s. They lived in Caines Village, an area settled by their ancestors that faces Pumpkinseed Island. Initially, the brothers worked on the rice plantations that surrounded their homes. After the Civil War, however, they earned a living from commercial gunning and fishing on local waterways. These ventures eventually led them to decoy carving. No one knows which brother carved specific decoys – rather, all seem to have been involved. Their output was small, probably not exceeding 300, and the decoys were probably produced for personal use in their business. In 1905 Caines Village and the surrounding plantations were purchased by Bernard M. Baruch, and the Caines became tenants. Although initially irritated by the brothers' hunting practices, Baruch eventually employed all of them (except Ball, who refused) as personal hunting guides for his guests.

Selected Group Exhibitions: *American Wildfowl Decoys*, U.S. Pavilion, World's Fair, Osaka, Japan, 1970; *Annual Mid-Atlantic Waterfowl Festival of Virginia Beach*, Virginia, 1977.

Miles Burkholder Carpenter

Miles Carpenter was born on May 12, 1889 in Brownstone, Pennsylvania. After

moving with his family to Waverly, Virginia, he eventually operated both a sawmill and icehouse, continuing the latter after retiring from the lumber business around 1955. Carpenter had carved small sculptures throughout his life, especially when business was slow and after retirement. However, it was not until his wife died in 1966 that he attempted larger pieces. Using a large watermelon sculpture as a trade sign, Carpenter attracted the attention of folk art dealer Jeffrey Camp who began to represent him in 1973. In 1983 he was honored with a Virginia Heritage award. After his death in 1985, Carpenter's son donated the family home and a portion of his father's work to establish the Miles B. Carpenter Museum in Waverly.

Solo Exhibitions: Anderson Gallery, Virginia Commonwealth University, Richmond, Virginia, 1971.

Selected Group Exhibitions: *American Folk Sculpture from the Hall Collection*, University of Kentucky, Lexington, Kentucky, 1974; *Folk Sculpture USA*, The Brooklyn Museum, New York, 1976; *Transmitters*, Philadelphia College of Art, Pennsylvania, 1981; *American Folk Art: The Herbert Waide Hemphill, Jr. Collection*, Milwaukee Art Museum, Wisconsin, 1981; *The Ties that Bind*, Contemporary Arts Center, Cincinnati, Ohio, 1986; *Made with Passion*, National Museum of American Art, Smithsonian Institution, Washington, D.C., 1990.

Anna D. Celletti

Anna Celletti painted during the mid-twentieth century in Brooklyn, New York. Her paintings were found at Bruckner Antiques in Queens, New York, by the Halls and Herbert Hemphill in August of 1979. The only information known about her was obtained from a juried exhibition label on the back of *Stalin as the Black Angel* which stated her name, address and occupation as a "lady barber."

Nathan Cobb Jr.

Nathan Cobb Jr. was one of three sons born to Nancy and Nathan Cobb Sr., a shipbuilder from Cape Cod, Massachusetts. When Nathan Jr. was a young boy his family moved to Oyster, Virginia. In 1839, his father purchased Grand Sand Shoal, a barrier island off the coast of Virginia, moved his family there, and renamed it Cobb Island. The elder Cobb then started a salvage business. When the salvage business began to falter, the Cobb brothers began market gunning the abundant wildfowl on the island. This eventually led to a large influx of hunters which encouraged the brothers to start their own hunting and guiding business. Subsequently, they built the Cobb Island Hotel to meet the needs of their growing clientele. It is generally believed that Nathan Jr. carved and painted decoys for the family business. In 1890 a storm destroyed many of the buildings on the island and forced most people, including Nathan Jr.'s brothers, to flee to the mainland, but Nathan remained. When another storm swept the island in 1896, Nathan and his family were evacuated by the Coast Guard. Cobb died in 1905.

Selected Group Exhibitions: *The Decoy Maker's Craft*, IBM Gallery of Arts and Sciences, New York, New York, 1966; *American Wildfowl Decoys*, U.S. Pavilion, World's Fair, Osaka, Japan, 1970; *Annual Mid-Atlantic Waterfowl Festival of Virginia Beach*, Virginia, 1977 and 1978; *The Decoy as Folk Sculpture*, Cranbrook Academy of Art Museum, Bloomfield Hills, Michigan, 1987.

Burlon B. Craig

Born in 1914, Burlon Craig was fascinated by local potteries as a boy. Eventually, potter Jim Lynn offered Craig a partnership in his mill in exchange for wood that the young Craig had been chopping. Craig also turned pots for his uncle Seth Ritchie during the 1930s. When his uncle died in 1940, Craig and Vern Leonard rented the mill. After returning

from naval service in 1945, Craig purchased a kiln from Harvey Reinhardt. Craig left North Carolina briefly in 1959-1960 to take a job at a California furniture company, but he continued to create pottery to supplement his income. Craig still operates his kiln in Lincoln County, North Carolina, although he now concentrates on stoneware for the tourist trade rather than utilitarian wares. Such tourist items include face vessels, face chicken waterers, face birdhouses, face spittoons, and face wall pockets.

James Augustus Crane

James Crane, born in 1877 in Winter Harbor, Maine, moved to Bath after the loss of his father in an accident at sea. Learning machinist and mechanical skills, he eventually moved to Pittsburgh, Pennsylvania, where he developed and manufactured an invention for a lock washer. Relocating to Portland, Maine, by 1909, Crane developed plans for a flying machine which he eventually constructed but never flew. His paintings, begun later in life, recall his youthful maritime environment. His work was discovered by Bennett Bean, an artist and teacher at Wagner College. Crane died in 1974.

A. Elmer Crowell

Elmer Crowell of East Harwich, Cape Cod, was born in 1862 into a family of wildfowl hunters. By the age of fourteen, he had begun to carve his own decoys. In his early years Crowell worked as a guide, market gunner, and supervisor at a private hunting camp. By 1908 and for the next thirty-six years, decoy carving was his chief occupation. His varied production, all for sale, included working as well as decorative ducks, shorebirds, miniature shorebirds and songbirds, slat geese, fish plaques and at least one great blue heron. Crowell stopped carving in 1944 due to crippling arthritis in his hands, and died in 1952.

Selected Group Exhibitions: *The Decoy Maker's Craft*, IBM Gallery of Arts and

Biographies

Sciences, New York, New York, 1966; *American Wildfowl Decoys*, U.S. Pavilion, World's Fair, Osaka, Japan, 1970; *Masterpieces of American Folk Art*, Monmouth Museum, Lincroft, New Jersey, 1975; *Exhibition of Classic Antique Waterfowl Decoys* (Third Annual), Oakbrook, Illinois, 1981; *An American Sampler*, Shelburne Museum, Vermont, 1987; *The Decoy as Folk Sculpture*, Cranbrook Academy of Art Museum, Bloomfield Hills, Michigan, 1987.

William Edmondson

Born circa 1870 in Davidson County, Tennessee, Edmondson was the son of freed slaves. Employed as a farmhand and railroad worker until an accident in 1907, he later worked as a hospital janitor. After the hospital closed in 1931, he received a dream from God who instructed him to become a stone carver. His earliest works were mostly tombstones and religious memorials which gradually developed into more elaborate figurative works. It was primarily through his sculpture that he supported himself, briefly working for the WPA sculpture section in 1939 and 1941. Sidney Hirsch, Edmondson's neighbor and a local scholar, introduced his work to the public. In 1937 Edmondson was the first black artist to be given an individual show by the Museum of Modern Art in New York. He died in Nashville in 1951.

Solo Exhibitions: Museum of Modern Art, New York, New York, 1937; Nashville Artist Guild, Tennessee, 1951; Cheekwood Fine Arts Center, Nashville, Tennessee, 1964; The Montclair Art Museum, New Jersey, 1975; Tennessee State Museum, Nashville, Tennessee, 1981.

Selected Group Exhibitions: *Trois siecles d'art aux Etats-Unis*, Musee du Jeu de Paume, Paris, France, 1938; *American Folk Sculpture*, Cranbrook Academy of Art Galleries, Bloomfield Hills, Michigan, 1972; *American Folk Sculpture from the Hall Collection*, University of Kentucky Art Gallery, Lexington, Kentucky, 1974; *Folk*

Sculpture USA, The Brooklyn Museum, New York, 1976; *Two Centuries of Black American Art*, Los Angeles County Museum of Art, California, 1976; *Transmitters*, Philadelphia College of Art, Pennsylvania, 1981; *Black Folk Art in America 1930-1980*, Corcoran Gallery of Art, Washington, D.C., 1982; *Black Art-Ancestral Legacy*, Dallas Museum of Art, Texas, 1989.

Robert A. and Catherine Elliston

Robert Elliston was born in Kentucky in 1847. He was first married to Margaret Cummiskey, who died along with their son of influenza. His second marriage was to Margaret's sister, Catherine, who had assisted with the care of her ill sibling and nephew. For the first ten years of their marriage, Robert Elliston worked in the buggy and carriage trade. In the late 1880s, he became interested in decoy carving and boat building while he and his family lived at the Undercliff Hotel in Putman County, Illinois. In 1889 he and Catherine built a home which included a decoy and boat building workshop as well as a honey bee apiary. They worked the apiary in the summer and made decoys in the winter with Robert carving and Catherine painting. The Ellistons became two of the earliest commercial decoy makers in the Midwest. Robert continued to carve until his death in the winter of 1915, and Catherine remained in their home near Bureau for several more years until she found someone to take over the apiary. During this time, she worked with another well-known Illinois decoy carver, Bert Graves, and taught his sister-in-law, Millie Graves, how to paint decoys. Catherine left Bureau in 1920 to live with her daughters, passing away in 1953.

Selected Group Exhibitions: *The Decoy Maker's Craft*, IBM Gallery of Arts and Sciences, New York, New York, 1966; *American Wildfowl Decoys*, U.S. Pavilion, World's Fair, Osaka, Japan, 1970; *Folk Art of Illinois*, Lakeview Museum of Arts and Sciences, Peoria, Illinois, 1982; *The Decoy*

as Folk Sculpture, Cranbrook Academy of Art Museum, Bloomfield Hills, Michigan, 1987.

Josephus Farmer

Josephus Farmer, born in 1894 near Trenton, Tennessee, was the son of freed slaves. Before moving to East St. Louis, Illinois, in 1917 to work for the Armour Packing Company, Farmer worked as a field hand. After marrying Evelyn Griffin in 1922, he received a message from God to preach as a Pentecostal minister. During the 1930s Farmer built roads with the WPA, later constructing buildings for the Defense Department. He moved to Milwaukee, Wisconsin, in 1947 and opened a small church. After retiring from a part-time job as a hotel porter, he began to concentrate on carving reliefs and dioramas. By the 1970s he began exhibiting his work at local libraries, galleries and community art festivals. Noted collectors Mr. and Mrs. Richard Flagg and Russell Bowman, director of the Milwaukee Art Museum, were instrumental in helping Farmer receive further exposure. He was honored with the Wisconsin Governor's Heritage Award in 1984, and after his wife's death in the same year he relocated to his son's home in Joliet, Illinois. Farmer died on November 15, 1989.

Solo Exhibitions: University of Wisconsin-Milwaukee Art Museum, Wisconsin, 1982.

Selected Group Exhibitions: *The Ties that Bind*, Contemporary Arts Center, Cincinnati, Ohio, 1986; *Made with Passion*, National Museum of American Art, Smithsonian Institution, Washington, D.C., 1990.

Erastus Salisbury Field

Born in Leverett, Massachusetts, in 1805, young Erastus Field was encouraged by his parents to begin painting portraits of family and friends. In 1824, Field traveled to New York to study for three months with artist-inventor Samuel F. B. Morse. In 1826, Field began a successful

career as an itinerant artist, traveling through Massachusetts, Connecticut and New York for the next ten years. He married Phebe Gilmore in 1831, settling temporarily in Hartford, Connecticut, and then Monson, Massachusetts, where his only child, Henrietta, was born in 1832. In 1841, Field returned to New York, changed his title from "portrait painter" to "artist," and began to paint landscapes based on classical themes. In New York, he developed a friendship with Abram Bogardus, a daguerrotypist, and started to use photographs as models instead of people. He returned to Massachusetts in the late 1850s and remained there until his death in 1900.

Solo Exhibitions: Amherst College and Amherst Historical Society, Massachusetts, 1947; The Abby Aldrich Rockefeller Folk Art Collection, Williamsburg, Virginia, 1963; Museum of Fine Arts, Springfield, Massachusetts, 1984; Museum of Modern Art, New York, New York, 1932; Springfield Museum of Fine Arts, Massachusetts, 1942.

Selected Group Exhibitions: *Where Liberty Dwells*, Albright-Knox Art Gallery, Buffalo, New York, 1976; *American Folk Painters of Three Centuries*, The Whitney Museum of American Art, New York, New York, 1980; *American Naive Paintings*, Flint Institute of Arts, Michigan, 1982; *Young Faces*, Hirschl & Adler Folk, New York, New York, 1987; *But Were They Good Likenesses?*, Hirschl & Adler Folk, New York, New York, 1989; *Between the Rivers*, The Sterling and Francine Clark Art Institute, Williamstown, Massachusetts, 1990.

Howard Finster

Howard Finster was born in 1916 in Valley Head, Alabama. He married Pauline Freeman in 1935 with whom he had five children. After retiring as pastor of Chelsea Baptist Church in Menlo, Georgia, Finster worked as a repairman in Pennville, Georgia. It was during this period that he received word from God to construct a "Paradise Garden" in the land around his shop. Incorporating discarded objects, Finster created numerous buildings including "The World's Folk Art Church, Inc." Subsequent divine messages directed him to create spiritual and biblical paintings. Such works came to national attention in a 1980 *Life* magazine article featuring folk art. In 1982 Finster was awarded the National Endowment for the Arts Visual Artist Fellowship in Sculpture, and two years later he was invited to represent the United States at the Venice Biennale. He began to number his works in 1976-1977, and had completed approximately 14,000 by 1990. Finster still resides in Pennville, Georgia.

Solo Exhibitions: Phyllis Kind Gallery, New York, New York, 1977; New Museum of Contemporary Art, New York, New York, 1982; Carl Hammer Gallery, Chicago, Illinois, 1983; Philadelphia Art Alliance, Pennsylvania, 1984; University of Richmond, Virginia, 1984; Cavin-Morris Gallery, New York, New York, 1986; Berea College Appalachian Museum, Berea, Kentucky, 1988; Museum of American Folk Art, New York, New York, 1989; Phyllis Kind Gallery, Chicago, Illinois, 1990; Crocker Art Museum, Sacramento, California, 1991.

Selected Group Exhibitions: *Missing Pieces*, Atlanta Historical Society, Georgia, 1976; *Folk Life and Folk Art*, Library of Congress, Washington, D.C., 1978; *Folk Art Since 1900*, The Abby Aldrich Rockefeller Folk Art Center, Williamsburg, Virginia, 1980; *American Folk Art: The Herbert Waide Hemphill, Jr. Collection*, Milwaukee Art Museum, Wisconsin, 1981; *Transmitters*, Philadelphia College of Art, Pennsylvania, 1981; *Reflections of Faith*, IBM Gallery of Science and Art, New York, New York, 1983; *The Shape of Things*, Museum of American Folk Art, New York, New York, 1983; *The Ties That Bind*, Contemporary Arts Center, Cincinnati, Ohio, 1986; *Baking in the Sun*, University Art Museum, University of Southwestern Louisiana, Louisiana, 1987; *Outside the Mainstream*, High Museum of Art, Atlanta, Georgia, 1988; *Made with Passion*, National Museum of American Art, Smithsonian Institution, Washington, D.C., 1990.

Edward Frerks Sr.

Born in 1903, Edward Frerks Sr. was the son of August Frerks, owner of the Lone Willow Resort in Winneconne, Wisconsin. Edward eventually succeeded his father in operating the resort. In addition, this hunter and fisherman carved decoys. During the 1930s he carved approximately sixty canvasback decoys. Frerks also carved an undetermined number of fish decoys which he used for spearfishing.

Selected Group Exhibitions: *Beneath the Ice: The Art of the Spearfishing Decoy*, Museum of American Folk Art, New York, New York, 1990.

Galloway

Galloway, whose first name and dates are unknown, worked in the Zanesville, Ohio, region during the last quarter of the nineteenth century. He is known to have worked at the Stein pottery until it was destroyed by fire. He then moved to the Star pottery which was founded in 1875 under the direction of Bulger & Worchester, and operated until 1888. The Star pottery produced yellow ware, Rockingham and terra cotta, although no identification marks were used. An 1879 price list from the Star pottery lists oval bakers, scalloped dishes, chambers, bedpans, pie plates, milk pans, covered butter pots and bowls.

Lee Godie

Although she refuses to reveal the date, her place of birth was Mudtown, Illinois. Godie was discovered in 1968 on the steps of the Chicago Art Institute where she was selling her canvases, touting them as "French Impressionist" paintings. Homeless at the time, she lived on the streets. She has been featured in *Art in America* (February 1985) as well as the *Wall Street Journal* (March 27, 1985).

Biographies

Solo Exhibitions: Carl Hammer Gallery, Chicago, Illinois, 1991.

Selected Group Exhibitions: *Contemporary American Folk and Naive Art*, School of the Art Institute of Chicago, Illinois, 1978; *Outsider Art in Chicago*, Museum of Contemporary Art, Chicago, Illinois, 1979.

Denzil Goodpaster

Denzil Goodpaster was born in 1908 in Deniston, Kentucky, where he raised tobacco all of his life on the land that his Russian immigrant grandfather had cleared. He married in 1929 and has one daughter. After retiring in 1970, Goodpaster attended the Sorghum Festival in West Liberty, Kentucky, where he saw a snake cane carved by an acquaintance. When the friend challenged him to do better, Goodpaster accepted and produced the first of his many canes. Goodpaster exhibited at local fairs throughout the 1970s, eventually winning the Kentucky Arts Council Al Smith Fellowship in 1985 and a Southern Arts Federation Fellowship in 1988. Goodpaster now resides in West Liberty, Kentucky.

Selected Group Exhibitions: *Contemporary American Folk and Naive Art*, School of the Art Institute of Chicago, Illinois, 1978; *Kentucky Woodcarvers*, Carl Hammer Gallery, Chicago, Illinois, 1980; *The First Annual Kentucky Folklife Celebration*, Kentucky Center for the Arts, Louisville, Kentucky, 1984; *The Unschooled Artist*, Anton Gallery, Washington, D.C., 1985; *Outside the Main Stream*, High Museum of Art, Atlanta, Georgia, 1988; *Sticks: Historical and Contemporary Kentucky Canes*, Kentucky Art & Craft Foundation Gallery, Louisville, Kentucky, 1988; *Local Visions*, University of Wisconsin-Milwaukee Art Museum, Wisconsin, 1990; *Step Lively: The Art of the Folk Cane*, Museum of American Folk Art, New York, New York, 1992.

Theodore "Ted" Gordon

Ted Gordon was born in 1924 in Louisville, Kentucky, into a strict Jewish home.

After his grandparents' business failed in 1938, the family moved to Brooklyn, New York, where Gordon attended high school. He then joined the Bricklayers, Masons, and Plasterers International Union, working his way West until he arrived in San Francisco in 1951, married Zona Chern, and graduated from San Francisco State College by 1958. Although he did not study art, he began to "doodle" line drawings in 1954. From 1961 to 1985 he worked as a hospital file clerk and receptionist. In 1981 Gordon encountered two art books – Michel Thevoz, *Art Brut* (New York: Skira/Rizzoli, 1976) and Roger Cardinal, *Outsider Art* (New York: Praeger, 1972) – in the hospital library that convinced him that his doodles qualified as art. He then sent drawings to Cardinal (University of Kent, Canterbury, England) and Thevoz (Curator, Collection de l'Art Brut, Lausanne, Switzerland). Both expressed interest in Gordon's work, and Thevoz accessioned several examples into the Lausanne collection. The Braunstein/Quay Gallery in San Francisco began to represent Gordon in 1981. In 1986 he and his wife retired to Laguna Hills, California.

Selected Group Exhibitions: *Pioneers in Paradise*, Long Beach Museum of Art, California, 1984; *Muffled Voices*, Museum of American Folk Art, New York, New York, 1986; *A Density of Passions*, New Jersey State Museum, Trenton, New Jersey, 1989.

Isaac Goulette

Born circa 1900 in Goulette's Point, Michigan, to a fish decoy carving family, Goulette pursued a career in the Department of Public Works for the City of New Baltimore, Michigan. Goulette, who also carved duck decoys, primarily created them for personal use, selling them only occasionally. Other fish decoys which he is known to have carved include suckers, shiners, and small herring-like fish. He died in New Baltimore in the mid-1960s.

Nazarenus Graziani

From 1884-1889, Nazarenus Graziani was Associate Pastor for the Parish of the Assumption of the Blessed Virgin Mary, a Roman Catholic church in Syracuse, New York. The only other known painting by Graziani, also of Assumption Church, was sold at an estate sale in February of 1964; its location is unknown.

Hamilton & Jones Pottery

The Hamilton Pottery was founded by James Hamilton in Greensboro, Pennsylvania, circa 1850, and operated until 1880. Hamilton's brother Leet was also an area potter. Eventually Leet's son-in-law joined James to form a company called Hamilton & Jones circa 1880. Greensboro's location along the Monongahela River, directly opposite Geneva, provided economical riverboat shipping, although the company also accessed wagon and railroad routes.

Bessie Harvey

Born in 1929 in Dallas, Georgia, Bessie Ruth White married Charles Harvey in 1944. She left her husband around 1960 and began working in private residences. After divorcing Harvey in 1968, she worked as a housekeeper's aide at Block Memorial Hospital in Alcoa, Tennessee. She retired in 1983 and married Carl Henry in 1989. As early as 1974, she began to create sculptures out of roots and branches, entering an annual art show at the hospital in 1978. There her art drew the attention of staff doctors, one of whom introduced her to Cavin/Morris Ethnographic Arts Gallery, New York, where she was represented for several years. She now sells her work from her home in Alcoa.

Solo Exhibitions: East Tennessee State University, Johnson City, Tennessee, 1989.

Selected Group Exhibitions: *Baking in the Sun*, University Art Museum, Lafayette, Louisiana, 1987; *Outside the Mainstream*,

High Museum of Art, Atlanta, Georgia, 1988; *Gifted Visions*, Atrium Gallery, University of Connecticut, Storrs, Connecticut, 1988; *Black Art-Ancestral Legacy*, Dallas Museum of Art, Texas, 1989.

Haxstun, Ottman & Company

The Haxstun & Company pottery operated in Fort Edward, New York, from 1857 to circa 1882. In 1867, Andrew K. Haxstun and William R. Ottman purchased a pottery from J.A. and C. W. Underwood. They operated jointly as the Haxstun, Ottman & Company, using the mark "Haxstun, Ottman & Co./Fort Edward, NY." In 1872 Haxstun left, Gilbert Ottman's brother joined, and the firm became Ottman Brothers & Co. Haxstun then built his own Fort Edward shop in 1875 in partnership with George S. Guy – their ware was marked "Haxtun & Co." or "Fort Edward Stoneware Co." By 1882, Guy had replaced Haxtun completely and was operating with W. H. Tilford.

William Lawrence Hawkins

William Hawkins was born in 1895 in Union City, Kentucky, where he farmed and broke horses. After marrying and moving to Ohio in 1916, he drove trucks, worked construction, and served in the army from 1918 to 1919. He began work for the Buckeye Steel Casting Company in Columbus in the early 1920s. After divorcing his wife in 1923, he remarried in 1925. Although he had begun painting in the 1930s, it was not until after retirement that it became his principal interest. In 1979, he came to the attention of Lee Garrett, an artist and neighbor who introduced his work to New York dealer Roger Ricco. Although the quantity of early works is unknown, his mature output is estimated at approximately 450 completed paintings. He received an Ohio Arts Council Individual Artist Fellowship annually from 1984 to 1988, and was featured in the PBS *American Masters Series* "The Mind's Eye: Black Visionary

Art in America." Hawkins died in Columbus, Ohio, in 1990.

Solo Exhibitions: Ricco/Johnson Gallery, New York, New York, 1984; Carl Hammer Gallery, Chicago, Illinois, 1984; Janet Fleisher Gallery, Philadelphia, Pennsylvania, 1986; Tarble Arts Center, Eastern Illinois University, Charleston, Illinois, 1989; Columbus Museum of Art, Ohio, 1990; Ricco/Maresca Gallery, New York, New York, 1990.

Selected Group Exhibitions: *Since the Harlem Renaissance*, Center Gallery of Bucknell University, Lewisburg, Pennsylvania, 1984; *Liberties with Liberty*, Museum of American Folk Art, New York, New York, 1986; *Interfaces*, Lancaster Gallery for Visual Arts, Ohio University, Lancaster, Ohio, 1986; *New Traditions, Non-Traditions*, The Riffle Gallery, Columbus, Ohio, 1989; *Into the Mainstream*, Miami University Art Museum, Florida, 1990; *Made with Passion*, National Museum of American Art, Smithsonian Institution, Washington, D.C., 1990.

Herter's Company

Originally a dry goods store, Herter's Company of Waseca, Minnesota, was founded in 1893 by Edward Otto Herter. Edward's son, George Leonard Herter, added a mail order business to the store in the 1930s which featured imported Chinese feathers used for tying fishing flies. Under George's management Herter's rapidly expanded and became internationally known for fishing and hunting equipment, especially decoys. By 1977 the company had opened stores in five states: Minnesota, Wisconsin, Iowa, South Dakota and Washington. Both the Minnesota and South Dakota stores had mail order businesses. Herter's was sold in 1980 and the new owner, Fran Bogner, currently operates a small combined retail outlet and mail order business in Beaver Dam, Wisconsin.

Lothrop T. Holmes

Lothrop Holmes was born in 1824 and lived on the South Shore of Kingston, Massachusetts. He was the son of a shipbuilder and worked as superintendent of the local cemetery. In his leisure time he hunted and made both duck (canvas-covered Oldsquaw and Mergansers) and shorebird (Yellowlegs, Blackbellied Plover and Ruddy Turnstone) decoys.

Selected Group Exhibitions: *The Decoy as Folk Sculpture*, Cranbrook Academy of Art Museum, Bloomfield Hills, Michigan, 1987; *Five Star Folk Art*, Museum of American Folk Art, New York, New York, 1990.

Jesse Howard

Jesse Howard was born in 1885 in Shamrock, Missouri. He left home in 1903, working odd jobs while traveling to California. After two years, he returned to Missouri where he married Maude Linton, with whom he had five children, and successfully farmed his own land. In 1944 they purchased property in Fulton which they referred to as "Sorehead Hill." Howard began to fence the entire twenty acres, creating signs and buildings while his wife worked in a shoe factory. In 1952, Fulton residents petitioned unsuccessfully to have Howard institutionalized. In 1954 he visited his state representative in Washington, D.C. in order to obtain protection from vandalism. His work came to the public's attention through an *Art in America* (Sept.-Oct. 1968) article. Howard died at his home in 1983, after which his environment was dismantled.

Solo Exhibitions: 200 W. Superior Street, Chicago, Illinois, 1992.

Selected Group Exhibitions: *Naives and Visionaries*, Walker Art Center, Minneapolis, Minnesota, 1974; *Contemporary American Folk And Naive Art*, School of the Art Institute of Chicago, Illinois, 1978; *Transmitters*, Philadelphia College of Art, Pennsylvania, 1981; *Word and Image in

Biographies

American Folk Art, Bethel College, North Newton, Kansas, 1986; *The Ties that Bind*, Contemporary Arts Center, Cincinnati, Ohio, 1986; *Made with Passion*, National Museum of American Art, Smithsonian Institution, Washington, D.C., 1990.

Ira Hudson

Ira Hudson was born in 1876 and except for a brief stay in New Jersey, lived his entire life on Chincoteague Island in Accomac County, Virginia. He was one of the few full-time professional decoy carvers and boat builders in that area. Although Hudson rarely hunted, he produced extremely lifelike working decoys for local hunters. In addition, Hudson carved miniature decoys, flying birds and fish. He also repaired and repainted decoys by other makers. Hudson died in 1949, his total output estimated to be in excess of 25,000 decoys.

Selected Group Exhibitions: *Gunners Paradise*, Museums at Stony Brook, Long Island, New York, 1979; *Philadelphia Wildfowl Exposition*, Museum of The Academy of Natural Sciences, Pennsylvania, 1979.

J. C. Huntington

J. C. Huntington, whose birth and death dates are unknown, was a retired railroad worker who lived in Sunbury, Pennsylvania, during the early to mid-twentieth century. Two painters associated with Bucknell University in Lewisburg, Pennsylvania, Blanchard Gummo and Bruce Mitchell, encountered Huntington while all three were in the countryside painting outdoors. Impressed with Huntington's work, they acquired many of his paintings, most of which became part of the collection of Patricia and Gerald Eager, who then introduced his work to the public.

Selected Group Exhibitions: *Made with Passion*, National Museum of American Art, Smithsonian Institution, Washington, D.C., 1990.

Luther Jones

Luther Jones worked in the Livingston, Kentucky area during the second half of the twentieth century as an employee of the Louisville & Nashville short-line railroad which ran through Kentucky and Tennessee.

Shields Landon (S. L.) Jones

Born in 1901 in Indian Mills, West Virginia, Jones worked as a laborer and foreman for the Chesapeake and Ohio Railway. Before retiring in 1967, Jones took a painting class at the Hillsdale, West Virginia, YMCA. After the death of his first wife in 1969, he returned to his childhood hobbies of playing the fiddle and carving small animals. After re-marrying in 1972, he began to make larger carvings and heads which he displayed at the Pipestem State Park gift shop. Jones now resides in Pine Hill, West Virginia.

Selected Group Exhibitions: Museum of American Folk Art, New York, New York, 1977; *Contemporary American Folk and Naive Art*, School of the Art Institute of Chicago, Illinois, 1978; Abby Aldrich Rockefeller Folk Art Center, Williamsburg, Virginia, 1980; *Transmitters*, Philadelphia College of Art, Pennsylvania, 1981; *American Folk Art: The Herbert Waide Hemphill, Jr. Collection*, Milwaukee Art Museum, Wisconsin, 1981; *A Time to Reap*, Seton Hall University, South Orange, New Jersey, 1985; *Outside the Main Stream*, High Museum of Art, Atlanta, Georgia, 1988; *O, Appalachia*, Huntington Museum of Art, West Virginia, 1989; *Made with Passion*, National Museum of American Art, Smithsonian Institution, Washington, D.C., 1990.

Charles Kinney

Born in 1906 in Vanceburg, Kentucky, Charley Kinney and his brother Noah worked on their father's tobacco farm. After letting the farm run wild in the mid-1970s, Charley returned to his childhood hobby of painting. His work first came to theattention of faculty at nearby

Morehead College. Kinney died April 7, 1991.

Selected Group Exhibitions: *Folk Art of Kentucky*, Kentucky Fine Arts Gallery, Lexington, Kentucky, 1975; *God, Man and the Devil*, Mint Museum, Charlotte, North Carolina, 1984; *The Ties that Bind*, Contemporary Arts Center, Cincinnati, Ohio, 1986; *Outside the Main Stream*, High Museum of Art, Atlanta, Georgia, 1988; *O, Appalachia*, Huntington Museum of Art, West Virginia, 1989; *Local Visions*, Morehead State University, Kentucky, 1990.

Lawrence Lebduska

Lawrence Lebduska was born in Baltimore, Maryland, in 1894, but was trained at a technical school in Leipzig, Czechoslovakia, after his family returned there. Back in New York by 1912, Lebduska took a job painting decorative murals and opened his own decorating business three years later. Around this time, he also began to paint various fables and fantasies for pleasure or gifts. His work was discovered by violinist-collector Louis Kaufman. Widely exhibited throughout the 1930s and 1940s, Lebduska also worked for the WPA Federal Art Project in New York City during this period. He disappeared from the art scene for twenty years and was finally rediscovered in 1960 by Eva Lee, a Long Island dealer who encouraged him until his death in 1966.

Selected Group Exhibitions: *Masters of Popular Painting*, Museum of Modern Art, New York, New York, 1938; *Seventeen Naive Painters*, Museum of Modern Art, New York, New York, 1966.

William H. Lo

William H. Lo signed his only known painting "Wm. H. Lo" and apparently worked in the early twentieth century along the New England coast. *The Prussia* was found in Connecticut.

Marvin "Mase" Mason

Born in Sheboygan, Wisconsin, circa 1940, Marvin Mason remembers making his first decoy at the age of five under the instruction of his father. In Tower, Michigan, by the time he was a teenager, Mason continues to make fish decoys, primarily in the winter.

Ben Miller

Ben Miller, born in 1917, worked as a miner for most of his life, retiring in 1965 due to black lung disease. Miller carved simple walking sticks as a young man, but it was not until he accepted a job with the University of Kentucky's reforestation program and was inspired by eccentric root formations and thigmotropes that he began to carve more elaborate canes. The artist currently resides in Brethed County, Kentucky.

Selected Group Exhibitions: *Sticks: Historical and Contemporary Kentucky Canes*, The Kentucky Art and Craft Foundation Gallery, Louisville, Kentucky, 1988; *Made with Passion*, National Museum of American Art, Smithsonian Institution, Washington, D.C., 1990; *Step Lively: The Art of the Folk Cane*, Museum of American Folk Art, New York, New York, 1992.

Peter Minchell

Peter Minchell was born in 1889 in Treves, Germany. He immigrated to the United States in 1906, finally settling in Florida by 1911. He worked construction, beginning to draw only after retiring in 1960. His circa 1972 *Geological Phenomena* series that depicted natural disasters brought him to the attention of Robert Bishop, late director of the Museum of American Folk Art, New York, who included him in *Folk Painters of America* (E.P. Dutton, 1979). Minchell's date of death is unknown.

Selected Group Exhibitions: *American Folk Art: The Herbert Waide Hemphill, Jr. Collection*, Milwaukee Art Museum, Wisconsin, 1981; *Made with Passion*, National Museum of American Art, Smithsonian Institution, Washington, D.C., 1990.

Sister Gertrude Morgan

Gertrude Morgan was born in 1900 in Lafayette, Alabama. Actively involved with the Baptist church throughout her youth, she became a fundamental evangelist after receiving a divine message to "Go and preach, tell it to the world." Delivering sermons throughout Georgia and Alabama, she eventually settled in New Orleans, Louisiana, in 1939. There she co-founded an orphanage, child care center and chapel. After a message from the Lord informed her that she was "married to the lamb, Christ," she dressed only in white. A 1965 hurricane destroyed her first mission, but within a few years she had rebuilt her "Everlasting Gospel Mission" in a local gallery owner's building. Although she had painted throughout her life, she returned to it with renewed vigor after the destruction, using her painting as a vehicle for religious messages. She sold her work through her landlord, E. Lorenz Borenstein, and used the income to support her mission. She received yet another sacred message in 1978 which instructed her to stop painting, and she died in 1980.

Solo Exhibitions: Union Gallery, Louisiana State University, Baton Rouge, Louisiana, 1972; Anderson Gallery, Virginia Commonwealth University, Richmond, Virginia, 1972.

Selected Group Exhibitions: *Louisiana Folk Paintings*, Museum of American Folk Art, New York, New York, 1973; *Contemporary American Folk and Naive Art*, School of the Art Institute of Chicago, Illinois, 1978; *American Folk Art: The Herbert Waide Hemphill, Jr. Collection*, Milwaukee Art Museum, Wisconsin, 1981; *Black Folk Art in America 1930-1980*, Corcoran Gallery of Art, Washington, D.C., 1982; *A Time to Reap*, Seton Hall University, South Orange, New Jersey, 1985; *Muffled Voices*, Museum of American Folk Art, New York, New York, 1986; *Rambling on My Mind*, Museum of African-American Life and Culture, Dallas, Texas, 1987; *Outside the Main Stream*, High Museum of Art, Atlanta, Georgia, 1988; *Made with Passion*, National Museum of American Art, Smithsonian Institution, Washington, D.C., 1990.

Inez Nathaniel-Walker

Born Inez Stedman in Sumter, South Carolina, in 1911, she married a man named Nathaniel in 1924. She moved to Philadelphia in 1940 to escape farm labor, eventually settling in New York by 1949 where she worked in an apple processing plant. In 1970 she was convicted of the "criminally negligent homicide" of a male acquaintance who had abused her and she served a one-year sentence at the Bedford Hills Correctional Facility in New York State. In order to isolate herself from other inmates, Inez began to draw. Elizabeth Bayley, a remedial English instructor at the facility, showed some of Inez's drawings to Pat Parsons, an art dealer who purchased most of her work. Inez, who remarried (Walker) in 1972, remained in contact with Parsons until 1980, after which she went into seclusion. She died in Willard, New York, in 1990.

Solo Exhibitions: Webb-Parsons Gallery, Bedford, New York, 1972 and 1974.

Selected Group Exhibitions: *Six Naives*, Akron Art Institute, Ohio, 1973; *Contemporary American Folk and Naive Art*, School of the Art Institute of Chicago, Illinois, 1978; *Transmitters*, Philadelphia College of Art, Philadelphia, Pennsylvania, 1981; *Black Folk Art in America 1930-1980*, Corcoran Gallery of Art, Washington, D.C., 1982; *Muffled Voices*, Museum of American Folk Art, New York, New York, 1986; *Gifted Visions*, Atrium Gallery, University of Connecticut, Storrs, Connecticut, 1988; *Made with Passion*, National Museum of American Art, Smithsonian Institution, Washington, D.C., 1990.

Biographies

E. & L. P. Norton Pottery

The Norton Pottery, founded in 1793 by Revolutionary War veteran Captain John Norton, was the first pottery established at Bennington, Vermont. For the next 101 years, it was operated by succeeding generations of Nortons. In its early years, the pottery produced redware covered with a thin clay slip or lead-glazed. By the early nineteenth century, the pottery was producing salt-glazed stoneware items. From 1845 to 1847, Julius Norton, John's son, formed a partnership with his brother-in-law Christopher Webber Fenton. Although Fenton sought to expand the firm's range of ceramic items, the Norton pottery continued to emphasize stoneware and crockery, adding only a mottled glazestoneware called Rockingham ware. The Norton pottery began to sell wholesale glassware, china and pottery in 1885 due to a declining demand for stoneware. The Norton dynasty ended in 1894 with the death of Edward Norton, a great-grandson of John.

John W. Perates

Born in 1895 in Amphikleia, Delphi, Greece, John Perates was heir to five generations of family wood carving. After immigrating to the United States in 1912, he settled in Portland, Maine, where he joined the local Greek Orthodox Church and made furniture for the J. F. Crockett Company. In 1930 he founded the J. H. Pratt Company ("Pratt" being a simplification of his own name), and when business was slow he carved icons which he called "furniture for the House of the Lord." He donated his works, which also included a pulpit and altar screen, to his church. Perates died in Portland in 1970.

Selected Group Exhibitions: *Transmitters*, Philadelphia College of Art, Pennsylvania, 1981; *American Folk Art: The Herbert Waide Hemphill, Jr. Collection*, Milwaukee Art Museum, Wisconsin, 1981; *The Ties that Bind*, Contemporary Arts Center, Cincinnati, Ohio, 1986; *Made with Passion*,

National Museum of American Art, Smithsonian Institution, Washington, D.C., 1990.

Elijah Pierce

Elijah Pierce was born in 1892 in Baldwyn, Mississippi, onto a farm that his father, a former slave, owned. Pierce was ordained a minister around 1920, following in the footsteps of his father who was a deacon. By the age of sixteen, Pierce had decided to become a barber rather than continue to farm. When his first wife died in 1917, he left Baldwyn and took odd jobs until finding steady work as a barber in Danville, Illinois. After 1924, he moved to Columbus, Ohio, with his second wife, where he opened his own shop in 1954. Although he had always whittled, Pierce did not begin any elaborate\carvings until his wife praised a small sculpture representing an elephant; other animals as well as figural and religious subjects soon followed. He sold many of these small works at churches and fairs during the 1920s and 1930s, carefully explaining the story behind each image to his customers. Pierce was discovered in 1971 by Boris Gruenwald, a sculpture student at Ohio University, who began to arrange public exhibitions of Pierce's work. In 1980 Pierce received an honorary doctorate in fine arts from Franklin University in Columbus, and in 1982 he received a National Heritage Fellowship. Pierce died in Columbus in 1984.

Solo Exhibitions: Hopkins Hall Gallery, Ohio State University, Columbus, Ohio, 1971; Krannert Art Museum, University of Illinois, Urbana, Illinois, 1972; Columbus Gallery of Fine Arts, Ohio, 1973; Columbus Museum of Art, Ohio, 1993.

Selected Group Exhibitions: *Untitled III*, The Penthouse Gallery, Museum of Modern Art, New York, New York, 1972; *McCarthy-Pierce Exhibition*, Pennsylvania Academy of Fine Arts, Philadelphia, Pennsylvania, 1972; *Folk Sculpture USA*, Brooklyn Museum, New York, 1976; *Contemporary American Folk and Naive Art*,

School of the Art Institute of Chicago, Illinois, 1978; *Transmitters*, Philadelphia College of Art, Pennsylvania, 1981; *Black Folk Art in America 1930-1980*, Corcoran Gallery of Art, Washington, D.C., 1982; *Gifted Visions*, Atrium Gallery, University of Connecticut, Storrs, Connecticut, 1988.

Bruno Podlinsek

Bruno Podlinsek was an employee of Duquet and Sons Heating Company in Highland, Michigan. He spontaneously created *The Greeter* while assembling various ducts and parts in the early 1980s. Once finished, he mounted it above the company storefront to serve as a trade sign. The Halls purchased the piece directly from Podlinsek in 1987.

Nate Quillen

Nate Quillen was a locksmith and cabinet maker until the mid-1870s when he began making boats and decoys for the Pointe Mouille Shooting Club near Rockwood, Michigan, where he also worked as a personal hunting guide for Connecticut businessman Lyman B. Jewell. A prolific carver, it is estimated that Quillen produced two hundred decoys annually between 1875-1900. During this period his hollow decoys were sold to club members for one dollar, and his solid decoys (with knots that prevented hollowing) were sold to non-members for twenty-five cents. Quillen was forced to quit carving late in life due to pleurisy; he died in 1908.

Selected Group Exhibitions: *Annual Mid-Atlantic Waterfowl Festival of Virginia Beach*, Virginia, 1977; *The Decoy as Folk Sculpture*, Cranbrook Academy of Art Museum, Bloomfield Hills, Michigan, 1987.

Martin Ramirez

Martin Ramirez was born in 1885 in Jalisco, Mexico. He worked as a laundry man in Mexico, eventually moving to America to work on the railroads. The culture shock that he experienced in this country led to hallucinations and

delusional behavior. He was ultimately picked up by Los Angeles authorities in 1930 and placed in an institution. After seven months, he was transferred to De Witt State Hospital in Auburn, California, where he remained mute and was classified as a paranoid schizophrenic. Befriended by psychologist Dr. Tarmo Pasto, Ramirez showed him a roll of his drawings in 1948. Dr. Pasto encouraged his creativity and showed the work to Chicago artist Jim Nutt, who was then teaching at Sacramento State College. Nutt, along with Chicago dealer Phyllis Kind, purchased and began to restore and exhibit Ramirez's work. Ramirez remained institutionalized until his death in 1960.

Solo Exhibitions: Goldie Paley Gallery, Moore College of Art, Philadelphia, Pennsylvania, 1985.

Selected Group Exhibitions: *Contemporary American Folk and Naive Art*, School of the Art Institute of Chicago, Illinois, 1978; *Transmitters*, Philadelphia College of Art, Pennsylvania, 1981; *Pioneers in Paradise*, Long Beach Museum of Art, California, 1984; *A Time to Reap*, Seton Hall University, South Orange, New Jersey, 1985; *Cat and Ball on a Waterfall*, Oakland Museum of Art, California, 1986; *Muffled Voices*, Museum of American Folk Art at Paine Webber Art Galley, New York, New York, 1986; *Hispanic Art in the United States*, Museum of Fine Arts, Houston, Texas, 1987; *Made with Passion*, National Museum of American Art, Smithsonian Institution, Washington, D.C., 1990.

H. Rhodenbaugh Pottery

The Rhodenbaugh Pottery was located in Middlebury, (now East Akron) Ohio, during the latter half of the nineteenth century. Stoneware from this pottery is incised with "H. Rhodenbaugh."

Anthony Joseph Salvatore

Salvatore was born in 1938 in Youngstown, Ohio. He claims to have always painted "in the service of the Lord." In 1973, Salvatore was involved in an automobile accident, after which he underwent a series of spinal operations and began to concentrate on painting. From 1975 through 1981, a prominent Youngstown businessman paid for Salvatore's correspondence courses at W.B. Grant Bible College in Dallas, Texas. Salvatore was eventually ordained a Pentecostal minister, although he supported himself by working in the laundry room of the Seminary School Society of the Mission of the Sacred Heart in Chicago. In the late 1970s David Colts, a Youngstown dealer, discovered Salvatore's work and became his agent. Salvatore still resides in Chicago.

Solo Exhibitions: Akron Art Museum, Ohio, 1989; Cavin-Morris Gallery, New York, New York, 1992.

Selected Group Exhibitions: *Muffled Voices*, Museum of American Folk Art at Paine Webber Art Gallery, New York, New York, 1986; *The Ties that Bind*, Contemporary Arts Center, Cincinnati, Ohio, 1986; *New Traditions, Non-Traditions*, Riffe Gallery, Columbus, Ohio, 1989.

John "Jack" Savitsky

Savitsky was born in 1910 in New Philadelphia, Pennsylvania. After completing the sixth grade, Savitsky, like his father before him, began work in the Pennsylvania coal mines. By the age of twelve he was working full time as a slate picker. Later, he was employed by a sign painter, and painted barroom murals and mirrors in exchange for liquor. After marrying in 1932, Savitsky became a contract miner in Coaldale, Pennsylvania. By the time the mine closed in 1959, Savitsky suffered from black lung disease and was forced to retire. His son, Jack Savitt, a newspaperman, suggested that Savitsky take up painting. By 1961, Savitsky had

made the acquaintance of Sterling Strauser, an artist in East Stroudsburg, Pennsylvania, who encouraged, purchased and arranged for the exhibition of work by various local folk artists including Savitsky. Savitsky died in Lansford, Pennsylvania, in 1991.

Selected Group Exhibitions: *American Folk Art: The Herbert Waide Hemphill, Jr. Collection*, Milwaukee Art Museum, Wisconsin, 1981; *How the Eagle Flies*, Meadow Farm Museum, Richmond, Virginia, 1989; *Made with Passion*, National Museum of American Art, Smithsonian Institution, Washington, D.C., 1990.

Amateur "Mat" Savoie

Born in 1896, "Mat" Savoie, a self-taught barber, cobbler and folk artist lived in Nequac, New Brunswick, Canada. He began carving decoys at the age of nine, and continued to carve until the late 1960s. Most of his decoys were made for local hunters and sportsmen who frequented hunting camps in the Tabusintac area. In addition to carving more than five thousand working and decorative decoys, Savoie also made crooked knives, miniature animals, boats and sleighs. He died at age 87 in 1983.

Selected Group Exhibitions: *American Folk Sculpture from the Hall Collection*, University of Kentucky, Lexington, Kentucky, 1974; *The Bird Decoy: An American Art Form*, Sheldon Memorial Art Gallery, University of Nebraska, Nebraska, 1976.

Benjamin J. Schmidt

"Benj" Schmidt was born in 1884 near Detroit, Michigan. He began to carve decoys in 1914, initially for his own use and later for local hunters. His first workshop was in the basement of a house, but he later moved his growing business to Center Line where he opened a decoy shop and worked with his brother Frank for several years. Schmidt sold his decoys at wholesale prices to Hudson's Department Store as well as several other sport-

Biographies

ing goods dealers in the Detroit area. Schmidt died in 1968.

Solo Exhibitions: *Ben Schmidt: A Michigan Decoy Carver, 1884-1968*, Birmingham, Michigan, 1970.

Selected Group Exhibitions: *The Bird Decoy: An American Art Form*, Sheldon Memorial Art Gallery, University of Nebraska, Nebraska, 1976; *The Decoy as Folk Sculpture*, Cranbrook Academy of Art Museum, Bloomfield Hills, Michigan, 1987.

John Scholl

John Scholl was born in 1827 in the kingdom of Wurttemberg, now West Germany. Trained as a carpenter, Scholl immigrated to America in 1853 with his fiancee. After marrying in New York City, they settled in Schuylkill, Pennsylvania, where Scholl worked as a carpenter. By 1870, he had purchased a farmstead in Germania, Pennsylvania, and built a home in a highly ornamental Victorian style, incorporating various architectural patterns. Although he had always whittled, he began more ambitious pieces while in his eighties. Visitors came to his home to see his work and Scholl began to give guided tours which his son continued after Scholl's death in 1916. The house was closed to the public in 1930. In 1967 an antiques dealer purchased the Scholl family's collection and sold it to Adele Earnest in Stony Point, New York, who arranged for its exhibition.

Solo Exhibitions: Marian Willard Gallery, New York, New York, 1964 and 1967; William Penn Memorial Museum, Harrisburg, Pennsylvania, 1979.

Tom Schroeder

Born in 1886, Tom Schroeder began hunting at twelve years of age and decoy carving shortly thereafter. He supported this hobby by working as a cartoonist for the *Detroit News*, later making his fortune as an advertising executive. Between 1948 and 1956 Schroeder entered his decoys in the International Decoy Makers Contest in the National Sportsmen Show held annually in New York City. In 1949 he won four first place awards, including "Best Amateur Decoy." In succeeding years he continued to win major awards that established his national reputation. Although Schroeder carved for seventy years, his output was not large. In later years he added miniature and lifesize decorative decoys to his repertoire. He died in 1976 at the Hutzel Hospital in Detroit.

Selected Group Exhibitions: *The Decoy as Folk Sculpture*, Cranbrook Academy of Art Museum, Bloomfield Hills, Michigan, 1987.

John Schweikart

John Schweikart was born in 1870, the third son of five children, to German immigrant parents. John's father, a stonecutter and woodworker, brought his family to Detroit in 1859 from Wizenhausen. In 1873 they moved to Belle Isle in the Detroit River where they owned and operated a commercial fishing venture. In 1879 the family moved back to the mainland when the city of Detroit purchased the island for a park. The Schweikarts continued to operate their fishing business as well as an ice company and tavern. John learned many skills from his craftsman father, eventually becoming a partner in the family owned boat building business. He and his brothers were well-known for producing the fastest racing yachts on the Detroit River, which included his boat *The Huntress*. Although the exact dates of John's carving career are unknown, he probably did most of his carving between 1900 and 1920. He continued to use both his yacht (which was moored at the family's retreat on Strawberry Island) and his decoys until his death in 1954. His decoys were used by successive Schweikart generations until the late 1970s.

Selected Group Exhibitions: *The Decoy As Folk Sculpture*, Cranbrook Academy of Art Museum, Bloomfield Hills, Michigan, 1987.

Gordon Sears

Born in 1897 in Windsor, Canada, Gordon Sears was raised in Michigan. A hunting and fishing guide for all of his life, he lived on Plumbush Island at the southernmost end of the middle channel of the St. Clair River. He died in Michigan in 1967.

George M. Sibley (Mr. X)

George M. Sibley was born in Fulton, New York, in 1861, the son of Elizabeth and James A. Sibley. The elder Sibley moved his family to the Chicago area at an undetermined date and began his own commission merchant business. The younger Sibley, a hunter and fisherman like his father, worked at Murray Nelson & Company before moving to his father's firm. In 1899 George founded Sibley & Company, which manufactured the Sibley Decoy, with financial backing from his father. The company was located in Whitehall, Michigan. Production only lasted three to four years with a total output of 1000-1500 decoys. Shortly after his father's death in 1901, Sibley moved to Colorado to join his brother James' foundry business. There, George and his brother founded the Highland Gun Club north of Denver. George Sibley died in 1938.

Selected Group Exhibitions: *Folk Art of Illinois*, Lakeview Museum of Arts and Sciences, Peoria, Illinois, 1982.

Drossos P. Skyllas

Drossos P. Skyllas was born in 1912 in Kalymnos, Greece, where he worked as an accountant for a tobacco business. After World War II he and his wife came to America and settled in Chicago, Illinois. Once there, Skyllas did not seek employment, but pursued a career as a professional painter while his wife supported them. Although his work was for sale, high prices discouraged customers; likewise, portrait commissions starting at $25,000 were sought but never received.

Skyllas exhibited at several local shows before his death in 1973. In 1974, a friend mentioned his paintings to William Bengston who, after viewing the work, began to sell it through the Phyllis Kind Gallery.

Selected Group Exhibitions: *Chicago and Vicinity Show*, Illinois, 1967, 1969, 1973; *Transmitters*, Philadelphia College of Art, Pennsylvania, 1981; *The Ties that Bind*, Contemporary Arts Center, Cincinnati, Ohio, 1986.

Lloyd Sterling

Decoy maker Lloyd Sterling was active in Crisfield, Maryland, in the early to mid-twentieth century, and probably worked as a market gunner. Some of the bodies of his decoys were cut on a band saw by the Ward brothers.

Selected Group Exhibitions: *Philadelphia Wildfowl Exposition*, Museum of The Academy of Natural Sciences of Philadelphia, Pennsylvania, 1979.

Luis Tapia

Born in 1950 in Santa Fe, New Mexico, Luis Tapia worked as a stock boy in a Western Wear shop, eventually becoming store manager. He attended college at New Mexico State University, Las Cruces, from 1968-69. During the 1960s, Tapia realized that he knew little about his Hispanic heritage, and began to listen to Hispanic music and view *santos* in museums and churches. By 1971 he had begun to support himself by creating contemporary *santos* and restoring Southwestern style furniture. He exhibited his work in the early 1970s at the Spanish Market in Santa Fe but was criticized for his innovative style and lack of adherence to traditional *santos* types. Tapia is now well recognized as a modern Southwestern *santero*. He received a National Endowment for the Arts grant in 1980, and currently resides in Santa Fe.

Solo Exhibitions: Governor's Gallery, Santa Fe, New Mexico, 1982.

Selected Group Exhibitions: *Hispanic Crafts of the Southwest*, Taylor Museum, Colorado Springs, Colorado, 1977; *One Space/Three Visions*, Albuquerque Museum, New Mexico, 1979; *Ape to Zebra*, Museum of American Folk Art, New York, New York, 1985; *Santos Statues and Sculpture, Contemporary Woodcarving from New Mexico*, Craft and Folk Art Museum, Los Angeles, California, 1988; *Hispanic Art in the United States*, Museum of Fine Arts, Houston, Texas, 1988; *1989 Invitational Exhibition*, Roswell Museum and Art Center, New Mexico, 1989; *Chispas! Cultural Warriors of New Mexico*, The Heard Museum, Phoenix, Arizona, 1992.

Mose Tolliver

Born in 1919 southeast of Montgomery, Alabama, in the Pike Road Community, Mose Tolliver was the son of a sharecropper. Tolliver worked variously as a tenant farmer, laborer and gardener, occasionally creating root sculptures and carvings in his spare time. He became a full time artist only after a load of marble crushed his legs in the late 1960s while he was working in the shipping department of a furniture company. A former employer encouraged him to paint, and Anton Haardt praised and purchased his work in the late 1970s. In 1978, curator Mitchell D. Kahan recognized Tolliver with a one-person exhibition at the Montgomery Museum of Fine Arts. Tolliver now lives in Montgomery, Alabama.

Solo Exhibitions: Montgomery Museum of Fine Arts, Alabama, 1981; Museum of American Folk Art, New York, New York, 1993.

Selected Group Exhibitions: *Transmitters*, Philadelphia College of Art, Pennsylvania, 1981; *Black Folk Art in America 1930-1980*, Corcoran Gallery of Art, Washington, D.C., 1982; *A Time to Reap*, Seton Hall University, South Orange, New Jersey,

1985; *Muffled Voices*, Museum of American Folk Art, Paine Webber Art Gallery, New York, New York, 1986; *Baking in the Sun*, University Art Museum, Lafayette, Louisiana, 1987; *Outside the Mainstream*, High Museum of Art at Georgia-Pacific Center, Atlanta, Georgia, 1988; *Gifted Visions*, Atrium Gallery, University of Connecticut, Storrs, Connecticut, 1988.

Edgar Tolson

Born in 1904 near Lee City, Kentucky, Edgar Tolson was the son of Rebecca Maddox and James Perry Tolson, a farmer and minister. Tolson attended school through the sixth grade, and married his first wife, Lily Smith, in 1925. Together they had four children. In 1942 Tolson married Hulda Patton of Campton, Kentucky, with whom he had fourteen children. Tolson held a variety of jobs including chairmaker, carpenter, tombstone carver, coal miner, farmer, shoemaker and preacher. In 1957 while on jury duty in Campton, Tolson suffered a stroke that left his right arm and leg severely impaired. As a form of therapy, Edgar began to carve wood. Also a source of amusement to his children, this activity was to become his future vocation until his death in 1984 at the age of eighty.

Solo Exhibitions: University of Kentucky Art Museum, Lexington, Kentucky, 1981.

Selected Group Exhibitions: *1973 Biennial of American Art*, Whitney Museum of American Art, New York, New York, 1973; *Folk Sculpture USA*, Brooklyn Museum, New York, 1976; *Contemporary American Folk and Naive Art*, School of the Art Institute of Chicago, Illinois, 1978; *Transmitters*, Philadelphia College of Art, Pennsylvania, 1981; *God, Man and the Devil*, Lexington,Kentucky, 1984; *The Ties that Bind*, Contemporary Arts Center, Cincinnati, Ohio, 1986; *Outside the Mainstream*, High Museum of Art at Georgia-Pacific Center, Atlanta, Georgia, 1988; *Made with Passion*, National Museum of American Art, Smithsonian Institution, Washington, D.C., 1990.

Biographies

Bill Traylor

Bill Traylor was born a slave in 1854 on the George Traylor plantation near Benton, Alabama. After the 1863 Emancipation Act, he remained there as a farm hand. In 1938, after the death of his wife and the Traylors, he moved to Montgomery where he began to draw while sitting outside a pool hall or a nearby vegetable market. Local artist Charles Shannon soon noticed Traylor and visited him regularly on Monroe Street until 1942 when he went to live with family in Detroit. No work survives from this period, and it is assumed that Traylor, who lost a leg to gangrene around this time, temporarily stopped drawing. Traylor returned to Alabama in 1946, at which time the State sent him to live with a daughter. Though he tried to resume drawing, the familiarity of Monroe Street was missing. Traylor was placed in a nursing home in 1947 and died shortly thereafter.

Solo Exhibitions: New South Art Center, Montgomery, Alabama, 1940; Fieldston School, New York, New York, 1941; R. H. Oosterom Gallery, New York, New York, 1979; Montgomery Museum of Fine Arts, Alabama, 1982; Hammer and Hammer Gallery, Chicago, Illinois, 1982; Mississippi Museum of Art, Jackson, Mississippi, 1983; Hill Gallery, Birmingham, Michigan, 1983; Hirschl and Adler Modern, New York, New York, 1986; North Carolina Museum of Art, Raleigh, North Carolina, 1988.

Selected Group Exhibitions: *Southern Works on Paper 1900-1950*, Southern Arts Federation, Atlanta, Georgia, 1982; *The Black Presence in the American Revolution*, City College of New York, New York, 1982; *Black Folk Art in America 1930-1980*, Corcoran Gallery of Art, Washington, D.C., 1982; High Museum of Art, Atlanta, Georgia, 1983; *Artists on the Black Experience*, University of Illinois, Chicago, Illinois, 1983; *Since the Harlem Renaissance*, Center Gallery, Bucknell University, Lewisburg, Pennsylvania, 1984; *Made with Pas-*

sion, National Museum of American Art, Smithsonian Institution, Washington, D.C., 1990.

Obediah Verity

Obediah Verity lived in Seaford, Long Island, New York. Seaford records show that at one time there were six Obediah Veritys living there. Consequently, specific information on Obediah the decoy carver is scarce. All that is known is that he was a lifelong bayman. Gene and Linda Kangas have suggested possible life dates of circa 1850-1910 based upon the most intense period of wildfowl hunting on Long Island.

Selected Group Exhibitions: *Gunners Paradise*, The Museums at Stony Brook, Long Island, New York, 1979; *The Decoy as Folk Sculpture*, Cranbrook Academy of Art Museum, Bloomfield Hills, Michigan, 1987.

Lemuel T. Ward Jr. and Stephen Ward

Stephen and Lemuel Ward were born in Crisfield, Maryland, in 1895 and 1896 respectively. Their father, L. Travis Ward Sr., was a bayman, barber, boatbuilder and decoy maker who taught his sons the same skills. Stephen carved his first decoy in 1907; Lem followed in 1918. Initially, both brothers became barbers, carving only in their spare time and keeping their decoys for personal use. In 1926, following the death of their father, they formed a partnership and began to produce commercial decoys. Generally Stephen carved and Lem painted. Between 1930 and 1959, the Wards produced thousands of decoys. In the 1950s they phased out their working decoy business and concentrated on making decorative decoys. Their total output of working and ornamental decoys is estimated at over 50,000.

Selected Group Exhibitions: *The Decoy Maker's Craft*, IBM Gallery of Arts and Sciences, New York, New York, 1966; *American Wildfowl Decoys*, U.S. Pavilion, World's Fair, Osaka, Japan, 1970; *Annual*

Mid-Atlantic Waterfowl Festival of Virginia Beach, Virginia, 1977 and 1978; *Gunners Paradise*, The Museums at Stony Brook, Long Island, New York, 1979; *Philadelphia Wildfowl Exposition*, Museum of The Academy of Natural Sciences, Pennsylvania, 1979; *The Decoy as Folk Sculpture*, Cranbrook Academy of Art Museum, Bloomfield Hills, Michigan, 1987.

Charles Edward "Shang" Wheeler

Charles "Shang" Wheeler was born in 1872 in Saugatuck, Connecticut. At sixteen he left home for various jobs as a fieldhand, fisherman, pipefitter, boatbuilder, fishing and hunting guide, yacht crewman and market gunner. While in his twenties, he was also an amateur boxer and umpire for local football clubs. Around 1900, Wheeler moved to the Stratford area where he became involved in the cultivation and harvesting of oysters. In 1912 he became the general manager of Connecticut Oyster Farms in Milford and worked there until his retirement in 1946. Wheeler also served two terms in the Connecticut House of Representatives (1923-26) and one term in the State Senate (1927-28). Wheeler spent his leisure time fishing and carving decoys, a craft he began at the age of eight. In August 1923 he entered and won first prize in the amateur category of a Bellport, Long Island, decoy contest. In twelve of the twenty-five years that Wheeler carved, he won first place in the amateur category of decoy carving at the annual International Decoy Makers Contest in New York City. Wheeler was also a political cartoonist for the *Bridgeport Herald*, drew hunting and fishing scenes in pen and ink, and occasionally painted landscapes in oil. He died in 1949.

Solo Exhibitions: Old State House, Hartford, Connecticut, 1983.

Selected Group Exhibitions: *The Decoy Maker's Craft*, IBM Gallery of Arts and Sciences, New York, New York, 1966; *American Wildfowl Decoys*, U.S. Pavilion, World's Fair, Osaka, Japan, 1970; *Master-*

pieces of American Folk Art, Monmouth Museum, Lincroft, New Jersey, 1975; *Annual Mid-Atlantic Waterfowl Festival of Virginia Beach*, Virginia, 1977; *Three Centuries of Connecticut Folk Art*, Wadsworth Atheneum, Hartford, Connecticut, 1979; *An American Sampler*, Shelburne Museum, Vermont, 1987; *The Decoy as Folk Sculpture*, Cranbrook Academy of Art Museum, Bloomfield Hills, Michigan, 1987.

White's Pottery

Born in Vermont, Noah White arrived in Utica, New York, in 1828 to work as a laborer and boat captain on the Erie Canal. In 1834 he began manufacturing stoneware on shares at the Samuel H. Addington Pottery. By 1839, he had bought out both Addington Pottery and the George Nasa Pottery. His son Nicholas A. White as well as several other relatives worked with him. The pottery operated under various names including N. White & Sons and Noah White, Son & Company. After Noah died in 1865, Nicholas continued the business under the name N. A. White. In 1875, under the direction of Charles N. White, the firm became Central New York Pottery until that changed to White's Pottery, Inc. in 1899. White's Pottery outlasted all other Utica potteries, ceasing stoneware production in 1907, although it continued to operate as the C. N. White Clay Products Company until closing permanently in 1910.

Whittemore Pottery

Albert O. Whittemore was originally a manufacturer of beaver hats in New York City. He relocated to Havana, New York, in the early 1860s due to a depletion of beaver pelts. Although not a potter himself, he became proprietor of the Whittemore pottery in Havana from 1868 to circa 1893. The pottery property was known as the Schuyler Stoneware works because of its location in Schuyler County. During the first year of operation, Whittemore was in partnership with George W. Hall; after that, he operated alone until a fire

destroyed the pottery in 1893. He was also involved with stoneware works in Elmira, New York, from 1866-1867. During the height of his success he built a mock Italian villa called "Westover Hills," although after a fire and other setbacks he sold his home, moved to the Havana flats, and ran a coal and lumberyard.

Aaron Augustus "Gus" Wilson

Augustus Aaron Wilson was born in 1864 on Mount Desert Island, Maine. He worked as a fisherman, later becoming a lighthouse keeper for the Spring Point Light off the coast of South Portland, Maine, until he retired at the age of 66. During his years as a lighthouse keeper, Wilson began carving decoys, first for personal use and gradually for local hunters. Eventually, Wilson decoys became so well known that he was hired to carve them for the Edwards and Walker Sporting Goods Store in Portland. During his career, Wilson's output is believed to have exceeded 50,000 decoys. He died in 1950 at the age of 86.

Selected Group Exhibitions: *The Decoy Maker's Craft*, IBM Gallery of Arts and Sciences, New York, New York, 1966; *American Wildfowl Decoys*, U.S. Pavilion, World's Fair, Osaka, Japan, 1970; *Annual Mid-Atlantic Waterfowl Festival of Virginia Beach*, Virginia, 1977; *The Decoy as Folk Sculpture*, Cranbrook Academy of Art Museum, Bloomfield Hills, Michigan, 1987.

Joseph Yoakum

Born in either 1886 or 1888 in Window Rock, Arizona, Joseph Yoakum ran away from home as a teenager, joining various circuses and taking jobs as a sailor and railroad porter. He was in the Army during World War I and stationed in Clermont-Ferrand, France. He finally settled in Chicago in the late 1950s, where he claimed to have run a small ice cream parlor. Around 1962, Yoakum had a dream in which God appeared and ordered him to draw. He later moved to a storefront on Chicago's South Side where he displayed

and occasionally sold his drawings. It was not until a small exhibition in a church coffeehouse prompted an article in the *Chicago Daily News* that his drawings came to the attention of Whitney Halstead, an art historian at the Art Institute of Chicago. Halstead introduced Yoakum to other faculty and students who supported and purchased his work. Yoakum died in Chicago at the Veterans Administration Hospital in 1972.

Solo Exhibitions: Pennsylvania State University Art Museum, 1969; School of The Art Institute of Chicago, Illinois, 1971; Whitney Museum of American Art, New York, New York, 1972; University of Rhode Island, Kingston, Rhode Island, 1973.

Selected Group Exhibitions: *Contemporary American Folk and Naive Art*, School of the Art Institute of Chicago, Illinois, 1978; *Outsider Art in Chicago*, Museum of Contemporary Art, Illinois, 1979; *Transmitters*, Philadelphia College of Art, Pennsylvania, 1981; *Black Folk Art in America 1930-1980*, Corcoran Gallery of Art, Washington, D.C., 1982; *A Time to Reap*, Seton Hall University South Orange, New Jersey, 1985; *Muffled Voices*, Museum of American Folk Art at Paine Webber Art Gallery, New York, New York, 1986; *A Density of Passions*, New Jersey State Museum, Trenton, New Jersey, 1989; *Made with Passion*, National Museum of American Art, Smithsonian Institution, Washington, D.C., 1990.

Albert Zahn

Albert Zahn was born in Pomerania, Germany, in 1864. He worked as a sheepherder until 1880 when he came to the United States to escape military service. Zahn settled in Baileys Harbor, Wisconsin, where he worked as a well digger until he had saved enough money to purchase a dairy farm. Around 1924, Zahn gave the farm to his son and retired with his wife to another house in the Baileys Harbor area. After moving to his new home Zahn began to carve, apparently inspired by visions. He decorated his house with

carved birds and referred to it as the "Bird House." Intrigued by the "Bird House," many Baileys Harbor tourists purchased Zahn's carvings in the 1920s and 1930s. Zahn died in 1953.

Selected Group Exhibitions: *Folk Sculpture USA*, The Brooklyn Museum, New York, 1976; *Grass Roots Art: Wisconsin*, John Michael Kohler Arts Center, Kohler, Wisconsin, 1978.

Selected Bibliography

Abby Aldrich Rockefeller Folk Art Center. *American Folk Paintings and Drawings Other Than Portraits from the Abby Aldrich Rockefeller Folk Art Center.* Boston: Little, Brown in association with Colonial Williamsburg Foundation, 1988.

Academy of Natural Sciences of Philadelphia. *Philadelphia Wildfowl Exposition.* Exhibition catalogue. Sponsored by The Women's Committee of the Academy of Natural Sciences of Philadelphia, 1979.

Akron Art Institute. *Six Naives: Ashby, Borkowski, Fasanella, Nathaniel, Palladino, Tolson.* Akron: Akron Art Institute, 1973.

Albanese, Catherine L. "Appalachian Religion." In *Encyclopedia of Southern Culture,* edited by Charles Reagan Wilson and William Ferris. Chapel Hill: University of North Carolina Press, 1989.

Ames, Kenneth L. *Beyond Necessity: Art in the Folk Tradition.* Wilmington: Winterthur, 1977.

Apfelbaum, Ben, Eli Gottlieb, and Steven J. Michaan. *Beneath the Ice: The Art of the Spearfishing Decoy.* New York: E. P. Dutton, 1990.

Ardery, Julie. "The Designation of Difference: A Review of the Folk Art Press." *New Art Examiner* (September 1991), pp. 29-32.

Armstrong, Tom. "The Innocent Eye." In *200 Years of American Sculpture.* New York: Whitney Museum of American Art, 1976.

Baldwin, James. "A Talk to Teachers." (1963) *Graywolf Annual Five: Multicultural Literacy.* St. Paul: Graywolf Press, 1988.

Barber, Edwin Atlee. *The Pottery and Porcelain of the United States.* New York: Feingold & Lewis, 1893.

Barber, Joel. *Wild Fowl Decoys.* New York: Dover Publications, Inc., 1954.

Barret, Richard Carter. *Bennington Pottery and Porcelain: A Guide to Identification.* New York: Bonanza Books, 1958.

Beardsley, John, Jane Livingston, and Octavio Paz. *Hispanic Art in the United States: Thirty Contemporary Painters and Sculptors.* New York: Abbeville Press, 1987.

Belk, Russell W., et al. "Collectors and Collecting." *Advances in Consumer Research* 15 (1988), pp. 548-553.

Benedict, Stephen, ed. *Public Money and the Muse: Essays on Government Funding for the Arts.* New York: W. W. Norton, 1991.

Bensch, Christopher. *The Blue and the Gray: Oneida County Stoneware.* Utica: Munson-Williams-Proctor Institute, 1987.

Bernard Danenberg Galleries. *Elijah Pierce: Painted Carvings.* New York: Bernard Danenberg Galleries, 1972.

Bishop, Robert. *American Folk Sculpture.* New York: E. P. Dutton, 1974.

———. *Folk Painters of America.* New York: E. P. Dutton, 1979.

Bishop, Robert and Pat Coblentz. *A Gallery of American Weathervanes and Whirligigs.* New York: E. P. Dutton, 1981.

Black, Mary. *Erastus Salisbury Field 1805-1900, A Special Exhibition Devoted to His Life and World.* Williamsburg: Colonial Williamsburg, 1963.

———. *Erastus Salisbury Field: 1805-1900.* Springfield: Museum of Fine Arts, 1984.

Black, Mary and Jean Lipman. *American Folk Painting.* New York: Clarkson N. Potter, Inc., 1966.

Blair, C. Dean. *The Potters and Potteries of Summit County 1828-1915.* Akron: Summit County Historical Society, 1965.

Bonesteel, Michael. "Chicago Originals." *Art in America* 73 (February 1985), p. 131.

———. "Bill Traylor: Creativity and the Natural Artist." In *Bill Traylor Drawings.* Chicago: Chicago Office of Fine Arts, 1988.

Boothroyd, A. E. *Fascinating Walking Sticks.* New York: White Lion Publishers, 1973.

Bronner, Simon J. *American Folk Art: A Guide to Sources.* New York: Garland Publishing, Inc., 1984.

———. *Chain Carvers: Old Men Crafting Meaning.* Lexington: University Press of Kentucky, 1985.

Burrison, John. *Brothers in Clay: The Story of Georgia Folk Pottery.* Athens: University of Georgia Press, 1983.

Cahill, Holger. *American Primitives.* Newark: Newark Museum, 1930.

———. *American Folk Sculpture.* Newark: Newark Museum, 1931.

———. *American Folk Art: The Art of the Common Man in America 1750-1900.* New York: The Museum of Modern Art, 1932.

———. "Folk Art." *Art Digest* (December 15, 1932), p. 14.

Cardinal, Roger. *Outsider Art.* New York: Praeger Publishers, Inc., 1972.

Carnes, Mark C. *Secret Ritual and Manhood in Victorian America.* New Haven: Yale University Press, 1989.

Carpenter, Miles Burkholder. *Cutting the Mustard.* Tappahannock: American Folk Company, 1982.

Christensen, Erwin O. *The Index of American Design.* Washington, D. C.: National Gallery of Art, 1950.

Cincinnati Art Museum. *Twentieth Century American Icons: John Perates.* See essay by Michael Hall. Cincinnati: Cincinnati Art Museum, 1974.

"Cobb's Island." *Forest and Stream* (July 26, 1883), p. 502.

Cole, Wanda. *Grass Roots Art: Wisconsin.* Madison: University of Wisconsin, 1978.

Colt, Priscilla. *Edgar Tolson: Kentucky Gothic.* Lexington: University of Kentucky, 1981.

Columbus Gallery of Fine Arts. *Elijah Pierce, Woodcarver.* Columbus: Columbus Gallery of Fine Arts, 1973.

Columbus Museum of Art. *Elijah Pierce, Woodcarver.* Columbus: Columbus Museum of Art, 1992.

Contemporary Arts Center. *The Ties That Bind: Folk Art in Contemporary American Culture.* See essays by Eugene W. Metcalf and Michael Hall. Cincinnati: The Contemporary Arts Center, 1986.

Corn, Wanda M. "Coming of Age: Historical Scholarship in American Art." *The Art Bulletin* 70 (June 1988), pp. 188-207.

Corn, Wanda, Gerald Silk and Albert Boihme. "Scholarship in American Art." In *Smithsonian American Art Network*, supplement to 4, no. 2 (Fall 1991).

Cranbrook Academy of Art Galleries. *American Folk Sculpture: The Personal and the Eccentric.* Bloomfield Hills: Cranbrook Academy of Art, 1972.

Cranbrook Academy of Art Museum. *The Decoy as Folk Sculpture.* Bloomfield Hills: Cranbrook Academy of Art, 1987.

Crandell, Bernard. "Decoy Art Speaks to Julie Hall." *Wildfowl Carving and Collecting.* Harrisburg: 1985.

Cubbs, Joanne. *The Gift of Josephus Farmer.* Milwaukee: The University of Wisconsin-Milwaukee Art History Gallery, 1982.

Davis, Wade. *Passage of Darkness.* Chapel Hill: University of North Carolina Press, 1988.

Delph, John and Shirley. *New England Decoys.* Exton: Schiffer Publishing, Ltd., n.d.

Dewhurst, C. Kurt and Marsha MacDowell. *Rainbows in the Sky: The Folk Art of Michigan in the Twentieth Century.* East Lansing: Michigan State University, 1978.

Dewhurst, C. Kurt, Betty and Marsha MacDowell. *Religious Folk Art in America.* New York: E. P. Dutton, 1983.

Dike, Catherine. *Cane Curiosa.* Paris: Les Editions de'l'Auteur, 1983.

Dissanayake, Ellen. *What Is Art For?* Seattle: University of Washington Press, 1988.

Doty, Robert. *By Good Hands: New Hampshire Folk Art.* Manchester, New Hampshire: Currier Gallery of Art and University Art Galleries, University of New Hampshire, 1989.

Doucette, Joseph and C.L. Collins. *Collecting Antique Toys.* New York: Macmillan Publishing Company, 1981.

Duffus, Robert. "The Age of Play." (1924) *Annals of America.* Vol. 14. Chicago: Encyclopedia Britannica Incorporated, 1968.

Dunlap, William. *History of the Rise and Progress of the Arts of Design in the United States.* Vol. 1. New York: Dover Publications, 1969.

Earnest, Adele. *The Art of the Decoy.* New York: Brahmhill House, 1965.

Eaton, Allen H. *Immigrant Gifts to American Life: Some Experiments in Appreciation of the Contributions of Our Foreign-Born Citizens to American Culture.* New York: Russell Sage Foundation, 1932.

_____ . *Handicrafts of the Southern Highlands.* New York: Dover Publications, Inc., 1973. Originally published by Russell Sage Foundation, 1937.

Ellis, Anita J., Genetta Gardner, Dennis Kiel, and Otto Charles Thieme. *The Fine Art of Folk Art.* Cincinnati: Cincinatti Art Museum, 1990.

Emans, Charlotte. "In Celebration of a Sunburst: The Sculpture of John Scholl." *The Clarion* (Fall 1983), pp. 56-59.

Engers, Joe, ed. *The Great Book of Wildfowl Decoys.* San Diego: Thunder Bird Press, Inc., 1990.

Fagaly, William A. *David Butler.* New Orleans: New Orleans Museum of Art, 1976.

Ferguson, George. *Signs and Symbols in Christian Art.* New York: Oxford University Press, 1959.

Ferris, William, ed. "Vision in Afro-American Folk Art: The Sculpture of James Thomas." *Journal of American Folklore* 88 (1975), pp. 115-131.

_____ . *Local Color: A Sense of Place in Folk Art.* New York: McGraw-Hill, 1982.

_____ . *Afro-American Folk Art and Crafts.* Jackson: University Press of Mississippi, 1983.

Finore, Diane. "Art by Bill Traylor." *The Clarion* (Spring/Summer 1983), pp. 42-49.

Fitzgerald, Ken. *Weathervanes and Whirligigs.* New York: Brahmhill House, 1967.

Fleckenstein, Henry A., Jr. *Shorebird Decoys.* Exton: Schiffer Publishing, Ltd., 1980.

_____ . *American Factory Decoys.* Exton: Schiffer Publishing, Ltd., 1981.

Folk Art Finder. Quarterly newsletter. Essex: Gallery Press, March 1980-1992.

Folk Art Messenger. Quarterly newsletter. Richmond: Folk Art Society of America, 1987-1992.

Fox, Nancy Jo. *Liberties with Liberty: The Fascinating History of America's Proudest Symbol.* New York: E. P. Dutton in association with Museum of American Folk Art, 1985.

Franco, Barbara. *White's Utica Pottery.* Utica: Munson-Williams-Proctor Institute, 1969.

_____ . *Fraternally Yours.* Lexington: Museum of Our National Heritage, 1986.

Fuller, Edmund L. *Visions in Stone.* Pittsburgh: University of Pittsburgh Press, 1973.

Gard, Ronald J. and Bryan J. McGrath. *The Ward Brothers' Decoys: A Collectors Guide.* Plano: Thomas B. Reel, 1989.

Gaylord, Benjamin H. "Gus Wilson: Maine's Elmer Crowell." *North American Decoys* (Winter 1975), pp. 6-12.

Genauer, Emily. "The Satisfaction of Folk Art." *New Haven Register* (March 15, 1976).

Gerdts, William. *Painters of the Humble Truth.* Columbia: University of Missouri Press, 1981.

Glassie, Henry. *Pattern in the Material Folk Culture of the Eastern United States.* Philadelphia: University of Pennsylvania Press, 1968.

_____ . *The Spirit of Folk Art: The Girard Collection at the Museum of International Folk Art.* New York: Harry N. Abrams, Inc. in association with Museum of New Mexico, Santa Fe, 1989.

Goldie Paley Gallery, Moore College of Art. *The Heart of Creation: The Art of Martin Ramirez.* Philadelphia: Goldie Paley Gallery, Moore College of Art, 1985.

Goldin, Amy. "Problems in Folk Art." *Artforum* 14 (June 1976), pp. 48-52.

Goldwater, Robert. *Symbolism.* New York: Harper & Row Publishers, Inc., 1979.

Gouma-Peterson, Thalia and Patricia Matthews. "The Feminist Critique of Art History." *Art Bulletin* 69, no. 3 (September 1987), pp. 326-57.

Gowans, Alan. *Learning to See: Historical Perspectives on Modern Popular/Commercial Arts.* Bowling Green: Bowling Green University Popular Press, 1981.

Grave, Alexandra. *Three Centuries of Connecticut Folk Art.* New Haven: Art Resources of Connecticut, 1979.

Greer, Germaine. *The Obstacle Race: The Fortunes of Women Painters and Their Work.* New York: Farrar Straus Giroux, 1979.

Grier, Katherine C. *Celebrations in Wood: The Sculpture of John Scholl (1827-1916).* Harrisburg: William Penn Memorial Museum, 1979.

Grosh, Reverend A. B. *The Odd Fellows' Manual.* Philadelphia: Theodore Bliss, 1968.

Hackley, Larry. *Sticks: Historical and Contemporary Kentucky Canes.* Louisville: The Kentucky Art and Craft Foundation, 1988.

Haid, Alan G. *Decoys of the Mississippi Flyway.* Exton: Schiffer Publishing, Ltd., 1981.

Hall, Julie. "John Schweikart." *North American Decoys* Part I (1977), pp. 23-31.

_____. *The Sculpture of Fred Alten.* Ann Arbor: The Michigan Artrain, 1980.

Hall, Michael D. "American Folk Sculpture." *The Cranbrook Magazine* 3 (Winter 1972), pp. 5-10.

_____. "You Make it with Your Mind: The Art of Edgar Tolson." *The Clarion* 12 (Spring/Summer 1987), pp. 36-43.

_____. *Stereoscopic Perspective: Reflections on American Fine and Folk Art.* Ann Arbor: UMI Research Press, 1988.

_____. "This Side of Oz: A Heart for the Tin Man." *Metalsmith* 8, no. 2 (Spring 1988), pp. 22-27.

_____. "The Mythic Outsider: Handmaiden to the Modern Muse." *New Art Examiner* 19, no. 1 (September 1991), pp. 16-21.

Hartigan, Lynda Roscoe. *Made with Passion.* Washington, D. C.: National Museum of American Art, 1990.

_____. "American Handmade Canes." *Antiques* 142 (October 1992), pp. 522-529.

Hemphill, Herbert W., Jr., ed. *Folk Sculpture USA.* See essays by Daniel Robbins, Michael Kan, and interview with Michael Hall by Sarah Faunce. Brooklyn: The Brooklyn Museum, 1976.

Hemphill, Herbert W., Jr. and Julia Weissman. *Twentieth-Century Folk Art and Artists.* New York: E. P. Dutton, 1974.

Herman, Bernard and David Orr. "Decoys and Their Use: A Cultural Interpretation." In *Philadelphia Wildfowl Exposition.* Philadelphia: The Academy of Natural Sciences of Philadelphia, 1979.

Hirschl and Adler Folk. *Source and Inspiration: A Continuing Tradition.* New York: Hirschl and Adler Folk, 1988.

Hood, Fred J. "Kentucky." In *Encyclopedia of Religion in the South*, edited by Samuel S. Hill. Macon: Mercer University Press, 1984.

Horne, Catherine Wilson, ed. *Crossroads of Clay: The Southern Alkaline-Glazed Stoneware Tradition.* Columbia, South Carolina: McKissick Museum, University of South Carolina, 1990.

Horwitz, Elinor Lander. *Contemporary American Folk Artists.* Philadelphia: J. B. Lippincott Company, 1975.

Huster, Harrison H. "White Wing and Surf Scoters." *North American Decoys* (Summer 1978), pp. 32-34.

INTAR Latin American Gallery. *Another Face of the Diamond: Pathways Through the Black Atlantic South.* New York: INTAR Latin American Gallery, 1989.

Isham, Samuel. *History of American Painting.* New York: The MacMillan Co., 1905.

Jackson, Lowell, ed. *Benjamin Schmidt: A Michigan Decoy Carver, 1884-1968.* Birmingham: Private publication, 1970.

Janis, Sidney. *They Taught Themselves: American Primitive Painters of the 20th Century.* New York: The Dial Press, 1942.

Jasper, Pat and Kay Turner. *Art Among Us/Arte entre nosotros.* San Antonio: San Antonio Museum Association, 1986.

John Michael Kohler Arts Center. *From Hardanger to Harleys: A Survey of Wisconsin Folk Art.* Sheboygan: John Michael Kohler Arts Center, 1987.

_____. *Religious Visionaries.* Sheboygan: John Michael Kohler Arts Center, 1991.

Johns, Elizabeth. "Histories of American Art: The Changing Quest." *Art Journal* 44, no. 4 (Winter 1984), pp. 338-344.

_____. *American Genre Paintings: The Politics of Everyday Life.* New Haven: Yale University Press, 1991.

Johnsgard, Paul A., ed. *The Bird Decoy: An American Art Form.* Lincoln: University of Nebraska Press, 1976.

Johnson, Jay and William C. Ketchum, Jr. *American Folk Art of the Twentieth Century.* New York: Rizzoli Press, 1983.

Jones, Mervyn. "Freemasonry." In *Secret Societies*, edited by Norman MacKenzie. London: Aldus Books, Ltd., 1967.

Jones, Michael Owen. *The Hand Made Object and Its Maker.* Berkeley: University of California Press, 1975.

_____. *Exploring Folk Art: Twenty Years of Thought on Craft, Work, and Aesthetics.* Ann Arbor: UMI Research Press, 1987.

Kane, Steven. "Snake Handlers." In *Encyclopedia of Southern Culture*, edited by Charles Reagan Wilson and William Ferris. Chapel Hill: University of North Carolina Press, 1989.

Kangas, Gene and Linda. "Underwater Decoys: Fish." *North American Decoys* (Spring 1978), pp. 14-23.

_____. *Decoys: A North American Survey.* Spanish Fork: Hillcrest Publications, Inc., 1983.

Kaufman, Barbara Wahl and Didi Barrett. *A Time to Reap: Late Blooming Folk Artists.* South Orange: Seton Hall University and Museum of American Folk Art, 1985.

Ketchum, William C., Jr. *All-American Folk Arts and Crafts.* New York: Rizzoli Press, 1986.

Klamkin, Charles. *Weather Vanes: History, Design, and Manufacture.* New York: Hawthorne Books, 1973.

Koch, Ronald M. *Decoys of the Winnebago Lakes.* Omro, Wisconsin: Rivermore Pubs, 1988.

Kogan, Lee. "New Museum Encyclopedia Shatters Myth." *The Clarion* 15 (Winter 1990-91), pp. 55-56.

Kuspit, Donald B. "American Folk Art: The Practical Vision." *Art in America* 68 (September 1980), pp. 94-98.

_____. "The Appropriation of Marginal Art in the 1980s." *American Art* (Winter/ Spring 1991), p. 134.

LaFollette, Suzanne. *Art in America.* New York: W. W. Norton & Co., 1929.

Lampell, Ramona and Millard Lampell. *O, Appalachia: Artists of the Southern Mountains.* New York: Stewart, Tabori and Chang, 1989.

Larkin, Oliver W. *Art and Life in America.* New York: Holt, Rinehart and Winston, 1949.

Larsen-Martin, Susan and Lauri Robert Martin. *Pioneers in Paradise: Folk and Outsider Artists of the West Coast.* Long Beach: The Long Beach Museum of Art, 1984.

Lavitt, Wendy. *Animals in American Folk Art.* New York: Alfred A. Knopf, 1990.

Leibowitz, Joan. *Yellow Ware: The Transitional Ceramic.* Exton: Schiffer Publishing, Ltd., 1985.

Lipman, Jean. *American Folk Art in Wood, Metal and Stone.* New York: Pantheon Books, 1948.

_____. *Provocative Parallels: Naive Early Americans/International Sophisticates.* New York: E. P. Dutton, 1975.

Lipman, Jean and Alice Winchester. *The Flowering of American Folk Art (1776-1876).* New York: The Viking Press in cooperation with Whitney Museum of American Art, 1974.

Lipman, Jean, Robert Bishop, Elizabeth V. Warren, and Sharon L. Eisenstat. *Five Star Folk Art: One Hundred American Masterpieces.* New York: Harry N. Abrams, Inc. in association with Museum of American Folk Art, 1990.

Lipman, Jean and Tom Armstrong, eds. *American Folk Painters of Three Centuries.* New York: Hudson Hill Press, Inc., 1980.

Lippard, Lucy R. "Making Something from Nothing (Toward a Definition of Women's 'Hobby Art')." In *Get the Message?* New York: E. P. Dutton, 1984. Originally published in *Heresies* 4 (Winter 1978).

_____. *Mixed Blessings: New Art in A Multicultural America.* New York: Pantheon Books, 1990.

Little, Nina Fletcher. *The Abby Aldrich Rockefeller Folk Art Collection.* Williamsburg: Colonial Williamsburg, 1957; distributed by Little, Brown and Company.

Livingston, Jane and John Beardsley. *Black Folk Art in America 1930-1980.* Jackson: University Press of Mississippi and Center for the Study of Southern Culture for the Corcoran Gallery of Art, 1982.

Los Angeles County Museum of Art. *Parallel Visions: Modern Artists and Outsider Art.* See essays by Russell Bowman, Roger Cardinal, Carol S. Eliel, Barbara Freeman and Jonathan Williams. Princeton: Princeton University Press, 1992.

Lucas, Nora. "The Icons of John Perates." *The Clarion* (Winter 1981), pp. 36-41.

Machmer, Richard S. and Rosemarie B. *Just For Nice: Carving and Whittling Magic of Southeastern Pennsylvania.* Reading: The Historical Society of Berks County, 1991.

Mackey, William J., Jr. *American Bird Decoys.* New York: E. P. Dutton, 1965.

Manley, Roger. *Signs and Wonders: Outsider Art Inside North Carolina.* Raleigh: North Carolina Museum of Art, 1989.

Maresca, Frank and Roger Ricco. *Bill Traylor: His Art - His Life.* New York: Alfred A. Knopf, Inc., 1991.

Marshall, Howard W., ed. *Missouri Artist Jesse Howard, With a Contemplation on Idiosyncratic Art.* Columbia: Missouri Cultural Heritage Center, 1983.

Marzio, Peter C. *The Democratic Art.* Boston: David R. Godine, Publisher, Inc., 1979.

Mason, Carol I. *Introduction to Wisconsin Indians: Prehistory to Statehood.* Salem: Sheffield Publishing, 1988.

McCoubrey, John W. *American Art 1700-1960.* Englewood Cliffs: Prentice Hall Press, 1965.

Mendelowitz, Daniel M. *A History of American Art.* New York: Holt, Rinehart and Winston, 1969.

Merkt, Dixon. *Shang Wheeler and the Housatonic Decoy.* Hartford: Old State House, 1983.

Metcalf, Eugene W. "Black Art, Folk Art and Social Control." *Winterthur Portfolio* 18 (Winter 1983), pp. 271-89.

_____. "The Problem of American Folk Art." *Maine Antique Digest* (April 1986), pp. 34-35.

_____. "Modernism, Edith Halpert, Holger Cahill, and the Fine Art Meaning of American Folk Art." In *Folk Roots, New Roots: Folklore in American Life,* eds. Jane S. Becker and Barbara Franco. Lexington: Museum of Our National Heritage, 1988.

_____. "Artifacts and Cultural Meaning: The Ritual of Collecting American Folk Art." In *Living in a Material World: Canadian and American Approaches to Material Culture,* ed. Gerald L. Pocius. St. John's, Newfoundland: Institute of Social and Economic Research, Memorial University of Newfoundland, 1991.

Meyer, George H. *American Folk Art Canes: Personal Sculpture.* Detroit: Sandringham Press, 1992.

_____, ed. *Folk Artists Biographical Index.* First edition. Detroit: Sandringham Press in association with Museum of American Folk Art, 1987.

Miele, Frank J., ed. "Folk or Art?: A Symposium." *Antiques* 135 (1989), pp. 272-287.

Miller, Steve. *The Art of the Weathervane.* Exton: Schiffer Publishing Ltd., 1984.

Milwaukee Art Museum. *American Folk Art from the Milwaukee Art Museum.* Milwaukee: Milwaukee Art Museum, 1988.

_____. *American Folk Art: The Herbert Waide Hemphill Jr. Collection.* See essays by Russell Bowman, Donald B. Kuspit, and dialogue between Michael D. Hall and Herbert W. Hemphill Jr., Milwaukee: Milwaukee Art Museum, 1981.

Morehead State University. *Local Visions: Folk Art from Northeast Kentucky.* See essay by Adrian Swain. Morehead: Morehead State University, 1990.

Museum of American Folk Art. *American Folk Art: Expressions of a New Spirit.* New York: Museum of American Folk Art, 1983.

Museum of Modern Art. *Masters of Popular Painting: Modern Primitives of Europe and America.* New York: The Museum of Modern Art in collaboration with the Grenoble Museum, France, 1938.

National Gallery of Art. *101 American Primitive Water Colors and Pastels from the Collection of Edgar William and Bernice Chrysler Garbisch.* Washington, D. C.: National Gallery of Art, 1966.

_____ . *An American Sampler: Folk Art from the Shelburne Museum.* Washington, D. C.: National Gallery of Art, 1987.

Novak, Barbara. *Nature and Culture.* New York: Oxford University Press, 1980.

Oakland Museum of Art Department. *Cat and a Ball on a Waterfall: Two Hundred Years of California Folk Painting and Sculpture.* Oakland: Oakland Museum, 1986.

Parmalee, Paul W. and Forrest D. Loomis. *Decoys and Decoy Carvers of Illinois.* DeKalb: Northern Illinois University Press, 1969.

Patterson, Tom. *Howard Finster, Stranger from Another World.* New York: Abbeville Press, 1989.

Philadelphia College of Art. *Transmitters: The Isolate Artist in America.* Philadelphia: Philadelphia College of Art, 1981.

Pierce, James Smith. *Unschooled Talent.* Owensboro: Owensboro Museum of Fine Arts, 1979.

_____ . *God, Man and the Devil: Religion in Recent Kentucky Folk Art.* Lexington: Folk Art Society of Kentucky, 1984.

Prown, Jules. "Style as Evidence." *Winterthur Portfolio* 15 (Autumn 1980), pp. 197-210.

_____ . "Mind in Matter: An Introduction to Material Culture Theory and Method." *Winterthur Portfolio* 17 (Spring 1982), pp. 1-19.

Quimby, Ian M.G. and Scott T. Swank, eds. *Perspectives on American Folk Art.* New York: W. W. Norton & Co., 1980.

Rhodes, Lynette I. *American Folk Art from the Traditional to the Naive.* Cleveland: Cleveland Museum of Art, 1978.

Ricco, Roger and Frank Maresca with Julia Weissman. *American Primitive: Discoveries in Folk Sculpture.* New York: Alfred A. Knopf, 1988.

Riffe Gallery. *New Traditions Non-Traditions: Contemporary Folk Art in Ohio.* Columbus: The Riffe Gallery, 1989.

Roberts, Warren E. *Viewpoints on Folklife: Looking at the Overlooked.* Ann Arbor: UMI Research Press, 1988.

Rodman, Selden. *Artists in Tune with Their World: Masters of Popular Art in the Americas and Their Relation to the Folk Tradition.* New York: Simon and Schuster, 1982.

Rosen, Seymour. *In Celebration of Ourselves.* San Francisco: California Living Books in association with San Francisco Museum of Modern Art, 1979.

Rosenak, Chuck and Jan. *Museum of American Folk Art Encyclopedia of Twentieth-Century American Folk Art and Artists.* New York: Abbeville Press, 1990.

Rubin, Cynthia Elyce, ed. *Southern Folk Art.* Birmingham: Oxmoor House, 1985.

Rumford, Beatrice T. *Folk Art in America: A Living Tradition.* Atlanta: The High Museum of Art and the Abby Aldrich Rockefeller Folk Art Collection, 1974.

Rumford, Beatrice T. and Carolyn J. Weekley. *Treasures of American Folk Art from the Abby Aldrich Rockefeller Folk Art Center.* Boston: Little, Brown and Company, Bulfinch Press in association with The Colonial Williamsburg Foundation, 1989.

Schlereth, Thomas J. *Cultural History & Material Culture: Everyday Life, Landscapes, Museums.* Ann Arbor: UMI Research Press, 1990.

Schmidt, Alvin J., ed. *The Greenwood Encyclopedia of American Institutions: Fraternal Organizations.* Westport: Greenwood Press, 1980.

Siporin, Steve. *We Came to Where We Were Supposed to Be.* Boise: Idaho Commission on the Arts, 1984.

_____ . *America's Folk Masters: The National Heritage Fellows.* New York: Harry N. Abrams, Inc., 1992.

Sirlot, J. E. *A Dictionary of Symbols.* New York: Philosophical Library, 1962.

Spargo, John. *The Potters and Potteries of Bennington.* Boston: Houghton Mifflin Company and Antiques Incorporated, 1926.

Starr, George Ross, Jr. *Decoys of the Atlantic Flyway.* New York: Winchester Press, 1974.

Stein, Kurt. *Canes and Walking Sticks.* New York: Liberty Cap Books, George Shumway Publishers, 1974.

Steiner, Jesse F. *Americans at Play: Recent Trends in Recreation.* New York: McGraw-Hill Incorporated, 1933.

Stearns, Harold E., ed. *Civilization in the United States.* London: Jonathan Cape, 1922.

Stevens, Albert C., ed. *The Cyclopedia of Fraternities.* New York: E. B. Treat and Co., 1907.

Stone, Lisa. "The Painted Forest." *The Clarion* (Winter 1985), pp. 54-63.

Taylor, Ellsworth. *Folk Art of Kentucky.* Lexington: University of Kentucky Fine Arts Gallery, 1975.

Taylor, Joshua C. "The Folk and the Masses." In *America as Art.* Washington, D. C.: Smithsonian Institution Press, 1976.

Thistlethwaite, Mark. *Grand Illusions.* Fort Worth: Amon Carter Museum, 1988.

Thevoz, Michel. *Art Brut.* New York: Rizzoli, 1976.

Thompson, Robert Farris. *Flash of the Spirit: African and Afro-American Art and Philosophy.* New York: Random House, 1983.

_____ . "The Circle and the Branch: Renascent Kongo-American Art." In *Another Face of the Diamond: Pathways Through the Black Atlantic South.* New York: INTAR Latin American Gallery, 1989.

Thurston, Herbert and Donald Attwater, eds. *Lives of the Saints.* Vol. 4. New York: P. J. Kennedy and Sons, 1956.

Tonelli, Donna. "The Sibley Decoy: The Identity Behind the Real Mr. X." *Decoy Magazine* (July/August 1991), pp. 8-13.

Torgovnick, Marianna. *Gone Primitive.* Chicago: University of Chicago Press, 1990.

Townsend, Jane. *Gunners Paradise: Wild-fowling and Decoys on Long Island.* Stony Brook: The Museums at Stony Brook, 1979.

Tuckerman, Henry T. *Book of the Artists.* New York: James F. Carr, 1966.

Truettner, William H., ed. *The West as America.* Washington, D. C.: Smithsonian Institution Press, 1991.

University of Kentucky Art Gallery. *American Folk Sculpture from the Hall Collection.* Lexington: University of Kentucky Art Gallery, 1974.

University of Southwestern Louisiana. *Baking in the Sun: Visionary Images from the South, Selections from the Collection of Sylvia and Warren Lowe.* Lafayette: University Art Museum, University of Southwestern Louisiana, 1987.

University of Wisconsin-Milwaukee Art Museum. *Folk Art Carvings of Northern New Mexico.* Chicago: The Design Foundation, 1989.

Vlach, John Michael. *The Afro-American Tradition in Decorative Arts.* Cleveland: Cleveland Museum of Art, 1978.

_____. "Holger Cahill as Folklorist." *Journal of American Folklore* 98 (1985), pp. 148-162.

_____. *Plain Painters.* Washington, D. C.: Smithsonian Institution Press, 1988.

_____. "Morality as Folk Aesthetic." In *The Old Traditional Way of Life: Essays in Honor of Warren E. Roberts*, ed. Robert E. Walls and George H. Schoemaker. Bloomington, Indiana: Trickster Press, 1989.

_____. *By the Work of Their Hands: Studies in Afro-American Folklife.* Ann Arbor: UMI Research Press, 1991.

_____. "The Wrong Stuff." *New Art Examiner* 19 (September 1991), p. 23.

Vlach, John Michael and Simon J. Bronner, eds. *Folk Art and Art Worlds.* Ann Arbor: UMI Research Press, 1986; 2d ed. Logan: Utah State University Press, 1992.

Wadsworth, Anna. *Missing Pieces: Georgia Folk Art 1770-1976.* Atlanta: Georgia Council for the Arts and Humanities, 1976.

Walker Art Center. *Naives and Visionaries.* New York: E. P. Dutton, 1974.

Walsh, Clune, Jr. and Lowell G. Jackson. *Decoys of Michigan and the Lake St. Clair Region.* Detroit: Gale Graphics, 1983.

Wampler, Jan. *All Their Own: People and the Places They Build.* Cambridge: Schenkman Publishing Co., 1977.

Webb, Vaughan. "Sculpture." In *Southern Folk Art*, edited by Cynthia Elyce Rubin. Birmingham: Oxmoor House, 1985.

Webster, David S. and William Kehoe. *Decoys at the Shelburne Museum.* Shelburne: The Shelburne Museum, 1961.

Weller, Jack E. *Yesterday's People.* Lexington: University of Kentucky Press, 1975.

Welsh, Peter C. *American Folk Art: The Art and Spirit of a People, from the Eleanor and Mabel Van Alstyne Collection.* Washington, D. C.: Smithsonian Institution Press, 1965.

Wendel, Bruce J. and Doranna. "Winning Moves: Painted Gameboards of North America." *The Clarion* (Winter 1985), pp. 48-63.

White, William Chapman. *Adirondack Country.* New York: Alfred A. Knopf, Inc., 1967.

Wilmerding, John. *American Art.* New York: Penguin Books, 1976.

Winchester, Alice, ed. "What is American Folk Art? A Symposium." *Antiques* 57 (May 1950), pp. 335-62.

Yoder, Don. *Discovering American Folklife: Studies in Ethnic, Religious, and Regional Culture.* Ann Arbor: UMI Research Press, 1990.

Yoshitomi, Gerald D. "Cultural Democracy." In *Public Money and the Muse: Essays on Government Funding for the Arts*, edited by Stephen Benedict. New York: W. W. Norton, 1991.

Young, Dan S. "Those Great South Carolina Decoys." *North American Decoys* (Fall 1978), pp. 6-10.

Zug, Charles G., III. *Turners and Burners: The Folk Potters of North Carolina.* Chapel Hill: University of North Carolina Press, 1986.

Film:

Light, Allie and Irving Saraf. *Possum Trot – The Life and Work of Calvin Black.* San Francisco: Light-Saraf Films, 1976.

Rogers, Fred. *Old Friends . . . New Friends.* Pittsburgh: Family Communications, Inc., 1980.

Index of the Artists

Index of the Collection

Contributors

Kenneth L. Ames is Chief of Historical and Anthropological Surveys and State Historian at the New York State Museum's Cultural Education Center in Albany, New York. He is the author of *Beyond Necessity: Art in the Folk Tradition* (Winterthur Museum, 1977).

Russell Bowman, director of the Milwaukee Art Museum and curator of the exhibition, has addressed issues in folk and outsider art in "Varieties of Folk Expression: The Hemphill Collection," in *American Folk Art: The Herbert Waide Hemphill Jr. Collection* (Milwaukee Art Museum, 1981), "Martin Ramirez: A Visionary Journey," in *The Heart of Creation: The Art of Martin Ramirez* (Goldie Paley Gallery, Moore College of Art, 1985) and in "Looking to the Outside: Art in Chicago, 1945-75," in *Parallel Visions: Modern Artists and Outsider Art* (Princeton University Press, 1992).

Julie Hall, an art and cultural historian, is currently completing a doctoral dissertation at New York University entitled "American Individualism and Nineteenth-Century Fraternal Associations," that will include a discussion of the role and significance of lodge hall paraphernalia. She is the author of *Tradition and Change: The New American Craftsman* (E. P. Dutton, 1977).

Michael D. Hall, a well-known sculptor and artist-in-residence at Cranbrook Academy of Arts from 1970-1990, is the author of numerous essays on American folk art, including "A Sorting Process: The Artist as Collector," *Folk Sculpture USA* (The Brooklyn Museum, 1976), "The Hemphill Perspective — A View From A Bridge," in *American Folk Art: The Herbert Waide Hemphill Jr. Collection* (Milwaukee Art Museum, 1981) and "Hands-on Work: Style as Meaning in the Carvings of Elijah Pierce," in *Elijah Pierce: Woodcarver* (Columbus Museum of Art, 1992). His collected critical essays appear in *Stereoscopic Perspective: Reflections on American Fine and Folk Art* (UMI Research Press, 1988).

Jeffrey R. Hayes, consulting curator of the exhibition, is Associate Professor of Art History at the University of Wisconsin-Milwaukee, author of *Oscar Bluemner* (Cambridge University Press, 1991) and a contributor to *The Advent of Modernism* (High Museum of Art, 1986) and the *Expressionist Landscape* (Birmingham Museum of Art, 1988).

Lucy R. Lippard is the author of numerous books, including *Mixed Blessings: New Art in a Multicultural America* (Pantheon, 1990), and a contributing editor to *Art in America*.